SCULPTURE
WEST AND EAST
Two Traditions

OTHER BOOKS BY HERBERT CHRISTIAN MERILLAT

The Island: First Marine Division on Guadalcanal
Legal Advisers and Foreign Affairs
Legal Advisers and International Organizations
Land and the Constitution in India

SCULPTURE
WEST AND EAST
Two Traditions

HERBERT CHRISTIAN MERILLAT
Illustrated with photographs

DODD, MEAD & COMPANY · NEW YORK

ISBN: 0-396-06703-4
Library of Congress Catalog Card Number: 72-3934
Printed in the United States of America

TO C.C.M. AND R.E.L.M.

Acknowledgments

I WANT to thank friends who have helped me in a multitude of ways—Ralph and Carolyn Backlund, Catherine Drinker Bowen, Lewis and Emily Callaghan, Elizabeth La Branche, Mary Isabel Knox, Peter Storrs, John S. Thacher, Lane and Sanya Timmons, Richard and Helen Venn, and Edward Weismiller. I am also grateful to the staffs of the libraries of the Freer Gallery of Art and the National Gallery in Washington, where I did much of my reading for this book, and to Allen T. Klots, Jr., of Dodd, Mead & Co., who has helped with understanding, encouragement, and efficiency, to bring this effort to fruition.

Without implying any responsibility on their part for my statements of fact or opinion, I would like to thank those in the world of art who have assisted in various ways—Jeannine Auboyer, John Boardman, Yvon d'Argencé, Jan Fontein, Grace Morley, John Rosenfield, Benjamin Rowland, Laurence Sickman, Harold P. Stern, John Tancock, Cornelius C. Vermeule, and Bonnie Young. I am also grateful to the many members of museum staffs who have helped me to gather the illustrations.

I have drawn heavily on the writings of others, scholarly and popular. Some of the authors whose works I have used are mentioned in the text or in the short list of suggestions for Further Reading.

Preface

WHY does the Buddha have a knob on his cranium and long, pendulous earlobes? Who are the oddly named figures seen along with him, and what do his own various guises mean? Why do male figures in stone from India have belly bulges, sometimes slight, sometimes pronounced? Are those distracting struts and buttresses on many Greco-Roman marble statues really necessary?

In eight trips around the world and uncounted visits to museums I had gradually learned the answers to some of the questions that come to the mind of anyone who looks at sculpture. After a third of a century of browsing at home and abroad—increasingly, in recent years, in Asia—I realized how slowly and unsystematically most of us learn to enjoy, be moved by, understand, "appreciate," works of art we see on familiar ground or on a foray into new territory. Those years of looking at sculpture would have been far more satisfying if, at the outset, I had had the benefit of a better introduction to what I was about to see. On that eighth circumnavigation, standing in one of the Archaic rooms of the National Museum in Athens, I decided to write the book that I wished had been at hand some thirty-six years earlier.

Sculpture is my subject; more specifically, monumental sculpture—carved and molded objects more or less life-size—leaving aside smaller statuettes and figurines that are of a rather different order. I have dealt mainly with sculpture in the round or near-round—freestanding statues or works in very high relief, which we readily perceive by sight and touch as three-dimensional. Even thus limited, the

field is vast. I decided to concentrate on the two major traditions. In
the West the book starts with Greece at the close of the seventh cen-
tury B.C., and takes Rodin as a convenient and appropriate stopping
point. Three-dimensional art of the twentieth century, it hardly needs
be said, calls for a different sort of understanding and sensibility, largely
outside the older traditions. In the East, India just before the Christian
era is the starting point, from which we move with Buddhism (and
sometimes Hinduism) through China, Japan, and southeast Asia.

To speak of "two" traditions is to gloss over many sub-traditions
and offshoots from the main trunks that we find from time to time and
place to place. But there are consistencies in form and theme that give
each of the two a unified and different character. The twain have
sometimes met, but they are distinct. There is no discussion of other
important traditions—those of Egypt, the Middle East, Africa, and
the pre-Columbian Americas, although it should be noted in passing
that radiations from the Middle East have reached and affected both
of the major traditions.

This book is an introduction to the subject, not a survey. There
are excellent handbooks that give the novice (or, for that matter, the
more experienced) a general view of the art of a particular period or
culture. For those who want to dig more deeply there is a vast and
growing store of scholarly writing by art historians, archaeologists,
iconographers, and critics who have devoted their lives to studying
the art of a chosen civilization. Or, within a given culture, they have
concentrated on the works of a limited period in a selected region, or
of a particular artist or school. Unfortunately few of us have the lei-
sure (or, perhaps, the inclination) to read more than a small part of
this rich outpouring. A few specialized books are noted in the sugges-
tions for Further Reading.

The aim of this book is more modest than that of the more com-
plete and detailed surveys written by specialists. Yet, compressed and
incomplete as it must be, I hope it will give the reader some sense of
the sweep and development of the two traditions over more than two
millennia. I hope that he will be helped to enjoy sculpture from any
time or place within those traditions, through learning more about
recurring themes and becoming more perceptive of developments in
form.

For illustrations I have tried to select objects that form connecting
links in the chain of artistic development or decline, or that have spe-
cial aesthetic appeal. Some familiar statues and reliefs have been left

out to make place for carvings and castings less well known. Not all of them are free from scholarly controversy about attribution to a particular sculptor or place or period. Such problems are likely to be of more interest to specialists than to other visitors to museums; here I have noted only a few instances where the proper attribution is in question.

From a photograph we can get some notion of what a piece of sculpture looks like. In Malraux's "museum without walls" anyone, anywhere, can see works from all times and places. Two-dimensional reproductions, however, are an unsatisfying substitute for the real thing. In sculpture three-dimensionality, size, and surface textures are at the heart of enjoyment. I have had the good luck to see, at one time or another, most of the objects illustrated in this book.

To a considerable extent I have relied for illustrations on major museums in the United States. They are far richer in traditional sculpture than is commonly realized, especially in Asian works. Not all the important collections, unfortunately, can be adequately represented in the limited number of photographs. If, in addition to the experience possible in the United States, we can visit Europe, we will have an even more adequate view of the traditions. For a satisfying experience of the Renaissance we must go to Italy, and for much of the best of ancient Greece to the museums of Europe and to Greece itself. For a comprehensive look at Khmer art we should go to the Musée Guimet in Paris or to Cambodia itself, and for Javanese to the Dutch museums or to Indonesia. Many of the treasures of India can be seen only in that subcontinent. For the best in early Japanese sculpture we must visit Nara and Kyoto. But if we are limited to American collections, we will have feast enough. I have tried to write an introduction to traditional sculpture that will be useful to the man or woman who responds to this form of art wherever it may be.

Only a little is said in these pages about materials and techniques. There has been a long controversy between those who urge the special virtues of direct carving in stone or wood and those who favor modeling in wax or clay, usually with a cast-metal figure as the eventual product. For the one, carving is supreme; "truth to the materials" imposes a discipline to work within the space defined by a block of stone or log of wood and to bring out its distinctive qualities, and the inept carver has little chance to repair his errors. For the other, modeling permits the artist to work "organically," to build his figures from the core outward, and to express himself more freely. We can be neu-

trals in this quarrel, and enjoy both Michelangelo, the carver, and
Rodin, the modeler. At the same time, we should be aware of the dif-
ficulties, opportunities, and limitations inherent in the use of this or
that material or technique.

I have assumed that the reader is more or less acquainted with
the relevant religions, currents of thought, and history in the West. The
social background of sculpture is given in more detail for the less famil-
iar East. I have tried to keep to a minimum references to the stylistic
and dynastic periods into which art history is usually divided. System-
atic classifications of that kind, however important for the scholar and
student of art, are often confusing to the general viewer. And yet we
should learn to recognize works from a few key periods. The Glossary
explains some of the unfamiliar terms, especially from Asia, and in-
cludes some reminders for those who may have forgotten their Greek
mythology.

Not unexpectedly, my plans for this book met a mixed reception
from those whose professional careers are concerned with sculpture or
the visual arts more generally. Some have looked askance at such an
undertaking by one who has not spent his life in the specialized study
of the subject. A few have welcomed what might be a fresh eye and
voice: "we experts tend to write for each other, and to say the same
things." Some have been benevolently neutral, helping if not always
encouraging. For the most part I have visited museums and other sites
as a member of the general public, seeing the things that any museum-
goer can see, forming my own opinions and noting my own impres-
sions. Occasionally I have turned to scholars in museums and universi-
ties for advice on some puzzling question or permission to see objects
not currently on exhibit. I have extensively consulted, of course, the
relevant literature. This has been, however, mainly a personal explo-
ration, leading to a personal statement.

H. C. L. MERILLAT

Washington, D.C.

Contents

SCULPTURE
WEST AND EAST
Two Traditions

The titles of works of art that are illustrated in the book appear in italics in the text. The identifying numbers of illustrations referred to in the text appear in brackets.

CHAPTER

1

The Greek Achievement

THE ARCHAIC PERIOD

THE seventh and sixth centuries B.C., the Archaic period in Greece, are our starting point. The roots of Greek sculpture reach further into the past, and into other lands, but in this period began the great burst of activity that is distinctively Greek. In their innovation and experimentation the Greeks differed markedly from their neighbors in Egypt and the Near East on whose traditions they built. Those older civilizations are outside the scope of this book. Here let us simply note that within their rigid conventions in sculpture they yielded a remarkably rich variety and subtlety that continue to delight. The basic Egyptian conventions, spanning millennia, changed little in those thousands of years. Quite apart from the distinctive expressiveness of Egyptian art, its rugged simplicity and steady devotion to fundamental cubes and pyramids have inspired modern artists preoccupied with essential geometric form. By and large, however, Egyptian styles in plastic art evolved within fairly narrow limits.

Greek sculpture, in contrast, exploded with innovation after

1

the seventh century. The ferment was, of course, part of the broader and unprecedented exploration by the Greek mind of the universe and the human condition. No ancient culture except the Brahmin in India sought so thoroughly to knit together all knowledge and experience in a unified whole. The Greeks early understood the difference between rational thought and attempts to understand matters that lie beyond the reach of reason. After the Olympian pantheon had become more an instrument of civic control than a focus of devotion, myth and allegory continued to provide convenient symbols for poetic truth. Throughout, plastic art was a favored mode of presenting such symbols, and the human body a favored form, as gods, goddesses, heroes, and allegories.

One set of conventions learned from the Egyptians concerned "frontality": a god or royalty or more ordinary mortal stares straight forward, the left foot of a standing figure always placed a bit ahead of the right, shoulders squared, the arms held stiffly at the sides or crossed in certain established ways, with musculature undefined. The early Archaic figures of the Greeks embody the same conventions. The first Greek change from this static style came a century or two before the golden Periclean age in Athens, the Classical period beginning in the middle of the fifth century B.C.

We can trace the development in a number of major museums in the Western world. In the United States several collections provide a good view of the Greek experiment and achievement. The British Museum in London and the Louvre in Paris are even better, and the museums of Rome richer still. Best of all, of course, is Greece itself, even after the long looting by other nations.

In the Louvre, for example, we find some important early Archaic works. The *Lady of Auxerre* (dated seventh century B.C. by the experts) could be Egyptian except that she lacks the expressiveness that sculptors along the Nile managed to achieve

even within the limits of their conventional forms [1]. She owes
something to Crete. The figure is crude, severe, stylized, more in-
teresting, perhaps, as an historical link than as a thing of beauty.
The facial features are large, the brow low, and long coils of wig-
like hair fall over the shoulders in front. A long-fingered hand is
held to the chest, between small breasts. (For a long time to come,
the breasts of Greek female effigies will be understated, and will
never approach the amplitude of the Indian.) Her long skirt is
elaborately incised with geometric patterns typical of the period.
How she came to the town in central France where she was found
is not known.

Also in the Louvre is the somewhat later *Hera of Samos*. (We
ought not, incidentally, always take seriously the attribution of
godly names to particular effigies of males and females, although
this particular one seems certain to have been in a temple of
Hera, queen of the Olympian gods. Often, especially in early
works, the identification is not known with any certainty.) This
figure is almost circular in cross section, like a column, reminis-
cent of the twelfth-century kings and queens in the Royal Portal
of Chartres Cathedral where the long cylindrical bodies, in simi-
lar straight-falling garments, not only suggest columns but are in
fact part of the structural support of the arch [2, 48]. Some have
suggested that the *Hera's* form comes from imitating, in stone,
shapes that were dictated by the carving of a tree trunk. Her head
is missing. The right arm is held stiffly down at the side, in the
approved Egyptian convention, the left arm (mostly missing) held
across the chest. The breasts are slight. Straight or slightly curved
lines mark the folds of the garments, diagonally in the upper
mantle, straight down in the long skirt.

Moving into the sixth century B.C. we find an abundance of
conventional male and female figures known as *kouroi* (young
men) and *korai* (girls). Some of these were images of gods (Apollo
and Aphrodite, they are sometimes dubbed) used as votive figures
in shrines. Others were memorials to the dead.

Before we look at a few selected *kouroi* and *korai* let us note a few common characteristics. The Egyptian tradition is still strong. In standing figures the left foot is always forward. The laws of frontality are followed. The heads are nearly sexless. Facial features, especially in the early figures, are much the same in both males and females, and the hair of both hangs in long ringlets. The main indication of gender is the garments—or, more accurately, the lack of garments in the males. The women are small-breasted, the men usually slim-waisted with the same swelling upward of the chest to squared shoulders that we will find in Hindu sculpture.

Most museums that have major collections of ancient Greek art have a few of these early statues, at least in fragments. By far the best place to trace their development is in the museums of Athens—the National and the Acropolis—which provide enough examples for the viewer to see for himself the subtle changes in style that took place through the sixth century B.C.

There are, indeed, so many of these ancient marbles that we may wonder why there are relatively few surviving originals from the later Classical period of the fifth and fourth centuries. The answer seems to be that many of these were found in the "Persian Debris," the images destroyed or damaged when the Persians captured the sacred precincts of the Acropolis in 480. These desecrated statues were later buried. In one day of excavating in 1886 fourteen *korai*, or Archaic maidens, were found in one hole. Others have survived from Attic cemeteries. Later, bronze became the favorite medium of sculpture. Few bronzes survived the systematic looting by the Romans and the demands of later warriors who valued the melted-down metal more highly than the forms bestowed on it by Greek masters. As we will note more fully later, most of the statues from Classical times that we see are later marble copies of works that were originally cast in bronze.

The men are wholly nude, the women fully clothed. There are several reasons for the display of male flesh. By the middle of

the sixth century athletic contests were well established in the civic life and inter-city rivalries of Greece. In Athens there was a major contest every four years—the Panathenaic games. Competitors ran, threw, and wrestled naked. Male nudity was accepted as natural, and even regarded as a sign of superiority over lesser "barbarian" people, trammeled with garments, who did not make the same affirmation of the proud wholeness of the human being. Natural, and also beautiful. The aesthetic impact was presumably enhanced by the widespread practice of "Greek love" between males, then regarded as the ideal form of erotic attachment and friendship. Women held a low status; they were regarded as bearers of progeny and housekeepers. Not until the fourth and third centuries is there a similar interest in the female body.

One of the early *kouroi,* dated at the end of the seventh century, is in the Metropolitan Museum in New York [3]. The heroic statue is top-heavy with an oversize head. Incised lines or grooves indicate the rib cage, shoulder blades, leg muscles, shin bones, and other major features of muscle and bone. A colossal *kouros* of the same period (about 600 B.C.) stands in the National Museum of Athens. Again there are the tentative efforts to depict bone structure and musculature as we observe it in nature. The chest (one of the first to do so) shows four straight lines on each side of a central furrow (the "tendinous inscriptions" of anatomy, somewhat inaccurately placed) and two slanted lines to define the rib cage. The navel is one circle within another. The groin muscles and knees are strongly pronounced. The spine is marked by a furrow in the back. The eyes, which in later *kouroi* will come closer to life, are bulging half-circles, like those of the New York *kouros.* Apparently the face is expressionless; it is hard to be sure, for the nose and mouth are missing.

Both the National and Acropolis Museums in Athens abound in *kouroi*. It is fascinating to trace the gradual development of more naturalistic features as sculptors became sharper observers of human anatomy and bolder in carving what they saw.

Pick a few features—eyes, ears, collar bone, shoulder blades, nipples, navels, pubic hair, knees, calves—and notice how their treatment varies from time to time and place to place through the sixth century. One of the later *kouroi* shows how far the sculptor's skill and interest in depicting the human body had developed in little over half a century. This one, dated about 540 B.C., was a funerary monument dedicated to a young warrior named Kroisos [4]. In comparison with the New York *kouros* he is much closer to the living model in every respect, yet he retains the basic Egyptian conventions of frontality.

Quite apart from tracing the trend toward anatomical naturalism, the visitor who stands in a forest of Archaic figures of youths and maidens—say, in the Acropolis or National Museums in Athens—will find that he begins to pick out some favorites. For example, a *kore* from the first quarter of the sixth century (Catalogue No. 593) in the Acropolis Museum seems to stand out from the rest of these rather austere girls. The lines are simple and clean, but she is more delicately modeled than many of the others. The folds of the robe are also simple, but more detailed than in some earlier figures. The breasts, as usual in this period, are small. Here they are high and close together. One arm, in the Archaic tradition, is held straight down close against the body, holding a ring or garland. The other is crossed over the chest, holding a red amphora. Some of the red coloring is still there. We see it more vividly in the so-called *Peplos Kore* in the same museum (dated later in the century, about 530 B.C.) with hair and lips tinted red and traces of green in the dress [5].

Another illustration [6] shows a more sumptuous *kore* from about the same date, probably from the island of Chios. Here the folds of the garments and the fall of the plaited strands of hair help define a distinctly feminine figure. Her tunic, seen at the left shoulder, was painted blue, now turned to green, and the embroidered outer dress is red and green. These traces of color remind us that what we are seeing is quite different from what the Greeks

of the sixth century saw. To them the statues standing in museums would seem washed out and ghostly. All sculptures, whether free-standing or in relief, were brightly painted. Today we see, now and then, only vestiges of the pigment.

The conventions of the time, as we have noted, barred sculptors from carving the feminine figure in the nude. But they had a free hand in depicting her garments, and for this we may be grateful. A *kore* of the late sixth century has come a long way from the *Lady of Auxerre* or *Hera of Samos*. She is much more naturalistic and, even more notably, the carving of her garments is much more sophisticated. From straight or almost-straight folds, indicated by incised lines, we have moved through zigzag lines or ridges to more daringly carved, more naturalistic folds with looping, overlapping edges to the cloth. These are still simple and controlled, just hinting at the elaborately swirling garments that come later in Greek sculpture.

THE FIRST SIGNS OF MOVEMENT

Among the Archaic sculpture in the Acropolis Museum is the immensely pleasing *Moscophoros*—man bearing a calf—dated about 570 B.C. One wonders if the experts have dated it accurately, so finely modeled and superbly composed it is, and so surprising a departure from the early *kouros* figure [7]. There is a restrained but accurate naturalism about it that we do not find until later in other free-standing figures. Notice the strong forearms, crossed and holding the legs of the calf, likewise crossed, that is draped around his shoulders. The calf-bearer is smiling— the Archaic smile that we see in most sculpture of this period. The smile varies somewhat among the *kouroi* and *korai*— sometimes smug, sometimes gentle and contented, sometimes vapid. One wonders how the convention arose. It continues through the sixth century. The same feature occurs—quite independently, we must suppose—in the early Buddhist carvings of

China [139, 141]. Some scholars say that the trauma of the Persian Wars (490–479 B.C.) wiped the smile from the Greek face, but it is missing from some of the later figures of the sixth century and early fifth, in the transition from the Archaic to the Classical styles.

The calf-bearer is still frontal. But the mere fact that he is carrying a calf, which is itself carefully modeled, is a notable change from the standard *kouros*. As we move into the middle and late sixth century we find more and more departures from the Egyptian pattern.

Near the Moscophoros in the Acropolis Museum is the trunk of a horseman and a fragment of his mount, called the *Rampin Horseman* (named after a former owner). The head is in the Louvre [8]. He wears the trace of a smile. The hair and beard are elaborately but stylistically carved, and are still touched with red. His head is inclined to the right—a departure from the convention of frontality—and the whole ensemble of horse and rider, very much alive, foreshadows the later development of movement.

The slight motion of the Rampin rider's head means much more than a small departure from the well-established artistic canon of frontality, daring as that might be in itself. It is also a sculptor's early attempt to carve a figure in the round without depending on an outline he could draw or incise on the stone block he worked with, as the Egyptians did. Clearly, as a matter of technique, it is much harder for the sculptor to know just where he is going and where he will end up when he is no longer creating a purely frontal figure. Before, he could follow guidelines on the front and sides of the block, regulating how they would meet in the interior to give him his basic shapes, then add whatever refinements and detail he wanted. Now, moving the head or body around their central axis or tilting them at the joints, his task is much more difficult. The outlines constantly change as he gets deeper into the stone.

In reliefs, as in painting, it is relatively easy for the artist to show movement. A figure in the round is a challenge of a differ-

ent order. Again, modeling in a pliable material like clay or wax a sculptor can build up the figure from the core out, and make corrections if he is not satisfied with the way it is taking shape. For the carver there is no second chance once the chisel has gone wrong.

A magnificent bronze dated late sixth century can be seen in the National Museum in Athens, the heroic figure called the *Apollo of Piraeus*. There are still characteristics of the Archaic style, but also substantial changes. The right foot rather than the left is forward, both arms are raised, the hair is disordered and defined in less detail than usual, and the jaw line unusually straight. According to experts the circumstances of its discovery in 1959 during excavations for a sewer in the port of Athens—"digging for a better Piraeus"—leave little room for doubt about its antiquity, but it may be later than Archaic times [9].

Early in the fifth century, before and during the Persian Wars, sculptors fashioned in bronze and marble other figures that show growing mastery of anatomy and willingness to experiment with departures from Archaic conventions. One of the most famous is the life-sized *Charioteer,* dated about 475 B.C., now in the Museum at Delphi [10]. (A smaller copy in bronze can be seen in the Boston Museum of Fine Arts.) The full-faced young man, with eyes of inlaid stone and paste still almost intact, is dressed in the long tunic of a charioteer. His left arm is missing, but his right still holds the reins of his horses.

Another smaller figure from about the same date, similar in many respects to the charioteer, is the *Critian Boy* in marble, now standing in the Acropolis Museum in Athens, so-called because it might have been sculpted by Critios, the teacher of Myron [11]. A version in bronze stands in the Louvre. Lord [Kenneth] Clark has called it "the first beautiful nude in art." In its fine modeling, natural pose with the weight on one leg and hip somewhat raised on that side, and regular face turned a bit to one side, it is far removed from the early *kouroi*.

Seeing these works we realize that we are witnessing an im-

portant transition in sculpture, the beginning of a final break with conventions that had long inhibited Greek artists, a new preoccupation with nature, and an assured command of the human form.

THE GOLDEN AGE

Only a few years separate the *Critian Boy* from the majestic bronze *Poseidon* (sometimes called a Zeus), standing nearly seven feet tall in the National Museum in Athens, intact except for the trident he once was launching from his right hand and the stones that made his eyes [12]. The bearded god is one of the first single figures in the round shown in action and one of the few statues of the period to come down to us in the original bronze. From about the same date (460 B.C.) come the reliefs on the so-called *Ludovisi Throne,* now in the National (Terme) Museum of Rome, and its companion piece in the Boston Museum of Fine Arts on which Eros weighs two figures in the scales while two women (life-giving Aphrodite and Persephone, Queen of the Underworld, according to one version) sit at either side, one smiling and the other in grief [13, 14]. The delicate carving of the draperies shows an interest in bringing out the female form. These reliefs also show an attempt to get away from strictly frontal or profile figures. The result is not entirely happy. Aphrodite rising from the sea (if indeed she is the central figure on the *Ludovisi Throne*) presents her breasts, chest, and shoulders straight on to the viewer while her head is turned ninety degrees in profile. Similarly the seated ladies in the Boston relief have legs and heads in profile, while their upper torsoes are twisted a sharp quarter-circle toward us.

At about the time these other figures were being fashioned the great temple of Zeus at Olympia was being built. The figures in the pediments were almost, but not quite, in the round; the backs were not finished off. These and the high, deeply undercut

reliefs of the metopes, or panels, of the interior frieze, are land-
marks in the transition from the Archaic to the Classic. A splen-
did marble *Apollo,* still almost intact, stood at the center of the
west pediment, face turned to look along an upraised arm (much
the same pose as the *Poseidon* we have just seen), watching the
stony battle between centaurs and Lapiths. He is now in the
Olympia Museum [15].

This struggle was a favorite theme of Greek sculptors, and
appears again later in the century in the frieze of the Parthenon
in Athens. The King of the Lapiths, who were quiet and friendly
people, had invited the centaurs, half-men, half-horses, to the
wedding of his daughter, despite his guests' reputation for sav-
agery and bad manners. During the festivities the drunken cen-
taurs tried to make off with the Lapith women and children, and
a great fight ensued. For Greek artists it was a symbolic struggle
between civilization and barbarism. Perhaps out of awareness that
alliances rapidly shift and today's enemy may be tomorrow's
friend, the Greeks rarely depicted their wars as historical events.
More certainly the preference for symbol and allegory reflected
their constant search for the general truth that lies behind the
particular incident. In any event, the Persian Wars and other
major military contests usually turn up in sculpture as battles be-
tween Lapiths and centaurs or Greeks and Amazons.

Our picture from the Olympia metopes [16] depicts a scene
in the life of the hero Heracles, son of Zeus by Alcmene (a Queen
of Thebes, whose bed the god invaded in the guise of her hus-
band). His exploits of strength and courage made him a favorite
of the Greeks. Here we see him carrying the world on his shoul-
ders, about to return it to Atlas, who has come back with the
golden apples of the Hesperides. Athena looks on. One metope
from the same series at Olympia is in the Louvre. These are sim-
ple, almost severe figures, finely carved and modeled but with no
frills. There are still only two basic viewpoints—frontal and
profile—and no attempt to make sophisticated transitions be-

tween them. Like Aphrodite on the *Ludovisi Throne,* Athena presents her body straight at the viewer, while her head is sharply turned ninety degrees to the left. They are perhaps at the high-water mark of the clean-cut and rather austere Doric style of the mainland west Greeks in contrast with the softer Ionian style of the east Greeks, in what is now the Turkish coast and offshore islands.

This was the period when Myron flourished. In the fifth and fourth centuries, and later, we hear a great deal about individual sculptors and their works. The names of the major ones are familiar to us: Myron, Phidias, Polyclitus, Praxiteles, Scopas, Lysippus. What is less well known to us is the fact that we have never seen a sculpture that can be confidently attributed to any of them. There are Roman copies galore—at least they are copies of statues having the same themes that the famous artists are known, from literary sources, to have wrought in stone or bronze. More likely the originals were in bronze, for that was the favored medium, so the copies or replicas in marble are even further removed from the master sculptors' own work. There is no way of knowing how faithfully the copyists caught the nuances of the masters. Indeed, there may be so many variations among copies that we cannot even be certain of the basic pose of the supposed original.

It is an unsatisfactory state of affairs for those to whom the name of the sculptor is the signal to admire a particular work. The artists' names, however ambiguously conferred on statues in some of the museum labels, do at least serve as guideposts to significant changes in style and technique. Myron is known to have fashioned in bronze an athlete in the act of throwing a discus. Accordingly the bronze torso and replicas or reconstructions of the complete figure of a man in such a pose are generally thought to be copies of Myron's original. In any event the well-known Discobolos is a remarkable feat for the mid-fifth century B.C. It is the first known free-standing figure of a man in violent action—not

just standing with body turned and arms raised, but with body doubled up and twisted on its axis within a balanced and stable composition. Someone has thought to test the "reality" of the pose by making movies of a man winding up to hurl a discus. Not surprisingly, no single frame matched the attitude of Discobolos. That may be an amusing sort of exercise, but it is quite irrelevant to the sculptor's problem of expressing movement convincingly —and without, it should be noted, the assistance of flying draperies. But, like the bronze *Poseidon* [12], Discobolos is like a high relief removed from its background. Neither is, in that sense, wholly in the round. Neither would convey much to the viewer if seen head on.

Two other landmark statues, from the second half of the fifth century, are the *Doryphoros* (lance-bearer) and Diadoumenos (boy tying a fillet in his hair) attributed to Polyclitus, of which many copies exist. The *Doryphoros* in our illustration is a copy in Naples [17]. The Greek mind, like that of many cultures, was intrigued by mathematics as a key to other harmonies, including those of the sculpted human form. Apparently the Greeks never developed in the same minute detail as the Brahmins of India instructions for the size or proportions of icons of their gods, but it is clear that they did have some guidelines, varying from time to time. One such canon was developed by Polyclitus. It has been lost, but the statues of his school of sculpture give us a fair idea of his rules. Two features stand out. The head is somewhat larger than in later figures. And the male torso is chunkier, with exaggerated muscles, especially where the abdomen joins the thighs. The line of the ileac furrow, where the loin muscles overlap the top of the pelvic bone, and the fold of the groin is deeply indented. Taken with the remainder of a muscle-builder's chest and belly muscles they form what has been called the "aesthetic cuirass."

The Polyclitan statues mark the final demise of the Archaic conventions, and an innovation of greatest importance for West-

ern sculpture. Strict frontality had long ago disappeared. The head had been turned, the arms raised, bones and muscles better defined in many free-standing statues from the late sixth century on. But still the weight had been more or less evenly balanced on both feet, as in the bronze *Poseidon* and in the *Apollo* of the Olympia pediment. In the *Critian Boy* there was a slight suggestion of an *hanché* attitude—the out-thrust hip of the leg supporting the weight—which is now much more pronounced in the work of Polyclitus's school. From now on it will be the standard form for the standing human figure, soon even for the female, whose curves it especially graces. The whole body shifts into a complicated balance, with a lower shoulder on the weight-supporting side, a higher on the side of the "free" leg, which is typically stretched out a bit behind the central axis.

PHIDIAS AND OTHERS

The developments we have traced took place largely in the first half of the fifth century. The Persians had been driven back, and the alliance of city-states that had opposed them began quarreling again among themselves. Athens, however, achieved a brief ascendancy in a period of unaccustomed peace in the third quarter of the century. Pericles was the dominant political figure in Athens, and among his projects for the glorification of his city was the re-creation of the Acropolis. Its crowning glory was to be the Parthenon, the Temple of Athena Parthenos (Virgin), a patron goddess well deserving of the city's gratitude. These great works were entrusted to Phidias, who had already won a reputation as a sculptor.

To see his work as a carver of marble figures we should visit the British Museum, which has, in the Elgin Marbles, most of the friezes and groups from the pediments of the Parthenon (although there are important fragments in other places, especially Athens and Paris). But can we speak of it as "his" work? That he

planned and managed the new creations in architecture and sculpture that became the glory of Athens we can be certain. Whether or not he did a significant amount, or any, of the actual carving is an open question. We do know that he got into serious trouble for alleged peculations as manager of Athenian artistic works and was eventually exiled, despite vigorous defense by Pericles.

The friezes and pedimental figures are so well known that I am tempted to pass over them quickly. But every new look at them brings out fresh points, and they are, with considerable justice, regarded as the culminating achievement of Classical Greece. In the outer frieze appeared the Panathenaic procession, held every four years, in which the citizens of Athens climbed up the hill of the Acropolis from the agora below to bestow a new garment on the colossal image of Athena within the Parthenon. Several features of these reliefs (now mostly in London) should be noted. In many of them the sculptors have overcome the problem of twisting a body on its axis in a controlled and convincing way. Within a thickness of a few inches of stone the Phidian carvers have succeeded in giving their compositions astonishing depth, several animals or humans superimposed on each other without crowding. Here "Greek drapery" is highly developed. A horseman's swirling mantle accents the movement of his charger, and its folds help define the torsos and legs. The highlights made by protuberances pressing against cloth bring out the shapes of breasts and thighs and knees. The faces, which have been impassive and almost expressionless since the Archaic smile disappeared, remain the same in the Parthenon carvings. A centaur lifts a struggling Lapith woman from the ground, or a rider controls his prancing mount, or a maiden escorts the new garments for the image of the goddess—and all wear the same wooden expression of someone in a daydream. This Greek insistence on the "idea" of a beautiful human face, unsullied by the accidents of individuality or by the play of temporary feelings, may begin to

daughters, she was better off than Leto, who had only two children. Leto's son and daughter, the gods Apollo and Artemis, had been sired by Zeus. To avenge the affront, Apollo dispatched Niobe's sons and Artemis killed the daughters, including the unfortunate girl in our illustration. This is one of the early attempts to depict a female unclothed, or almost so. Few find it entirely successful. Apart from the nubile breasts, the figure is thick and mannish.

A few full nudes have come down to us from the late fifth and early fourth centuries, but we must wait until the second half of the fourth for the emergence of the female form in full glory. The sculptor Praxiteles, according to a story repeated by Pliny, made two images of Aphrodite, using the courtesan Phryne as his model. One was clothed and one not. He offered the citizens of the isle of Cos their choice. They preferred the more conventional figure of the goddess in seemly garments, and the rejected statue wound up in the town of Cnidos, long a center for the cult of Aphrodite. Even though marble flesh, in even franker terms, was by no means foreign to these neighbors of the Near Eastern fertility goddess Astarte (in whom Aphrodite had her origins), the Cnidian statue caused a considerable sensation. Many thought it an impiety to the goddess. It was a tourist sight for centuries.

The figure is now so familiar that it is hard to imagine the stir. The goddess of love is stepping into her bath, hip thrust out above the leg supporting her weight, the other leg flexed as if she is about to take a step, one hand grasping a towel and resting on a large urn, and the other poised modestly over, but not quite covering, her pubic area. The full, round breasts are a marked change from past conventions. The version illustrated here is from the Vatican [22]. There are, however, dozens of copies—forty-nine, by one count—and we cannot be certain which, if any, is a true replica of the statue that stood in Cnidos, so sensuous, front and back, that men wanted to reach out and touch it. To the modern eye the Vatican version is probably less alluring than

the armless and headless one in the Louvre.

After the epiphany of the nude Aphrodite on Cnidos the statues of undraped ladies grew rapidly in number in the Greek and wider Hellenistic world. And in almost every conceivable posture: modestly shielding, but also calling attention to, the bosom and mons ("Venus of Modesty"); crouching; leaning to put on a sandal; drying the hair. Some are full-bodied women, some nubile girls. That the impassive, idealized, and generalized Classical faces can also be individual and supremely beautiful we can see from such carvings as the *Bartlett Head* in the Boston Museum of Fine Arts, made in the Praxitelean manner in the fourth century [23].

In our illustration of the Cnidian Venus you will notice that the face strongly resembles that of another famous statue by Praxiteles—the somewhat larger than life-size *Hermes* of Olympia. It would be hard to tell from the face alone whether one or the other is man or woman. The *Hermes* too is so familiar that we tend to pass it by with no more than the look that we think is required for a sculpture so famous. It deserves closer attention [24].

Like male figures of the Polyclitan school, those of the earlier fourth century tended to be stocky and over-muscular. In a large bronze *Heracles,* found in the sea off the isle of Anticythera (now in the National Museum in Athens), the torso is still thick and broad and the "aesthetic cuirass" still evident. But the head is smaller in proportion and legs longer [25]. In the Praxitelean *Hermes* the bulky chest and abdomen have been much refined. The whole body is supple and graceful without being effeminate, in contrast to the softness of many products of Praxitelean sculptors. Conceivably this masterpiece is an original from the chisel of Praxiteles himself—one of the few existing free-standing works that could possibly be attributed to any of the major Classical sculptors—but that is a matter of long and complicated scholarly controversy.

One late Classical masterpiece is the frieze from the Mausoleum of Halicarnassus in Asia Minor, carved in about the middle of the fourth century. The long band of reliefs depicts the battle between the Greeks and the Amazons. In the illustration, from one of the panels now in the British Museum, the Greeks seem to be having the better of it [26]. One Amazon, her tunic swept aside by violent motion to reveal most of her body, is still fighting, if somewhat defensively. A second is about to receive the *coup de grâce*. The series of figures is like a set of toppling dominoes. The fighting ladies fare distinctly better in some other panels. In all of them the sculptors (most of the eminent Greek masters then living, it is said, including Scopas) have made generous use of strong diagonals; compare this panel with the Durga relief at Mamallapuram in India [124]. The uncluttered reliefs from the Mausoleum recall the austere simplicity of those on the Temple of Zeus at Olympia [16], but the modeling of the later figures is more sophisticated and the action far livelier.

AFTER ALEXANDER THE GREAT

In the third quarter of the fourth century B.C. Philip and Alexander of Macedon conquered the Greek city-states and most of the known world between Rome in the West and China and India in the East. When Alexander's death at the age of thirty-three ended his career in 323 B.C. his empire split into smaller units. One successor kingdom was based on Macedon itself north of Greece, another on Alexandria in Egypt, another on Pergamon in what is now Turkish Anatolia, and still another on Antioch in Syria. Politically Greece itself became a provincial backwater. In learning and art, however, it remained preeminent, with the cultural center of gravity shifting from Athens to the eastern shore of the Aegean. Greek remained the common language of the educated elites throughout the "civilized" world, like English in India and other former British colonies today.

The new Hellenistic world was cosmopolitan, not civic. Armies and athletes were hired professionals, not free citizens of small states. Government was imperial, not local. The main patrons of the arts, including sculpture, were no longer city-states building local sanctuaries and local government structures but emperors, governors, and rich businessmen out to glorify their names with temples and to decorate their palaces and villas. The Hellenistic period is usually dated from the reign of Alexander (336–323 B.C.) to the Augustan empire of Rome beginning in 31 B.C. As it wore on Rome began to make inroads into the Hellenistic world, taking over Greece itself by 146 B.C. and Asia Minor and Egypt thereafter.

Lysippus, court artist to Alexander the Great, was the last major sculptor in the transition from the Classical to the Hellenistic. One of his contributions to development of the Greek tradition was a new canon of proportions for the human figure, with a smaller head and more slender body, replacing Polyclitan rules for making chunky musclemen. Another was to twist the body somewhat more daringly on its central axis, creating forms that would be understood and pleasing from any point of observation. Before, statues were carved or cast mainly to present one plane and were meant to be seen from the front or some other particular point. The *Hermes* of Praxiteles, otherwise very Lysippan, was fashioned to be seen from the front and, in the marble version that we have seen, was not even completely finished in the back. The Apoxyomenos (athlete scraping the oil from his arm), attributed to Lysippus, displays both the new canon of tall slenderness and the greater torsion.

"Then art stopped," said Pliny of the period after Lysippus. The comment has some truth if it is taken to mean that by then the Greeks had mastered most of the problems of presenting the human body in marble or bronze. They had started with the rigid, blocklike frontality of the early Archaic period. They had moved in Classical times to more anatomically accurate bodies

and faces, but still restrained by notions of the "ideal" and with figures still largely frontal or in profile, or in combination, without subtle and convincing transitions. They had learned to use drapery to help define the contours of a body and to indicate motion. With Polyclitus they had discovered the more natural pose of a standing body, with the weight mainly on one leg, and the other bodily adjustments that go with the *hanché* attitude. They had experimented with different ways to bring out musculature, in the Polyclitan aesthetic cuirass and then in more naturally modulated surfaces. They had learned to twist the human body on its spinal axis and tilt it at major joints.

But art by no means stopped with Lysippus. Some of the most satisfying Greek sculpture comes from the last three centuries before Christ. What carvers now did was to apply more daringly the lessons they had learned, and add embellishments, especially in the use of drapery for decoration, that the Classical period would have shunned. Twisting, or torsion, of the body became more common and more pronounced, and faces much more expressive. Groups of two or three figures were organized in more complicated interlocked relationships and used to take advantage of the possibilities for spiral composition. Greater naturalism is the keynote of Hellenistic sculpture.

There were also changes in mood, intention, and theme. By now artists were not seriously trying to present the human body as an ideal of beauty and incarnation of the divine. For the most part they wanted to titillate, flatter, or amuse their new patrons rather than inspire reflection on eternal verities. Ordinary people, from all parts of the known world—not just the gods, heroes, and athletes of Greece—were regarded as proper objects of the sculptor's interest: a mature and muscular professional boxer, his brutish face scarred and nose broken [27]; a massive, arrogant prince from Syria [28]; an old peasant woman coming from market, with an incongruously firm body bent under her burdens [29]; a barbarian Gaul, defeated in a war in Asia Minor, killing his wife

and then himself to avoid capture [30].

In the *Suicidal Gaul* we find the new emotionalism, fidelity to nature, and use of torsion at their peak. From the face of the dead or dying wife to that of her husband is a turn of 180 degrees. His nudity, still full of life, contrasts dramatically with the draped and sagging body of his spouse. Blood has begun to spurt as the dagger descends—almost certain to be checked by his collar bone, it appears. The group could be, and undoubtedly was, an inspiration for some of the serpentine statuary of the Baroque period eighteen centuries later.

The *Laocoön* in the Vatican, from the second century, is the most familiar example of the new taste for depicting human faces and bodies contorted with feeling [31]. Laocoön, priest of Apollo in besieged Troy, pleaded with the Trojan leaders not to take within the city walls the Greeks' wooden horse. To silence him (according to one version of the tale) Athena, who wanted the Greek ruse to succeed, sent two serpents from the sea to strangle the priest and his sons. The discovery of the work in an excavation in Rome in the sixteenth century (Michelangelo was there when it was dug up) stirred Renaissance sculptors' own interest in showing groups in violent action.

The Hellenistic artists favored pairs or groups (of humans, or of humans and animals) over single figures in action. After the Discobolos there is seldom a lone, free-standing body in such an attitude of effort or struggle. For statues in the round, standing without the support of any background, groupings incidentally helped to solve a technical problem. Casting statues in thin bronze the artist can stand his figures on small and narrow surfaces—such as human feet—joined to a broader base, without fear that they will topple. Carving in heavy marble he has a much more challenging problem. Thus we commonly find sculptures of single standing figures supported by a tree trunk or high vase or other device. And often, especially in Roman marble copies of works that were originally in bronze, we see ugly struts that con-

nect the body with its support, distracting the viewer from more important things [17, 22].

When standing bodies touch in some way they lend each other support, or one of the figures in a kneeling or crouching position will give the necessary stability. A similar concern for a firm footing may account in part for the half-draped female statues, of which the *Venus of Milo* (Aphrodite of Melos) in the Louvre is the most famous example. She is also, despite her tiresome familiarity, immensely pleasing. The garment falling in folds from her hips gives her a solid base. It also helps define a more solid conical form than is seen in the human body standing on its legs with empty space between them, and its roughness sets off the fleshlike smoothness of her torso [32]. The *Aphrodite of Cyrene* in Rome's Terme Museum, of uncertain date, is probably the most appealing of all to the American eye [33].

The *Victory of Samothrace,* as familiar as the *Venus of Milo,* is also of the second century B.C. and also stands in the Louvre [34]. Her lower garments too help give stability to the winged goddess. Her swirling draperies, the clinging "wet" style, define the feminine form and help suggest the motion of landing from flight on the prow of a ship. The massiveness of the cloth wrapped round her right leg, carved into ridges and canyons, is an example of the extravagant Hellenistic use of draperies for decorative effect. There are many more extreme cases in the works of this period, where arbitrary bunchings of cloth and organizations of deep folds have little to do with the way that cloth behaves in nature. In her original setting outside a shrine, the *Victory* was meant to be seen from the front and left side. Visitors to that famous staircase in the Louvre over which she presides can see that the right rear part has been left unfinished.

The art of the ancient Greeks had by this time run its full course of experimentation, innovation, and development, from the frontal, stiff simplicity of the early *kouroi* to the contorted naturalism of *Laocoön.* It was a remarkable achievement, un-

matched in any culture, but then no other society, except those later influenced by the Greeks, was inclined to explore so thoroughly the road to naturalism. The extravagances of the latest Hellenistic phase—intensely emotional expressions, extreme bodily torsion, artificial poses, arbitrary arrangements of voluminous draperies, sentimental themes—have put it low in modern critical favor, like the similar extravagances of Baroque sculpture. But we have seen some of the nuggets amid the dross. For better or worse, the tradition that the Greeks established and developed so deeply impressed itself on Western civilization that we find its traces all about us even today.

CHAPTER

2

Rome to Renaissance

Others will better mold the breathing bronze,
Draw out the lifelike face from marble block . . .
Remember, Roman, *thy* art is to rule
O'er other peoples, found their peace in law,
Put down the proud and spare the humble ones.

Aeneid

T HE "others," of course, were the Greeks. Virgil's relegation
to them of the plastic arts (along with rhetoric and astron-
omy) while the Romans went about the serious business of
governing an empire did not mean that Romans scorned either
the Greeks or their art. As their grip tightened on Greece itself
and on the whole Hellenistic world the Romans looted the con-
quered territories of their treasures. They became the West's first
art collectors, carrying off, or buying from those who had carried
off, the best of Greek sculpture for their temples, public build-
ings, and villas. Romans could enjoy the authentic works of the
great masters, which we can never see. Phidias's colossal Zeus at
Olympia was taken to Constantinople, his Athena to Rome.

After an abortive revolt in Athens in 46 B.C. Roman plunder-

ing was wholesale. Shiploads of art treasures were moved to Rome. Some of the best Greek statues that we can now see have been recovered from wrecks of that period, such as the bronze *Poseidon* found off Cape Artemesium [12].

But the plunder did not satisfy the Roman appetite for sculpture. Moreover, there was much new sculptors' work to be done. Emperors must have statues and reliefs glorifying themselves and their battles. Those who could afford them wanted portraits of selves and families, and burial chests for their dead. Architecture, the practical art form that most deeply engaged Roman interests and skills, produced buildings that must be decorated, from public hippodromes to private houses. Greece provided most of the craftsmen who manned the Roman workshops. They turned out carvings and castings by the thousand. In Rome alone, in the fourth century A.D., nearly four thousand bronzes were counted. Greek works were copied in marble on a large scale. As early as the first century B.C. copying machines (still used today in improved form) had been devised to make easier the production of replicas.

"DRAW OUT THE LIFELIKE FACE"

The main novel contribution to the development of sculpture in all this activity was Roman portraiture. Until Hellenistic times the Greeks had avoided naturalistic individual portraits, just as in the theater actors always wore masks. They had a philosophical preference for the general idea—of a god, a goddess, philosopher, or statesman—that lies behind the particular embodiment. At certain times, at least, they feared the cult of the powerful man; an individual glorified in art was raised above his fellows. In their own down-to-earth fact-minded way, the Romans wanted sculptors to depict individuals as honestly and truly as they could. The emperors were somewhat of an exception; a bit of flattery on the artist's part was not rejected. But even imperial

busts were closer to nature than the early Greeks had been accustomed to make for themselves.

In a cabbage patch of Roman heads the viewer may find himself inventing games to keep up his interest. A possible one, which works best with heads of emperors, is to try to read the character in the stone or bronze, then check one's findings against some such account of imperial Rome as Gibbon's *Decline and Fall.* For example, I have made the following notes:

CALIGULA (A.D. 37–41): slightly undershot jaw, thin-lipped, handsome in a rather weak way (but one must discount a possible element of flattery), probably not a strong character. Gibbon does not start his history until the second century A.D., but other sources remind us that Caligula was vicious and cruel, and probably mad.

ANTONINUS PIUS (138–161): strong face, to the extent it can be seen through a full beard; rather close-set eyes; you would buy a retirement lot in Arizona from him. Gibbon gives him high marks, "that amiable prince" who "diffused order and tranquillity over the greatest part of the earth."

CARACALLA (211–217): very short hair, short beard (as if he had simply neglected to shave for two or three days), oval head, and arrogant, cruel face with deep-set eyes under frowning brows. Gibbon confirms: "the demeanor of Caracalla was haughty and full of pride"; he was "the common enemy of mankind," "a monster whose life disgraced human nature" [35].

BALBINUS (238): moon-faced, large double chin, small mouth, rather petulant expression, and mean face. According to Gibbon he was less mean than weak, holding the throne only a short time with a co-emperor who despised him as "a luxurious noble" before both were murdered by the Praetorian Guard.

In any major Greco-Roman collection there is bound to be a portrait or two of the Emperor Augustus. The head with a wide cranium, a V-shaped face tapering from the broad temples to a small chin, and a long, noble Roman nose, becomes a familiar and somehow reassuring sight, like an old friend [36].

Through the first three centuries A.D., before the Roman Empire became Christian, large standing portraits of the great and wealthy, as well as busts, abounded. These solemn figures in stone and marble soon pall. They became routine and repetitive, and were turned out *en masse* from the sculptors' workshops. To see just how badly Roman portraiture could go wrong, look at the heroic bronze, from the third century A.D., in New York's Metropolitan—pin-headed, thin-armed, barrel-chested, a parody of the human figure [37]. It is labeled as possibly a portrait of the Emperor Gallus, who ruled briefly and without glory in the middle of the third century. It has been suggested that the massive torso is meant to give an impression of power.

After the center of empire shifted to Constantinople in the third century there was very little more monumental sculpture. A few life-size statues of emperors and important officials have come down to us from the fourth century. Some of them can be found in the Archaeological Museum in Istanbul. A colossal statue in bronze, possibly of the Emperor Marcian, stands in Barletta near Bari on the eastern coast of Italy [38]. Cast in the fifth century, standing more than sixteen feet high, it is the last surviving example of Roman triumphal statuary.

"INSTANT SYMPATHY
OR INSTANT CONTEMPT"

Before we take up Roman sculpture in other forms we should back up a bit and look briefly at another civilization on the Italian peninsula which flourished and declined at about the same time as the Greeks.

About all that is now known of the Etruscans comes from

their tombs. The Romans who vanquished them, after Etruscan kings had briefly ruled Rome itself, left few traces. Their language has never been deciphered. It is thought that the Etruscans came in several waves of migration from Asia Minor, establishing their rule in west-central Italy by about 800 B.C. Etruria became the dominant state in that region for several centuries, finally falling to the Romans in 280 B.C. Through most of this history their art had been strongly influenced by the Greeks, but retained a ruggedly simple and appealing character of its own.

The first time he "consciously saw" Etruscan things, wrote D. H. Lawrence, he was "instinctively attracted to them. And it seems to be that way. Either there is instant sympathy or instant contempt and indifference." Perhaps indifference is a common reaction, but seldom, surely, contempt. Always an admirer of primitive vitality and a scorner of "boiled-down" artiness, Lawrence found much to praise in Etruscan vigor and directness, which he preferred to the "perfection" of the Greeks. The victorious Romans disparaged the Etruscans, their former rulers, in every way and much of their denigration has become standard scholarly comment. With a fresher and less prejudiced eye, the viewer may find himself agreeing with Lawrence.

One distinctive form of Etruscan art was the cinerary urns—boxes, usually of easily worked alabaster, carved in deep relief, to hold the ashes of the deceased, whose effigies in miniature rested on the lids. The reliefs often have a rugged liveliness, giving scenes like the battle between Greeks and Amazons. The figures on the lids are usually reclining bodies, dwarfish in comparison with disproportionately large heads, often with faces that only an archaeologist could love.

The most pleasing pieces are small bronze figurines and engraved jars, works that lie outside the scope of a book on monumental sculpture. One favorite theme, however, should be mentioned. It is an Etruscan warrior with crested helmet and leathern corselet, surprisingly naked below mid-buttocks. He is likely to be

found in any substantial Etruscan collection. The Metropolitan Museum in New York has six versions, of which one appears here [39]. This theme was picked up in the three most famous pieces of monumental Etruscan sculpture, on view in the Metropolitan for many years, which turned out to be not Etruscan at all, but Roman—of an epoch two millennia later.

These three big terra-cotta figures were a thin warrior six feet tall; another warrior eight feet tall with huge crested helmet, his right arm poised to launch a spear, and his legs planted in a fighting stance; and a colossal helmeted head four and a half feet high. For a quarter of a century there was heated scholarly discussion about their authenticity. At last one of the skeptics tracked down in Rome a seventy-eight-year-old tailor who said he had worked with a group of restorers in nearby Orvieto; they had forged the statues back in 1914. The gang, having fashioned the huge figures, had broken them into pieces to heighten the impression of antiquity.

The large standing warrior was delivered in seventy-eight fragments. Any lingering doubts about the fact of forgery were dispelled when a representative of the Metropolitan Museum flew to Rome with a cast of a hand from which the thumb was missing. A thumb-shaped piece that the surviving forger had kept, apparently for sentiment's sake, fitted exactly. Moreover, chemical tests of the glazes turned up compounds not known in Etruscan times.

Art News reported that another fragment of the "original" was also missing. It seems that the fakers had equipped the heroic statue with a male organ of appropriate size. A curator then in charge of the Classical department of the Metropolitan, apparently for reasons of delicacy, did not include this feature on the reassembled warrior. A later curator found the part and attached it, but a few months afterward a person or persons unknown broke it off. It has not been seen again, in public.

Among the authentic Etruscan pieces of monumental size are

the lids of sarcophagi (much larger than the cinerary urns) carved
with reliefs of husband and wife lying side by side, with arms
about each other, close in death as in life. Our illustrations show
a charming relief in stone from the Boston Museum of Fine Arts
[40], and another, built up as figures in the round in terra cotta,
from the Villa Giulia in Rome, the main museum for Etruscan
works [41].

OTHER ROMAN MEMORIALS

Apart from true-to-life portraits the Romans sponsored two
other distinctive forms of memorials. Those of one type cele-
brated military victories and other imperial happenings, in the
form of relief panels. Some adorned arches of triumph and others
were made into narrative strips in bronze, like that spiraling
round the Column of Trajan. The reliefs on these monuments
were often placed so high, and carved or cast on so small a scale,
that they were all but lost to the viewer for whose edification they
were created. Seeing them in museums as displaced fragments we
can observe them better than the Romans for whom they were in-
tended.

More accessible, and more enduring in their impact on the
sculpture of the distant future, were the memorial sarcophagi for
the dead of affluent families. Any substantial collection of Greco-
Roman art is likely to have at least one example. Visitors to the
Louvre will recall a long room lined with sarcophagi that leads
from the entrance to the *Victory of Samothrace*. Most people
hurry through on their way to richer rewards. Yet these and other
Roman receptacles for the dead are often delightfully carved,
show the gradual decay of the antique style and tradition, and
form an important link with the primitive art of the Christian
Empire. Later they served as ancient models in the revival of the
antique tradition a thousand years after the end of pagan rule in
the Roman world.

The themes of the reliefs are usually combinations of a god and a mortal, appropriate to commemorate the passage of a human soul into the unknown, ushered or looked after by a god. One favorite scene shows Bacchus, or Dionysos, worshipped by the mystic sects, alone or with Ariadne, the Minoan princess he mated on Naxos after her abandonment by Theseus. Another depicts the moon goddess Selene with her beloved shepherd youth Endymion, doomed by her to eternal slumber. Our illustration from the Walters Gallery in Baltimore shows Dionysos and Ariadne [42]. The god (his head is missing) leans on a companion in the bacchanalian revels. A satyr lifts the wraps from Ariadne, sleeping and not yet aware that Theseus has deserted her.

These reliefs are typically crowded with flora and fauna, and with human figures that tend through the years to become more squat and blocklike. Interest in presenting the human body seemed to wane toward the end of pagan Rome. It is as if, after sculpture reached a peak of naturalism in Hellenistic times, there was nothing fresh to find along that road, and a withdrawal into more primitive forms ensued. Moreover, even before Christianity was formally established as the state religion, there was a philosophical turning to the life of the spirit and depreciation of the physical world. The carvings on sarcophagi form an easy and natural link between the pagan and Christian eras. The shepherd with a lamb draped round his shoulders, for example, was often used in bucolic scenes in pre-Christian reliefs. He readily became the Good Shepherd in the new religion.

GRAVEN AND MOLTEN IMAGES

Junius Bassius, a prefect of Rome, died in 357, forty-five years after Constantine embraced Christianity. He received Christian burial in a sarcophagus that gives us an early example of themes in the new religion carved in forms borrowed from the old. It now rests in the Vatican Museum [43]. Eight panels show

scenes from the Old and New Testaments. Adam and Eve stand in naked modesty, awkward and large of head but still unmistakably in the antique tradition. Christ, enthroned and flanked by Peter and Paul, and again, entering Jerusalem astride an ass, is carved as a blandly handsome young Roman, reminding us that the Holy Land was part of the Greco-Roman world. Abraham and Daniel look like Roman patricians.

Such early portrayals of Christ and saintly personages caused considerable uneasiness among the faithful. Were they consistent with the new religion, which banned idolatry? The question was variously answered at different times and places during the next few centuries. A waning paganism was not extinguished overnight by the conversion of the emperor in 312, or even by the formal edicts of Theodosius in 380 that proscribed worship of the old gods and ordered destruction of their shrines. Pockets of paganism survived, especially in the Hellenized cities like Athens, Alexandria, Antioch, and Rome. But the ancient sculpture was practically at an end. The tradition we have traced, beginning with Greek Archaic figures in the seventh century B.C., was suspended for centuries. The making of statues in the round faded out. Relief carving, on sarcophagi and other memorials, lasted longer, but became more and more decorative and geometric, with less emphasis on and cruder carving of the human figure.

The new Christian art for the most part shunned everything that smacked of the old cult of the body. It was meant to turn the thoughts from fleshly pleasure and worldly life to the welfare of the soul and the hereafter. "Thou shalt not make unto thee any graven image, or any likeness of anything that is in heaven above, or that is in the earth beneath, or that is the water under the earth. Thou shalt not bow down thyself to them nor serve them." Sculpture more than painting gave offense under the Mosaic law, for most pagan gods took the form of idols in stone or bronze. For a long time Christians had scruples about presenting Christ or God except in symbolic form, and a divine figure was not intended to be a portrait.

But even in the first three centuries of the Christian era, when such scruples were at their strongest and the religion existed underground, Christians used painting and sculpture in their shrines. A synod of bishops in Spain about 315 adopted a canon forbidding pictures in the church "lest what is worshipped be what is painted on the walls." But in practice the trend was against so rigorous a rule. A letter from Pope Gregory to a bishop at the beginning of the seventh century states a view more in accord with practice. Pictures, he said, are used in churches so that "those who are ignorant of letters may by merely looking at the walls read there what they are unable to read in books"—a precept that a Brahmin priest or a Buddhist abbot could heartily endorse.

The Eastern Church based on Constantinople never did officially tolerate statues in the round, and more reluctantly than the West accepted painting. In the eighth century a wave of iconoclasm swept through the Eastern Empire, when it appeared to the high clergy that image-worship in churches was leading to a pagan revival. A council in 754 denounced artists who "with unclean hands would bestow a form upon that which ought only to be believed in the heart." All images, it ruled, should be erased or destroyed. A succession of emperors backed the policy, but there was massive resistance, and the proscription was abandoned by the end of the century. The second Council of Nicaea in 787 recognized "veneration" of images as a legitimate accessory to Christian worship.

THE YEARS OF CLOTH

If the human figure in any form was suspect, undraped it was many times more so. For about five centuries after the Roman Empire in the West comes to an end we will see few nudes in Christendom. In the eleventh century we will see the unclad body only when it incorporates someone sinful and condemned—Adam and Eve in the Garden, after eating the apple, or one of

the damned in a scene of the Last Judgment. The sensuousness of pagan nude sculpture is wholly proscribed.

The body disappeared under an envelope of swirling draperies. Medieval sculptors, forbidden to investigate and depict the human form, lavished as much attention on the intricate ways in which cloth creases, crumples, folds, and hangs as a Hellenistic carver gave to muscles and bone structure. Some of the results were highly imaginative, having little to do with the way cloth behaves in humdrum nature.

After the long night of the Dark Ages a new interest in sculpture emerged about the year 1100, when the Church was at the height of its power in the long struggle with the temporal empire. The pope had humbled the emperor at Canossa in 1077. Sculpture first reappeared in the belt that includes northern Spain, southern France, and northern Italy. These were the countries where the Romance languages were evolving from Latin, and the new sculpture is usually labeled Romanesque.

We are entering a period that is confusing for the professional art historian and even more so for the more casual viewer of sculpture. We are used to hearing and seeing the labels Romanesque and Gothic. But at the same time as characteristics usually called Romanesque were still strongly evident in the southern belt of European Christendom, the Gothic impulse was shaping buildings and statues in the northern belt (northern France, England, the Lowlands, and Germany), and continued there long after parts of the south, notably Italy, had turned to the classic tradition for inspiration. While the Renaissance was blooming in Florence in the Quattrocento—the 1400's, the fifteenth century—the north was still largely Gothic, and remained so for a long time.

Moreover, the geographic dividing lines were not as sharply defined as the statement of them might imply. Western Christendom was still very much a unity. Ideas and churchmen freely moved back and forth and pilgrims from many lands traveled the

roads to Rome and Santiago de Compostela.

Still, an understanding of some differences between what is called Romanesque and what is labeled Gothic is helpful to enjoyment of sculpture of the period from 1100 to 1400—the Middle Ages. The architectural differences are probably the most familiar—the solid, rather squat Romanesque buildings based upon the Roman arch and dome, in contrast to the soaring walls and towers and large windows of the Gothic, based upon the pointed arch and flying buttress. Romanesque sculpture often took the form of carvings on the capitals of columns; in the Gothic style arched portals and façades were richly decorated with carvings of free-standing or high-relief figures. There was a shift in the underlying philosophical and religious basis of art, from the agonies of the damned to the hopes of the saved, with the Virgin Mary as an intercessor in the Court of Heaven.

Romanesque sculpture is more austere and severe than the somewhat later Gothic. An enthroned Virgin and Child from Auvergne in France, now in the Metropolitan Museum of New York, gives us the flavor of the twelfth century [44]. In The Cloisters in New York can be seen a somewhat less severe Romanesque version of the same theme in painted birch, made in Burgundy in the first half of the twelfth century. In contrast, an early Gothic version in painted oak, carved in the Île de France early in the thirteenth century, has none of the sternness and austerity of the earlier figures [45]. This warm and gentle pair is in the Boston Museum of Fine Arts.

Also in The Cloisters is a twelfth-century crucifix of painted wood from northern Spain. This is Christ Triumphant, still alive, with eyes wide open, defying death on the cross. His body is painted in flesh tones, eyes black, lips red, crown gold, and the loin cloth knotted at the waist hangs in folds to the knees [46]. Another famous Romanesque crucifix (or, more accurately, *Descent from the Cross*) is found in the Louvre. Known as the Courajade crucifix, after its donor, it comes from Burgundy, made in

the first half of the twelfth century. Like The Cloisters figure, it is of painted wood. These are favorite Romanesque themes—Christ triumphant over death and the Virgin as Queen of Heaven. Both Christ and Mary are depicted as rather distant, even forbidding, characterizations, more to be venerated and held in awe, perhaps even feared, than to be loved.

Something of the same stiffness and austerity can be seen in the few sculptures that remain from the Abbey of St. Denis in Paris, done in the middle of the twelfth century. Some historians call this the beginning of the Gothic, others the end of the Romanesque. Abbot Suger, seeking to make a "sumptuous setting" for worship, added architectural and sculptural touches that ushered in the Gothic. The Metropolitan in New York has a columnar statue of an Old Testament king from the abbey's cloister—frontal, sober-faced (so far as we can tell; it is badly damaged), a tubular body befitting the statue's function as a "working" column, with the garment falling in vertical lines. Two other heads of kings from the façade of St. Denis are found in the Walters Gallery in Baltimore. Their faces are symmetrical, hair stylized and parted in the middle, and noses smashed.

"WHEN YOUNG IT WAS A SMILE"

Very similar, and of the same transitional period, are the kings and queens of the western Royal Portal of Chartres Cathedral [48]. Although the figures are still frontal and simple, and the bodies tubular (these too are "working" columns), there is a human warmth about the faces that was lacking in the older Virgins and holy men. These statues have been lyrically praised. Huysmans said of the Queen (the second from the right in our illustration) that "never in any period has a more expressive figure been thus wrought by the genius of man," and that the carving on the West Portal was "beyond a doubt the most beautiful sculpture in the world." It is indeed superb of its kind and will always

have an especially strong appeal for those most drawn to sculpture, in any tradition, that is trembling between the geometric simplicity and frontality of the archaic and the full-bodied ripeness and greater naturalism of a more mature art—the later *kouroi* or the *Critian Boy* from Greece, for example [11], or a Mathura torso from India [104], or a Sui dynasty Bodhisattva from China [145], or a pre-Angkor Hindu god from Cambodia [177].

A hundred years after the West Portal was erected the North Porch of Chartres was being built (begun about 1215, and completed about 1275). More than seven hundred figures carved in stone fill the recessed arches and tympani, dominated by the Virgin over the central door, enthroned and crowned, with Christ sitting at her left. This is Mary's porch and, indeed, Chartres is her cathedral. A gentleness and lovingness mark Gothic sculpture, replacing to a large extent the awesomeness (Mary as the austere Queen of Wisdom, Christ sitting in judgment) that pervaded Romanesque. "Whatever Chartres may be now," wrote Henry Adams, one of its ardent admirers, "when young it was a smile."

The figures of Old and New Testament worthies are still long and tubular in the North Porch of Chartres, but the stiff frontality is gone. The saints and prophets stand in varied poses [49]. The newer, freer style probably owed some debt to Greco-Roman models. Antique statues were known in medieval France and England, along the pilgrim routes. Henry of Blois, Bishop of Winchester, carried some ancient carvings back to England with him from a visit to Rome in the twelfth century. The Abbot of Westminster brought from Rome artisans and materials to build parts of his new abbey in the thirteenth.

The antique influence on sculpture was most evident in drapery. Barred from an interest in the human body, craftsmen seemed to turn eagerly to the garments in which that form was swathed. After the shallow lines in relief of the first Chartres figures there followed, in the thirteenth century, more pronounced ridges and, in places, some of the complexity of folds in clothing

from Greek Classical and later times. And finally Gothic sculptors created elaborate compositions of ridges, cascades of folds, deep hollows, and other concave patterns [50, 52]. The Virgin in our illustration, now standing in The Cloisters in New York City, comes from Strasbourg Cathedral, from the middle of the thirteenth century. She was once part of a choir screen of that period, demolished to make way for a new altar [50]. Much of her original coloring remains—the flesh tones of her face, the blue of her robe, and the gold of her mantle and crown. Whether it was simply the garments of the times or the discovery by sculptors of a phenomenon that much intrigues their counterparts in the twentieth century—that the hollows and dark places hold much interest for the viewer—it is clearly true that concavities as well as the convexities that usually dominate sculpture are much more prominent than ever before.

The Strasbourg Virgin is still rather severely rigid, in an almost frontal pose. As the years went by, the poses of the standing Virgins and lady saints became not only *hanché* but exaggeratedly so. Not only the hip of the leg that bears the weight is thrust out, but the abdomen too, much like the Tang Kuan-yins from China [51, 146, 147, 148]. It is a natural pose for a woman supporting a baby on her side. For most of the remainder of the Middle Ages the images of holy women had this sweetness of face, a cocoon of garments arranged in elaborate folds, and, apart from the head and costume, rarely any trace of femininity in what little of her bodily shape may be seen. Still later in the Gothic style the saintly women sometimes became ladies of fashion. A German saint of the early sixteenth century (when Italy was well into the Renaissance but the northern belt of Christendom was still mainly Gothic) of painted and gilded lindenwood, now standing in The Cloisters in New York, displays contemporary chic—a rich red gown closely cinched at the slender waist, a jeweled necklace, plump breasts pressing out from a low tight bodice, and an elaborate mantle [52].

The Gothic mood was not always sweet and charming. Especially in Germany the agonies of Christ and saints were sometimes vividly shown. A favorite theme of the fourteenth century was the Pietà, or Mary mourning over the body of Christ. Some mystics in both Germany and Italy said that the Virgin took Christ's body in her lap after he was lowered from the cross and, in the agony of her grief, imagined that he was again a child. In our Rhenish example from the fourteenth century, now in The Cloisters, the reversion of Christ to childhood is proclaimed in the dimensions of the body [47]. In many Pietà groups, including the famous one by Michelangelo in St. Peter's in Rome damaged by a madman in 1972, the same idea is projected by the way in which Mary supports the dead Christ's head with a hand behind his neck, as a mother supports a child's wobbly head.

THE GOTHIC NUDE

In medieval art, as we have noted, the nude disappeared almost entirely, buried in layers of cloth. The human body became shameful instead of glorious. Only the damned and the dead, beginning with scattered small examples in the tenth century, could appear unclothed. Then Christ began to be shown almost nude in the final sacrifice of crucifixion, usually with some wisp of garment round his middle. We can only guess at the human form that lies beneath the elaborately rumpled robes of the lady saints. From the generally prevailing flatness of chest and narrowness of shoulders we can assume that the breasts are small and placed high and close together. From the curve of the weight-supporting hip and of the garments in front we can suppose a high waist and long, rounded abdomen.

The few nudes in painting or relief sculpture from the eleventh and twelfth centuries confirm these impressions. Lord Clark has described the canon, so different from that of the Greeks, that governed the Gothic ideal of the human body: the distance be-

tween the navel and lower part of the breast should be twice as long as the distance between the breasts. (The classical formula made these distances equal.) The resulting narrow-chested, small-breasted, long-torsoed female figure, broad of hip, buttock, and belly, has what he calls the same "ogival rhythm" as late Gothic architecture. At its worst the formula produces a body shaped like a beet, broad end down, with fat tapered legs attached. At its best it can yield shapes as alluring as that of the *Cyrene Venus*.

In the thirteenth century we find a few signs of late medieval interest in the human body as something delightful and beautiful. One example comes from a famous pulpit in the Baptistery at Pisa, on which Nicola Pisano, about 1259, carved a nude Hercules or *Fortitude* among the six allegorical figures that top the capitals of the supporting columns [53]. It is a pre-Renaissance effort to recapture the antique spirit. The figure is squat, large of head, but unmistakably inspired by Greco-Roman models, probably from sarcophagi. Heracles (or Hercules) and other Greek heroes, as distinct from gods, became favorite themes of sculptors and painters in late medieval times and the early Renaissance. The ban on pagan idols could be skirted by portraying legendary heroes as allegories of Christian virtues.

At the Doge's Palace in Venice we can see a splendid specimen of the Gothic ideal of female beauty in a marble *Eve* carved by Antonio Rizzo [54]. It dates from late in the fifteenth century, when the Gothic influences that had seeped down from northern Europe still lingered in northern Italy, long after the Renaissance had begun in Florence. Compare her with some antique works embodying the ancient Greek ideal [20, 22, 32, 33].

Half a century later Nicola's son Giovanni carved another nude on another pulpit, in the cathedral at Pisa. An allegory of *Prudence* or Temperance, she shows some antique influence but also much of Gothic [55]. Her posture was obviously inspired by that old and much-copied Greco-Roman favorite, the Venus of Modesty, whose hands shield her bosom and mons. But there is

little of ancient notions of beauty in the blocklike head. Seen from behind, *Prudence* is even less alluring. The back is crudely and roughly finished, and slopes to drooping buttocks that are a common feature of the bulbous Gothic female torso.

Among other figures on the same pulpit is a Fortitude (Heracles/Samson), nude, with a long Gothic body, thin arms, thick thighs, and the same somewhat sagging nates as *Prudence*. These works of Giovanni Pisano are a backward step (if one thinks of the movement toward Classical revival as an advance) from his father's figure of the same allegory in the Baptistery.

Andrea and Nino Pisano, also father and son, helped to establish Pisa as a major center of pre-Renaissance sculpture. Both the Louvre and the Victoria and Albert Museum in London have graceful, attenuated figures in painted wood from Annunciation scenes—the one an angel, the other a Virgin—that were carved by Nino or at least in his workshop. A full Annunciation group from a Pisan atelier of the same period, about the middle of the fourteenth century, also stands in the Louvre. These sweet and gentle dark-haired figures bring to a happy close the period of Italian Gothic. The earlier thirteenth-century Nicola gave us an early and rare glimpse back into the pagan and humanist past of Greece. In general, however, the sculptors of Italy as of the rest of Europe clung to the established and safe tradition of medieval Christianity, producing little that was fresh or innovative in the fourteenth century. The Nicola Pisano experiment has been called the "false dawn" of the Renaissance, or the "proto-Renaissance." The real one did not dawn until the fifteenth century.

CHAPTER

3

City of Davids

FLORENTINES of the Renaissance thought of their city, with good reason, as a new Athens and, with less warrant, a new Rome. Fortunately for our present interests the visual arts flourished more vigorously than the art of republican government. It was one of the most astonishing periods of sculptural flowering in history. Mary McCarthy remarked that its statuary "is part of the very fabric of the city—the *res publica* or public thing."

The rebirth of the ancients' interest and confidence in humankind produced several generations of remarkable sculptors from about 1400 to the middle of the 1600's. We will look mainly at three masters who were rocked in that Florentine cradle and one who was a son of Rome. All four modeled or carved large standing figures of David. The Judaic hero-kings and prophets, sanctified for Christians by their place in the Old Testament, were safe and natural vehicles for the artist's renewed interest in the human body and personality. First they appeared in seemly draperies; later and more daringly without such envelopes. Old Testament figures and allegories of virtues were the first to escape

from the inhibitions of earlier Christian art. The pagan heroes and gods and mythological characters of ancient Greece followed. First David and Samson, then Apollo and Hercules.

In the fifteenth century the Roman Church was struggling to retain its last strongholds of temporal power, against the "Roman" Emperors in Germany, the French kings, and the city-states of Italy. Soon it was to be more gravely challenged in both religious and lay authority by the reformers and emerging nations of northern and middle Europe. The rediscovery of Greek and Roman texts and art led to a renewed interest in pagan philosophy. Medieval awe of God and his earthly representatives was giving way among the learned to a humanism in which man as a more self-knowing, self-reliant creature was the central interest. Through the fifteenth and part of the sixteenth centuries the Church and humanists maintained an uneasy accommodation through a Neoplatonism that merged with Christian doctrine the ancient notions of individual man as a fleeting manifestation of eternal, universal "reality."

Some of the popes themselves were ardent classicists and generous patrons of arts based on antique models. Artists were no longer anonymous medieval craftsmen who selflessly repeated (although with flashes of freshness and individuality) approved and well-worn religious themes. With their new freedom of expression Renaissance artists became distinct and individual personalities, often able to talk as equals to the princes of State and Church who were their main patrons.

PROUD YOUTHS

Donatello (1386–1466) is the first of our four. Looking back from our present point in time we may not immediately see what an innovator he was, and how sharply he had broken with the medieval variant of the Western tradition. To us the Renaissance *type* of his marble *David*, one of his earliest statues in the round,

is so familiar that it now seems unremarkable [56]. The biblical hero, transformed from traditional bearded king into youthful giant-slayer, is shown after his triumph, and Goliath's head is at his feet. His weight is on his left foot, and his left hand rests on a slightly thrust-out hip. The head above a long neck wears a proud and confident expression. His jerkin fits closely, molding the chest, and a leg is exposed by the loosely worn mantle. The Renaissance body is beginning to emerge from its medieval wraps.

David's head is wreathed in flowered foliage that has been identified as the amaranth, meaning in Greek the "unfading," a purple flower symbolic of the enduring memory of heroes. The pouch of his sling rests on the giant's head, but there is no sign of the thongs, which must at one time have led to one of the hands. It is known that between the time Donatello originally carved the statue in 1408–1409, as a religious figure, and in 1416, when it was moved from his workshop—not to the Cathedral for which it had been commissioned but to the Palazzo Vecchio as a symbol of civic pride and victory over enemies—some changes were made to emphasize its new role. In one expert's view, his right hand once held a scroll, now nearly obliterated, which would have been a fitting attitude for an Old Testament prophet but not for a civic hero. The statue bears an inscription in Latin: "To those who bravely fight for the fatherland the gods will lend aid even against the most terrible forces."

Similar characteristics are found in Donatello's *St. George* made a few years later, now standing in the Bargello in Florence [57]. "This proud youth with the long Florentine neck," one chronicler of the period's art has called him. Both face and pose are more convincing—more natural and individual—than the somewhat mannered marble *David*. The expression, with a slight frown, is complex: defiant and confident, yet troubled, involving the viewers (in an un-Gothic way) as he stares over our heads at the approaching dragon. The saint, commissioned by the armorers' guild, was originally armed. His right hand, now empty,

once grasped a weapon, and drill holes in the head indicate that he once wore a bronze helmet. This was Rodin's favorite sculpture of the early Renaissance.

There followed other Donatello saints for Florentine churches including the Florentine guilds' church of Or San Michele, where there was continuing rivalry among sculptors for commissions to fill its niches, and among guilds for excellence in the statues they contributed. All are highly individual; all fix the observer with intent eyes. Our illustration [58] shows a prophet, apparently the obscure Habakkuk, one of the most expressive of these religious statues at Or San Michele. With a bald head, long face framed by a short beard, and piercing eyes beneath a slightly wrinkled brow, he became known as the *Vecchio Zuccone* (Old Pumpkin-head) and was one of Donatello's own favorites. The biographer of Renaissance artists, Vasari, reports that the sculptor used to take oaths "by the faith I bear to my Zuccone." Further, wrote Vasari, when Donatello was working on the lifelike statue, he would look at it and say, "Speak, speak, or the bloody flux take you." But Vasari is an unreliable reporter, and wrote long after Donatello died. We know very little about the life and personality of this first great Renaissance sculptor, beyond the evidence of his work. Unlike Michelangelo, a prolific writer, he left no letters or writings.

Donatello later spent about ten years in Padua, where he produced some famous reliefs. Upon his return to Florence his work indicates that he had undergone a dramatic change in personality. He moved toward an exaggerated, almost grotesque, naturalism, perhaps under the influence of grim themes more familiar to the gloomy north of Europe than to Italy. His St. John the Baptist, wild of dress and eye, with unkempt hair, stands in wood in Venice. *St. Mary Magdalen*—old, skinny, haggard, dressed in rags or skins—stands in painted wood in the Baptistery in Florence [59]. She is one of the few female saints to be found in Florence, apart from the Virgin herself, and clearly has little to do

some of his later work, like the *Magdalen* and St. John, he explored the outer reaches of naturalism, where it borders on grotesquerie and parody.

THE FUTURE KING AGAIN

Andrea del Verrocchio (1435–1488) was Donatello's successor as court sculptor to the Medici. Like Donatello, he was unmarried, withdrawn from public life, dedicated to his work, a master modeler and caster of bronze sculpture, and creator of a famous *David* [61]. Verrocchio's bronze version of the young hero and future king bears certain resemblances to the earlier bronze: weight on right leg, right hand holding a sword (much smaller this time), left hand resting on hip, with Goliath's head at his feet (providing, incidentally, stability to the statue), and the muscles those of a boy, not a man. But the stance of Verrocchio's is much more solid, and the two are quite different in mood. Verrocchio's David is not naked, but clad in a close-fitting sleeveless jerkin and kilt-like lower garment. The somewhat over-large head looks older than the adolescent body. His facial expression still recalls the psalmist and friend of Jonathan, but is not as dreamy as Donatello's. Like most early Renaissance sculpture, this one was meant to be seen from one point of view—in this case, from slightly to the right, so that it would be looked at head on. Donatello's, on the other hand, was more truly in the round, and can be seen with pleasure from profile or back as well as front.

Verrocchio's life overlapped that of Donatello, and for some time they were rivals, although most of the younger artist's famous works, including the *David,* were done after Donatello's death. The creator of the first bronze nude never knew of his younger colleague's implied reproach for frivolity. Verrocchio too did a massive equestrian statue, of the Venetian Condottiere Colleone, which invites comparison with Donatello's Gattamelata. Colleone has an exaggeratedly intense expression—at once arro-

gant, ruthless, and forceful—more to be expected in later Baroque sculpture than in that of the fifteenth century.

Verrocchio's workshop was one of the most important schools of the Renaissance. Leonardo da Vinci was among his students. Terra-cotta busts of his two major patrons, Lorenzo and Giuliano de' Medici, attributed to Verrocchio, now standing in the National Gallery in Washington, give us a glimpse of his expressive powers [62, 63]. Lorenzo the Magnificent was the real ruler of Florence late in the fifteenth century, although the republican forms still stood. He was the grandson of the great Cosimo, the successful banker and merchant who fastened family rule onto the city. Lorenzo's brother Giuliano was the idol of the younger set, famous for his beautiful mistresses, love of sports, and other graces. A rival family, the Pazzi, tried to kill them in 1478. Giuliano fell with fifteen dagger wounds before the high altar of the Florence Cathedral, at the moment when the Host was being elevated during Mass. Lorenzo escaped, to consolidate his rule. Verrocchio and his assistants have caught the character of the two brothers in baked earth: Lorenzo, tough but intelligent, with a distinctive ski-jump nose; Giuliano handsome and haughty.

Our other example of Verrocchio's work is *Christ and St. Thomas,* a two-figure group skillfully fitted into a niche of Or San Michele intended for one [64]. He has put the Doubter a step below Christ, just outside the niche, reaching out a hand to touch the wound. The statue was commissioned by the Commercial Tribunal, which supervised all the guilds. These careful merchants, it is said, chose Doubting Thomas as a symbol of caution and incredulity.

WITH NURSE'S MILK

Michelangelo Buonarroti de Simone was born shortly before dawn on March 6, 1475. Mercury and Venus were in the house of Jupiter, indicating that "marvellous and extraordinary works,

both of manual art and intellect," were to be expected from him, according to Vasari. He came of a family of faded nobility, whose modest claims to respect he was always eager to reinforce. In his early years he was brought up by a family of stonecutters in the nearby marble-bearing hills where, he later said, he imbibed the skill of carving with his nurse's milk. In his adolescence he served as apprentice for a time to the painter Ghirlandaio and lived for three years in the charmed circle of Lorenzo the Magnificent, then ruler of Florence and a notable patron of the arts. There he was exposed to fifteenth-century Neoplatonism and saw the works of predecessors—Donatello and Verrocchio—whom he was soon to outshine.

One of his early works, carved before he was twenty, was found in 1963 in the Friary of Santo Spirito in Florence. Michelangelo had studied anatomy in the friary hospital, and made the wooden crucifix for the brothers who had thus befriended him. The work disappeared about 1600. A German art historian found it hanging in a hallway of the friary leading to the kitchen, and recognized it as the missing crucifix—an identification that did not go unchallenged but seems now to be generally accepted. Christ has the slim body of a young man, wholly nude, and painted in naturalistic flesh tones that were found beneath the layers of paint and varnish of the rediscovered crucifix. His large head, seeming too heavy for the slight body, is a precursor of similar distortions [65].

WHITE GIANTS

Bigness in sculpture enjoyed a vogue in fifteenth-century Florence. The city fathers aspired to set up a group of twelve huge statues high above the street on the buttresses of the wall surrounding the apse of the cathedral. Donatello received a commission to make one of them in 1410. He produced a terra-cotta Joshua, three times life-size, which became known as the *homo*

magnus et albus—the white giant—intended to symbolize civic virtue and freedom. Being much lighter than marble, it was a more appropriate figure for the high buttresses than the David that Michelangelo later made. The Donatello colossus was removed in the seventeenth century after it had decayed.

About 1486 a colossal head and hand, dating from imperial times, were found in Rome. The discovery caused considerable stir. Before this the managers of the Cathedral had entrusted a huge slab of Carrara marble to a sculptor, or perhaps more than one, destined to be one of the giants on the cathedral buttresses. There is some evidence that it went to the aged Donatello, who put some assistants to work on it. In any event, the work was botched and the block lay unfinished for years. In 1501 it was turned over to Michelangelo. It became the familiar *David*, a towering nude nearly fourteen feet high [66]. By the time the statue was finished, the citizenry wanted it, as they had earlier wanted Donatello's, as a civic rather than a religious symbol. Florence had just been delivered from a painful occupation by the armies of Cesare Borgia. A commission of thirty, set up to decide on the location, finally settled on a spot in front of the Palazzo Vecchio, in the Piazza della Signoria (the ruling body of republican Florence). In 1873, to preserve it from weathering, it was moved to the Accademia, and a smaller copy later was set up on its original site.

Michelangelo's marble *David* followed Donatello's in bronze by some sixty years. Both are nude. The later sculptor chose to show the young hero at the moment when he was about to launch his missile. The sling, barely noticeable from the front, stretches across his back from the left hand, holding the ends at the shoulder, to the big right hand that conceals the stone. The searching, defiant, quizzical expression as David looks toward Goliath is well known. The contemporary taste for hugeness was indulged not only in the statue's size but in the disproportionately large head and hands. Were they suggested by the recent finds in Rome? A

more probable explanation is that distortion was a favorite device of Michelangelo, especially suitable to suggest David's awkward age. Donatello and Verrocchio too had modeled their bronze Davids with somewhat out-size heads. Michelangelo's own head, according to a friend's description, was disproportionately large for a slender but broad-shouldered body.

"HUMAN FORMS SUBLIME"

To depict the unclothed human body, above all the male body, in its infinitely variable attitudes, was the consuming interest of Michelangelo's life. When painting the ceiling of the Sistine Chapel he used nudes not only for the main panels and major elements of decoration but also for "fillers" where other artists would have used graceful curlicues of vegetation or geometric patterns. His early plans for the vast memorial tomb of Pope Julius II, never executed except for a few individual figures, called for lavish use of nude statues. One intended for that monument survives in the so-called *Dying Slave,* which now stands in the Louvre [70].

According to his own repeated professions, Michelangelo sought to marry Neoplatonic and Christian doctrine in the human figure. God is manifest in the body. The artist's task is to conceive the perfect man and fix the perfection in marble or bronze or oils.

> Nor hath God deigned to show Himself elsewhere
> More clearly than in human forms sublime
> Which, since they image Him, alone I love.

In these words of a sonnet Michelangelo tried to express what he so often had said in stone. In humankind the divine comes briefly to earth, the eternal and universal idea expresses itself for moments in individual forms, but at the same time it yearns to re-

turn to the home of universal being. He almost never painted or sculpted portraits, preferring the ideal generality to the accidental particular. Two heads thought to be self-portraits in stone, however, have survived: the face of the defeated man in *Victory* [71] and of Joseph of Arimathea in the *Pietà,* or *Deposition* [72].

That Michelangelo found sensual as well as spiritual delight in the contemplation of the young male body is beyond doubt. It is evident in his work and in his letters and poems. As to whether this adoration also led to physical intimacy, the reader can find a broad spectrum of speculation and explanation, if not final enlightenment, in accounts by biographers ranging from the sculptor's contemporaries and near-contemporaries, through Victorians and Freudians to post-Freudians.

Later in life Michelangelo's interest in the body ran afoul of the renewed puritanism of the Counter-Reformation. His mural painting of the Last Judgment in the Sistine Chapel was characteristically full of naked figures in varied attitudes. Even the essayist and wit Aretino joined the criticism of the lavish display of flesh, telling Michelangelo, "your art would be at home in some voluptuous bagnio, certainly not in the highest chapel in the world." "Imitate the modesty of Florence," he advised; by now a more prudish Florence, as befitted the times, had affixed a gilded leaf to his *David*.

The complaint came with ill grace from Aretino, who was not only a libertarian in such matters and the father of modern pornography but was also moved by obvious malice. He had long and unsuccessfully importuned Michelangelo to make him a present of a sketch or drawing, which would have substantial value because it came from the master's hand.

Before Michelangelo's death one pope commissioned a friend and follower of the master to paint bits of cloth on some of the more conspicuous nudes in the Last Judgment. The disciple thereby earned the name *Il Brachettone,* or "Breeches-maker." When informed of this commission, Michelangelo is said to have

remarked that the pope should be told this was a small matter, easily set straight: "Let him look to setting the world in order; to reform a picture costs no great trouble." Later popes continued the pious work of draping the painted nudes, with damaging results to the Last Judgment.

"YOU FRIGHTEN EVERYBODY, EVEN POPES!"

There was nothing leering or frivolous in Michelangelo's depiction of the nude. Seriousness and gravity marked all his art. He had in overflowing measure the quality of *terribilità*—granitic, uncompromising integrity and earnestness, at once inspiring and forbidding. A lofty style, grave and decorous, he advised a contemporary, is essential to great work. It is, he wrote, "not enough that a master should be great and able" in order to make an image of Christ: "he must also be a man of good conduct and morals, if possible a saint, in order that the Holy Ghost may rain down inspiration on his understanding." Michelangelo's faces do not smile (nor, as we shall see, do Rodin's). Even the Madonnas do not look with tenderness and maternal pleasure at the infant Christs, or with horror and sadness at the crucified ones. They are withdrawn.

In his personal life Michelangelo was forbidding. Frugal to the point of parsimony, yet generous with his father and brothers, he lived in such squalor that he would allow few to see him at home. He was quick of temper, sharp of tongue, and pettily jealous of other artists whom he saw as rivals. "Remember," wrote a friend, reproachfully and reassuringly, "eagles do not prey on flies." His true vocation for sculpture and consummate skill at his calling gave him assurance in the presence of the mighty of his time, who vied for his services. He often quarreled with them.

The master's first papal patron, Julius II, an exemplar of *terribilità* himself, complained that Michelangelo "is terrible; one

cannot get on with him." And a friend assured the sculptor that a later pope, whose support Michelangelo felt unsure of, really "loves you, but you frighten everybody, even Popes!" Michelangelo had little use for the ways of courtiers or the vanities of Society. "I am bound to confess," he wrote, "that even his Holiness sometimes annoys and wearies me by begging for too much of my company." He saw no reason to dance attendance when there was more serious work to do. In all this there seems to have been no pretentiousness or arrogance; he was almost wholly lacking in "side."

Michelangelo disliked having anyone work with him. It was probably this strong temperamental preference to work alone as much as a feeling of artistic integrity that set him off from other master artists of his own and later times, whose workshops so teemed with apprentices and skilled assistants that it is sometimes impossible to attribute a particular work to the master himself. The problems of attribution and integrity increased with advances in the techniques for copying, enlarging, and reducing. We will look more closely at these in the next chapter.

HOW SWEET TO SLUMBER

Michelangelo and the popes could not ignore each other, however uneasy and troubled their relations might become. For the sculptor the papacy was a major patron. More than that, the pope could use his temporal and religious power to preempt an artist's time and scare off competing petitioners. For the popes, Michelangelo was the towering artistic talent of the times. However much they might dislike his temperamental thorniness or anti-authoritarian politics, he and he alone could bestow on their memorials and churches the supreme excellence they wanted.

When spiritual and lay power were as concentrated in one person as they were in Pope Clement VII, Michelangelo had little choice but to carry out his orders. Clement was a Florentine,

the bastard son of Giuliano de' Medici, who had been killed in the
Pazzi conspiracy [63]. He was determined to rule Florence indi-
rectly. And as pope his authority in Rome, Michelangelo's other
main place of work, was supreme—except when the German em-
peror's forces sacked the city and briefly held him prisoner in
1527.

During these grim years, when Italy was caught between the
rivalries of popes, emperors, and kings of France, Florence distin-
guished itself with one last espousal of independence and republi-
canism. In 1527, after the sack of Rome, they evicted the Medici
again. But Clement was determined to recapture the city for his
family, and made common cause with his imperial enemy to lay
siege. Betrayed by their own military commander, the Florentines
finally capitulated. At one point Michelangelo fled the city. The
Medici returned, this time to fasten their rule on the city as un-
disguised despots for two centuries, until the family itself died
out.

With these painful events fresh in his mind, Michelangelo re-
sumed work, on Clement's orders, on a grand memorial to the
Medici in Florence. He had somewhat earlier made preliminary
plans for the tombs and other sculptured groups in the Sacristy of
San Lorenzo Church, where, according to the original plans, two
Lorenzos and two Giulianos were to be buried and glorified.
These were Lorenzo the Magnificent, early protector of Michelan-
gelo, and his murdered brother Giuliano, and two members of
the family bearing the same names who ruled later. Only the sec-
ond pair were actually buried and memorialized in the chapel, in
sculptures that far outshine their undistinguished subjects.

In addition to two seated figures, representative of the recent
deceased, two famous pairs of figures recline on the sarcophagi
below. These are *Night* and *Day* [67, 68] and Dawn and Dusk,
female and male nudes that dominate the Sacristy of San Lorenzo.
If the Medici looked on them as mourning for the family, we may
be fairly certain that they meant something quite different to Mi-

chelangelo: the parlous state of the times (owing in large part to Medici ambition and ruthlessness), the fleetingness of time, the agony of being in the temporal plane at all, and the sadness-sweetness of returning to an eternal home.

In one of his poems, written years after completion of the memorial, he left little doubt about the thoughts he meant to evoke through the monumental nude woman, left leg drawn up in an almost erotic attitude, large but firm breasts with prominent nipples—the universal mother—with head lowered as in sleep, leaning against the right hand, which is propped by its elbow against the upraised left leg.

> How sweet to slumber here, when all about
> My marble carcass shame and woe prevail . . .

The shame and woe were in no small part traceable to the Medici. It has been suggested, however, that this sentiment was a political afterthought. *Night's* pose was suggested by a Roman sarcophagus on which the central figures were Leda and the swan, the mortal woman coupling with Zeus disguised as a bird. These unions and other close relationships between mortals and immortals, it will be recalled, were favorite themes of Roman sepulchral carvings [42]. To Renaissance Neoplatonists like Michelangelo they readily became symbols of man's return to God in death and a Christian after-life. In this version of Leda, the swan, embraced by one of her legs, has been replaced by an owl who stares out at the observer from under her knee, and other symbols of night, death, and sleep. As Leda she welcomes death as the love of a god; as Night she mourns the destructiveness of Time.

In 1529 Michelangelo painted a Leda in the same posture, but this time with the swan. The picture was intended for the Duke of Ferrara. The painter, however, was piqued by a slighting remark made of his offering by the duke's messenger, a rich merchant, and refused to let him have it. He then turned the paint-

ing over to a servant who took it to France. The Leda eventually wound up in the possession of King Francis and remained at the French court until Louis XIII's Minister of State Desnoyers condemned it to destruction, on grounds of indecency. It is thought to have survived this sentence, but has disappeared from public view. A copy by Rosso is in the National Gallery in London [69].

The esoteric meanings that a good Neoplatonist like Michelangelo could pack into the series on Leda/Night all touch on themes like the bittersweetness of living and dying, the sorrow of leaving the world but also the joy of union with God. At a simpler level the impact of the few powerful pieces in the rather austere Sacristy (fortunately for the clean, sparse effect of the whole, Michelangelo did not make as many figures as he originally intended to do) is one of pervading sorrow and grief—but probably not for the Medici.

Night is very nude, but few will find her an erotic figure. Her pronounced, even exaggerated femininity, rare among sculptures of this time, is mature and gravid, speaking more of the earth-mother than of Venus.

UNFINISHED BUT WELL DONE

Night's companion more or less repeats the position of her legs. But in *Day* a thickly muscled male back is presented to us instead of *Night's* very female front. The man's heavy head peers at us over his right shoulder—like the sun, one critic has commented, rising over a mountain range. The unfinished face is oddly like the owl's in the companion piece. The *contrapposto*—twisting of the body in one direction then back again—is more pronounced than in *Night*. Indeed, *Day* is so unnaturally contorted that he may displease, but he is tense and full of coiled power. He gives an impression of awakening and becoming, but of not being very happy about what he is waking to.

This is one of Michelangelo's many works that are not fin-

ished. The effect, intended or not, is of a figure straining to be released from its encasing stone. Or it may seem that the carver has tried to reduce his creation to few essentials, leaving inessentials in crude outline. Rodin, more than three centuries later, certainly intended his own *non finito* marbles to have such impacts. With Michelangelo the reasons for unfinished works are less certain. There are several explanations to choose from. Perhaps each is in part accurate.

Some think that Michelangelo, like Rodin, deliberately left many figures half-embedded in their natal marble to heighten the impression of becoming, of being born or of awakening, perhaps reluctantly and full of foreboding, into the round of worldly existence. In a related view, Michelangelo was being "true to his material"—a virtue much cultivated and admired in twentieth-century sculpture—finding the idea for his figure hidden in the raw block, letting its shape and dimensions influence the form into which he translated his idea, and making this relationship obvious by leaving much of the emerging figure embedded in the basic material. For some the unfinished pieces are in part a touch of technical bravura. The sculptor shows, in the uncompleted portions, the marks of pointed and claw chisels that tell of his techniques, contrasting with the polished surfaces of the finished parts. Some have accused Michelangelo of temperamental instability, of inability to see projects through to completion, of easily getting bored with an idea and wanting to move on to something else. To others it seems that he was simply unable to keep up with the many demands on his time; he was the victim of conflicting pressures and orders from powerful patrons, each wanting first priority for his own latest pet project. Unlike most artists of his times, he worked almost alone instead of with a squad of assistants. His patrons, knowing the pace at which other workshops produced, may have expected faster results than he was able to give.

Whatever the reasons may have been, the unfinished statue is

now recognized as a Michelangelo "type." Some of his most pow-
erful works, like the *Day* in the Sacristy of San Lorenzo, are in-
cluded. Another is the *Dying* (or is he Awakening?) *Slave* [70].
This is one of several male nude figures the master planned for
the grandiose tomb of Pope Julius II in St. Peter's—a project
that hung over him most of his life, was never finished, and was
finally reduced to a relatively small memorial, including the fa-
miliar Moses, in another church. Quite probably the *Slave* was in-
spired by the *Laocoön* [31], which Michelangelo was one of the
first to see when it was found in Rome. The *Slave* is much more
controlled and less violently expressive than the priest in the
Roman group or the son whose pose is much like that of Michel-
angelo's figure. There is the same ambiguity between awakening
and going to sleep, the same sense of struggle for release, found in
Day.

The *Slave,* along with a mate in a more dynamic and tightly
coiled attitude, now stands in the Louvre. Seeing them in a room
full of other Renaissance sculpture (including two nearby nudes
of about the same size from Florentine workshops) we are acutely
aware of the powers that set Michelangelo off from other sculp-
tors.

Another carving intended for the Julius memorial had a
great impact on later sculptors. Its basic pose has been repro-
duced again and again, and the idea of an intertwined pair in op-
position. The *Victory* [71], now in the Palazzo Vecchio in Flor-
ence, shows a nude young man, in more pronounced *contrapposto*
than in earlier works, with one knee on the neck of a crouching
old man. The pair is puzzling and disturbing. As a matter of for-
mal organization, why is there the strong line of the victor's arm
across his chest, apparently doing nothing more important than
to hitch up the flimsy garment about to fall from his shoulder?
Both the victor and the vanquished look strangely unconcerned
about the struggle just concluded. Scholars have suggested several
possible meanings. One, not widely accepted, is that this is Mi-

chelangelo's statement of his conquest by a brilliant young Roman to whom he was long and devotedly attached. More probably it has an allegorical meaning—the achievement of organized form (the victor is more highly finished) out of chaotic mass (the old man is rough) or the contrast between contemplation and activity. Romain Rolland called it an "image of heroic doubt" and a "victory with broken wings."

SOME MATTERS OF STYLE

"The science of design," Michelangelo told a contemporary, "is the source and very essence of painting, sculpture, architecture"—indeed, "of all the sciences." There is really one art or science, he said, and that is *disegno,* design. The Italian word implies more than skillful and accurate drawing. It includes the perception and reproduction of basic form, reduced perhaps to essential geometric figures, in the objects to be presented. Like the artists of many times and places, those of the Renaissance were fascinated by mathematics and preoccupied with ideal proportions of objects they created and with underlying geometric forms.

Michelangelo shared this interest only to a limited degree. He distrusted mathematical rules for proportions and mechanical means of measuring. The artist, he said, must depend on "the compass in his eyes and not in his hands." But he is reported to have advised sculptors to take the pyramid and twisting serpent as the basic forms to follow in their compositions. Combined they result in a flamelike form. And apparently another of his rules was that of "one, two, three": take the thinnest part of the leg; double that for the thickest part between knee and foot (the calf); triple it for the thigh.

His own devotion to the *figura serpentinata* is evident in the four-figured *Pietà,* sometimes called *Deposition,* which stands in the Cathedral in Florence [72]. The limp, lifeless body of Christ,

and the figure of Joseph of Arimathea standing over him, twist in *contrapposto*. While carving the *Pietà* late in life Michelangelo grew angry and discouraged at his slow progress, faults in the marble, and the proddings of a servant, who was also his friend, to get on with the job. He took a hammer and hacked at the sculpture, badly damaging the left side. A friend rescued the mutilated group and some of the fragments. The left leg of Christ is still missing. After Michelangelo's death another sculptor repaired it as best he could, and finished the figure of Mary Magdalen kneeling at Christ's right. Her disproportionately small body is a jarring note in this superb group. The face of Joseph is thought to be one of the two self-portraits of Michelangelo he made in stone. Mary the Mother's love and grief are evident less in her unfinished face than in the physical closeness. Christ's missing left leg was presumably thrown across her own—another intimate touch.

Again the pyramidal composition and serpentine design appears in the combined grouping of *Night, Day,* and the Medici prince brooding above them in the Sacristy of San Lorenzo, and still again in the *Victory*. Michelangelo had revived the torsion of the human bodies so liberally used by Hellenistic sculptors, but where antique sculptors used the device to portray violent action, as in the *Laocoön* and *Gaul Killing Himself* [30, 31], Michelangelo's coiled power is controlled, subdued, and introspective. None of Michelangelo's sculpture depicts great activity.

AN ASIDE ON A VIRTUOSO

Any survey of Renaissance sculpture would refer to a dozen or more artists who are not mentioned here. We are seeing a limited and selected few. It is not exactly a sample, for our four sculptors of Davids were extraordinarily imaginative and technically skilled men. They were major pace-setters, whose new developments in style produced the models from which their contem-

poraries and followers started, not always with happy outcomes.
But one other innovator deserves at least a quick look.

Giovanni Bologna, or Giambologna (1529–1608), was born in
the Low Countries, studied in Rome, and lived much of his life
in Florence. He spanned the gap between Michelangelo, who
died in 1564, and Bernini, born in 1598. His special claim to our
attention is that he carried the serpentine style of Michelangelo a
big step further, creating not only single figures but groups in as-
cending spirals that present to the viewer continuously shifting
points of view as he walks around the sculpture. Some of his
highly polished bronzes are well known, especially the Mercury
—a virtuoso exercise in monumental balance. The flying messen-
ger of the gods rests wholly on the toes of one foot. But it is two
works in marble that set a style for later generations of sculptors,
showing groups of two or more people in opposition to each
other.

There are three stock ways to show a clash of wills between
two people, or a human and an animal: one may run away, with
the other in pursuit; having caught up with the pursued, the pur-
suer may lift him or her off the ground in a gesture of triumph,
or the "now-I've-got-you" attitude may arise while the contest be-
tween two antagonists still continues; finally, in a struggle be-
tween two opponents, the victor in a show of strength may be
shown towering over the vanquished. In his Victory [71] Michel-
angelo gave currency to this last stock situation, which has been
repeated many times since.

In Samson and the Philistine, now in the Victoria and Albert
Museum in London [73], Giambologna shows this third pose. It
is very much a walk-around statue, as few had been up to that
time. Despite the strong contrapposto of Michelangelo's Victory it
is still meant to be seen from one point of view. We know from
surviving plaster models that Michelangelo was moving toward
the creation of spiraling figures in action, but he never executed
them in marble. In Giambologna's Rape of the Sabine Woman,

the number of violently involved figures has grown from two to
three, interlaced in an upward twisting pattern, starting with the
older man (father or husband of the abductee?) kneeling on the
ground, through the young Roman raptor, and ending with his
Sabine victim, whose hand reaching to the sky finishes off appro-
priately the serpentine flame within the elongated pyramid [74].

Giambologna, we are told, did not know for certain until he
was well along with this work just what he would call it. The sub-
ject matter interested him less than the technical challenge of
carving three intertwined human figures. It is a challenge he bril-
liantly met. We may wonder if Michelangelo would have been as
interested in a technical problem without regard to the subject
matter or the emotion he wanted to evoke. Probably not. Even in
the more or less anonymous nudes that people so much of Michel-
angelo's painting and drawing (in which the "meaning" is of little
or no concern) there is evident a passionate interest in the nude
as such, a vocation to depict in every conceivable attitude what
the sculptor regarded as God's most splendid work. This passion
seems to be lacking in Giambologna.

LESS THAN PERFECT PEARLS?

The theatricality of Giambologna's *Rape* is a fitting intro-
duction to the work of Giovanni Lorenzo Bernini (1598–1680),
master sculptor of the Baroque period of art and of the Counter-
Reformation in religion and politics. Born in Naples, he was the
son, and was to become the father, of a sculptor. He spent most of
his life in Rome, and quickly became to the seventeenth century
what Michelangelo had been to the sixteenth.

The 1500's saw the Protestant challenge to the authority of
the Roman Church, and the response of Rome in the form of
stricter doctrine, renewed asceticism, a tighter rein on venality
and worldliness within its ranks, and a new effort to retain souls
in the Old World and win them in the New. The Council of

Trent (1545–1563) was the watershed in this movement. Humanist interest in the human body was one of the casualties of a stricter doctrine and practice. Images as such were not proscribed by the Church of Rome as they were by many of the new Protestant sects. Indeed, icons that were properly rooted in Christian history and doctrine, and decently clothed, were welcome as a means of proselytizing—as "the books of the uneducated." "With respect to representations of Christ, the Virgin Mother of God, and the other saints" the Council of Trent decided that the "reverence shown to them is paid to the prototypes that they body forth." But the era of the fig leaf had started. We have already noted that "breeches" were put on figures in Michelangelo's Last Judgment. In sculpture most of the body again went under wraps, in garments even more billowing than those of the Middle Ages. To depict even the Christ Child without clothes was disapproved.

The display of emotions (especially of anguish, ecstasy, horror, and adoration seemly for saints and martyrs) and of dramatic scenes, in ways that would instruct and indoctrinate the unlearned, was part of the new Baroque style. It had its roots in the distortions and bodily movement of Michelangelo and Giambologna. The word Baroque seems to have come from the Portuguese *barroco* (Spanish *barrucco*), meaning a rough or imperfectly shaped pearl. The French used it in the same sense, but by the late eighteenth century applied it to anything irregular and bizarre. At that time it was used in art criticism as a term of disparagement of the flamboyance of late Renaissance art, which, according to contemporary taste, was inferior to a restrained and grave classicism. The *Laocoön* [31] became one favorite Hellenistic model for Baroque sculpture, with agonized or otherwise highly expressive faces and bodies contorted in violent motion. Swirling draperies became a new element, more and more conspicuous as the seventeenth century wore on.

FROZEN MOMENTS

Bernini's work tells the story. His early sculpture still used themes from antiquity and still used the nude, with concessions to the new modesty. Three famous marbles date from the period 1622–1625. One, *Apollo and Daphne,* uses the situation of pursuit; one figure chases the other [75]. As in the other two groups, Bernini has sought to freeze in marble a crucial moment in the action. At last the god has succeeded in catching the reluctant nymph, but in the moment of triumph he loses her. She begins to turn into a laurel tree. The expressiveness of face and body fit the moment, except for the mannered way in which Apollo, while running, holds out his right arm behind him. The Apollo owes much to the familiar Roman Apollo Belvedere of the first century A.D., which had been uncovered recently in Rome. The faces are much alike and the positions of the right arms almost identical, even though the gesture poorly fits the Bernini theme.

By *Laocoön* out of Giambologna's *Rape of the Sabine* Bernini's *Pluto and Persephone* was born [76]. Again, the sculptor has frozen a climactic moment. Pluto has just snatched up Persephone (or Proserpine in the Latin version) and is carrying her off to his underworld kingdom, past the three-headed Cerberus who guards the portal (and incidentally lends solid support to the heavy marble pair of gods). The unhappy daughter of Ceres starts to cry out—to her mother (or perhaps to us, for Bernini tended to involve his audience, to project the action beyond the stage). The projection is even more apparent in *David* [77]. The sculptor has chosen to show him just after he has hurled his stone from the sling. His body is twisted round in the very model of *figura serpentinata,* and his face grimaces with concentration and physical effort. His eyes are fixed on his enemy, somewhat behind us, and, of course, taller than we are. Bernini is said to have used his

own face as the model for the *David*. Certainly the noble nose, in profile, looks much like that in portraits of Bernini.

ILLUMINATOR OF A CENTURY

These three works were done by Bernini for the Cardinal Scipione Borghese and still stand in the Borghese Palace in Rome. After the *David* was completed in 1624 Bernini had little time for further private commissions. Soon he was working full time for the papal establishment, turning from antique pagan themes almost exclusively to religious art. The Jesuit program of instruction through sculpture and painting was coming into full development. Bernini was one of the Church's most valued propagandists, as architect, sculptor, painter, and stage designer. He planned and in part executed some of the principal monuments in St. Peter's in Rome: the ornate baldachin supported by four spiral columns that stands over St. Peter's tomb; the Cathedra of St. Peter; the semicircular porticoes on the approaches to the church; and some of the huge statues of saints and tombs of popes.

Bernini was a close and trusted friend of Pope Urban VIII (1623–1644) and flourished under his patronage. Urban called him a "rare man, sublime artificer, born by Divine Disposition and for the glory of Rome to illuminate the century." One of his religious statues in St. Peter's is of *St. Longinus,* a composite of the Roman soldier who pierced Christ's side with his spear and the centurion who, hearing Christ's dying words and witnessing the earthquake and darkening skies, recognized him as "truly the Son of God." A variant legend has it that blood spurting from the wound or running down the spear touched the soldier's ailing eyes and restored full sight. We see him here at the moment of conversion [78]. The agitated garments are a good example of Bernini's use of drapery for dramatic effects. Large folds radiate from his left elbow, the strongest line being a continuation of the

outstretched left arm, picked up again in the right a bit above. Michelangelo could not have made so widely reaching a statue; he carved his figures from single blocks. Bernini used several pieces to make this large figure.

Bernini's culminating work is the chapel in the Church of Santa Maria della Vittoria commissioned by the Cornaro family of Venice, where *St. Teresa in Ecstasy* is the dramatic centerpiece [79]. Here all Bernini's skills had full scope. The central group is ensconced in an architectural setting, with lighting effects that give you the feeling you are watching a staged production. By a *trompe-l'oeil* effect Bernini shows various high clerics, members of the Cornaro family, conversing or watching the main scene from two balconies that flank the central stage. In the vault above painted angels cavort in a blue heaven.

Of the dramatic scene portrayed, let the principal actor speak. St. Teresa of Avila, a Spanish Carmelite, telling of her mystic transfixion by Divine Love, said that she was visited by an angel, "small and most beautiful," who held a golden spear tipped with flame. "He appeared to me to be thrusting it at times into my heart and to pierce my very entrails. When he drew it out, he seemed to draw them out too, and to leave me all on fire with a great love of God." The pain, she reported, was so great that it made her moan, "and yet so surpassing was the sweetness of this excessive pain that I would not wish to be rid of it."

If you see in the saint's expression an ecstasy not entirely spiritual, you belong to a numerous company. Presumably Bernini was wholly unaware of a possible *double entendre*. He was a devout son of the Church, a papal knight at twenty-two, and a faithful lifelong servant of his religion. Among the touches of genius in the *Teresa* is the very different treatment of the draperies of the two principals—soft and flamelike on the angel, who wears an ambiguous smile, and stiff fabric tumbled in sharp folds for the saint. Teresa's garments are a geological event. Of her body

only the face, a hand, and a foot are visible, sticking out from the craggy clothing.

BREEZY MANIACS?

All major sculptors and their schools have had ups and downs in critical and popular favor. Bernini perhaps has had more than most. His exuberant style, emotionalism, swirling draperies, delight in movement and naturalism, offend many moderns. The swing against the Baroque, of which he is the great exemplar, began as early as the seventeenth century. In the nineteenth Charles Dickens thought the works of Bernini and his disciples "the most detestable class of productions in the wide world." "Breezy maniacs," he called them, "whose every fold of drapery is blown inside-out; whose smallest vein, or artery, is as big as an ordinary forefinger; whose hair is like a nest of lively snakes."

A good many viewers nowadays agree. Yet Bernini was superb of his kind. He was different from Michelangelo in several ways. His sculpture was extroverted, and the Florentine looked inward. He was full of movement and dramatic action, where Michelangelo, although full of coiled power, was restrained and controlled. For reasons not necessarily arising from his personal taste Bernini's figures are clothed in agitated garments, while the nude was everything for Michelangelo. The main criticisms of Baroque sculpture apply to the contemporaries and successors of the two giants who did not share their genius and who let the touches of extravagance become central to their work.

4

On to Rodin

SHIFT TO FRANCE

I N 1664 Bernini was invited to the court of Louis XIV. He made the trip from Rome to Paris in the style of a potentate, received with honors at every stop. Although his visit lasted less than a year it was a symbol of a major change in art and politics. The most dazzling secular monarch of the times, ruler of a rapidly rising nation-state, had succeeded in taking away from the pope, however briefly, the Western world's most eminent architect and sculptor. The center of gravity was shifting to France, which would become, and remain for two and a half centuries, the principal home of European sculpture.

In other countries of post-Renaissance Europe there were sculptors of competence, and sometimes remarkable talent. Even in France there were no towering figures for a long time and sculptors were drugged on antiquity; only the Greeks or their later interpreters could serve as respectable guides. But in France there were occasional challenges to the ruling academies, if no really bold innovations. The two centuries of sculpture in Europe

after Bernini are a dull country we must cross to get to Rodin. The few refreshing sights along the way, the few interesting hills arising from a flat prairie, are mostly in France. We will look at some of these and leave the plastic art of other nations—German, British, Dutch, and so on—to more comprehensive surveys of European sculpture.

To the annoyance of his hosts, Bernini made no secret of his low opinion of French art. Go to Rome to study, he advised French painters. Yet he admired Poussin, the strictest of classicists in theme and form—perhaps because Poussin had worked in Rome, for forty years. The reaction against Bernini and his followers had already started in France. French artists were consciously sloughing off the extravagances of Baroque and returning to purer classical forms.

In the eighteenth century a taste for the antique continued to dominate but was modified, especially in the decoration of the parks and palaces of kings and nobles, by a new levity and prettiness. An odd mixture of rationalism, royal absolutism, and aristocratic hedonism marked the France of the later Kings Louis. The lightness and charm of rococo became the hallmarks of aristocratic art. The rising bourgeoisie embraced the plainer classicism. In both the religious impulse is almost wholly lacking. Sculpture of religious themes continues, of course, but it has a made-to-order look, with none of the intensity of Michelangelo or devotion of Bernini. Boucher was the artistic arbiter of sophisticated eighteenth-century, before-the-deluge taste.

There is little reason to linger over the ornamental works in which the period abounds. Any major collection of sculpture in the Western world is likely to have examples, which the visitor is so used to regarding as garden decoration (as, indeed, much of it was intended to be) that he may pass by with little notice. The Metropolitan Museum in New York, for example, has four limestone statues representing the four Elements—Air, Earth, Fire, and Water—from the 1760's. They formerly graced a château

near Rouen, as somewhat over-life-size ladies with small heads, pretty faces, rather small breasts that are sometimes covered by, sometimes free of, the clinging garments. Each is accompanied by a cherub who holds a symbol of the Element: a sheaf of grain for Earth, a shepherd's pipe for Air, a torch for Fire, and a jar for Water. These and their myriad sisters are the sculptured counterparts of painted figures by Boucher and Fragonard—sweet, fleshy, and light-hearted.

THE NEW CLASSICISTS

Alongside such charming confections, insubstantial as cotton candy, the more sober side of the tradition was being developed by the neoclassicists, who looked to the ancient world, directly or through the Renaissance, for their inspirations and models. Jean-Baptiste Pigalle (1714–1785), a favorite of Madame de Pompadour, combined an interest in the antique with a liking for the graces of rococo. A *Mercury* is his most celebrated work, known to Americans through a terra-cotta figure, painted to look like bronze, in New York's Metropolitan Museum [81]. (A marble made from this is in Berlin and a smaller marble statuette in the Louvre.)

A less-known but arresting Pigalle is his seated nude of *Voltaire* [82]. Classicism, of course, implies nudity, or near-nudity, usually in an unindividual, idealized form. Eighteenth-century sculptors and painters carried the convention to improbable lengths. The Institut de France wanted to honor Voltaire, the incarnation of the century's spirit of rationalism and humanism. They commissioned Pigalle to make a portrait. To everyone's surprise, including the subject's, the statue emerged not only as a nude, but as a naturalistic nude, the shrunken body of the philosopher having been copied from that of an old army veteran. Voltaire, after some initial embarrassment, is said to have accepted the nudity with the comment that, clothed or not, his body was

not likely to inspire lewd ideas in ladies' minds. Such naturalism was not regarded with favor by classicists who valued the ideal above the "real."

The *Voltaire* now sits in the Louvre, where its direct honesty strikes a refreshing note in a room of sentimental eighteenth-century Psyches, Eroses, Venuses, and allegories. The vogue of nude portraits continued. Pigalle carved one in marble of Louis XV, which was destroyed during the Revolution. Half a century later Canova did a highly idealized (and therefore acceptably "classical") Napoleon, clothed only in a fig leaf and a mantle that is draped over one arm. He stands, in heroic attitude, in the Wellington Museum in Apsley House, London. Canova also sculpted Napoleon's sister Pauline, in the guise of the Victorious Venus, holding the apple awarded her by Paris. She reclines seductively on her couch, dressed only in a loose nether garment that covers thighs and knees [83]. Pauline married into the Borghese family of Rome, and the neoclassical monument to her stands in the Villa Borghese. Someone asked the lady if she did not object to posing for Canova in the nude. "Not at all," she replied. "Canova has a warm stove in his studio." The vogue for nude portraits even reached the other side of the Atlantic, where the Father of His Country emerged in marble as a colossal seated Olympian Zeus, naked to the waist. The sculpture by Horatio Greenough, the first American sculptor to study in Italy, can be seen in the Museum of History and Technology of the Smithsonian Institution in Washington.

As the statues of the Bonapartes indicate, Antonio Canova (1757–1822) was more of a classicist than the French Pigalle, preferring the idealized form and generalized bland face to the vividly individual. With Canova the center of sculpture shifted again briefly to Italy. Born in the village of Possagno near Venice (now the site of a museum of his works), he spent most of his life in Rome. His first important work in marble was *Theseus and the Minotaur,* now in the Victoria and Albert Museum in London

[80]. While Canova was working on this group in Venice, the patron who had commissioned it had a plaster cast made of Theseus's head and displayed it to a group of artists and critics. They mistook it for an example of antique Greek workmanship—the highest possible praise for a sculptor of the time. The change from the Baroque is striking. Flying draperies, emotional faces, writhing bodies, outward-reaching groupings have given way to a quietly composed, placid-faced, encapsulated group, free of frills and extravagance.

A bit later he made the Cupid and Psyche that stands in the Louvre (a plaster model is in the New York Metropolitan). This was a favorite nineteenth-century theme. Flaubert found it so fascinating that he walked around it several times and at last "kissed under the armpit of the swooning woman." It was, the old man added, the only sensual kiss he had bestowed in a long time. Modern viewers are likely to be less stirred.

Canova's idealized bodies with expressionless Phidian faces, incarnating suitably poetical or upliftingly allegorical subjects, were not greatly admired by critics and practitioners of the so-called Romantic persuasion. The word came into common use during the eighteenth century, first referring to the fantasies and strangeness of medieval romances, then coming to mean several attitudes and characteristics in art that are opposed to the classical tradition: the vivid and emotional as against the cool and intellectual; the individual and personal as against the general and ideal; the varied experience of ordinary people as contrasted with the behavior, presumably noble and grand, of the elite and conventional heroes; expressiveness by individual artists instead of relatively impersonal immersion in the tradition; the aesthetic validity of the ugly and plain as well as the beautiful.

The labels Romantic and Classical are convenient shorthand for referring to these conflicting tendencies, but most individual sculptors were not unambiguously identified with one or the other school. By and large classicism was the prevailing

mode in the academies, the national institutions that perpetuated the tradition, imparted instruction to the aspiring, and tried to set standards of excellence. To the extent that more imaginative, restless, and innovative young sculptors rebelled against this rigid academism they tended to be labeled Romantic. But both overlapping groups were rooted in the classic tradition, finding beauty in the idealized human body, in proper proportions, in antique themes, and in standard pyramidal compositions, and differing mainly in the extent to which Romantics made some departures from that tradition.

SOME CAUTIOUS REBELS

Most of the sculptors noted in this chapter were considered rebels against the ruling academies. If we find their work now unexceptional, the banality of the sculptural establishment that found them revolutionary can be imagined. In 1972 a group of rooms in the Louvre was newly dedicated to French sculpture between the Renaissance and Rodin. It is the best possible place to get an impression of eighteenth- and nineteenth-century carvings. All the artists referred to here are represented, and a good many more in addition.

Jean-Antoine Houdon (1741–1828) is represented there by several portrait busts and by one version of his graceful nude *Diana,* made for somebody's garden. Houdon's life spanned the French Revolution. While the Bourbons still reigned he was a favorite with the world of fashion. After their fall his talents were available to the new republic and later the empire. Houdon was best known for his portraits, including those done during a brief sojourn in the newly independent United States. Among these were busts of Washington, Jefferson, and Franklin. His seated full-length portrait of Voltaire, unlike that made by Pigalle, is fully robed. There are many familiar versions of his bust of the philosopher.

In his pre-Revolutionary years Houdon did several fashion-
able nudes, but even under the Bourbons a new puritanical trend
brought some criticism. In the 1780's he made several versions in
different media—terra cotta, marble, and bronze—of a nude
Summer and an almost nude *Winter,* also called *La Frileuse,* or
Shivering Girl. A marble version of the lady, whose head and
shoulders are draped in a shawl but whose nether regions are
bare, was rejected by the Salon de l'Académie in 1783, on
grounds of indecency. It might be asked, said one prudish critic,
"why the 'Venus of the beautiful buttocks' [a famous antique
nude in the Naples Museum] does not give offense, while one is
shocked by this one, who shows her behind like an animal." It is
a perceptive remark, and it is hard to think that Houdon was not
being deliberately provocative. A bronze version, cast by him in
1787, was finally shown in the Salon of 1791. It had belonged to
the former Duc d'Orléans and eventually found its way to the
United States, where it now stands in the Metropolitan Museum
in New York [85]

Presumably it is only a coincidence that one of Houdon's ear-
lier religious statues strikes an almost identical pose. This is *St.
Bruno* standing in the church of St. Maria degli Angeli in Rome.
The shrouded top and bare bottom of the Shivering Girl are here
reversed [86]. The simple, straight-hanging, almost foldless robe
has left far behind the agitated draperies of Bernini's saints [78,
79]. The lack of features in the massive underpinnings helps call
attention to the saint's head. We have already seen one example
of this principle at work, and will see others [79, 84, 91].

François Rude (1784–1855) grew up during the Revolution
and remained a republican at heart, even when he served em-
perors. His first sign of originality was a seated, grinning Neapoli-
tan Fisherboy, a theme that became a great favorite, with varia-
tions, with other sculptors. Within hailing distance of Rude's
statue in the Louvre there is another by Duret of a young fisher-
man dancing the tarantella, one by Carpeaux of a fisherboy with

a shell to his ear, and a marble by Falguière of a similar boy who
has just won a cockfight. The cheerful expression of Rude's young
Neapolitan, and the humbleness and "foreignness" of the subject,
brought Romantic approval, while the body's classic beauty won
praise from academia.

Rude's best-known work, seen by every visitor to Paris, is the
group in high relief on the Arc de Triomphe entitled the Depar-
ture of the Volunteers but more popularly known as the Marseil-
laise. It is full of motion and emotion, the marks of a Romantic.
Our illustration shows the *Awakening of Napoleon to Immortal-
ity*, now in the Louvre [84], made after the return of the em-
peror's body for burial in the Invalides. The General stirs himself
from sleep on St. Helena, represented by the rough rocky base.
The wreathed head and epauletted shoulders emerge from their
wrappings; "the cloak gives the impression of a steamer-rug," said
one unimpressed critic. The head and face are the only elabo-
rately developed features, recalling the earlier *St. Teresa* of Ber-
nini, and the later *Balzac* of Rodin, where massive geologic
grounds erupt in faces that are the central points of interest [79,
91].

A mid-nineteenth-century sculptor who was constantly re-
buffed by the conservatives of the Academy was Antoine Barye
(1796–1875). His offense was in being too naturalistic. He became
famous as a modeler of animals, his favorite themes being combat
between them or scenes of one devouring another. Important
American collections of his work are found in the Walters Gallery
in Baltimore and the Corcoran in Washington. Partly because he
was so poor, Barye cast many of the bronze figures himself, an ac-
tivity that fewer and fewer modelers were undertaking. Most
bronzes were cast by commercial foundries from plaster molds
supplied by the sculptors. Identifying "real" Barye bronzes is dif-
ficult. After the artist's death a firm bought some models from
Barye's workshop and seems to have reproduced them on a fairly
lavish scale. The problem of authenticating "originals" is a perva-

sive one in modern sculpture, possibly most acute with small statuettes and figurines that are more readily reproducible and transportable than monumental pieces. Later in this chapter we will dig a bit more deeply into these matters.

Jean-Baptiste Carpeaux (1827–1875) was a pupil of Rude. His most famous work was the group called "La Danse" made to adorn the Opera in Paris. The main figures are three lively and joyful nudes, leaping and dipping in attitudes of the dance. "Rarely had the formulas of the academies had to sustain a ruder shock," said Rodin, who went to see the group unveiled. Many in bourgeois Paris objected to so much public nudity. But, said Rodin, Carpeaux's really unpardonable crime in the eyes of the academicians was to give so much vitality to the carved stone. Carpeaux modeled with "suppleness and passion" and the others "with a dead hand." The group still stands attached to the front wall of the Paris Opera, in lively contrast to three other dull and academic groups that share the wall. A replica is in the Louvre.

Carpeaux's first important work, modeled while he was studying in Rome, was the group of *Ugolino and His Sons,* which seems to owe something to the *Laocoön* for inspiration. Ugolino was an Italian nobleman caught up in the long war between Guelphs and Ghibellines in Italy. Dante recounted the story of his imprisonment by his enemies and condemnation, along with his sons and grandsons, to die by starvation. The Carpeaux group depicts his agony as he begins to gnaw on his own fingers in famished despair. The youngest of his grandsons seems already to have died at his feet. The original bronze stands in the Louvre; a marble version is in the Metropolitan in New York [87]. There was a storm of protest from the academics, at the horror of the theme, the "vulgar" naturalism of the figures, and the expressiveness of the faces—all the usual complaints against Romantic tendencies. But Emperor Napoleon III, despite the critics, became Carpeaux's patron.

"I AM A BRIDGE"

The Pigalles, Rudes, and Carpeaux made some notable departures from the academic formulas in the eighteenth and nineteenth centuries. But the first truly fresh voice in the West after the Renaissance was Rodin's. In his later years Rodin saw himself as a transitional link between the long Western tradition reaching back to ancient Greece and the new twentieth-century sculpture that consciously departed from that tradition. "I am a bridge," he said, "joining the two banks, the past and the present."

Auguste Rodin (1840–1917) came of a poor family of minor civil servants, was a wretched student, and early showed a consuming interest in drawing and sculpture. He had some training in a school of design, but was never admitted to the École des Beaux-Arts. The guardians of the artistic establishment who controlled entrance there realized that they were dealing with a rebel. After early years of poverty, working at odd jobs for others, at the age of twenty-four two important things happened. He fell in love with Rose Beuret, a simple peasant girl turned seamstress who bore him a child and stayed at his side the rest of his life— and who became his wife fifty-two years later, sixteen days before her death.

In the same year he met Carrier-Belleuse, a fashionable sculptor who turned out statuettes *en masse* and sometimes had commissions to help decorate public monuments. Carrier gave him steady employment for a time. Rodin became adept at producing sculptures in Carrier's style, which were sold bearing his employer's signature. He went to Brussels with Carrier to work on decorations for the new Stock Exchange, and stayed on with Carrier's successor, Van Rasbourg. In the hope of making a little money on the side he made an agreement with his new employer. Each would make popular figurines. Rodin would sign the ones destined for sale in France, Van Rasbourg those to be sold in Bel-

gium. Rodin, as so often before his successful middle age, got lit-
tle from the deal. By 1875, however, he had saved enough to visit
Italy. His liberation from academism, he said later, came from
seeing Michelangelo.

The next year Rodin completed his first major standing
figure, the famous Age of Bronze. When it was shown in the 1877
Salon, conservative critics, annoyed by the praise it won for vigor-
ous naturalism, noised it about that parts of the statue were cast
from a living model. Indignant, Rodin went to great pains and
costs to nail the lie, even getting plaster casts of the Belgian sol-
dier who had served as his model. Somewhat later official Paris
showed its confidence by buying the figure for the Musée du Lux-
embourg and few took the false charge seriously for long. But
Rodin remained sensitive all his life about the accusation.

THE TEMPLE THAT MARCHES

Rodin was as devoted to the human body as Michelangelo.
The sight of the human form, he said, sustained and stimulated
him. "I have a boundless admiration for the naked body. I wor-
ship it." Even if the completed statue was to be clothed, as in the
Burghers of Calais and Balzac [90, 91], he would first model it in
the nude. Later in life, when he could afford to do so, he hired
male and female models to wander about his studio without
clothes while he watched and waited for one to move by chance
into some attitude that he wanted to capture. Then he would
ask the model to freeze in that pose while he quickly drew
with pen or molded in clay.

St. John the Baptist [88] grew out of a chance encounter.
One day an Italian peasant knocked on his door, unannounced,
and asked to be hired as a model. Rodin reported that he saw in
him a blend of physical strength and mystical force that suggested
the Baptist. The peasant took off his clothes, mounted the mod-
el's stand, and stood straight, head up, feet firmly planted, one be-

fore the other, a foot or so apart—an attitude that no skilled model would strike and no academic sculptor think worthwhile to copy. For Rodin the movement seemed entirely right and true and he cried out, "But it's a walking man!" He resolved to reproduce the pose.

For more than two thousand years sculptors had shown the act of walking by arranging the feet as one observes them in nature—weight on the flat of the forward foot, the heel of the rear foot rising as the weight comes off it. In *St. John* (and in the headless Walking Man that was made as a preliminary study) both feet are firmly planted. Rodin insisted that there was a theory behind this and similar representations of movement: activity could best be shown in a static figure by depicting at the same time two sequential positions in a continuous movement of arms or legs or other parts, not in the frozen attitudes that would appear in a camera shot.

Like many other Western sculptors Rodin was quite evidently fascinated by the human body not only for its sensual qualities and its "humanness" but also for its remarkable combination of fixed and flexible elements that make it a structure of unique interest for a sculptor to work with. "The human body is the temple that marches," he said. Michelangelo said much the same: "it is a moving architecture."

SOME MATTERS OF METHOD

Rodin was a modeler, not a carver. So were most nineteenth-century sculptors, who more and more tended to leave the task of making marble or stone versions of their works to professional carvers. Rodin always worked from a living model. He spoke often of reading and reproducing the model's "contours"—that is, the outlines or profiles that a human figure makes as it revolves on its axis. He studied the contours carefully, even climbing a ladder to get the outlines as seen from above. Typically he would

first quickly make a maquette or sketch in clay, applying pellets of the material to build up the desired figure. From this he or assistants would make a full-size statue in clay. Dried clay does not long survive, and a negative plaster mold would be made from which a final "positive" in plaster or in bronze could be cast.

He made an unusual number of plaster casts while still searching for the final figure. Some forty studies, for example, made for his *Balzac* have been preserved in plaster or bronze or both.

The actual casting of bronzes was done by commercial foundries, the one most often used by Rodin in his lifetime being Alexis Rudier's whose cachet appears on many Rodin "originals." Rodin then customarily finished the piece off or supervised the final chasing and polishing, and washed it with acids for the desired patina with the assistance of a professional *patineur*.

The marbles were mostly carved by skilled assistants or commercial stone-workers. The story (first put about, it is said, by other sculptors) got well established that Rodin himself never put a chisel to the marbles that bore his name, especially in his later years. But there is clear evidence, from models and students and friends, that he did sometimes work on the marbles himself, even in old age. No one doubts, however, that most of the work of this kind was done by others in his busy studio or by assistants working outside under his supervision.

TENDER AND DELICATE MYSTERY

Rodin was an ardent admirer and bedder of women. Desire seemed to grow with age and success. Even in his later years he was constantly beset by women, for whom it was fashionable to have affairs, however transitory, with the master. The long-suffering Rose lived in terror of losing him forever. At least twice it seemed that he had indeed left her, but he always came back. His grand passion for Camille Claudel and later long infatuation for

the American-born Duchess of Choiseul were more serious than unnumbered casual conjugations.

He regarded women with a mixture of lechery, awe, respect, and cynicism. In portraits he preferred to use bronze for men, marble for women. While insisting on the most ruthless honesty in sculpting male portraits (which often offended his distinguished sitters), he thought that an artist should be more "respectful and discreet" in portraying women; "we must be circumspect in unveiling their tender and delicate mystery." He seemed also to favor marble for his imaginative lyrical and erotic works, which he turned out in profusion during the 1880's and later, beginning with his passionate affair with Camille. These pieces proclaim his ambivalent attitude toward women. There are the soft, delicate, lyrical, "sweet" ones, and there are the baldly sensual and assertive ones. His enchantment is most evident in the hundreds of sketches, on paper and in clay, that he made of women models in attitudes of physical abandon.

Rodin showed men and women (and sometimes two or more women) together in erotic attitudes that are unusually explicit in Western sculpture. Not unexpectedly such a display of sensuality lifted Third Republic eyebrows. Even in his last years, when the state was considering a plan to turn his studio in the Rue de Varenne into a national museum, one ground for hesitation was the "indecency" of many of his works. At Chicago's World Columbian Exposition in 1893, officials put The Kiss and another sensual marble in a room separate from the other Rodins lent by the French government, accessible only on application.

It is especially in the marbles that we find a sculptural effect that has come to be considered characteristic of Rodin. He learned it from Michelangelo, whom he greatly admired. We do not know for certain Michelangelo's reasons for leaving many carvings unfinished. With Rodin it is clear that he wanted to bring out a sharp contrast of a crudely roughed-out background and unfinished features with the polished surfaces and high finish

of other features. He used the technique often in his sensual figures. There are many lovingly carved female forms where breasts, faces, thighs, or expanses of backs and buttocks have been highly finished, while the extremities of hair and hands or feet are merged in the rough marble.

One admirer and biographer who met Rodin when the master was in his late forties wrote that he often stopped work on a figure the moment he had found the essential movement or attitude that he had been trying to capture, leaving the rest unfinished.

Given Rodin's deep interest in the female nude, as obsessive as Michelangelo's in the male, we realize with a start that his "serious" works, the major monumental bronzes, are almost always of men.

THE GATES OF HELL

The serious and the sensual types coalesced in an ambitious work that Rodin started in 1880 and never finished. Michelangelo too had had a long unfinished project, the tomb of Pope Julius, which hung over him most of his life. In Rodin's case, however, the incomplete work was a continual source of ideas and a showplace for experimental studies of works that later became autonomous sculptures.

This was the *Gates of Hell,* originally commissioned to be installed as the doorway of a new Museum of Decorative Arts [89]. Rodin undoubtedly had in mind the great doors of the Baptistery in Florence whose bronze panels ushered in the sculptural Renaissance. His own doors were to be based on Dante's *Inferno.* As the years went by they became a more generalized view of man's gloomy lot, but always some major groupings in that riot of twisting bodies were based on themes drawn from Dante. At the top center of the doorway, in the rectangular tympanum of panel below the lintel, Dante himself broods over the scene; the figure

has become familiar around the world, in many different sizes, as The Thinker. Quite possibly it owes something to Carpeaux's *Ugolino* [87].

Rodin seemed to pay little attention to the names given his works. His first famous statue, The Age of Bronze, was also called tentatively The Vanquished and Man Awakening to Nature. There was a similar adaptability in individual figures, and even individual limbs. They might be joined in pairs or groups; they might stand apart by themselves; they might, from one guise to another, change slightly in their basic posture and emotional attitude; heads and limbs might be transposed from one figure to another, or set aside as separate objects until some need arose for them. Rodin had an assortment of heads, arms, hands, legs and feet that he called his "giblets."

In Fugit Amor a man is stretched out on his back, legs somewhat apart and hanging down, arms reaching back behind him and over his head. In the Prodigal Son the same male figure, slightly modified, is set upright on his knees. Now his upward-reaching arms take on the attitude of prayer or beseeching.

One of Rodin's biographers saw the door in plaster, about eighteen feet high, set up in Rodin's studio in 1887. At times he ripped out most of the writhing figures that covered the doors, preferring to stress their architectural qualities. A plaster cast of the *Gates* in this depopulated state now stands in the museum at Meudon, where Rodin lived the last twenty years of his life. Later he restored most of the figures, which reach up, fall down, or stretch across the entire expanse with little regard for boundaries of door panels, pilasters, tympanum, or lintel. In 1924 Jules Mastbaum of Philadelphia ordered two casts in bronze, one for the Musée Rodin in Paris and the other for the museum he was then establishing in Philadelphia.

A major group not related to the *Gates* was the *Burghers of Calais,* commissioned by that city in 1884 as a monument to six townsmen. In 1347, when King Edward III of England was be-

sieging Calais, these six had offered themselves as scapegoats for
their fellow citizens, ready to die for them if that should be their
captor's wish. The group's leader, Eustache de St. Pierre, and his
five companions are shown in highly individual attitudes as they
walk toward the city gates to deliver themselves [90].

The city fathers who asked Rodin to undertake the work
were not enthusiastic about this stark group but finally accepted
it. It seems Rodin originally meant for the *Burghers* to be iso-
lated figures walking in procession to their doom. When it was
decided they should be organized into a single group he thought
first it should be placed high on a pylon to give a silhouette
against the sky, and then at ground level, as though the burghers
were mingling with their present-day townsmen. After first being
put on a conventional pedestal in Calais they now stand, as Rodin
intended, at ground level. Another casting stands outside the
Houses of Parliament in London; it is, unfortunately, on a pedes-
tal, and the effect of six closely related figures is impaired. Other
castings in bronze, with no pedestal beyond the base that holds
the group together, are in the Rodin Museum in Philadelphia
and in the grounds of the Musée Rodin in Paris.

One aspect that disturbed the city fathers who were expect-
ing a more conventional civic monument, and the Parisian cul-
tural establishment, was the lack of "composition" in the accepted
sense. The pyramid and cone had become so inevitable as the
basic forms of sculpture that this group of six, the same height
and standing on the same plane, was shocking. Yet the *Burghers*
is tightly composed in a different way, by gestures of bodies,
heads, and hands.

A BEAR IN A BAG

Rodin's last major work was also his most controversial. The
French, especially those in the world of art and fashion, divided
almost as bitterly over his *Balzac* [91] as they did over Dreyfus.

The master had been asked to make a monument of the novelist for the Société des Gens de Lettres. Rodin immersed himself in his subject—read Balzac's novels, went to his home town to study local "types," had a suit made to Balzac's measurements, and studied whatever photographs, paintings, and drawings were available of the man who had died when Rodin was ten years old. Some forty pieces survive of various studies the sculptor made, of the head and of the body, clothed and unclothed. A room in the Musée Rodin in Paris is devoted to the fascinating history of the idea. Many of the studies, preserved in bronze, can be seen in the Los Angeles County Museum of Art, and other museums in the United States and abroad have some of the castings in plaster or bronze.

As usual, Rodin started with nude models. In the early studies Balzac is seen as a powerful but pot-bellied man, striding like St. John, with arms folded across the chest. Eventually he settled upon a stocky and muscular model and clothed him in a loose-fitting Dominican robe of the kind Balzac often wore. When the first plaster cast of it was seen by a startled Paris, a storm of criticism broke, with ardent partisans for and against the work. It was called, among myriad unflattering epithets, the "work of a mind in complete confusion," a "lump of plaster thrown or kicked together by a lunatic," a "snowman," and "a bear in a bag." The literary society that had commissioned the statue refused to accept it. Rodin turned down several high offers from others, and kept the plaster statue in his own garden in Meudon, overlooking Paris. It was only cast in bronze and placed in its present location at the intersection of the Boulevards Raspail and Montparnasse in 1939. Other bronze copies stand outside the Musée Rodin in Paris and in the Sculpture Garden of the Museum of Modern Art in New York.

We are well aware of the powerful body beneath the robe that is loosely held by the folded arms. Rodin chose this garment not only because it was typical of the writer but because it would

suggest the body and yet not tie the wearer to any given epoch of male fashion.

SOME PROBLEMS OF PEDIGREE

There are many major collections of Rodin's works scattered around the world. The biggest in the United States are in Philadelphia and San Francisco (Palace of the Legion of Honor). Other important collections can be seen in the Cleveland Museum of Art, the Los Angeles County Museum of Art, and the Metropolitan Museum in New York. The good-natured rivalry among public and private collectors is based in part on the matter of pedigrees. Of all the many Rodins in the world, which can be said to be from the master's hand? Are there different degrees to which a particular object can be said to be "his"?

For example, more than forty castings have been made in bronze of the life-size Age of Bronze. Legally, it seems, all may rank as originals. But when a casting is made after an artist's death (one that he had no opportunity to finish off, to give a patina, to approve, or even to see) some interesting questions arise. The cachet of the bronze foundry might seem to be a clue as to whether a casting was made while Rodin was still alive—if that is considered an important question for commercial or artistic reasons. But the name of the skilled bronze-caster he most often used, Alexis Rudier, was inscribed by the foundry long after Alexis had died, and long after Rodin had died. Few copies bear a date.

The confusion becomes all the greater when we look at versions that have been enlarged or reduced from the first one approved by the sculptor. By mechanical processes, adapted from those used in making copies of statues, works of a different size can be readily produced. These enlargements and reductions were made during Rodin's life (presumably at his direction and under his supervision). The first version, for example, of the Age of

Bronze was 1.8 meters high. Other "approved" versions are found at 1.1 and 0.6 meters. It seems, moreover, that there are not yet reliable public records as to the combined number of copies of most objects that were cast during Rodin's life and after his death.

There are other related problems. But this whole range of questions is of more concern to art historians, museum administrators, and prospective purchasers than those of us who go to museums to look at Rodin's works. Proper attribution is a problem whenever groups of assistants in large workshops have helped to produce a work of art. By the nineteenth century few sculptors were carving statues from their own plaster models. The casual viewer could well take the point of view that the more castings made of a Rodin (or other master), to be seen in more museums, the better—unless deteriorated molds, poor casting, copies made from copies, and the like result in a marked loss of quality. (It is distressing, for example, to find in the Museé Rodin in Paris a casting of the *Prodigal Son* bearing a large patch between his shoulder blades, another on the left buttock, and a right-angled scar on the right buttock caused by a badly aligned piece-mold.)

OF PLASTERS AND MARBLES

We have already noted that Rodin's marbles, like those of many sculptors, were often made in large part by other hands. In the process of translating the plaster cast, made from Rodin's own clay model, into marble, significant changes might take place. There are differences, for example, in versions of his *Christ and Magdalen*. The plaster cast from the figure that Rodin modeled in clay is preserved in the Musée Rodin in Paris [92A]. Mary Magdalen throws herself on the dead Christ, still transfixed on the cross. It is a roughly finished, spare, strongly cruciform group. From this model a marble was made, which is now in the Thyssen Collection in Lugano, Switzerland, and a plaster cast made

from *that* is in the Palace of the Legion of Honor in San Francisco [92 B]. (Another can be found in the Museé Rodin Paris.)

In the marble (and casts made from it) the distinct form of the cross is blurred in the heavy masses that have been added to the background. The figures have become embedded in the marble. The modeling is much more voluptuous. Indeed, the marble version must be the most sensual Magdalen in art history, a world away from Donatello's [59]. And the traces of Rodin's own finger work as he modeled the clay are, of course, lacking in the marble. Possibly Rodin, in creating this startling expression of the Magdalen's adoration, had in mind the notion, prevalent in the Middle Ages, that her love for Christ was not wholly of the spirit. It may well be that Rodin's idea of sensual as well as spiritual adoration glows more vividly from the marble than from the first plaster model. We must assume that Rodin, whether or not he actually did any of the carving himself, closely supervised the making of the marble version. It is, in short, "his."

Another example of such changes is found in the Rodin Museum in Philadelphia, which has two versions of *Eternal Springtime*. This is one of Rodin's most popular and most widely reproduced works [93 A & B]. For the marble version, from which one of the bronze versions was formed, substantial additions were made to the base and background to prop up the outstretched arm and leg of the male figure. Perhaps what the bronze has lost in lightness and airiness it has made up for in stability and a more "convincing" base for the oddly outstretched arm.

It is in the large bronzes that we best see the imprint of the master's hand, the distinctive rippling and vibrant surface that is one of Rodin's significant contributions to the art of sculpture. "To me," he once said, "the whole of a head or a body appears like a fluid mass agitated by a great wind." He managed with remarkable success to capture that appearance and convey it to his viewers.

The biggest of the many collections of original plaster casts is

probably the one least visited, in the Villa des Brillants at Meudon, south of the Seine, where Rodin lived his last twenty years on a green hill overlooking Paris. There he and Rose are buried, and there a museum has been built to house a large number of plaster sketches and finished casts.

The Western tradition that started in ancient Greece was not buried with Rodin. It was, however, grievously stricken before he gave it new life, and declined with his passing. New forms of sculpture exploded in the twentieth century, in much of which the tradition was deliberately rejected. This is no place to inquire into the reasons for the radical questioning of the tradition or to consider the innovations spurred by contemporary dissatisfaction with the old conventions. That is another story.

Let us just note that among the new strands of thought and effort have been a searching for basic geometric forms, a rejection of the naturalistic, an interest in sculpture as an autonomous form of art untainted by associated meanings, an insistence on individual expressiveness that would have left reeling the Romantics of the nineteenth century, and a great curiosity about the plastic possibilities of new materials. Thoughtful students of history and art have suggested that traditional sculpture, growing from religious and humanist faiths now weakened, is not likely to revive. Will there be future Michelangelos and Rodins, dedicated to that tradition, giving it their own fresh interpretations? It would be foolish to predict. As we shall see in the next few chapters, vigorous traditions do fade and die.

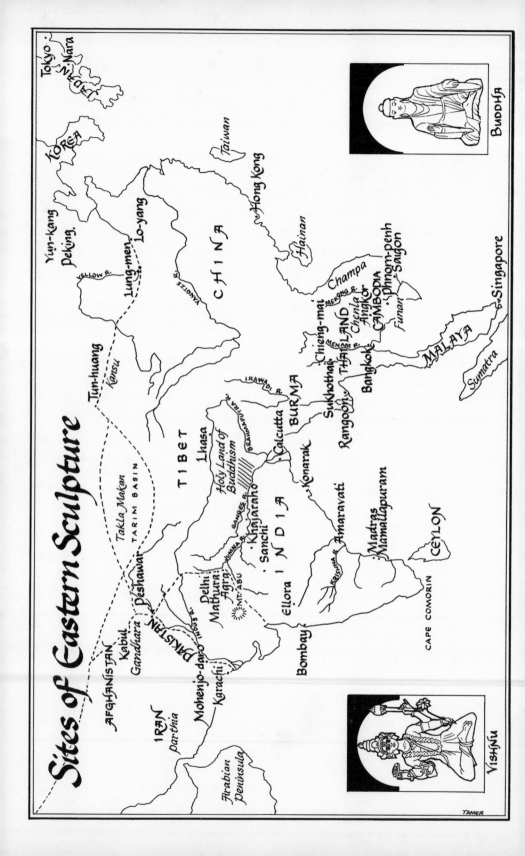

Sites of Eastern Sculpture

BUDDHA

VISHNU

TAMER

CHAPTER
5

India:
Mainly About Buddha

THE Western eye is likely to blink uncomfortably at first
sight of Indian sculpture, and the Western mind to recoil.
The beholder is now on unfamiliar ground. His tendency
to measure art against Greek standards is challenged and shaken.
He is confronted by strange gods and goddesses, often many-
armed, bearing bewildering names that hold little or no meaning
for him, and enacting scenes drawn from epics and religious writ-
ings that wake few echoes in his own experience. He finds figures
that are, although definitely human, rounded and pneumatic,
with none of the underlying bone structure, muscles, and joints
that the Greeks sought so painstakingly to describe in their pur-
suit of naturalism.

Clearly if the Westerner is to enjoy and understand India's
prolific sculpture he is going to have to work at it, to clear his
mind of preconceptions, and to open it to novelty. He will find
the effort rewarding. He is preparing himself, not only for the art
of India, but for that of all of Asia that lies to the north and east

and south. Buddhist and Brahmin themes and forms, developed in India, spread to Nepal, Tibet, China, Korea, Japan, southeast Asia, and the islands of Indonesia and Ceylon. Although the fact is often forgotten, India is the artistic gateway to these other lands and cultures, each of which interpreted the Indian material in its own idiom, blended it with indigenous cultural strains, and developed distinctive styles.

A FEW DATES

For our purposes we need not know much about the dynasties that ruled at different times in various parts of India, the rivalries of kings and regions, or incursions from outside. By and large, it is enough to be aware of three general historical epochs, defined by trends in religious belief and social organization that affected plastic art. Crudely oversimplified these are the Vedic, the Buddhist, and the Puranic, or Medieval, periods.

In the first, ranging from about the middle of the second millennium to the middle of the first B.C., the Aryans swept in, probably from what is now Iran, to the plains of the Five Rivers (Punjab) and the Ganges in northern India. They subjugated, mixed with, or pushed southward the native Dravidians. The Aryans established a political and social order, and cults of worship systematically explained in their sacred texts, the Vedas. These were encyclopedias of worldly and other-worldly knowledge, credos, and precepts, ranging from metaphysical speculation and religious ritual to guidance on all the concerns of daily life, including the most intimate human relationships.

Their priestly leaders were intent on bringing together in one unified system the answers to all human questions. Everything one needs to know, it was said, is in the Vedas. Among the Aryans' creations was the caste system, in which everyone had a certain position in life, with defined duties and responsibilities. Not unexpectedly the Brahmins, the priestly highest caste, who

devised and developed this remarkable machinery of social and political control, held the main levers of power as interpreters of the will of the gods and advisers to earthly rulers. The Vedic pantheon—gods identified with elemental forces like sun, fire, and rain—mixed with the nature spirits of the earlier natives. The tree gods, fertility spirits, snake deities, and other images drawn from nature survived the Aryan invasion and to this day figure in Indian worship and art. From this Vedic period in which northern India was made Brahmin, or in common Western terms Hindu, little sculpture remains—if, indeed, it ever existed.

The second artistic period, which we may call Buddhist, stretches from the end of Buddha's life in the sixth and fifth centuries B.C. to the seventh or eighth century A.D. Buddhism, like Jainism, which was roughly contemporary, grew as a protest against Vedic Brahminism. The Brahmins preached that one's status in life was fixed, until the next rebirth, by the caste into which one was born, and that one's hope of a better status in the next incarnation lay in living according to the rules laid down by Brahmins. Buddhism rejected the definitive importance of caste (and the ascendancy of the Brahmins) and taught that all humans equally could find salvation, defined as release from the cycle of rebirths, by freeing themselves from worldly attachments. Both Gautama Buddha and Mahavira, the founder of Jainism, were of the Kshatriya or warrior caste, ranking second to the Brahmins in the Hindu hierarchy.

Buddhism was attractive to those who felt trapped, in this life and the next, by Brahmin doctrine. Unlike Brahminism, however, the new religions did not offer a definite social and political order. And in the end they lost out to a resurgent Brahminism, which began to be clearly predominant in the seventh and eighth centuries A.D. During the prior millennium Buddhism was never in unchallenged ascendancy. It existed alongside Brahminism. But powerful rulers embraced Buddhism, great Buddhist monasteries grew up, major universities were built on it, and its influence

spread northward and eastward and southward through Asia. The end of Buddhist influence in India did not come on a well-defined date. It simply gave way gradually before a popular preference for Hinduism and a determined effort by the Brahmins to reassert supremacy.

Today Buddhism is a minor religion in India, embraced by a relative few who want to escape from the rigors of the caste system. Dr. Ambedkar, leader of the Untouchables during the period when India was gaining independence, led many of his fellow out-castes into Buddhism as a religion that would free them. The movement was not unlike that among blacks in the United States, some of whom, despairing of a future within the dominant white Christian society, have recently turned to Islam.

The Puranic, or Medieval, period in India lasted in terms of our sculptural interests until the Mogul invasions, roughly from 700 to 1500. This was the period of most luxuriant growth in Indian sculpture, and the one from which we will find most of the examples of Hindu art that we are about to look at in the next chapter. The Hindu pantheon remained as diverse as ever. More and more, however, the elemental Vedic gods were relegated to minor positions. Religious writings in the Puranas—sacred texts interpreting and supplementing the Vedas—focused on three aspects of the godhead: Brahma, the universal essence; Shiva, god as creator and destroyer; and Vishnu, the preserver, god in his benevolent and loving aspect.

Shaivism, the worship of Shiva, became dominant in much of south and southeast India, and Vaishnavism, the worship of Vishnu, in the north and center. Shaktism, the worship of the Great Goddess, Shiva's consort, alternately mother and destroyer, became a powerful third sect in eastern India and parts of the southwest. Curiously, Brahma, the unchanging essence of the universe, never emerged as a great cult god.

Visitors to museums where Indian sculpture is shown will usually find individual works identified by dynasty. Some of the

dynasties ruled more or less all of India as we know it today, some were limited to the north or south, or to parts of those broad areas. To help readers place works within the general threefold framework suggested above a table of principal dynasties is given below. Moreover, some of these are of special importance in the development of Indian sculpture. We should, at the very least, be able to recognize works from the Kushan dynasty, or the Guptas, or the Pallavas in the south.

PRINCIPAL DYNASTIES IN INDIA

Indus Valley Civilization	3000–1500 B.C.
Vedic Period	1500–500 B.C.
Buddhist Period	500 B.C.–A.D. 600
Maurya Dynasty	321–184 B.C.
Sunga Dynasty	185–72 B.C.
Early Andhra	72 B.C.–A.D. 50 (southern)
Kushan Dynasty	A.D. 50–seventh century (northern)
Later Andhra	A.D. 50–320 (southern)
Gupta Dynasty	320–600 (northern and central)
Medieval or Puranic Period	600–1526
Pallava Dynasty	600–850 (southern)
Chalukya	550–750 (western; Deccan)
Rashtrakuta	750–975 (western; Deccan)
Pala and Sena	750–1200 (northeastern; Bengal)
Ganga	1076–1586 (eastern; Orissa)
Chola	850–1150 (southern)
Hoysala, Pandya, and Vijayanagar	1100–1565 (southern)
Mogul Period	1526–1857

SOME DISTINCTIVE FEATURES
OF INDIAN SCULPTURE

The human figure in Indian sculpture is far less naturalistic than in Greek works after the Archaic period. Whether of deities, their attendants, demons, or earthly men and women the figures are clearly human. There is almost no attempt, however, at any time or place to present to the viewer a body or face with the detail of muscles, bone structure, flesh folds, and expression that we observe in living beings. The most striking feature of these human images is their pneumatic, well-filled look, the reduction of the human head and body to a few basic convex volumes with smooth surfaces. We will look into the religious reasons for this later.

The faces are strangely sexless. We can hardly distinguish male from female in the heads, although details of hairdressing and ornament, to the initiate, or the rare presence of facial hair, will inform us. Below the neck the women are indubitably female. Huge melon breasts, wasp waists, swelling pelvises and ample thighs embody the Indian ideal of feminine beauty. John Kenneth Galbraith once observed that the more underdeveloped the country, the more over-developed the women.* As Ambassador to India he was, presumably, moved in part to make the remark by the exuberant femininity of India's sculptured goddesses, celestial attendants, and dancers. The male body is distinguishable mainly by broader shoulders and the absence of breasts. It too is typically small in the waist and the thighs are apt to be generous. Above the waist the man's chest usually flares upward, but there is little or no indication of muscles or bone structure. On male and female figures alike the legs are tapering columns, with only the suggestion of joints. Indeed, one would hardly

* A friend who has visited New Guinea, one of the least developed lands in the world, confirms Galbraith's generalization.

know that knees, ankles, and elbows exist. Indian sculpture treats these joints as smooth curved surfaces joining the appropriate limbs in continuous flowing lines. Calves are barely hinted at, if defined at all.*

Details of dress or ornament are usually carved or modeled in shallow relief or incisings. The human figure is seldom shown completely nude, but the clinging garments, barely indicated, often give the impression that there are no clothes at all. Occasionally the folds of clothing are carved in a naturalistic style akin to that of the Greeks, but there is seldom the swirl of drapery or elaboration of folds that the Greeks and their followers used to suggest movement or to help define the main volumes of the body. Indian sculptors accomplished much the same thing with intricate and lavish ornamentation—girdles, belts, sacred cords, necklaces, garlands, looping scarves, and the like.

Differences and changes in all these elements of form are evident, even to the untrained eye, as the carver's art develops in various parts of India. A Gupta Buddha of the sixth century A.D. has come a long way from the crude, massive *yakshas* of the second century B.C. [98, 111]—almost as long a way as the Olympia *Hermes* from the New York *kouros* [3, 24]. With all the changes, however, there is a remarkable constancy in form and theme throughout the history of Indian sculpture. One scholar of Indian art, Philip Rawson, has remarked that it has always ploughed a narrow furrow deep.

Most Indian sculpture is meant to be seen from one point of view. Apart from the free-standing bronzes, mainly from south India, most sculpture is attached to a background—a cave wall or temple niche or frieze. In short, it is typically done in relief, though often in very high relief and sometimes almost fully in the

* The Abbé Dubois, a sharp, if somewhat jaundiced observer of the south Indian scene as a Jesuit missionary late in the eighteenth and early in the nineteenth centuries, noted that the calves of Indian men's legs are meager, and that well-developed leg muscles "are not considered any sign of beauty."

round except for a link with its ground. From early times the bodies shown in relief, where only the surfaces presented to the viewer are modeled, often have thick unmodeled "connective tissue" from those surfaces to the background. Later on we will want to consider a bit more fully the intimate connection of sculpture and architecture in India that makes the typical Indian stone statue a work in the almost-round or in high relief.

THE VERY OLD AND THE OLD

No significant sculpture from the Vedic epoch survives. For our purposes Indian sculpture begins about the second century B.C., with themes drawn from nature worship and Buddhism. But long before, from about the middle of the third millennium B.C. into the second, a civilization existed in the Indus Valley, in what is now Pakistan, of which traces have been found. Two small statuettes of this era are show here [94, 95]. Both are now in the National Museum in New Delhi.

One is a figure of a dancing girl or nature spirit in copper, found in Mohenjo-daro, with torso and limbs like thick wire and a face astonishingly full of character for so tiny a volume. The other is a male torso, also from Mohenjo-daro, its most striking features being a well-filled belly and a body in torsion, twisted in dance. There may be some link between these very old pre-Aryan modelings and the sculpture that emerged more than a thousand years later in Buddhistic times. But this, on present archaeological evidence, would be speculation. The possible connections would not be of much concern to us except for the bulging belly of the male, and the *hanché,* hip-thrust-out, attitude of both.

For the first surviving monumental Indian statues we must leap across more than a millennium, to the second century B.C. and the colossal *yakshas,* or nature gods, that have been found in recent years in northern India. One of these, found in the village of Parkham, now stands in the Mathura Museum of Archaeology

just south of Delhi [96]. Nearly nine feet tall, the massive, frontal figure is bare above the waist except for a neck ornament and a band round the chest. The lappets of his lower garment fall between his legs from the knot at his groin, a recurring and distinctive decorative feature in later Indian sculpture. His most prominent feature is a protruding belly, which looks as if a great blister of stone had been added to a more conventional human figure. This and other examples of the archaic period of Indian sculpture are, for most of us, likely to be more interesting as a base point from which Indian sculpture developed than for their aesthetic appeal. Yet they exude uncommon strength. Villagers where they have been found took comfort, it is said, from the colossi's commanding presence. These huge images of forest gods may well be precursors of the standing Buddhas that begin to appear three or four centuries later. From this same Mauryan period some small, finely carved stone heads, now in the National Museum in Delhi, remind us that the Indians were then capable of making vivid human features [97].

In the earliest Buddhist art the link with nature worship continued to be strong. We see this influence in works of the first centuries B.C. and A.D. from some remarkable sites of Buddhist stupas, or grave mounds, the domed structures originally used to cover graves or relics, that became a conventional form of Buddhist temple architecture. One of these sites is at Sanchi in central India, from which we show in the illustrations one of the four elaborately carved ceremonial gates guarding the approaches to the Great Stupa [98]. A female figure from another gate is also shown [99]. She is an early example of a theme that will recur time and time again. A *yakshi,* or female fertility deity, in the form of a tree spirit (the males of the species are called *yakshas,* as we have noted) is used as a bracket for one of the crossbars of the gate. She is in an *hanché* posture. The hip supporting her weight is thrust out to form a long sweeping arc from ankle to waist. It continues through the *yakshi*'s ample breasts and is picked up by

an arm raised over her head, bent at the elbow, with a hand grasping a bough of a stylized tree. Her other arm hangs through a forked branch of the tree and her free foot—the one not bearing her weight—is crossed behind the other to touch the trunk of the tree. She is nude except for the decorated belt that encircles her hips, a necklace falling between her breasts, and leg and arm bracelets. The mons area is clearly marked.

Is she a direct descendant of the dancing girl of Mohenjodaro, hand on out-thrust hip, fashioned in metal about two thousand years earlier? Some experts think so. However that may be, she is certainly intimately involved with the tree. The two intermingle, seeming to draw strength from each other. The torso of her sister, a similar tree or fertility spirit from another gate to the Great Stupa at Sanchi, is one of the treasures of the Boston Museum of Fine Arts [100]. Unfortunately the Boston figure is badly damaged. Although she lacks her head, legs below the lower thighs, arms, and one breast, in pose and impact she is remarkably like some of the Greek Aphrodites that have come down to us, especially the famous Hellenistic original from Melos (Milo) now in the Louvre [32]. Similar tree spirits from Sanchi can be seen in the Los Angeles County Museum of Art, which has much of the superb Heeramaneck collection of Indian sculpture.

THE BUDDHA APPEARS

In the elaborate Sanchi relief carvings, as in others up to some time in the second century A.D., the figure of the Buddha himself never appears. Reliefs in India, and more accessible to us in American and other Western museums, show a mixture of themes from nature worship and Buddhism—lavish carving of foliage and animals, and of nature deities, along with scenes from the lives of the Buddha. He himself is always represented by a footprint, a domed stupa, a Wheel of Law, or some other symbol.

Two series of reliefs at Amaravati on the Kistna River in

southeastern India, carved at different times in the second century A.D., mark the shift from symbolic to human representation of the Buddha. One scene from his life is his departure from the palace where he grew up, in privilege and pleasure, as a royal son. Having observed the misery of lowly people outside the palace, he resolved to give up his princely life, become an ascetic, and seek an answer to the question of human suffering. The Amaravati reliefs show him as he carries out his vow of renunciation and leaves the palace in the middle of the night—the Great Departure. In the earlier version an apparently riderless horse sets out from a gate at a brisk clip while an attendant solicitously holds a parasol over the invisible horseman. In the later, there are again the horse and parasol-bearer, but this time the Buddha-to-be is shown astride his mount.

The Boston Museum of Fine Arts has some relief panels from Amaravati. One of these shows the most crucial scene in the life of the Buddha-to-be. After years of wandering as an ascetic, Siddhartha Gautama decided that the secret he sought could not be found through withdrawal and self-mortification. He sat beneath a pipal (the Bo, or *bodhi,* tree, a species of giant fig that is one of the glories of north Indian flora) outside the town of Gaya. There he vowed that he would not leave his seat until he had solved the riddle of human suffering. During the forty-nine days that he sat there the demon Mara tempted him with visions of fleshly pleasure and worldly power and riches. Having failed to stir him, Mara turned to violence, assailing Gautama with hordes of demons, storms, and earthquakes. The future Buddha did not flinch. The *Assault of Mara* is shown in the top section of the Boston panel [101]. The temptresses tempt on the right side of the picture, and Mara's demons attack in the background. On the thronelike seat two cushions symbolize the Buddha. But notice the almost zoomorphic shape of the chair, with cabriole legs and arms that, even though broken, seem to stretch out. Behind the chair the Bo-tree rises with a long necklike trunk and a "head" of

foliage. It is as if the sculptor had gone as far as he dared to show the Buddha as a human being.

The appearance of the Buddha in human form in sculpture for the first time some six centuries after his death is clearly an event of importance. It marked a development in Buddhist theological and philosophical thought, incorporated into art. The Buddha himself made no claims to godhood. Quite to the contrary, he emphasized that his message was that of a man who had found the way to make life better for other mortals. Rejecting, in the end, the asceticism of the Brahmins as well as a prince's pursuit of pleasure and power, he preached the Middle Way, based on rules of conduct that would discipline (but not wholly suppress) worldly desires and lead men to live in compassionate harmony with other men and all animate things.

Without attempting to identify his own thoughts on an afterlife or rebirth or the existence of a personal god, or to trace how, after he had died, his followers came to different beliefs, we can be certain, simply from seeing Buddhist sculpture, that the Buddha became deified. Whatever the intellectual beginnings of Buddhism, it quickly became a popular religion that demanded devotion and obedience to powers not of this earth. Philosophy for the learned and images for the ignorant are precepts of almost every major religion, which must come to terms with ordinary people's needs and beliefs to be a popular faith. In sculpture around the turn of the millennium, the Buddha had already been deified even if his image did not appear. In the bas-reliefs from Amaravati the worshippers are in attitudes of adoration round the Wheel of Law, or the Buddha's footprints, or the Bo-tree under which he found enlightenment, or some other symbol that stands for the Enlightened One. The appearance of his physical image brought him into even sharper focus as a god to be worshipped.

Possibly that image, when we see it later in Mathura, came more or less directly from the earlier *yaksha* images. Some think so. There is a certain family resemblance between the colossal

figure from Parkham of the second century B.C. [96] and the standing Buddhas of the later period. Others trace the epiphany of the Buddha in human form to Greco-Roman influences reaching the borders of India through Gandhara. That is a matter we will want to look at more closely.

THE KUSHAN PERIOD: MATHURA

Whatever the sources of the Buddha image may have been, it became fully fitted out with conventional features, postures, and gestures by the second and third centuries A.D. Buddhism in its Mahayana (Greater Vehicle) form now promised salvation for all mankind if they were obedient to the teachings of Buddha and worshipped him. About the same time cults of personal devotion to the deity (*bhakti*) were growing in Hinduism too, challenging the old Brahmin rites of sacrifice to the gods and priestly magic. The Hinayana (Lesser Vehicle) branch of Buddhism still emphasized the need for monkish withdrawal from the world and purported to follow strictly the older scriptures. But it too accepted the image of the Buddha as a focus of devotion. In the centuries that lay ahead the Hinayana images tended to become more stylized and less individual than those of the Mahayana branch that spread through Nepal, Tibet, China, Korea, and Japan. We will from time to time want to look at some of the many sects into which Buddhism divided, for they affect the forms and themes of sculpture. For the moment let us simply note the emergence of the Buddha in idealized human form, in a religious movement that had become widely popular.

An important period of dynastic rule that is little known to most Westerners formed a watershed in Indian art. And it is the major meeting point between the Eastern and Western traditions. Late in the fourth century B.C. Alexander the Great reached the outer limit of his invasion of Asia, in the region that now forms Afghanistan and part of Pakistan. Some of his military com-

manders, soldiers, and followers stayed after his retreat. Although the lands in his wake remained primarily Asian, governance and art had a distinct Greek cast, and some local rulers were of Greek descent.

Late in the first century A.D., some three centuries after Alexander's withdrawal, the strong tribe of Yueh-Chih swept into the region from that fertile breeding ground of nomadic invaders in central Asia. Under the Kushan dynasty they established their rule in the Kabul Valley (until then under strong Greek influence), in all of what is now Pakistan, and in the upper Ganges Valley, reaching as far as Benares. The Kushan rulers adopted Buddhism as their religion and patronized its growth. They set up two capitals—one in Gandhara, the northern mountainous part of their realm, and the other in the Gangetic plain at Mathura, between Delhi and Agra on the Jumna River.

The Kushan empire was at the crossroads of China to the east, India to the southeast, and Parthia (present-day Iran) and Rome to the West. Several portraits of Kushan kings survive at Mathura, including an imposing statue of Kanishka I [102]. He stands in a strong triangular shape based on huge felt-shod feet splayed out in profile. His right hand rests on an enormous club or mace and his left clutches the hilt of a sword. The edges and folds of his kaftan and the lines of the weapons describe strong diagonal and upright perpendiculars. Even headless, Kanishka is the very picture of a mighty Eastern potentate. A later namesake called himself Maharaja (Great King) Ratiraja (King of Kings) Devaputram (Son of God) Kaisarasa (Caesar), appropriating the highest titles of India, Parthia, China, and Rome.

Other imperial portraits from Mathura show the Kushan rulers seated in European fashion, with feet on the ground, or squatting with both feet on the throne. Some images of gods are also shown in this curious squatting position. One icon (probably of the second century A.D.) is of Kubera, king of the *yakshas,* guardian of the northern quarter, and god of minerals and wealth

[103]. His left hand holds a cup and his right another object, possibly a money bag. He was known to enjoy the grape. Several Kushan carvings in relief show bacchanalian revels under his patronage.

A *Nagaraja,* king of the snake spirits, now in the Museé Guimet in Paris, is one of the most astonishing of Kushan sculptures from Mathura [104]. It is remarkable because the stiff, symmetrical postures of this fairly primitive school have given way to a relaxed, naturalistic pose, with careful modeling of anatomical features that is much closer to the *yakshis* of Sanchi [99] than the royal portraits and Buddha figures of Kushan Mathura. The Snake-King's "free" leg is a human leg, not a tapering tube. The protruding abdomen, with its deepset navel, is a feature we will take up in the next chapter. The garment is also remarkable—a transparent fabric below the waist contrasted with the heavy girdle, huge knot or sash, and looping folds that curve below the knee, and folds of cloth in front that continue the line of the genitals. Two coils of a serpent can barely be seen behind the figure on the left of the picture. The back view shows a solid mass of coils. A similar Snake-King is now in the Freer Gallery in Washington, but only from the waist down.

One of the landmark pieces of Mathura art of the second century A.D. is a small red sandstone statue of the Buddha, seated in the lotus position on a lion throne under the Bo-tree where he found Enlightenment. It is now in the Mathura Archaeological Museum. The Buddha's right hand is raised in the gesture of protection (*abhayamudra; abhaya* = have no fear; *mudra* = gesture or hand sign), and his left hand rests on his knee [105]. Behind his head is a solid circular nimbus or halo. On either side an attendant wields a fly whisk and above him two *gandharvas* (male heavenly spirits, not to be confused with the place-name Gandhara) are tossing flowers. The face is strong and intense, not as softly gentle and contemplative as the conventional Buddha image will become later. The hair is barely indicated, but the

ushnisha, or head bump, which will become one of the standard elements in Buddhist iconography, is already there. It appears as a tuft of hair, twisted into the shape of a conch shell. Also he has elongated ears, another invariable Buddha feature in the centuries to come, throughout Buddhist Asia, and the slight abdominal bulge that we almost always find in the sculpted Indian male figure. His only garment (besides a lower one barely indicated on the throne between his legs) is a body-clinging mantle thrown over his left shoulder, with stylized folds indicated by nearly parallel lines in low relief. These "string-folds," very different from the more naturalistic ones developed by the Greeks, but possibly derived from them, are found throughout the Buddhist world. This is one of the earliest known portrayals of the Buddha in the round, after it became permissible and correct to give him human form. An almost identical seated figure, damaged at the top of the head, is in the Boston Museum of fine Arts.

A standing Buddha of the Kushan period in Mathura, also still in the museum there, shows string-folds as incised lines in a garment that covers the whole body [106]. The cloth clings to him. Modeling of the body, rather than the lines of the string-folds, defines the underlying form. His left hand holds the hem of his garment and the right, somewhat damaged, is raised in the gesture of protection. It is an archetypal Buddha image that will be repeated again and again, with variations, wherever Buddhism reaches [111, 141, 150, 172], possibly deriving from the earlier colossal *yakshas* like that at Parkham.

The faces of these early Mathura Buddhas are round, earthy, and almost expressionless. The image has not yet acquired, in face or body, the serene, benign, and gracious appearance that emerges in the next two or three centuries, culminating in the Gupta period. The Kushan Buddhas from Mathura are in many respects very different from those in the style that was developing at the same time in the northern Kushan center in Gandhara. Let us now turn to that remarkable and influential school of sculpture.

THE KUSHAN PERIOD: GANDHARA

The impact of Greece, by way of Rome and Asia Minor, is at once evident in Gandhara's sculpture. The head of a human or divine figure is covered with the thick, wavy hair of Hellenistic man. The facial features are more European than Indian. Carving is sharper. Garments hang in voluminous Greco-Roman folds; they do not adhere to the body, indicated only by incised lines or shallow relief, as in the Indian style. The clothes themselves are Greco-Roman, not Indian. The ornamentation characteristic of Indian figures—necklaces, jeweled girdles, long looping garlands and strings of beads, arm and ankle bracelets—these, if there at all, are less lavishly displayed. Yet the themes are Indian—that is to say, Buddhist.

The marriage of the two cultures is, in the eyes of some, of both West and East, not a happy one. For the Westerner the first impression is likely to be pleasing. At the very least, the basic style is familiar (more Greek) and less disturbing to ingrained notions of "rightness" than the purer Indian forms. On longer acquaintance the effect may be less satisfying. To some it seems that here a decaying Hellenism, far from the main centers of Roman artistic production, is rather improbably interpreting Indian themes. The folds of drapery, for example, although clearly derived from Greco-Roman models, are sometimes crude, neither defining the underlying form convincingly nor behaving the way fabrics do in nature [107]. The faces are not modeled as skillfully as their contemporaries in the Roman world [42]. Yet their sharply chiseled features have an appeal of their own. Certainly they are unique. Once seen in several examples the Gandhara face of the second and third centuries is unforgettable and easily recognized.

Indians, for their part, often have objections of a different sort to Gandharan carvings. They lack, it is said, the spirituality that Indians expect to find in religious images, and do find in the

products of craftsmen untainted by the contacts with the West to which Gandharan carvers were subjected. The Buddhist images from the northern center of Kushan rule seem cold and alien. It should be remembered that, for a long time at least, Brahmins regarded the period of Kushan rule as an unfortunate episode of foreign domination, best erased and forgotten. Even the early Mathura images sometimes draw negative Indian comment on the ground that they are too earthbound, unspiritual, and uninspiring.

Here, for the first time in these pages, a distinction must be made between the Buddha himself and the Bodhisattvas, men who have attained or are capable of enlightenment but who, instead of passing over into nirvana, choose to remain on earth, share the suffering of other humans, and bring their fellow men comfort. As early as Gandhara the difference between the perfected Buddha and the possible Buddha is evident in art. The Bodhisattva, still a mortal dwelling on earth, gives the sculptor a freer hand to show him in a variety of worldly guises. The Buddha's, almost from the beginning, is a much more otherworldly image.

The Gandharan Bodhisattva illustrated [107] is now in the Boston Museum of Fine Arts. There are many similar ones in other museums, wherever there is a substantial collection of Gandharan art. Our Boston Bodhisattva shows all the Greco-Roman features earlier mentioned: hair, garments, folds of drapery, sharply carved facial details. He might be a prince or general or governor of a province instead of a holy man, an Apollo rather than an Indian guru. Even the Buddha himself in Gandhara has a more worldly look than he later came to have [108]. But the same could be said of our strong, earthy Buddha from Mathura in the Kushan period [105, 106].

There is continuing debate as to whether the Gandhara or the Mathura Buddha came first, and as to the extent of Greco-Roman influence in setting the elements of the Buddha image that

became conventional wherever he was portrayed. There may be a bit of cultural chauvinism in the scholarly differences. Perhaps some Westerners are too easily persuaded that this widespread artistic form grew from familiar Greek roots, while Indians and those steeped in the traditions of Indian art too quickly reject any suggestion that the Buddha image was not of purely Indian origin.

MARKS OF THE BUDDHA

Whatever the true sources of the Buddha image may be, we see in the Kushan sculptures of both Gandhara and Mathura certain common features, postures, and gestures that became conventions of Buddhist iconography thereafter. The Buddhas from both places have the topknot known as *ushnisha,* the cranial protuberance that is a sign of superhuman wisdom. In the Gandharan carvings it appears to be simply a knot of hair tied at the top [108, 110]. In the early Mathura images too it seems to be a twisted tuft of hair [105, 106]. Some scholars think that originally it was simply the gathering of hair round which a princely turban was wrapped. By the time the hair is in small snail-like coils or knobs, as in the images of Gupta times and elsewhere in Asia, it is clear that the artisans and the learned men who guided them did not regard the *ushnisha* as simply a mop of hair [111, 113, 157, 160, 187]. One of the future Buddha's first acts upon renouncing his princely life was to lop off his long hair to a length of two inches, with a sword.

The *urna,* a round spot on the lower forehead between the brows, also became conventional in the Kushan dynasty. "A hairy white mole, soft like down" was among the thirty-two traditional marks of a *Mahapurusha*—a man of extraordinary powers, a superman destined to be a great ruler or spiritual leader. Siddhartha Gautama Sakyamuni was such a one. A blemish on the face seems generally in Asia to have been a sign of an exceptional man. Con-

fucius is said to have had a prominent bump on his forehead. A leading scholar of Asian art, John Rosenfield, having examined coins of the Kushan dynasty, reports that Kanishka and an earlier king each had a prominent wart on the left side of his face. He adds that warts also appeared on the foreheads of Parthian kings from neighboring Iran.

Exaggeratedly long ear lobes have become another fixed feature of Buddha images. In ancient and medieval India both men and women commonly pierced their ears and hung them or plugged them with massive ornaments, distending the lobes. Indian sculpture for centuries shows earrings and earplugs of prodigious size on both sexes [103, 109, 110, 135]. The Buddha, having put aside the princely trappings of his young manhood, including ear ornaments, was left with ear lobes greatly stretched.

EVENTS IN THE BUDDHA'S LIFE

The events of the Buddha's life are as familiar to his devotees as the Nativity and Passion are to Christians. Without getting into the myriad associated stories of the lives of past and future Buddhas, and of those who hold back on the brink of Buddhahood, the Bodhisattvas, we will enjoy this prolific sculpture more if we are able to recognize some of the major episodes in Siddhartha Gautama's life.

A Gandharan relief in the Freer Gallery in Washington adds to what we already have learned. One panel shows his birth. Siddhartha Gautama Sakyamuni, who became the historic Buddha, was a prince (and later sage-*muni*) of the Sakya clan. In a dream his mother, Queen Maya, was told by sages that she would become the mother of a *Mahapurusha,* a superman. In the same dream a white elephant then walked round her couch three times, struck her on the right side, and entered her womb, impregnating her. When the time drew close to deliver her child, Maya set out for her old family home, borne on a litter. On the road she

wanted to rest in a grove of sal trees—the Lumbini Grove. After she stepped from the litter, supported by her sister, she reached up to grasp the branch of a tree, and at this moment her birth throes started. Standing, with her hand to the bough, she delivered the child through her right side.

Rather startlingly, in the Freer relief of the scene [109] (and many others), Queen Maya in labor looks like the tree spirit, in the same S-shaped, or *tribangha* (three-bend), posture that we saw in the Sanchi bracket [99], one hip thrust out, the opposite arm looped over the head to clutch a tree branch. The new-born infant, already equipped with a head knob, was received in a cloth held by gods and attendants.

We have already had occasion to refer to another major episode in Siddhartha Gautama's life, when we encountered him, in the symbolic form of two cushions on a chair as he resisted the assault of Mara [101]. The second panel in the Freer relief picks up the crucial episode at a later stage. Having failed to shake him by temptations and violence, Mara taunted him to prove that he was a man of exceptional wisdom. Gautama rested his hand on his knee, and with a finger touched the ground, calling the earth to witness. The response was a thundering endorsement in the form of quakes that toppled the last of the demons, two of whom can be seen tumbling to the ground below the Buddha in the Freer panel. The *bhumisparsamudra* (*bhumi*=earth or land; *sparsa*=touch), the earth-touching gesture, is a natural, simple position of the hand that tells the uninitiated little of the drama it symbolizes [110].

In a third panel (not shown in this book) the Buddha, now Enlightened after his ordeal under the tree in Gaya, preaches his first sermon in the Deer Park of Sarnath, just outside Benares. To five of the hermits who had shared his earlier life of asceticism he preaches on the Turning of the Wheel of Law—the lesson of the Four Noble Truths and the Noble Eightfold Path. The Truths are: life on this earth is suffering; the cause of suffering is craving

or desire; desire may be vanquished; the way to escape the slavery of desire is to follow the Eightfold Path. That Path is a combination of the Mosaic Decalogue and the Christian law of love; do not kill, lie, commit sexual misconduct, steal, be cruel, or do harm to any living creature; avoid malice and evil thoughts; meditate.

In the fourth Freer panel (also not included in the illustrations) appears the Death of Buddha, his passing into nirvana (*paranirvana*) at the age of eighty. The relief shows the bald-headed figures of his principal disciples and, before the bed on which he is stretched out, the hooded figure of his last convert. Local nobles touch their heads in grief. Like the other scenes, the recumbent figure of the dying Buddha, sometimes lying on his side, recurs often wherever Buddhism reached in Asia.

Images that often appear in Mahayana Buddhist sculpture in India and elsewhere are the Bodhisattvas, followers capable (*sattva*) of enlightenment (*bodhi*) who, as we have noted, choose to remain in this world and serve mankind. We will often encounter the difficult name Avalokiteshvara, who later becomes the Lord of Mercy in other parts of Asia and, having been transformed, on occasion, into a female, the Goddess of Mercy or Kuanyin in China (Kannon in Japan). The names and special characteristics of the Bodhisattvas change in different Asian settings and various sects of Buddhism. We will meet some of them in the chapters on China and Japan and on southeast Asia. Another principal figure is that of Maitreya, the Buddha-to-Come, who awaits in heaven his future birth in another cycle of the earth's history.

In the Freer reliefs one of the Bodhisattvas who becomes of great importance in some later sects can be seen. This is Vajrapani, the wielder of the thunderbolt (*vajra*=thunderbolt, diamond, or penis), the Buddha's faithful attendant and protector, grasping a roughly cylindrical object that thickens toward the ends. In the Deer Park panel a bearded Vajrapani looks over the shoulder of the Enlightened One. In the scene of his master's

death, his face grimaces in sorrow. In the Enlightenment panel he appears as a young man at the Buddha's left shoulder [110].

ASANAS AND MUDRAS

Beginning in Gandhara and Mathura certain standard postures and gestures developed into conventions of Buddhist and Hindu art. We will find the same basic *asanas* (seated positions) and *mudras* (hand gestures) as far afield as Japan and Indonesia. For the Buddha himself the almost invariable posture, when he is not standing, is the well-known lotus or the meditative position (*padmasana* or *dhyanasana*; *padma* = lotus; *dhyana* = meditation) with the legs folded under the body and each foot placed on the opposite thigh [105, 149]. Another sitting posture—the "half-lotus"—is very similar, except that the right foot rests on the left thigh and the left foot is drawn up under the body. This is the *virasana*, attitude of the hero (*vira*) [117].

The *lalitasana* is the posture of ease and relaxation. The figure is seated on a bench or dais, one foot hanging down and the other supported on the opposite knee [116]. In a similar posture, the *rajalilasana*, the attitude of *royal* ease, the right foot is raised to the level of the dais on which the figure sits, his right hand or elbow is on the raised knee, and the left leg rests in front of the body, or hangs down to the ground. The left arm, thrust out to the side or back, braces the body against the seat [152, 153]. The postures of ease are appropriate for Bodhisattvas in Buddhism and deities in Hinduism; some of the later figures in other parts of Asia are notably elegant and worldly. Such attitudes are *too* worldly, and therefore inappropriate, for the Buddha himself.

A frequent posture for the Maitreya (the Buddha-to-Come) and royal figures is the so-called "European attitude." The figure sits with his two legs hanging in front of him or resting on the ground, sometimes with feet crossed [139]. In the "pensive atti-

tude" the left leg hangs toward the ground or rests on the seat; the right, bent at the knee, is drawn in front of the body with foot resting on left knee; and the right elbow rests on the right knee with the right hand touching the chin. The posture was much favored by the Chinese and Japanese for Bodhisattvas. There is a superb example in Nara, Japan [156].

The *mudras,* or hand gestures, were almost fully developed as early as the Kushan dynasty. We have already met two of them: the *abhayamudra* (protective gesture, banishing fear) with the right hand raised, palm forward, fingers together [105, 114, 157]; and the *bhumisparsamudra* (earth-touching gesture) with one hand clasping or overhanging the knee, fingertips (or perhaps only the tip of one finger) pointing toward or actually touching the ground [105, 110].

We should be acquainted with some of the others. The *varamudra* (gesture of offering) has the left hand lowered, palm turned down and outward, and the fingers sometimes stiffly straight, sometimes slightly bent [111, 114, 157]; the *vitarkamudra,* or gesture of preaching, is almost like the *mudra* assuring protection—hand raised, palm forward—except that the thumb and one finger meet in a sign that we commonly make when emphasizing a point in discussion [158, 163]. The *anjalimudra* is the gesture of respect and adoration, palms pressed together before the chest [159]. In the *dhyanamudra* (gesture of concentration or meditation) the hands rest in the lap, one on top of the other, palms upward [117, 154]. The final major *mudra* is that of the *dharmachakra* (*dharma*=law of rules of conduct; *chakra*=wheel) in which the hands suggest the turning of the Wheel of Law by forming a circle of thumb and index finger of each hand, then bringing the two hands together, the palm of one turned out, the other in. None of the Buddhist images shown here demonstrates this gesture. In damaged statues the hands are among the first parts to disappear and we often have to guess what *mudras* an image is making.

THE LATER BUDDHA IMAGES

This sketch of a few forms and themes of Buddhist sculpture as they emerged in India in the second and third centuries A.D. will introduce the observer to other Buddhist art. It is staggeringly prolific. To avoid satiety we will be wise to concentrate on a relatively few chosen figures, because they are links in the development of Buddhist images or because they have an exceptional aesthetic impact. I have tried to identify some of these. There are more to come, as we move into the rest of Asia in later chapters.

Those of us who see Indian Buddhist sculpture only in museums should keep in mind that most of it comes from cave-temples. There are about twelve hundred such caves in India, and nine hundred of them are Buddhist.

Against the background of Buddhist art's origins in Kushan times we should look at some of the carving that comes to us from the Gupta dynasty of the fourth through the sixth centuries A.D. That period is the classical age of Indian art. Under the Guptas, who ruled most of India, Mathura was still a major center of the arts. Its craftsmen then produced some of the most satisfying sculpture in Indian history. To the untrained eye the differences between Gupta works and those from other times and places are not immediately evident, especially in badly eroded or mutilated cave and temple carvings. The themes and basic forms of Indian art, Buddhist or Hindu, remained remarkably constant for a long time. In some of the better-preserved figures, however, a greater refinement, a well-composed symmetry, an economy of line and volumes, and an absence of fussy ornamentation set off the Gupta sculpture from earlier and later work.

One standing Buddha in red sandstone, the usual material for Mathura sculptors, is a good starting point for looking at Gupta work [111]. This image, somewhat bigger than life, is now in the National Museum in Delhi. He wears an upper garment

that fits over most of his body like a poncho, down to his wrists and mid-shins. The continuity of the cloth from one arm to the other, clinging to and defining the arms and legs and torso, as a connecting membrane between the main volumes of the body below the head, gives a bat-wing effect that will become familiar to us in Buddhist sculpture throughout Asia. Lines in shallow relief, almost parallel, form stylized string-folds in the garment, radiating from the right shoulder over which the mantle is looped in deepening curves that help to define the torso and limbs. The mantle droops from the left arm in restrained but more natural folds. A slight ridge in relief across the midriff, and the concealed knot of a draw-string, indicate the beginning of the lower garment, or *dhoti,* under the top mantle. The head is smoothly oval, with facial features sharply but simply defined. The hair is in tight snail-like coils, in the manner that by now has become canonical for the Buddha image. He is clearly a lineal descendant of the Kushan Buddha from Mathura, but much more highly refined [106].

The Boston Museum of Fine Arts has a superb Buddha head of the Gupta period, well preserved except for a smashed nose. This too comes from Mathura and is carved of red sandstone. Smoothly round, symmetrical, idealized, serene, with eyes half-closed, it is what the Buddha image was meant to be—not the portrait of a man or god but the expression of an idea [113]. The Metropolitan Museum in New York has a standing Buddha in gilt bronze of the Gupta period, with typical clinging garments, string-folds (more widely spaced this time), and bat-wing effect. The slightly mongoloid eyes may mean that the statue came from Nepal [114]. A Gupta torso in the Nelson Gallery in Kansas City shows the same features of body and garments as the complete standing Buddha in Delhi [112].

JAINISM

An older contemporary of Siddhartha Gautama Sakyamuni was the teacher who became Mahavira (*maha*=great; *vira*=hero), the founder of Jainism. Like Gautama, the Great Hero was the son of a ruling Kshatriya (the warrior and princely caste, ranking second below the Brahmins in the fourfold Hindu caste system). He was born and died in what is now the state of Bihar. Mahavira became an ascetic at the age of twenty-eight, attained enlightenment after years of austerities, and preached as a *jina* (victor or conqueror) over the bondage of the material world. Jainism, like Buddhism, was a protest against Brahminism. It rejected the caste system and the authority of the Hindu priestly elite. Its central ethical principle was *ahimsa* (noninjury), or kindness to all living beings. It recognized no higher being than the perfect man. There had been, according to Jain belief, twenty-four men who had attained such perfection, known as *Tirthankaras* (Finders of the Ford). Mahavira was the latest of this line.

Two main branches of Jainism developed—the naked or "sky-clad" Jains, who held that a saint can own nothing, not even clothes, and the "white-clad" Jains. Jain statues are in some respects similar to Buddhist, but the faces and bodies are heavier. They have, and were meant to have, less of the ethereal quality of Buddha images. The Victoria and Albert Museum in London has a powerful twelfth-century statue in glistening shale of Parsvanatha, the twenty-third of the Jain Tirthankaras [115]. Like the Buddha he has elongated ear lobes, creases in the neck that had become a regular feature of images of the Buddha, and hair in tight coils. There is, however, no head knob. His shoulders are broad and arms long. Here we see most strikingly demonstrated the Indian rule that the shoulder and arm of a superman or god

should look like the trunk of elephant. The swelling abdomen, here accentuated by semicircular lines below the navel, indicates the breath control of yogi—a matter into which we will inquire more closely in the next chapter. The face is expressionless, and this is intended. The Jain Perfected Ones have purged themselves of all worldly dross, including the incidentals that distinguish one man from another. They look alike in their cool aloofness, and are meant to look alike. We can only tell one Finder of the Ford from another by the setting in which he appears and signs that may surround him.

Parsvanatha, for example, is depicted with a hood of snakes, and, in the image here pictured, a snake's body twists behind him. According to the Jain legend, a pair of demigods in the form of snakes, whom he had befriended in a previous incarnation, came to protect him from a hostile demon when he was meditating in the forest on the brink of perfection. In the Jain temple of one cave at Ellora is a statue of another Jain saint named Gommata, with vines growing round his legs and arms [116]. A solid Rubensesque Indrani, queen of the Vedic gods, sits on the other side of the chamber on her lion vehicle. Gommata was so immobile and withdrawn in contemplation that he did not notice the tendrils crawling up his limbs, just as another Savior stood unconcerned on an anthill. A Tirthankara in granite, of the eleventh century, can be seen in the Philadelphia Museum of Art, seated in the half-lotus position (*virasana*) [117]. His hands are palm up, one on top of the other, in the gesture of contemplation (*dhyanamudra*). He lacks distinguishing attributes, and therefore cannot be more precisely named.

Mount Abu in Rajasthan, covered by a large number of temples, is the best place to see Jain architecture and sculpture. Jainism, like Buddhism, was swamped by resurgent Brahminism during the Puranic period. Unlike Buddhism, it was not carried by missionaries outside India. Today it is a small sect, but far more influential than its numbers would indicate, for it is especially

strong in the business community.

Buddhism's last stronghold within India was in the north-east, in Bihar and Bengal, and most of the major works of Buddhist sculpture after the Gupta period come from that region.

6

Hindu Sculpture

THE ASCETIC AS HERO

THE Hindu mind is much concerned with the paradox of duality, with the dialectic of opposing forces. What seems beneficent contains the seeds of ruin and what seems cruel destruction may be redemption. The rain and sun that nourish can also flood and parch. Pairs of opposites that are separate, but are also twin facets of one reality, appear at every level of thought and imagery—good and evil, growth and decay, creation and destruction, love and hate, male and female, and so on.

There are unending cycles of birth, growth, fruition, decay, death, and rebirth, not only in human lives but in the universe. Even the gods eventually die and are reborn, and the cosmos disappears and reappears, in cycles measured by the numbers of astronomy rather than those of human history. "A thousand ages in Thy sight are like an evening gone." In world cycles of four million three hundred and twenty thousand years the world steadily declines in virtue and moral order toward its dissolution. It will come as no surprise to readers that we live at present in the

last and worst of the four world stages, or *yugas;* it still has more than four hundred thousand years to go.

Within this framework humans live out their own few years, die to enjoy whatever heavenly reward they have earned by following the rules of conduct appropriate to them (*dharma*), and are reborn in another form, also depending upon their conduct in previous incarnations. Both men and gods are caught in an unending cycle.

A basic cosmic theme that appears repeatedly in sculpture, as in the religious myths out of which Hindu art has grown, is recurring struggle between the gods (*suras* or *devas*) and the demons (*asuras,* antigods) who are half-siblings of the deities, progeny of the same primordial father by rival mothers, much like the Olympians and Titans in Greek mythology. From time to time the demons become so strong that they are able to make the gods yield great powers to them. Anarchy, misery, and all things evil are the lot of the world when the demons are dominant. Then some hero or god builds up enough psychic force to defeat the oppressive demon.

Yogic exercises and austerities are the means of accumulating the necessary soul-force to overcome the demons or the gods, as the case may be. By detachment from the material world, mortification of the flesh, inward contemplation, and denial of any outlet for one's own vital energies, the ascetic accumulates enough *tapas* (a sort of heat) to overcome his opponent. Fortunately, when the gods yield power to the demons, their grant usually contains an escape clause which human heroes and their divine allies are able to exploit.

In the yogic exercise necessary to build up *tapas* breath control is crucial. Holding of the breath for as long as, or longer than, the body can comfortably endure is the main means of inducing trance and inward contemplation and for holding in check bodily needs and wants. Such discipline enables one to endure the other austerities he must go through to build up *tapas,*

such as standing in an icy river on a winter day or sitting under a broiling sun in the Indian summer. Retention of the semen (*viriya*), it hardly needs to be added, is important. According to traditional notions of physiology and anatomy, it takes forty drops of blood to produce one drop of semen. This precious fluid is stored in a reservoir in the head, the most important part of the body, with a capacity of about seven ounces. Every male orgasm means the loss of a quantity of vital energy. A man who has a good store of semen becomes a superman. The implications for accumulation of *tapas* are evident.

With this background we can more readily see the pneumatic, convex, well-filled appearance of the sculpted Indian human figure not only as a sculptor's way of shaping and organizing volumes but as an expression of religious beliefs, as a culture's ideal view of man and god. The traditional hero in India was not a king or warrior or athlete. He was an ascetic sage. When our mentors in these matters—the art historians, archaeologists, Sanskritists, and other experts in Indian studies—tell us that Indian sculptures of the human figure are meant to be "full of sap" and "full of breath," expanding their chests and limbs and giving the skin a rounded tautness, we can now better understand them.

A MYSTERY: THE BELLY BULGE

The craftsman should make the image of a god "gentle looking and a little fat," according to one of those elaborate collections of precepts that the Brahmins drew up to guide every conceivable human activity. Does this injunction account for the slight bulge of the belly that we see on almost every human figure carved or molded by Indian artisans? If so, the underlying reason must lie in the matter just discussed—the aim to show a body full of sap and breath. Yet the slight abdominal protuberance appears in ordinary mortals, such as donors of temples, and in figures that are certainly not engaged in yogic exercises.

The uninitiated Westerner will be tempted to regard this feature, especially obvious in male figures, as a wryly amusing naturalistic touch. He will observe that where the girdle or lower garment is cinched around the waist or just below it the flesh of the abdomen protrudes a bit. All too true to life, he will think. Can it be that this is simply flab? But it is questionable for a Western male past his prime to read such a meaning into sculpture produced by a culture in which a bulging belly was a sign of affluence and well-being, and possibly of holiness and divinity.

The pronounced paunch that appears on certain icons clearly implies well-being. On one of the ceremonial gates of the early Buddhist stupa at Sanchi (about the first century A.D.) four squat, heavily paunched figures look out in four directions. These have been identified as *yakshas,* nature spirits worshipped by the Dravidians before the Vedic Aryans came into India. In Buddhist times they became guardians of the four quarters, progenitors of the guardian figures found elsewhere in Asia [161, 162]. A massive abdomen is part of the *yaksha's* standard iconography. Several colossal *yakshas* showing this feature, dating from the second or first century B.C., have come to light in India in recent years. We have already seen one of these, from the village of Parkham [96]. Kubera, king of the *yakshas,* guardian of the fourth quarter, and the old god of minerals and wealth, is always depicted with a protruding, well-rounded belly [103]. So is Ganesh, the later Hindu god of success, elephant-headed son of Shiva and Parvati [121].

Afflatus and flatulence—divine inspiration and gas on the stomach—come from the same root. Apparently the beach-ball bellies of the *yakshas* and Ganesh images indicate both well-being and godliness. Is the gentle bulge in most sculpted male figures, both Hindu and Buddhist, different in degree but not in kind? Is it rather to be explained by yogic breath control and bodily sap? Our mentors seem not to have addressed themselves specifically to such questions and we are left with the mystery.

SHIVA, THE GREAT GOD

Hindu sculpture, like the Hindu religion, dominates the Indian scene beginning in about the seventh or eighth centuries A.D. It was always there, flourishing alongside Buddhism and Jainism, drawing from and at the same time nourishing them with forms and themes. Together they produced an Indian art and religion wider than any one faith. And all three grew in a culture that existed before any of them became established in India, a Dravidian world worshipping nature spirits and fertility goddesses (*yakshas* and *yakshis*), snake deities (*nagas* and *naginis*), and spirits that might inhabit trees or stones or any natural thing. These spirits lived along with the gods of the newer religions—we will often see them—and survive to this day in the cults of Indian villagers.

We now approach the Hindu deities, through the sculpture that portrays their images and the occasions on which they have intervened in human affairs. In contrast to the Greek Olympus this is, of course, a living pantheon. No one now worships Zeus or Aphrodite, but Hinduism is a thriving religion. The Vedic gods of the early Aryans were identified with the elements: Surya, the Sun; Agni, Fire; Prithvi, Earth; Vayu, the Wind; and Indra, Rain, and also chief of the gods. There were others, but these are the onès we will most often encounter. They shared, with the nature and fertility gods, the worship of the mixed Aryan and Dravidian population in Vedic times. Later, and especially in the Medieval or Puranic period, reflecting a subtler psychology and philosophy, four major gods, aspects of the same one godhead, emerged as the focus of worship. Brahma, the passive essence of the universe, the god of creation, never became a great cult deity. The other three commanded large numbers of votaries: Shiva, the destroyer; Devi or Shakti, his consort and female aspect, and the Great Mother who emerges in most religions; and Vishnu, the preserver and god of love. The Vedic gods were relegated to a minor position.

Shiva and his consort—known as Devi, Shakti, Parvati, Uma, Durga, and Kali, among other names—are the male and female principles, complementary opposites, the *yang* and the *yin*. Together or separately, by acts of creation, they bring the passive Being of Brahma into the existential world. One of the cosmic struggles between gods and titans illustrates their roles. The eminent authority on Indian culture, Heinrich Zimmer, has told the story. A demon named Taraka had, by great austerities, accumulated enough *tapas* to force from Brahma a grant of invulnerability. Brahma made one condition, on the ground that no one, not even he, the supreme god, could be totally immune to death. The proviso was that Taraka would remain vulnerable to a child seven days old. Clearly, only the child of a great god could be any threat. Uma, a manifestation of the Goddess, took on the responsibility of generating such a child by her spouse Shiva. But Shiva, desolate at the loss of his wife in an earlier form, had withdrawn into deep yogic trances and undertaken great austerities. To win him, or even to get him to look at her, Uma would have to go through penances even more severe than his, and she undertook to do so. She ate only twigs and leaves, and finally nothing. In the summers she stood under the sun with four great fires blazing around her. In the winters she stood up to her neck in the icy Ganges at Hardwar, where it issues from the Himalayas. At the end of many thousands of years of such hardships she had built up enough *tapas* to draw Shiva to her. After some further tests she won him and they mated. Their offspring Skanda (also known as Karttikeya and Subramanian), who is the Hindu god of war, duly killed the demon Taraka. A remarkable small bronze from south India (dated about the twelfth century), which now stands in the Nelson Gallery in Kansas City, was thought to show the Great Goddess toward the end of her sufferings. We see her emaciated, intense, worshipping, and waiting for a sign from her lord [119].

Recently the figure has been identified as Karaikkal-Ammaiyar, a Shaivite lady of such extraordinary beauty that she constantly distracted priests and other men from their devotions. She

achieved sainthood by destroying her beauty through privations. That legend too invests the little bronze figure with deep emotional meaning, but I am reluctant to give up her earlier identification with Uma or Kali.

An exquisite example of Shiva's spouse in her benign aspect as Parvati is found in another south Indian bronze that stands in the Freer Gallery in Washington [118].

For a great many Hindus Shiva is the principal deity, the Great God embodying all aspects of the godhead. He is sometimes portrayed as the three-faced Trimukha, embodying the three roles of creator, preserver, and destroyer. An impressive example is found in the caves of Elephanta in Bombay harbor, from the eighth century A.D., at the extreme right side of the illustration [122]. There too we find an example of Shiva and his spouse Shakti, the male and female principles, united in one body—the half-man, half-woman Ardhanari [122]. Another sculptured image we will frequently encounter in India is Shiva as Nataraja, Lord of the Dance (natya = dance; raja = lord or ruler). The illustration shows one in bronze from south India, the region that developed metal sculpture most highly [120]. It now stands in the Nelson Gallery. There are many other images of Nataraja in the world's museums.

This version of Shiva has four arms. The first right hand, raised above shoulder level, holds a small drum, symbol of creation. The second right arm, wreathed by a snake, holds its hand palm forward to the viewer, in the sign of protection that we noted in the last chapter: abhaya, have no fear. The first left arm, balancing the right, holds a flame, the force of destruction. The second left hand points downward to the raised left foot, giving release, and the right foot stands on the dwarf Muyalaka, the embodiment of ignorance, whose destruction brings enlightenment.

Thus Nataraja displays the five activities of the godhead— creating, preserving, destroying, releasing from destiny, and granting true knowledge. Often we will see in Nataraja images

a circular or horseshoe arch alive with flames, representing the cosmos, which springs from his lotus pedestal and surrounds his dancing figure. Brahmin lore elaborates interpretations of the Dancing Shiva, highly charged with symbolism and, to the initiate (which few Westerners can pretend to be), rich in religious meaning. Brahma, the universal essence, must be inert and inactive until Shiva, the active principle, sets in course a new cycle of creation, which will itself eventually end in destruction, to await a new act of creation. The drama may take place in the cosmos, or in the world of nature, or in the human heart. God is immanent in all.

Shiva Nataraja's maleness is mainly evident in the absence of breasts. The face and broad hips, at least to one not yet used to the more exaggerated pelvises of the sculpted female figure, could equally well be those of a woman. This androgynous effect is typical of divine beings in Indian—and, indeed, of much other Asian —sculpture.

Shiva is represented in most shrines and temples by the *lingam,* or phallus, carved in stylized form as a simple stone or metal cylinder, or sometimes more naturalistically with a clearly indicated glans, perhaps with one or more faces of the god on the column. The *lingam* is often found on a circular platform representing the *yoni,* or female part. The prevalence of the *lingam* in India has made many Westerners, especially in more prudish times, very nervous. A French Jesuit missionary, Abbé Dubois, gave an account of the *lingam*'s origin as an object of worship, to which he reacted as one would expect: "It is incredible, it is impossible to be believed, that in inventing this vile superstition the religious teachers of India intended that the people should render direct worship to objects the very names of which, among civilized nations, are an insult to decency."

The myth that provoked these proper Victorian sentiments is, according to the Abbé's own account, as follows. Brahma, Vishnu, and various attendants, paying a call on Shiva at his para-

dise of Kailasha, surprised him in bed with his wife. Shiva's judgment was clouded by drink and lust, and the couple went on coupling. The visitors rebuked him, apparently as much for neglecting his duties as host as for doing his duties as husband with so little modesty. When he came to his senses Shiva not only felt shame; he and Durga *died* of shame, leaving this message: "My shame has killed me; but it has also given me new life, and a new shape which is that of the *lingam!* Regard it as my double self! Yes, the *lingam* is I myself and I ordain that men shall offer it henceforth their sacrifices and worship."

A more widely accepted version of the origin of the *lingam* as Shiva's symbol begins with a quarrel between Brahma and Vishnu. Each claimed to be creator of the universe. In a blinding flash a huge pillar appeared before them, seeming to have no top or bottom. The two gods decided to explore, Brahma flying upward in the form of a goose (his vehicle) and Vishnu digging downward as a boar (the boar-headed Varaha is one of his incarnations [129]). They searched in vain for the extremities. At last the pillar split open, revealing Shiva, to whom the other gods then did homage. This version has the virtue, in the eyes of Indians who became distressed at phallic meanings popularly given to the *lingam,* that the pillar need not be taken to be a male organ.

Shiva and his spouse, this time in the guise of Parvati, had another famous son—Ganesh, the god of obstacles and success, to be propitiated whenever one undertakes an important new venture. He has an elephant's head. Accounts vary as to its origin. According to one, the parents saw some elephants mating and decided to emulate them in the same form. In another version, Ganesh sprang from Shiva's forehead and Parvati, angered at a creation in which she had no part, wished the animal head on the boy. In still another the child's head was burned to ashes by the glance of another god, and Shiva ordered that it be replaced by the head of the first creature found asleep outside his palace. This happened to be an elephant. There are other stories. The illustration from

the Nelson Gallery in Kansas City shows him dancing [121].

With the elephant-headed god, as with other Hindu deities, the observer's reactions may depend on what preconceptions he brings to the viewing. One of my elderly Brahmin friends, who named a son Ganesh, has written that "for every purpose Ganesh remains the favorite deity. He is in all the temples, either by himself, or associated with his parents. He adorns the front gate of every house in India. His twinkling eyes and round belly are joyful to look at at all times. He is the most likeable of the gods." Abbé Dubois had a somewhat different impression. Ganesh, he wrote, "is represented under a hideous form, with an elephant's head, an enormous stomach, and disproportioned limbs, and with a rat at his feet." A rat is, indeed, Ganesh's vehicle or mount, as other animals are for other gods: the eagle for Vishnu, the bull for Shiva, and the lion for Durga or Shakti. Elephants and rats were considered to be among the most intelligent of animals.

THE GREAT GODDESS, SPOUSE OF SHIVA

Shakti, the female principle, complement and consort of Shiva, is the main cult deity of many Hindus, especially in Bengal and other parts of eastern India. Undoubtedly the lineal descendant of the Great Mother in earlier ages and other parts of Asia, she is known by many names—Devi, Parvati, Uma, Durga, and Kali among them. She is both Mother and Destroyer, and in her horrendous aspect is portrayed with face contorted, long tongue hanging out, wearing a long necklace of skulls round her neck, trampling a dwarf demon.

She is less fearsome but still imposing in another episode often shown in sculpture. Here she is Durga (dur = difficult or hard; ga = to go against) astride her vehicle, the lion, slaying the buffalo-headed demon Mahisha. The cosmic struggle follows lines by now familiar. Through severe austerities the demon Mahisha

had become invincible and, in the form of a gigantic water buf-
falo, had taken over the universe from the gods. The great and
lesser gods gathered and merged all their fiery energies (*tapas*)
into a single intense flame, which coalesced in the form of the
goddess Durga. Equipped with the weapons of all the gods—
Shiva's trident, Vishnu's club, and so on—Durga mounted her
lion and let out a great roar of defiance that brought the demon
buffalo to take up the challenge. A fearsome battle ensued as she
fought the demon armies. She vanquished them all and at the end
killed Mahisha himself.

An arresting portrayal of this drama is carved in deep relief
in one of the temples at Mamallapuram in southern India (also
sometimes referred to as Mahabalipuram), dating from the seventh
century A.D. [124]. Durga is shown astride her charging lion, her
eight arms bristling with weapons. With two she looses flights of
arrows at Mahisha. The demon buffalo dominates half the scene,
a powerful figure reaching almost to the top of the panel, rearing
back in a wary, watchful attitude, prepared to swing the huge
club that is clutched in his right hand, its heavy head resting in
his left. Durga, less bosomy than her sisters from northern India
(this restraint is a typical southern touch), is upright and serene,
and most of the other figures on her side of the composition are
also vertical. The bodies of the buffalo demon and of those
around him on his side of the panel are on a diagonal. A strong
slanted line runs up his extended right leg, through his torso,
along the prominent snout, and ending in his headdress. The
right forearm and the club it holds make an equally strong hori-
zontal line across his chest. Compare the use of diagonals and up-
rights with those in the battle of Greeks and Amazons on the
frieze of the Mausoleum [26].

There are many versions of the drama in Indian sculpture,
some of them showing only the principals just after a calm Durga
has dispatched Mahisha. The Boston Museum of Fine Arts has
two delightful carvings of this moment in deep relief. One is from
the same Pallava period as the wall relief at Mamallapuram

[123]. The other, four centuries later, is from Java [171]. An added element of the story is seen here. When the goddess cut the buffalo demon's throat, Mahisha quickly turned himself into human form and tried to escape through the neck. Durga killed him. The demon's last desperate move also appears in a thirteenth-century carving from the southern state of Mysore, now in London's Victoria and Albert Museum. Here we see the fussily elaborate ornamentation with which sculptures of that region and period were bedecked, in marked contrast to the simple, clean lines of the Pallava figures from Mamallapuram [125].

Durga's defeat of the demon is not only a dramatic and popular story; it is also a theological statement. The other gods, knowing that they could not defeat the titan, ceded all their powers and weapons to the Great Goddess. Her triumph was not only over Mahisha but also over her peers. Her followers could quite rightly worship her as the mightiest of them all.

THE DESCENT OF THE GANGES

Perhaps the most famous sculpture in India is one of the many deep reliefs at Mamallapuram. There the Pallava kings, at the beginning of the Medieval period, used outcroppings of rock to create a unique group of monolithic temples, cave shrines, and rock carvings. Their craftsmen turned the face of a rock wall nearly ninety feet long and thirty feet high into one vast relief, alive with figures of gods, demigods, snake spirits, celestial beings, sages, ordinary mortals, and animals [126]. A central cleft, down which water once coursed, is the focal point of their attention. In it a *naga* king and *nagini* queen, snake spirits with the heads and torsos of humans and the twisting tails of cobras, rise toward the top. Beneath them is another snake deity. In the Hindu celestial order, snake spirits are demigods, ranking below the great gods but above mankind.

There is disagreement, curiously enough, as to what story the

animated surface of the rock-wall tells. To some it is the *Descent of the Ganges;* to others *Arjuna's Penance.* In either version Shiva, towering above the other figures near the top of the rock, to the left of the cleft, plays a major role. The Arjuna tale concerns the rivalry between two sets of royal cousins, the Kauravas and Pandavas. At one point in their long struggle the five Pandava brothers and their common wife Draupadi go into temporary exile in the forest, but vow to return and vanquish their rivals. Arjuna, one of the Pandavas, is advised by a sage to undertake great austerities and thereby gain the help of Indra and Shiva. The gods, said the sage, should be induced to give Arjuna miraculous weapons, including invisibility in battle.

Following this advice, Arjuna suffered such hardships (his "penance") and generated so much fiery *tapas* that the woods around him were scorched. Alarmed, sages who were meditating in those same woods went to Shiva to ask that he make Arjuna desist from his self-mortification. The rest of the story is not directly pertinent to the Mamallapuram rock carving. Suffice it to say that Arjuna, after further tests imposed by Shiva, won the weapons he sought. If the vast relief is taken to be Arjuna's Penance, then he is the smaller figure in front of Shiva, standing on his left leg, holding his hands over his head, looking upward through the interlocked fingers at the sun, emaciated and old before his time—a very severe penance [127]. Most of the other figures are rushing toward him to watch in wonder.

According to the other version of the relief's theme, the ascetic standing on his left leg, and also shown in contemplation before a shrine just below, is a sage who sought the aid of Shiva in bringing the Ganges River down to earth. In some time long past the earth had been deprived of all water. The sage (by great austerities, of course) had persuaded the river goddess Ganga (Ganges) to descend, but such a torrent would have overwhelmed the earth if it came in one rush. Therefore, by further hardships, the sage enlisted the help of Shiva, who undertook to receive the

waters in his thick mat of hair and let it more gently and gradually fall to earth.

Among the most charming figures in this lively scene are some of the animals. The family of elephants is appropriately large—perhaps too large, for they distract attention from the rest —and skillfully carved. Just above the shrine before which the sage meditates a cynical monkey gazes toward the cleft. On the other side of the gash, in front of the elephants, a cat surrounded by mice imitates the posture of the sage, standing on one foot, raising his paws above his head, and gazing piously upward [127]. Lest this seem a blasphemous comment on the main scene, let us note an old Indian fable. A devious cat, by pretending to be an ascetic Brahmin, withdrawn from the world, gained the misplaced confidence of the mice—and eventually ate them.

Many of the pairs of figures flying toward the cleft from either side are celestial beings—*apsarases,* heavenly female spirits who make life in the Hindu paradises a continual delight, and *gandharvas,* male spirits who enjoy the *apsarases'* favors and the other pleasures of heaven until the time comes for their rebirths in the world of pain below.

VISHNU, THE PRESERVER

One of the three aspects of the supreme godhead is Vishnu, the preserver, the god of love and loyalty. Those who make him the chief object or symbol of their worship are called Vaishnavites. Along with the Shaivites, or Shiva-worshippers, they make up the two main branches of Hinduism. Most Hindus worship both but have a favorite of the two. Like the other gods, Vishnu has many names. He has many avatars, or incarnations, in which he has reappeared in the world to perform his godly role of protecting or preserving mankind in times of great danger. We will take up some of these below.

In sculpture he usually wears a high miterlike headdress,

conical or cylindrical. To the confusion of the observer looking for signs to distinguish the members of the Hindu pantheon from each other, Shiva too may wear what appears to be a lofty head covering. On closer look, it can usually be seen that what seems to be a crown is really a mop of long hair piled on top of his head. In some icons, more often seen in southeast Asia than in India, the figures of Vishnu and Shiva are combined, one half being the benign god of preservation, the other the more forbidding ascetic god of destruction. The headdress of such a *Harihara* is divided into two parts, even if united within a common form such as a cylinder. Vishnu's half will be the miter, Shiva's a coil of hair, often highly stylized [173, 175].

Vishnu is usually accompanied by his vehicle or mount, the eagle *garuda*. Among the symbols, or attributes, he holds in his hands are a wheel or disc, a conch shell, and a long staff or club. His consort is Lakshmi, goddess of wealth.

We will sometimes encounter Vishnu as *Anantasayanin*, lying in blissful repose on the coils of cosmic snake Ananta (Eternity) whose hooded heads are spread in a protective canopy over the sleeping god, and who in turn swims in the waters of pure essence. There is a good example at Mamallapuram [128]. We have already noted that world cycles last four million three hundred and twenty thousand years. A day in the life of a Brahma (the supreme god who lives a hundred such days) is a thousand times longer—roughly the age of the Moon. At the end of each Brahma-day comes an equally long Brahma-night, during which the universe dissolves into pure essence (the cosmic snake in the cosmic sea) to emerge again at the dawn of a new Brahma-day in material form for another span of four billion years and more. In the Anantasayanin the rebirth of the universe is often portrayed by a lotus issuing from the navel of the sleeping Vishnu, on which the figure of the four-headed Brahma sits. (In one twentieth-century theory of cosmology, matter is constantly replacing itself as it expands outward in the universe. As galaxies recede,

new ones coalesce from a thin soup of hydrogen atoms. From a more highly condensed primal soup of elemental proteins spring tiny strands of animate matter.)

On one occasion Vishnu outwitted demon titans who had gained control of the universe. Taking the form of a dwarf Brahmin he asked them if he could have, as a place to perform his devotions, whatever ground he could cover in three steps. The titans were amused, and readily granted this trifling boon. Then Vishnu revealed himself in his true nature. In three enormous strides he covered the whole universe. In this he is known as Trivikrama.

As Narasimha he is lion-headed, and destroyed a heretic king who doubted his divine powers. As Varaha, the cosmic boar, he rescued the goddess Earth from the seas of eternity into which demons had dragged her. One of the reliefs at Mamallapuram depicts the episode [129].

As Krishna the god is perhaps best known. Krishna's birthplace and principal place of worship was Mathura, a town we have already noted many times as the seat of the Kushan kings and for centuries a remarkable center of the arts. Tormented by a wicked king the people of that region appealed to the trinity of supreme gods. Brahma, it turned out, had given a pledge to the royal monster in question that he could be deprived of his life only by a nephew—the fine print in the concession. Vishnu then volunteered to be born of the king's sister Devaki, and implanted himself in her womb. The king, having got wind of what was happening, determined to destroy the child when it was born. The infant Krishna, however, was spirited away across the river immediately after birth, and exchanged for the newborn girl child of the cowherd Nanda and his wife.

Krishna grew up in a simple cowherd household and eventually fulfilled his mission to kill the king. Incidents of his childhood are a favorite theme of the little Indian folk-art brasses and bronzes that the traveler sees in profusion in bazaars and curio

shops. One shows him crawling on the ground, rolling a ball of butter that he has just stolen from the kitchen. When he reached the appropriate age his pranks turned to amorous games with the *gopis,* the lady cowherds who are familiar from Indian miniature paintings. Krishna is often shown with his blue body, playing the flute, leaning against a tree with one leg crossed over the other in a casual seductive pose. God of love both as *agape* and *eros* he became a great worldly lover, with thousands of marriages, affairs, and more casual couplings. But his love for the beautiful Rhada is the best known.

Once, while he was growing up among the cowherds and milkmaids, Krishna watched his friends preparing for their annual feast of thanksgiving to Indra, the old Vedic god of rain and king of the gods. He told them it would be more appropriate to worship and give thanks to the things of nature around them— things that sustained their lives, like the cows and land and grass and trees. More specifically, he suggested that they go to the nearby hill of Govardhana (Welfare of Cows) and give it offerings. When the people did so, Krishna was there on the mountain to receive their homage. Indignant at this affront from his worshippers, Indra loosed a deluge to drown the cows and people. Krishna protected them by lifting the hill Govardhana and holding it with one hand over their heads. There is a famous and delightful depiction of this scene in the rock carvings at Mamallapuram. The focus of attention is on one group among those sheltered from the rain god's wrath—a man milking a cow, which is nuzzling her little calf [130].

Like that of Durga slaying the buffalo demon, the scene of Krishna raising up Govardhana is an important theological statement. By his act Krishna is challenging the authority of the old Vedic gods and asserting the supremacy of a new god, Vishnu (of whom he is an avatar). He is preaching the need for personal devotion (*bhakti*) to the deity and to all nature as a replacement for ritual sacrifice and magical rites as a mode of worship. In the

myth, incidentally, Indra realized he had met his match and made his peace with Krishna-Vishnu, who tactfully took as one of his many names Upendra, a second Indra.

THE HEAVENLY ABODES

Most of the Hindu sculptures we have seen so far come from the end of the Buddhist period or early in the Medieval period of Hindu dominance, and most are found in cave-temples. The Gupta dynasty (fourth through sixth centuries A.D.) and those immediately following it, especially in the south, saw the finest flowering of Buddhist art. Icons of that religion then took forms that would last for a long time and spread to other lands. At the same time the Brahmins were drawing up, and passing on to the skilled craftsmen who actually did the work of carving, detailed rules for representing Hindu deities—their proportions and sizes (varying from god to god), their attributes or symbols, their postures and gestures. The White Huns, invading in the sixth century, brought down the Guptas and destroyed many of the existing works of art.

This period was a watershed in religious and artistic development, always two facets of the same vision of truth. Now began the growth of the Hindu temple as we know it. Major new shrines were no longer placed in caves but in structures above ground. Sculpture was integrated with this new architecture. The rise of regional kings and local lordlings after the collapse of central Gupta power assisted the Hindu resurgence. Wanting a religious sanction for their powers local rulers listened readily to the advice of Brahmins: achieve not only worldly respectability but also merit in the eyes of the gods by building impressive places of worship. According to Brahmin writings of the period, even a shrine in wood, the most usual building material, would earn a long sojourn in paradise before rebirth, a temple in brick far more, and a holy place in stone most of all. Along with their royal

alliances the Brahmins undertook vigorous missionary work throughout India. Merchant classes that had embraced Buddhism went into a decline. By the end of the eighth century Hinduism was the dominant Indian religion, with Buddhism surviving for a time mainly in Bihar and Bengal and in new Tantric forms that we will consider later.

The caves and monoliths at Ellora and Elephanta of the eighth century, and of Mamallapuram a century earlier, were among the last of the great cave-temples. We have already looked at some of the works of that period: the three-faced Shiva, embodying all the aspects of the godhead, and Shiva Ardhanari, combining male and female in one body at Elephanta [122]; Durga as slayer of the buffalo demon, Vishnu Anantasayanin asleep on the cosmic snake, Vishnu as the cosmic boar, Krishna holding up the hill Govardhana, and the *Descent of the Ganges* in Mamallapuram [123, 128,130, 126]. These great works in high relief are, for many, the culmination of Hindu art, carrying on the graces of the Gupta period and adding a new dynamism. The reliefs are full of action, but the actors are serene, as gods should be when fate requires them to intervene in the affairs of mortals. They go about their duties in detachment. All these carvings are from different parts of south India, below the divide of the Vindhayan mountains and less exposed to invaders than the North.

The open-air temples at Mamallapuram and Ellora are sculptures rather than structures. They were hewn out of monolithic formations. By far the most spectacular of these is the Kailashanath temple at Ellora, west of Bombay, a sculptural *tour de force* [131]. This temple complex was carved from the top down. The site was marked out on the top surface of a rock escarpment and craftsmen dug and scraped away the underlying rock to a depth of one hundred feet to create the buildings and columns that we now approach at the base of the cliff. Under the main shrine to Shiva we find, appropriately, a wall-carving of the demon Ravana shaking the Kailasha paradise of Shiva. The whole temple com-

plex culminates in the tower above that high-standing inner shrine, capped by a copestone like a round drum with curved top. This tower represents Mount Kailasha, the abode of Shiva and Parvati. (Kailasha is sometimes described as only one of the four paradises located on Mount Meru, the Olympus of the Hindus.)

There are thirty-four caves at that site. Some of these cave-shrines are Buddhist—mostly excavated and carved before the Shiva temple—and some Jain. One of the Buddhist monasteries was converted into a Vishnu temple before it was completed. One of the Jain temples was never finished. The whole group of sanctuaries at Ellora, culminating in the Kailashanath temple, can be taken as a triumphant expression of Hindu dominance.

We have already noted that most Indian stone carvings, even those presented almost fully in the round, are connected with their backgrounds. Indian sculpture is typically in high relief rather than free-standing. This tradition persisted as temples came to be built above the ground. And some of the main symbolic elements seen at Ellora and in earlier shrines were incorporated into the conventional designs of later Indian temples.

Architecture is beyond the scope of this book. From this period on, however, sculpture is so intimately connected with the temple buildings, forming together with them an expression of the same idea, that we must at least note the main forms of temple structure. These differ between north and south, and have many variations in detail within those broad regions and in the central zone. But some generalizations are possible.

The distinctive mark of the northern temple is the *sikhara,* or tower, similar to the soaring Gothic spires of Europe and created with the same intention. But they not only soar toward the gods; they are a physical representation of heaven. They rise skyward above the inner sanctum, the *garbhagraha,* or womb-chamber, where the principal image of the deity resides. The roofs of the other rooms leading to the holy of holies—the entrance porch and intermediate hall—are typically pyramidal and stepped up-

ward toward the towering *sikhara*. The famous temples of Bhuba-
neshvar in Orissa on the east coast of India, built from the sev-
enth to twelfth centuries, exemplify one major form of the tower.
It is a huge cylinder, curving in at the top, made up of many lay-
ers of flat stone wafers, with ribs (often repeating in small scale
the design of the central structure) that impart strong vertical
lines to the soaring whole. The capstone is a fat disc, ribbed along
its rounded edges, which in turn is topped by a smaller convex
disc, a finial, and perhaps a symbol of the god to whom the tem-
ple is dedicated—the trident of Shiva or the wheel of
Vishnu [132].

The grandest temple of them all in Orissa, which was dedi-
cated to the Sun God Surya at Konarak, is now in partial ruins.
The huge entrance hall and a hall for temple dances somewhat re-
moved from it survive. The high *sikhara,* intended to reach up
more than two hundred feet, long ago collapsed and only its base
remains. The whole was conceived as the chariot of the sun god.
The giant stone wheels, elaborately decorated, and the straining
horses can still be seen. In the upper tiers are some famous free-
standing statues of celestial female musicians, larger than life.
They are thick and heavy at close range, but, like most Indian
sculpture, they were meant to be seen from the front, and in this
case, from far below. Their faces have more individuality than
those of most Indian statues.

Some of the famous temples of Khajaraho in central India,
built in the tenth and eleventh centuries, have somewhat differ-
ent *sikharas*. Here there is the same upward movement from the
pyramidal roofs of the outer halls to the main tower over the
womb-chamber. But now the spire—for example, on the Citra-
gupta temple—has round it a cluster of smaller ones and the
whole structure is compressed into more of a unit than its Orissan
sisters, topped by a forest of upreaching forms. Twenty out of the
eighty-five temples that once stood in this remarkable complex
are still more or less intact [134].

Whatever the variations in style, the north Indian temple is the universe in microcosm. The sculpture on the lower courses around the building typically depicts human beings and animals and scenes from the popular epics. Above them come bands of higher beings—tree spirits, snake gods, and other nature deities that rank above humans in the celestial hierarchy. Then come the gods themselves and their heavenly attendants—female *apsarases,* male *gandharvas,* dancers, and musicians. And still higher there are no animate figures, for we have entered the uppermost ether, out of which visible forms of the lower world have been condensed.

The main distinctive feature of Hindu temples in the south of India is the high *gopura,* or gateway, which replaces the *sikhara* as the element reaching toward heaven. There are usually two or four such gateways in the wall around the temple enclosure. Unlike its northern cousin, which is free of sculpture in its highest reaches, the *gopura* teems with figures to the very top, as if the designers were trying not only to plant the idea of the universe but actually to depict it in all its profusion of forms and life. Each gateway is wide, ending at the top in a straight ridge line from which the cascade of carved images falls away steeply on either side. One well-known exemplar of the southern style is the twelfth-century temple at Tiruvannamalai [133].

THE EROTIC AND THE DIVINE

In a visit to the Metropolitan Museum in New York I once paused to look at a *maithuna* from Orissa. The term, usually meaning sexual union, is often translated as "loving couple." The Metropolitan pair, over-life-size, is the only example I have seen outside India of this theme as it was developed in Medieval sculpture in India. The sculptor had skillfully carved with the grain of the stone to bring out the roundness of the woman's buttocks and breasts. It is a superb piece [136]. Another example comes from

the famous temples of Khajaraho [137]. The lizard, incidentally, is alive.

Other visitors to the museum were rushing past, scarcely giving the carving a glance. Was this a vestige of the prudishness that has so long marked the Western approach to Indian erotic art, or simply indifference to Indian sculpture generally? In a time when Westerners (and westernized Indians) are more relaxed in such matters, I had supposed that we were well past the time when travelers to India, in some embarrassment, undertook the trip to Khajaraho or Konarak mainly to see forbidden sights. Western and Indian scholars now no longer gloss over the profusion of erotica as if it did not exist, or hasten to reassure each other and their audiences that the carvings were really not all that physical but an expression of great spiritual truths.

There was indeed a religious and philosophical basis for the explicitly sensual art of India that flourished in the Medieval period and less conspicuously long before. God as well as man desires to create. It is the ordained function of Brahma, the one god, to create the phenomenal universe out of pure essence. Through desire he divides himself into two, and then into the many—all the beings and matter of the visible world; and the many desire to return to the one god. *Yoga,* the denial of the material world through self-discipline, became the usual Hindu way of achieving reunion with god. But there is another way, *bhoga:* accept the world of sensation which god created, and achieve reunion with him through love, including its sensual enjoyment. In the worship of all three major Puranic gods—Shakti, the female energy embodied in the spouse of Shiva, Shiva himself, and Vishnu, god of love—cults grew up that treated the joining of man and woman as symbolic of union with god. The concept has not been unknown in the West, in pagan or Christian times, although there it has seldom been so explicitly expressed in plastic art.

These ideas became highly developed in the Tantric sects of Hinduism (and of Tantric Buddhism, as we shall see), named for

their sacred texts, the Tantras. Tantric practices apparently began in the seventh or eighth centuries A.D. The doctrine did not reject, but embraced, the phenomenal world, which to orthodox thought is an illusion. Some of its rites were practiced around Khajaraho. The Kaula cult, for example, preached a sort of homeopathic medicine: fight poison with poison, in carefully regulated doses. Five sources of pleasure, which are full of mortal peril for the common herd, can become means of liberation for the disciplined few. These are the five "M's," so called because in Sanskrit the name of each begins with the letter "m": wine, meat, fish, parched corn, and the union of man and woman (*maithuna*). Taken in small amounts under the guidance of a guru, with appropriate magic rites, these can be rid of the dangers that they hold for ordinary human beings. Accordingly Kaula rites were built around controlled indulgence in the forbidden pleasures, often including sexual relations with others than spouses.

This, briefly, is the religious basis for Tantric rites and the erotic art allied with them. But we may suppose that the Hindu interest in sex, shared with other humans, was not in practice entirely moored to such spiritual notions. As early as Vedic times, the compendia of learning and precepts that Brahmins composed to explain and govern every aspect of life did not neglect guidance on this major interest. The *Arthava Veda*, devoted to advice on the pursuit of worldly goods, abounds in prayers, magical incantations, and prescriptions of herbs and amulets for female fecundity, male virility, successful conception, confoundment of rivals, conquest of the beloved, and the like. *Kama,* or desire, was accepted in its sexual form as a natural preoccupation of humans. Khajaraho and Konarak are remarkably graphic and exuberant expressions of this interest. There, it is said, one can with diligence find all the eighty-four postures described in the *Kama Sutra* by the sage Vatsyayana, of uncertain date, perhaps the best known in a long line of Hindu commentators on the art of love.

Quite apart from some of their themes, the friezes of Khaja-

raho are of special interest as sculpture. As long ago as when they
made the early Buddhist reliefs Indian craftsmen knew how to
tilt the body at its knees, waist, and neck. Figures bend, stoop,
run, dance, and fly. But seldom in earlier work do the bodies *turn*
at these joints. Even when they present a profile or three-quarter
view, the surfaces seen by the viewer are almost entirely in one
plane, with perhaps a twisting of the head. This is changed in
many of the images of Khajaraho. A mortal woman or celestial
attendant—picking a thorn from her foot, holding a baby, em-
bracing a lover—is often twisted round the central axis of her
body, presenting back, side, and almost her face and front, in ex-
treme torsion [135]. The main difference between this develop-
ment and the corkscrew bodies of Greek sculpture in the third
century B.C. and later is that the Indian figures are still wedded to
their backgrounds, and not shown fully in the round. Therefore
one cannot walk around them, as late Greek statues invite one to
do, and the impression of a body turned vertically, and not just
horizontally, must still be gained from one point of view.

A second feature to note is that in the erotic carvings, how-
ever explicit the bodily postures may be, the faces wear a calm de-
tached expression. In this they are akin to the faces of the classic
Greek reliefs, where centaurs and Lapiths in death struggles
usually are expressionless. In Bernini's *St. Teresa* nothing in the
body (although much in the chaotic play of the garments) dis-
plays passion, while the face tells everything [79]. In the Khaja-
raho carvings the reverse is true. The bodies are vibrant and full
of feeling, the faces inert, or perhaps showing the trace of a serene
smile, lending some credibility to the thesis that what is por-
trayed is spiritual bliss, not bodily ecstasy. One must doubt, how-
ever, whether many viewers through the centuries have looked at
the sculptures with spirituality in mind.

SOUTH INDIAN BRONZES

One delightful form of Indian sculpture should be noted before we follow the Indian tradition into other parts of Asia. These are the bronze figures of gods, made by the lost-wax process, that were meant to be carried in processions. Art of this form was most highly developed in south India, mainly from the tenth century onward. Nataraja is one of the most frequent themes [120]. We have already seen the small bronze of the Goddess trying to gain the attention of Shiva [119]. The Freer Gallery in Washington has a remarkably graceful bronze processional image of Parvati, from the eleventh or twelfth century [118]. Here we see some of the distinctive southern elements in the ideal of feminine beauty: long, slender arms and legs; long nose with a thin ridge; a face somewhat squarer than those of her northern sisters.

OTHER TIMES AND PLACES

Our selective visit to Indian sculpture has taken us from the massive archaic *yakshas* before the Christian era and the remarkably sophisticated female figures shortly after, to the simple beginnings of Buddhist figures (mixed with Greco-Roman influences at Gandhara, remaining more purely Indian at Mathura), to the perfection of the Buddha image in Gupta times and gently rounded but vigorous Hindu art somewhat later in the resurgence of Hinduism in the south, and finally to the baroque exuberance of Khajaraho toward the end of the first Christian millennium. More fleetingly we have glimpsed the heavily ornamented carvings of Mysore and bronzes of the south, made about the same time.

Sculpture flourished in many other parts of India that we cannot take into account in a brief introduction. And it did not come to an end in the twelfth or thirteenth centuries. Later art,

however, seems to have fallen short of its earlier standards. With the incursions of iconoclastic Muslims, culminating in the establishment of the Mogul Empire in the sixteenth century, the production of monumental stone sculpture sharply diminished. The making of small folk images in metal, stone, and wood to some extent carried on the tradition.

CHAPTER

7

Along the Silk Road

S CULPTURE and Buddhism are inextricably linked in China. When Buddhism flourished, so did sculpture, which served its needs. When the religion waned after official banishment, so did plastic art. It is one of the mysteries of history that the Chinese lost interest in carving and modeling large-scale figures after six or seven centuries. We can only guess at the reasons.

Here I am speaking, as elsewhere in the book, of monumental sculpture—figures more or less life-size. Chinese interest and superb skills in small three-dimensional forms are well known from a wide range of carvings and modelings in a variety of mediums—ceramics, jade, lacquer, metal, ivory, and semiprecious stones. And we are not here concerned with the remarkable bronze ritual vessels of the Shang and Chou dynasties, in the second half of the second millennium B.C. and much of the first, that are among the most astonishing achievements of any ancient civilization.

There are a few surviving monumental figures, in relief and in the round, from the times before Buddhism came to China. Those in the round are more of an archaeological than aesthetic

interest—some crudely carved boulders, a horse with a fallen rider, and other figures such as primitive lions lining the spirit roads to tombs, from the Han dynasty. Some lively reliefs of imperial subjects, more interesting than the few surviving figures in the round, grace the tombs of late Han emperors and notables. But China seriously commences to engage our present interest from the time that Buddhism starts to spread as a popular religion.

A FEW DATES AND PLACES

Among the many dynasties that have ruled all or parts of China as we know it today we need only concern ourselves with a few, mainly those whose espousal or tolerance of Buddhism led to a flowering of sculpture. The Han dynasty, ruling in the two centuries before and two centuries after the beginning of the Christian era, for the first time united China and reached out into neighboring lands far to the west and south. From this period, as we have noted, there are few monumental figures of consequence, but the Hans opened China to foreign influences that brought in sculpture along with religion.

Emperor Wu, having fought off invading Huns from the north, sought out another barbarian tribe—the Yueh-Chih—on the western marches of his newly unified empire, to find out if they would join him in an alliance to keep the Huns at bay. Wu's envoy, the first Chinese official to venture into central Asia, found the Yueh-Chih establishing a huge domain of their own, the Kushan empire stretching from central Asia to the plain of the Ganges. It will be recalled from Chapter 5 that the twin Kushan centers at Gandhara in the mountains and Mathura in the plains created the first Buddha images.

Wu's probings into the west opened up a trade route through central China, connecting the Han Middle Kingdom with the empires of the west—the Kushans, the Parthians (in

what is now Iran), and the Roman world. For centuries thereafter caravans carried silk, lacquer ware, and other luxury goods from China to the west, and brought back, among other things, the sacred texts and images of Buddhism. Now and then the route was disrupted by nomadic incursions from the north. Chinese control of central Asia waxed and waned, leaving conflicting territorial claims that to this day trouble the juncture of national domains amid the snowcaps of south central Asia.

In the first centuries of the Christian era Buddhism and its icons moved through the mountain valleys in the northwest of the Indian subcontinent, across the forbidding passes of the Hindu Kush and neighboring ranges, into the oases of central Asia along the silk road, eventually into the heart of China and on to Korea and Japan. Two main routes girdled the inhospitable Takla Makan desert in the Tarim Basin. One skirted the southern edge, through the oasis of Khotan. The other passed the desert to the north. They joined near the Chinese outpost town of Tun-huang. From there the road went eastward to the heartland of China through the province of Kansu, then as now the main connecting land corridor between China and western Asia. By the second century A.D. there were flourishing Buddhist communities in the oases around the Tarim Basin. By the middle of the fourth century Buddhist sanctuaries were being built in the caves around Tun-huang. Buddhism, which had reached the Chinese heartland as early as the second century, began to flourish in the fourth.

With the collapse of the Han dynasty early in the third century there followed a long period of disunity in which north and south China were again divided, the north being victim of repeated barbarian invasions. Among the dynasties of this period were the Northern Wei, soon followed by the Northern Chi. These two dynasties, ruling for nearly two centuries after A.D. 386, presided over the first great flowering of Buddhist sculpture in China. The second came in Tang times, especially in the seventh and eighth centuries. We know little of what plastic art was pro-

duced in southern China. Buddhism flourished there, fed not only by refugees from the north but by missionaries and traders arriving by sea routes from India and southeast Asia. Most of the sculpture there has disappeared in the natural and manmade disasters of later centuries.

To help recall the dates of dynasties the following table gives a few that are of particular importance:

PRINCIPAL DYNASTIES IN CHINA

Dynasty	Dates and Comments
Shang	c. 1600–1030 B.C.
Chou	c. 1030–256 (the classic age; rise of Confucianism and Taoism)
Han	206 B.C.–A.D. 220 (unification of China; expansion to west and south; arrival of Buddhism)
Northern Wei	386–535 (first flowering of Buddhist sculpture)
Northern Chi	550–577 (transitional styles in sculpture)
Sui	581–618 " " " "
Tang	618–906 (second flowering of Buddhist sculpture; the Great Persecution, 845)
Sung	960–1279
Yuan (Mongols)	1260–1368
Ming	1368–1644
Ching (Manchus)	1644–1912

Because the advent of Buddhism is so important for our purposes, let us take a brief look at the conditions prevailing in China at the end of the second century A.D. that were propitious for the spread of the faith. The decay and dissolution of the Han empire had disillusioned many in the elite groups about the virtues of Confucianism. The Confucian virtues preached by the Hans—rationalism, loyalty to Emperor and family, respect for

order, performance of public and private duties, modesty—had
not saved China from ruin. There was an earnest questioning of
inherited values. For a time late in the third century it seemed
that the answer might be found in Taoism, incorporating the
quietist, individualist, poetic strains of Chinese thought. This
philosophy opposed and complemented the rigid conformities of
Confucianism and advocated that the individual adjust to the
order of nature, act spontaneously, and keep needs and desires to
a minimum.

It has often been said that every Chinese is publicly a Confu-
cian, privately a Taoist, giving rein in the intimacy of the family
to the earthier side of his nature, to a fascination with the myster-
ies that lie beyond the reach of cold reason, and to a taste for mag-
ic and superstition. But Taoism could not fill the gap left by a dis-
credited Confucianism. Elites and masses alike were groping for
some new framework of belief. For their own reasons the barbar-
ian invaders were attracted to Buddhism. As one early nomadic
conqueror is reported to have said: "Buddha, as a barbarian [that
is, non-Chinese] god, is the very one we ought to worship." At-
tracted first, it seems, by the prowess in magic of Buddhist priests,
the conquerors began to embrace Buddhism more seriously. It
gave them a legitimacy they could not claim under Confucian
principles, and saved them from the risk of being "Sinized."
Buddhist celibacy and freedom from family ties—the very things
that made the faith anathema to Confucians—made Buddhists ap-
pear more reliable as servants of barbarian power, and more de-
pendent on royal good will. And Buddhism preached hope, the
possibility of salvation for all, and a universal moral code for all
people regardless of race and status. From the middle of the
fourth century on, the Northern Wei became adherents and lav-
ish patrons of Buddhism.

Before we look at the sculpture produced under the new dis-
pensation, we should refresh our memories about the different
Buddha images that emerged from their birthplace in the Kushan

empire and identify the main divinities that developed. We will encounter them frequently in this and the next two chapters. The following table may help to fix them in our minds:

MAJOR BUDDHAS AND BODHISATTVAS

Divinity	Sanskrit	Chinese	Japanese
Historic Buddha	Siddhartha Gautama Sakyamuni; Tathagatha (Per- fected One)	Shih-chia	Shaka
Lord of the Western Paradise (Pure Land)	Amitabha	O-mi-to	Amida
Buddha-to-Come	Maitreya	Mi-lo	Miroku
Essential Buddha- Nature	Vairocana	Pi-lo	Roshana, Dainichi
Lord of Mercy	Avalokiteshvara; Padmapani (when holding a lotus)	Kuan-yin	Kannon
Lord of Wisdom	Manjushri	Wen-shu	Monju
Lord of the Underworld	Kshitigarbha	Ti-tsang	Jizo
Wielder of the Thunderbolt	Vajrapani		Kongo

It will be recalled that Mahayana Buddhism developed the notion of the Bodhisattva, a person who has achieved enlighten- ment but, instead of passing into nirvana, chooses to remain on

earth and minister to suffering mankind. The idea proved to be a wonderfully adaptable theological device, permitting the addition of new divinities that were responsive to changing popular religious needs, all within the framework of Buddhism. New sects grew up round individual divinities. Like Christianity, Buddhism developed along myriad sectarian lines. We will consider a few of the major cults.

The icons we will most often encounter, apart from Sakyamuni, the historic Buddha, are other manifestations of the all-pervading Buddha—Amitabha and Maitreya—and, among the Bodhisattvas, Avalokiteshvara (Lord of Compassion), Manjushri (Lord of Wisdom), and Kshitigarbha (Lord of the Netherworld), to give, for the moment, only their Sanskrit names. To add to the confusion, Maitreya is often presented as a Bodhisattva rather than a Buddha. One concept is useful in understanding their origins: in the beginning was Adi-Buddha, the primordial essence, from which the whole universe evolves—the Brahman, the Logos, the Word. The essential Buddha gave rise to a number of Dhyani (Meditation) Buddhas who in turn manifest themselves in human form in the physical world during the long cycles of history as Manushi Buddhas, of whom Sakyamuni was one. In their absences from this world the heavenly Buddhas may also work through the Bodhisattvas.

MAITREYA, THE MESSIAH

During the first major period of Chinese sculpture (the Northern Wei, in the fifth and sixth centuries) Maitreya was often portrayed. He is the Buddha-to-Come, the next Buddha to be made manifest in human form, who is now in heaven awaiting his mission on earth. By Hindu calculations (from which the Indian originators of Buddhism naturally borrowed) the next world cycle will not begin for hundreds of thousands of years. But the idea grew among Mahayana Buddhists in China that Maitreya (or

Mi-lo, as he is known in China) would appear on earth one thou-
sand years after the death of Sakyamuni, the latest Buddha to as-
sume human form. Much as Christian sects from time to time
(and especially in the first millennium) have expected the Second
Coming and set specific dates for its occurrence, Buddhists of the
Maitreya cult were sure that the universal Buddha would descend
to earth in the form of Maitreya at about the end of the fifth cen-
tury A.D. When these expectations were disappointed, interest
shifted to others in the Buddhist pantheon.

A striking Maitreya of this period is on a large stele now
standing in the rotunda of the University of Pennsylvania Mu-
seum in Philadelphia. It is a standing figure of painted limestone,
backed by a huge leaf-shaped nimbus [138]. The dominant color
of the aureole and robes has faded to a soft rose. The face and
thin neck are gilded. The hair of the head and *ushnisha* is ar-
ranged in broad coils, like Catherine wheels. The robe falls in
symmetrical folds, indicated by simple ridges, ending in the scal-
loped hems of the double garment.

A Maitreya of a more commonly encountered type is the
figure of sandstone, seated "European style" with legs crossed and
feet touching the ground, found in the Metropolitan Museum of
New York [139]. His right hand seems to be raised in the *mudra*
of protection. There is a slight smile on his face, and his robes are
symmetrically arranged with decorative features in low relief or
incised lines. This Maitreya comes from the caves of Yun-kang. In
China as in India, and in the oases of the central Asian desert,
cave-temples were a favorite form of Buddhist shrine. The first
one in China, as we have already noted, was at Tun-huang, the
gateway to China near which the two trade routes around the
Tarim Basin converged. In A.D. 366 pilgrims hacked out the first
shrine there in the soft sandstone of the region. Two other fa-
mous caves were started by the Northern Wei in the fifth century,
one at their far northern capital of Yun-kang, close to the Mon-
golian border, and later in the grey limestone of Lung-men near

their new capital of Lo-yang on the Yellow River. Sculptures from some of the caves, including many Maitreyas like that in the Metropolitan, can be found in major collections outside China.

A large frieze of the empress and her court, now in the Nelson Gallery in Kansas City, shows the influence of painting and calligraphy on this form of carving [142]. The ribbonlike curves and swirls of garments and decorations are like the brushstrokes of a hair pen. The same flat lines of two-dimensional art are also characteristic of carvings of figures in higher relief, or almost in the round, from the Northern Wei period [138, 139]. The remarkably sophisticated "Empress Relief" comes from one of the Lungmen caves, from the sixth century.

Another Maitreya on a stele, again from New York's Metropolitan, flanked by two Bodhisattvas, has an elongated body with the heavy blocklike head that marks many examples of Northern Wei carving [140]. An unusual standing Buddha image in the same museum is of gilt bronze—so unusual that its authenticity was at one time questioned. It is about four and a half feet high —large for a surviving bronze of this early period. The hands are in modified gestures of protection and offering, with the arms held more widely from the side and the hand gestures not as rigid as in the usual canon. He stands with feet somewhat splayed, not pointing straight ahead and equally bearing the body's weight as prescribed by Indian rules for the standing image of the Buddha [141]. Some experts have speculated that the unusual disposition of the hands results from faulty copying of an image from India or central Asia by a Chinese craftsman who did not fully understand the canonical rules. Certainly the whole figure proclaims its origins in the Gupta Buddhas from India [114]. The hair is arranged in broad whirlpool patterns somewhat like those of the sandstone Maitreya in Philadelphia [138]. It has been labeled "Probably a Maitreya."

It would be immensely satisfying to viewers of Buddhist figures if they could identify them without the benefit of museum

labels. The iconography of Buddhist images, however, is so full of
uncertainties and variations that the inexpert can be forgiven for
not always recognizing the form of Buddha or Bodhisattva that
they are looking at. Later on we will note a few identifying signs.

'AVE A LOOK!
IT *ESH* VARA

We might note now that if a Bodhisattva has a small Buddha
sitting in the lotus position on an ornament in his headdress, or if
he holds a long-necked vessel in his left hand, he is probably Ava-
lokiteshvara. (But a Maitreya also sometimes holds a similar
flask.) If he holds a lotus stem and blossom, he is probably the
same Bodhisattva under the name Padmapani (*padma*=lotus;
pani=holder). Avalokiteshvara, the Lord of Compassion, appears
in many guises, under many names, and long had many worshippers
throughout the Mahayana Buddhist world. " 'Ave a look! It ESH
Vara" is a mnemonic device I use to remember this complicated
name—somewhat irreverent and not entirely accurate, but close
enough. The etymology of the word is clouded and much argued.
One possible origin is in the Sanskrit root meaning "look," of
which "avalokita" could be a form signifying "what is looked at,"
or the visible world. "Ishvara" or "eshvar" means "lord." On this
reading Avalokiteshvara would mean "Lord of the World," an in-
terpretation reinforced by other names for Bodhisattvas—
Lokanathan and Lokeshvara—that unmistakably have that mean-
ing. He became, in east Asia, the protector and savior of all
threatened by physical and moral danger, from the sailor in a
storm at sea to the lecher coveting his neighbor's wife. He had a
Protean ability to assume any form best suited to the mission of
mercy at hand—more than thirty guises by most accounts. And
he was also a fertility god, able to bestow children on women who
prayed to him.

I have been referring to Avalokiteshvara as "he." In China

the deity is known as Kuan-yin ("Who constantly heeds the wor-
shipper's voice") which has long, and wrongly, been popularly
translated in English as the Goddess of Mercy. It is one of the
first things that a Westerner who looks more than casually at
Chinese plastic art is likely to learn—that at some point in the
development of the worship of Kuan-yin in China, "he" became a
"she." But this, like other Bodhisattvas, in strict theological
theory was sexless. Moreover, Kuan-yin was, as we have already
noted, able to assume many human forms, some of them being fe-
male. His/her role as a fertility god, the bestower of children,
usually that of a goddess in other religions, may have had some-
thing to do with the female identification. One student of Bud-
dhism, Sir Charles Eliot, has suggested that it was less a matter of
positive identification than a growing tendency of the Chinese to
think of this divine being as a woman, just as Christians tend
to think of angels (also without gender) as male. Hindus sometimes
called attention to the duality of the Supreme Being, combining
both male and female qualities necessary for creation, by depict-
ing Shiva as half-man and half-woman [122]. So it may be that
the Chinese sought to show male and female joined in one andro-
gynous human form. Their notions of *yin* and *yang*, femaleness
and maleness, as the complementary primal sources of all material
creation, are not far from Brahmin concepts.

Our own eyes readily confirm the androgynous character of
the Kuan-yin as we encounter the deity in monumental sculpture.
Beginning in Tang times a feminine softness and suppleness per-
vade the figure. Typically the pose is not only *hanché,* with hip
thrust out above the weight-supporting leg, but also with the ab-
domen too somewhat protruding to that side, giving a willowy ef-
fect. The heavy heads could be male or female. The looping gir-
dles and garlands of post-Gupta Indian sculpture are echoed in
Tang images of Kuan-yin, like those standing in the Freer Gal-
lery in Washington [146], New York's Metropolitan [147], and
the Cleveland Museum of Art [148]. The movement toward

roundness and more elaborate decoration had started in the northern dynasties that followed the Northern Wei late in the sixth century, as we can see from the Bodhisattvas from the Freer and the University of Pennsylvania Museum shown in our illustrations [144, 145].

They reached their opulent apogee in the Sung dynasty beginning late in the tenth century, when Kuan-yins, richly dressed and ornamented, lounge in attitudes of ease. One splendid example from this period, in the Nelson Gallery in Kansas City, is richly colored in red and gold, somewhat restored through the years [152]. The other is from the Metropolitan Museum in New York [153]. Plump of face and soft of body, they look more like courtiers and sybarites than the embodiments of divine mercy, yet they exude a commanding, almost arrogant, power, and perhaps, to a properly receptive eye, compassion.

There is rarely if ever, at least in monumental sculpture, any definite anatomical indication of femaleness. Where the chest is lightly covered (it is rarely exposed in China), there is little reason to think of the underlying reversed saucer as a woman's breast rather than a somewhat flabby man's sagging pectoral muscle. The only carving I have seen with an exposed and distinctly defined woman's breast is a Bodhisattva (Kuan-yin, presumably) in wood, of the Ming dynasty in the fifteenth or sixteenth century, now in Chicago's Art Institute. It is mainly in the little ceramic figures appearing long after Buddhism fell into official disfavor, often mass-produced like pottery Virgins in Christendom, that the willowiness, daintiness, and mode of dress unmistakably indicate femaleness.

THE PURE LAND, OR THE WESTERN PARADISE

When Maitreya, having failed to put in an earthly appearance, lost followers, another manifestation of the Buddha came to

be a principal focus of popular worship. Amitabha (called in China O-mi-to, in Japan Amida), the Buddha of Immeasurable Light, presides over the Western Paradise—the Land of Perfect Bliss, the Pure Land, where any man or woman could aspire to go if he were devoted to the Buddha, performed his acts of worship regularly, meditated, and abstained from taking life, stealing, unauthorized sexual pleasure, and intoxicants and narcotics. Based on a scripture translated from Sanskrit into Chinese in the second century A.D., the Pure Land school of Buddhism gained increasing favor with the common people in later centuries. Salvation was brought within the reach of everyone, and not limited to the monkish and learned. It is not easy to distinguish Amitabha from other Buddhas in sculpture. One so identified is a colossal figure in marble standing eighteen feet tall in the British Museum. Dated A.D. 585, it is a noble example of the transition, during the Northern Chi and Sui dynasties, from the flat, symmetrical blockiness of the Northern Wei to the fleshy roundness and ornateness of the Tangs. There is still the shallow relief and symmetrical pose and decoration of the fifth century, but also a definite three-dimensional roundness. We have noted other examples of this transitional style [144, 145].

THE UDAYANA BUDDHA

A young general who had fought for the last emperor of the fading Sui dynasty established his own rule in a reunited China and founded the Tang dynasty in 618. The Tangs brought Buddhism to its peak of influence in China, then presided over the first stages of its decline. Emperor Tai-tsung, the founder of the dynasty, was tolerant of Buddhism and encouraged its growth, seeing in it a unifying force. At the same time the royal court sought to regulate the rich Buddhist establishments, but the temples and monasteries continued to grow in power and wealth.

The University of Pennsylvania Museum in Philadelphia has

two unusual bas-reliefs made for the tomb of Tang Tai-tsung, founder of the Tang dynasty, showing his battle-charger and attendants [143]. Here we see, in shallow carving, one of those splendid Tang horses, so familiar from ceramics of the period. There are none, it seems, of monumental size in free-standing stone.

The religion was given new impetus by the return of the pilgrim Hsuan-tsang from India after a journey of fourteen years, bearing seven Buddha images and twenty-two horseloads of scriptural writings. (My somewhat inaccurate mnemonic device for him is "swan song.") Among the icons he brought back was one of sandalwood that had special sanctity throughout the Far East. The pilgrim told this story of the image's origins.

During the lifetime of Sakyamuni a King Udayana ruled over Kausambi, a little state near the junction of the sacred rivers Jumna and Ganges in northern India. The Buddha, after attaining enlightenment, visited paradise to preach his message to his mother. He was gone from earth three months, and the pious king grew anxious to behold his face. Accordingly the king arranged through a priest for a skilled craftsman to be transported to heaven, to make a likeness of the Buddha in sandalwood. "When Tathagata [the Perfected One, or Buddha] returned from the heavenly palace the carved figure of sandalwood rose and saluted the Lord of the World. The Lord then graciously addressed it and said, 'The work expected of you is to toil in the conversion of heretics, and to lead the future ages in the way of religion.' "

Thus Hsuan-tsang recounted the traditional story. He added that many foreign princes had tried to carry off the statue—the one "true" portrait of the Buddha—but no one had been able to move it. "They therefore worship copies of it, and they pretend that the likeness is a true one, and this [the one he beheld near Kausambi] is the original of all such figures." The Sinologist William Willetts has traced copies to various parts of China and Japan. One large standing Buddha in white marble, now in the

Victoria and Albert Museum in London, probably derives from
the Udayana image [150]. It is markedly different from Tang im-
ages of Bodhisattvas which, as we have seen, had become androg-
ynous, richly decorated, with hip and abdomen thrust out, and
willowy. But such worldliness would be inappropriate in icons of
the Buddha himself. This one shows strong Gupta influence, with
string-folds in wet-drapery, body-clinging garments defining the
bodily curves, and an unusually prominent abdomen, in a solidly
planted balanced posture. Unfortunately it has lost its head.
[Compare 111, 112, 114, 172.]

Another copy of the Udayana Buddha, supposedly brought
from China to Japan late in the tenth century, now stands in the
Seiryoji (popularly known as the Buddha Hall) in Kyoto. It is an
early example of Chinese sculpture in wood, a medium that was
later much used in the Far East. Another Tang Buddha that
harks back to the simplicity and serenity of Gupta models is a
seated figure in dry lacquer, now in the Metropolitan of New
York [149]. It still bears traces of its original coloring, now aged
into soft orange and gold. The robe drapes in a few wide curving
ridges, facial features are sharply defined, and the broad head
knob, like the rest of its hair, is a mass of irregular scratches.

Lacquer, like silk, was one of the luxury goods that Chinese
civilization gave to the world, much sought after by the Romans
and other "barbarians." As early as the fourth century B.C. the
Chinese were applying the juice of the lac tree to hemp, or to
hemp covering wood, in layer upon layer, to fashion statues and
various other artifacts. We will also find some superb examples in
Japan, where the technique was more highly developed.

THE GREAT PERSECUTION

Adherents of the two main strains of native Chinese philoso-
phy and faith had long resented the growth of Buddhism. Confu-
cianism was a conservative force rooted in the myths of China's

origins, and in the traditions and recorded history of the first great days of the Shang and Chou dynasties in the north, beginning in the second half of the first millennium B.C. The Confucian elite, made up of gentry and civil servants, preached the virtues of a stable social order based on filial peity, respect for elders and the family dead, and loyalty to the emperor as earthly representative of order in the universe. They had long attacked Buddhism as too metaphysical and "un-Chinese." How, for example, could the institution of monkish celibacy possibly be reconciled with the ideal of family responsibility and loyalty? "The people are drunk with Buddhism," said one Confucian critic; "it has entered the marrow of their bones."

Taoists, exponents of individual freedom and expression, in the poetic and mystical stream of Chinese thought as opposed to the Confucian duty-minded rationalists, also resented Buddhists' growing political influence and popular acceptance under tolerant or pious emperors. The government itself was worried, as others have been in similar circumstances in other countries, by the wealth and power of large, privileged, monastic institutions that contributed little to the economy. The imperial court had already restored some aspects of Confucianism it deemed useful, such as the civil-service examination system founded by the Hans, which broadened the base of the bureaucracy and kept it from becoming an entrenched hereditary elite. Sinologist Arthur F. Wright has pointed to some other factors that made the emperor more susceptible to the arguments of Buddhism's enemies in the middle of the ninth century: the decline of Buddhism in its homeland in India and consequent drying up of fresh ideas; a major rebellion a century earlier that had left the Tangs less self-confident and more xenophobic; and the continuing threats from central Asia.

In 845 all foreign religions were proscribed. The Buddhist establishments were confiscated or razed, and their inmates scattered. Mainly for this reason little bronze sculpture of Tang or earlier periods has survived. To see the classic Tang style we must

go to Japan. Stone figures, especially those in caves, seem to have escaped better, but monumental Tang sculpture is relatively scarce. We know Tang plastic art best through the superb ceramics of human and animal figures.

Buddhism did not disappear from China with the Great Persecution of 845. There had been earlier official repressions, in the middle of the fifth century and late in the sixth, from which Buddhism had revived stronger than ever. This time, however, there was, instead of a quick recovery, a long gradual decline, punctuated by occasional rallies. Buddhism remained strong among the peasantry and became blended in a popular religion with Taoist and local folk elements. The Neo-Confucianism that now became the official ideology had to accommodate ideas from Buddhism, including the importance of compassion. From time to time, in later centuries, especially when barbarian rulers dominated parts of China, Buddhism was officially tolerated or even encouraged.

SCULPTURE AFTER THE TANGS

After the repression of 845 there were spurts of creativity in sculpture, but the inspiration was fading. We have already looked at some examples of Sung works in the wood Kuan-yins that can be found in major Western collections of Chinese sculpture [152, 153]. These splendid beings are likely to be favorites with Western viewers. They are—to the Western eye at least—not only ambiguous as to gender but in their emotional impact. They can be seen as gentle, compassionate, promising the worshipper the boon he seeks, or as worldly, haughty, and indifferent. We can only speculate about the impression they made on devout Buddhists of the tenth and eleventh centuries.

In any event, they are thoroughly Chinese. There is scarcely a trace of the original Indian inspiration. They sit in canonical positions developed long ago in India—the *lilasana* and *rajalilasana,* attitudes of ease and royal ease—but with a distinctive

Chinese grace. The faces and decoration are Chinese, as is the wood from which they were carved.

The Sung Bodhisattvas are, in a sense, more naturalistic than the statues that came before. They sit in attitudes the human body might well assume, their faces are vitally human, and their robes and shawls, while fussy and "busy," fall in folds not far from what one would expect in raiment of this world. At the same time, Chinese sculpture was experimenting with forms even more closely imitative of nature.

The Buddhist deities, after all, are not meant to be human. While generally cast in human form, they partake of divine nature and should not embody the concerns of ordinary folk with age, death, sorrow, joy, and lusts. But in the tenth and eleventh centuries (and perhaps a bit later) a trend toward naturalism was carried much further with figures not set apart by their divinity. For some time, in both China and Japan, carvers in wood and modelers in clay and lacquer had been depicting Buddhist personages like guardian figures with close attention to anatomical detail. The guardians struck exaggerated poses and wore fearsome masks, but the muscles and bone structure were thoroughly human. In Tang years and later sculptors turned to the human face. Lifelike portraits of monks and Buddhist disciples gave freer scope to this impulse than divine images.

Among the major works of this kind were the pottery lohans discovered in the I-Chou caves near Peking. "Lohan," or in Sanskrit "arhat," is an elastic designation. In its most limited sense it refers to the disciples of the historic Buddha. Later it came to embrace saints and sages, usually dwelling alone in contemplation, who numbered in the hundreds. The group from I-Chou is one of the most remarkable sculptural productions to be found in any civilization. There were, it seems, at least eight of the sitting figures in the cave, made by applying layers of clay to iron armatures, then covering and firing the figures with lead glazes in three colors. They began to come into Western markets just be-

fore the first world war. Six are now in North American museums
—one in Boston, Kansas City, Philadelphia (University Mu-
seum), and Toronto, and two in New York's Metropolitan, with
an additional head in Cleveland.

These ceramic lohans depict Buddhist sages at various
stages of their progress toward enlightenment and at different
ages, from eager, intense youth to wise, world-weary old age.
The illustration shows the youngest, from the Nelson Gallery in
Kansas City [154]. The face needs no comment. The colors of
this, as of the others, are green, russet, and old ivory. There has
been much scholarly discussion, and testing of the glazes, to deter-
mine when the lohans were made, with a tentative consensus
that it was sometime in the tenth to twelfth centuries.

The same interest in naturalism is found in the smaller stone
lohan, probably from the twelfth century, now in the Brundage
Collection of the de Young Museum in San Francisco. [151]. He
bears a strong family resemblance to some of the carved saints
from the Romanesque and early Gothic periods of northern
Christendom.

THE FADING OF SCULPTURE

The quality of some of the post-Tang pieces makes one re-
gret even more keenly the decline of monumental sculpture
among so gifted a people. As late as Ming times there continued
to be a modest production—portrait statues, animals and guard-
ians lining the roads to imperial tombs, some Kuan-yins and other
Buddhist images—but it lacks fresh ideas and indicates little in-
spiration. Some of it shows marked decay from earlier excellence.

That the decline was related to a fading of Buddhism is ines-
capable. The faith and its expression in sculpture (as distinct
from painting) had risen and fallen together. Periods of budding,
flowering, and withering are familiar enough in the history of art
in other civilizations, all over the world, apparently related to the

vigor of a whole society and the strength of its unifying ideas. Asia in the second half of the second millennium was shocked by several traumas, undoubtedly affecting its artistic impulses, from which the West was spared—the iconoclasm of Muslim conquerors, subjection to Western colonizers, and, in the case of China, invasions by less civilized peoples from the north, especially the Mongols of Kubla Khan just before the Mings. But the mysterious link between Buddhism and sculpture in China still asks for explanation.

Some speculations that have emerged in discussions with scholars of Chinese history and art seem worth recording. Perhaps the Chinese, seeing sculpture for the first time as a device for the worship of Buddhist deities, never saw it as a form of art for expressing other ideas. When Buddhism fell into disfavor, interest in its three-dimensional accoutrements of worship faded out. Perhaps the Confucianists, in their long and more or less successful struggle to oust the "foreign" religion of Buddhism, saw sculpture, so closely identified with the faith, likewise as offensive. Perhaps sculpture, calling for hard work and dirty hands, did not appeal to the scholar-gentleman-administrator of the Confucian elite. Painting was the characteristic gentleman's art, something he could and did do, and was expected to do, with his own hands, from elegant calligraphy to pleasing landscapes. Perhaps it is best to leave the mystery there. Certainly we cannot hope to provide the answers ourselves.

SOME MATTERS OF STYLE

We have looked so far at Chinese sculpture largely in terms of its themes, with only passing attention to the developments in style through the centuries. Let us, then, look back at the same objects with the idea of identifying characteristics of form and style from period to period. Most of us get pleasure, upon entering a room full of figures from a certain civilization, if we are able

to trace for ourselves the threads of developing style, and to date for ourselves, at least roughly, the objects we are seeing.

NORTHERN WEI (386–535). Reliefs and even figures in the round (which were usually attached to a background) have more the quality of an etching or drawing than of three-dimensional shapes. The Empress Relief from one of the Lung-men caves, now in Kansas City [142], shows the tendency to depict folds of drapery in long, flat ribbons, recalling brushstrokes in calligraphy. The same pattern appears in the Maitreyas, standing and seated, in New York and Philadelphia [138, 139, 140]. Those same Maitreya figures show the large, blocklike heads that are characteristic of early work from northern China, contrasting with the roundness and careful drawing in the Empress group, a work much closer to traditional painting. The standing bronze Buddha in New York [141] is closer to the original Gupta models from India; there is little in this that is distinctively Chinese.

Balanced symmetry is another characteristic of the early sculpture—symmetry in the pose of the body, and in the flat decorative patterns of drapery. The two sides from the mid-line are almost identical except for the position of the arms and the adjustments in robes made necessary by the arm movements. A favorite and distinctive way of dealing with the folds of garments is to arrange them in a series of flat pleats, with a row of omega shapes at the hems or edges. They appear to have just come out of a steam-press.

There is little interest in the human body. One of the first things the Chinese did was to swathe their images in garments that give little indication of underlying forms. In 486 the Wei emperor decreed that his court should put aside their native nomadic garb and wear Chinese robes, as a step toward "Sinizing" the new regime. Such clothes, appearing on the Wei Maitreyas, serve well to cover upper parts of the body that the Indians left exposed.

The heads, on the other hand, tend to be over-large and blocklike, too heavy for their bodies. Many wear the archaic smile found in early Greek work. It is as if the sculptor wants to say that the body of man is not important; the head is everything. But we should keep in mind that most of these seemingly top-heavy statues were from caves, often placed in alcoves or arcades high above the viewer, where a competent sculptor, Eastern or Western, would allow for foreshortening.

NORTHERN CHI AND SUI (550–618). In these transitional styles, the flatness gives way to roundness, a two-dimensional quality to a three-dimensional, revealing the curves of the human form. The shapes and decoration are still mainly symmetrical, and the folds like ribbons, but the heads are more ovoid and carved with more attention to the detail of features. Standing postures are still stiff and frontal, but it is apparent that the Chinese are now taking more interest in the body [144, 145].

TANG (618–906). The *tribangha* (S-curve) posture has arrived from India, and with it a taste for more elaborate decoration. Bodhisattvas stand with not only the hip but also the abdomen thrust out. Necklaces, girdles, garlands, and shawls curve and loop in the contemporaneous Indian manner. An androgynous quality has come in with the greater roundness and softness and relaxation of posture. One famous priest complained that sculptors made images that looked like dancing girls, and "every court wanton imagines that she looked like a Bodhisattva" [146, 147, 148]. In some of the non-divine figures, like guardian kings and lohans, there is a strong trend toward naturalism, with expressive faces and some show of muscle.

SUNG AND LATER (after 906). The trend toward worldliness in Bodhisattvas is now given freer play. In seated postures, those of "ease" and "royal ease" are favored. Garments and ornaments are

more elaborate than ever before, and the androgynous quality is more pronounced. At the same time the trend toward naturalism is even stronger, especially in the expressiveness of the human face and careful definition of its features, culminating in real or imagined portraits of living humans like those of the lohans [151, 154]. In the caves of Mai-Chi-Shan, not seriously explored until the 1950's, stands a colossal and fearsome guardian king from Sung times, made of clay, whose muscular bared torso and arms seem to be as close to an anatomical study of nudity as the Chinese ever came. Other monumental clay figures in the same caves (the local soft stone is not suitable for carving) depict men and women as donors of religious statues or as attendants of the divinities that have the same naturalness and charm we know from small clay tomb figures of Tang times in which any substantial collection of Chinese art is likely to abound.

In sculpture in the round (as distinct from shallow reliefs, which are often full of action) only the fierce guardians of the faith, with aggressive stances and threatening gestures, gave the Chinese scope for showing figures in action. The strict conventions governing the making of icons allowed little change from tried and approved designs. The endless repetition of placid, serene figures soon palls. What is astonishing, however, is the extraordinary variety that Chinese craftsmen managed to achieve within the dictates of a rigid tradition.

CHAPTER

8

In the Sunrise Country

THE KOREAN CONNECTION

THE first image of the Buddha to arrive in Japan was chucked in a canal. It happened because the new religion was seen by the established elites as a challenge to their dominance. But in Japan, unlike China, there was not a deeply rooted old order, equipped with a traditional ideology of its own, to meet the invading faith. Let us see what lay behind the incident of the drowned bronze.

China was the radiating center of Buddhism in the Far East —or East Asia, as we now call it. Contacts between China and Japan, then just emerging from the Stone Age, probably began in Han times, about the beginning of the Christian era, but direct official relations seem not to have started until the fifth century. One Japanese envoy to the imperial court of the Sui later presented a message from his own ruler that began: "The Emperor of the sunrise country writes to the Emperor of the sunset country." The Chinese ruler was predictably offended at the implied assertion of equality, and refused to receive the mission. On the whole, however, the movement of traders, pilgrims, teachers

(from the Chinese side), and learners (from the Japanese) remained vigorous for a long time, impeded more by the perils of sea travel than by differing views of royal status.

When Tang power and opulence were at their height, many Japanese were among the foreign visitors and residents dazzled by the magnificence of the Chinese capital. They had come to learn the secrets of China's evident success and apply them at home, as hungrily as they absorbed what might be useful to them from the West in a much later time.

In the early days, however, the main channel for the movement of Buddhism and Chinese culture into Japan was Korea. During the fifth and sixth centuries the island kingdom was much preoccupied with its peninsular neighbor. Already there was a stirring of imperial ambition to take over Korea. The Japanese tried to play the Korean kingdoms against each other. At the same time Japan was heavily dependent upon Korean teachers and scribes to help them learn from and deal with the much more advanced Chinese civilization that had grown up across the water. The Koreans sent in scholars learned in the Confucian classics and Buddhism and, in the middle of the sixth century, an image of the Buddha.

The Sogas, one of three powerful families then vying for predominance in Japan, saw in the new religion a useful weapon against its two rivals. One of these had priestly functions in administering the rites of traditional nature worship (which later became known as Shinto, the Way of the Gods) and the other was a military clan responsible for defending the royal court. The Soga clan espoused Buddhism as a political weapon. It suffered a setback when an epidemic offered its rivals an opportunity to say that the national deities were offended. It was then that the Korean image of the Buddha, which had been entrusted to the Sogas, was thrown into a canal. The Sogas, however, triumphed in a war against their rivals. Soga dominance and Buddhism were both firmly established.

Support of a more fitting sort for the new religion came from the imperial family. Empress Suiko came to the throne in 593, determined to carry out the wish of her predecessor and husband to make Buddhism the state religion. In this she was helped by her remarkable son, Crown Prince Umayado, better known by the name Shotoku Taishi ("Sage-Virtue") later conferred on him. Shotoku was a statesman, philosopher, builder, and artist who himself became learned in the new religion. Later he was deified. In the thirteenth and fourteenth centuries, his name was invoked by Buddhist worshippers.

He was the author of a code of precepts issued for the guidance of the ruling classes, blending Confucian and Buddhist principles that were intended to assert the preeminence and authority of the emperor over the powerful clans. The declaration did not have much practical effect. Then and throughout Japanese history, until recent times, the imperial authority depended upon the support of one or a group of the great feudal families, with the Sogas wielding effective power at the time of Shotoku. But the Confucian theory of central authority was here for the first time clearly declared, and the Imperial support for Buddhism firmly stated.

SHOTOKU'S TEMPLE

The greatest Buddhist monument put up by Empress Suiko and Shotoku was the monastery temple of Horyuji near Nara, which still stands. Some of its buildings are those originally erected in the seventh century; some have been rebuilt after fires and wars. Artisans of all kinds were brought from Korea, and Korean sculptures were used as models.

In the Kondo, or Golden Hall, of Horyuji stands an altar some eighty feet long, its platform five feet above the ground, covered with a multitude of sculptures, carved ornaments, fringed canopies, banners, and other objects. Here we can see the first bloom-

ing of monumental Japanese sculpture. Wood and bronze were the favorite materials of the time. Among the figures on the platform-altar is an elongated Kannon (the Japanese name for Kuanyin, or Avalokiteshvara) of camphorwood, with traces of its original coloring, nearly seven feet high [155]. (An excellent modern replica stands in the British Museum.) He wears a crown of open-work bronze with jagged streamers of the same metal framing his face. His garment falls from the waist in ribbon-folds, with long scarves sweeping to the ground from his sleeves, punctuated by curling points. His left hand holds a long-necked flask and a small Dhyani Buddha is cut into the front of his crown; both are signs identifying him as Avalokiteshvara. The long, attenuated figure and ribbon-folds recall some of the early Chinese work of the Northern Wei period [140], and also the columnar carvings of early Gothic in Europe [48, 49]. The image has been thought by some to be Korean; at least it was probably carved by a Korean master. It is commonly called the "Kudara Kannon" after the Korean kingdom of that name.

Again Chinese influence, of a different kind, can be seen in an equally famous group in bronze in the Kondo of Horyuji—the trinity of the Shaka (Sakyamuni) Buddha flanked by two standing Bodhisattvas [157]. The Buddha sits, his hands in the gestures of protection and offering. His robes flow over the pedestal in a cascade of wavy, symmetrical, steam-pressed folds that is one of the delightful characteristics of early Japanese sitting Buddhas. All three figures have heavy, oversize heads, reminiscent of Northern Wei, with faces staring straight ahead, slightly smiling. The lips are thick and the noses are wide wedges. Behind the triad is a huge leaf-shaped nimbus of bronze, incised with flamelike lines. The two side figures also have smaller leaf-shaped halos of their own. An inscription identifies the group as the work of Busshi ("Master Craftsman of Buddhist Sculpture") Tori.

In the nearby nunnery of Chuguji is one of the gems of sculpture, not only of Japan but of the world [156]. Usually la-

beled a Maitreya (Miroku in Japanese), the Buddha-to-Come, it
has been thought by some to depict Sakyamuni himself as a young
man, or possibly the devout Prince Shotoku. By some accounts,
Shotoku was the carver. The youthful figure was carved in eleven
separate pieces of camphorwood, once gilt but now mellowed to
a glossy black. He sits in the "pensive attitude," with left leg
hanging to the ground, the other crossed with its foot resting on
the left knee, and the right elbow resting on the right knee, with
the hand barely touching his chin. His lower garment is arranged
across his lap in shallow trough-folds, spilling over the dais in the
familiar steam-pressed scalloped patterns. Some of the figure's
hair, indicated by a slight ridge along the sideburns, falls in two
stylized strands along the shoulders.

According to Tang texts, a boy wore his hair in two tufts
until he attained majority. Apparently this accounts for the dou-
ble head knob, which also appears in paintings of the period.
There is little identifiably of Chinese inspiration in this remark-
able figure. Nothing as expressive or finely modeled has survived
to us from China—or at least North China; possibly the carver
drew on a South Chinese model, but we cannot know, for almost
nothing has survived from that region. The Miroku's face is as-
tonishingly "un-ethnic"—not distinctively Japanese, or even Ori-
ental, in its gentle, serene expression. Note that in this early stage
of Japanese sculpture, and later, the Japanese were readier than
the Chinese to expose the upper part of the body and to indicate
underlying form.

There are a few pieces from the seventh century available in
Western museums, but most are small. To see monumental sculp-
ture of the seventh century—or of the eighth, for that matter—
we must go to Japan, and especially to Nara, where most of the
images are still enshrined.

In general there are far fewer examples of Japanese work, es-
pecially from the early period, than of Chinese in the West. A
weak China, forced to yield choice bits of territory and authority

to foreign powers, lay open for many years to the depredations of Western collectors and Chinese ready to sell in that market—looting for which we may now be thankful if somewhat conscience-stricken. Japan, on the other hand, was less vulnerable. For one thing, Buddhism remained a vigorous faith there much longer than in China, and many of its treasures were still actively worshipped when foreigners came back to Japan after the Meiji Restoration of 1868. Other images lay stacked in warehouses or storerooms of temples. Although the Japanese themselves did not attach much value to many of these forgotten objects until recent times, neither did foreign collectors. By the time Western interest was awakened, in this century, the Japanese had passed strict laws to safeguard such national treasures.

NARA AS CAPITAL

Early in the eighth century copper deposits were found in Japan, making large bronzes more feasible, and the imperial capital was moved to Nara. Up to this time the capital, or at least the emperor's palace, was moved each time the reigning sovereign died—in part, it seems, because a house in which a death had taken place was regarded as defiled and unclean. But Nara, the grandest city yet built in Japan, modeled after the Chinese capital, was to remain the seat of government and chief center of learning for seventy-five years. The Soga clan had been driven from power half a century before, and now the Fujiwaras were the dominant clan, pulling the strings of puppet emperors. The new combination of rulers promulgated the Great Reform designed to establish imperial power at the expense of the great local barons in Japan by centralizing government as much as possible in the capital.

The establishment of impressive monasteries and temples in the new capital was one way to reinforce imperial prestige. Through selected images in some of these we can see new devel-

opments in Japan, and we can also get the flavor of monumental
Tang sculpture in bronze which would otherwise be almost
wholly lost to us. Tang opulence and art were then at full flood,
but the masterpieces in bronze of Buddhist spiritual beings then
produced in China disappeared in the wake of the Great Persecu-
tion of 845 and later events. Only here at Nara can we find great
works of the period.

One of the temples is Yakushiji, dedicated to the Healing
Buddha, built early in the eighth century. One of its glories is the
big Sho-Kannon, standing eight feet high in one of the shrines.
The influences of India and Tang China are at once evident. His
face and body are pneumatic and breath-filled, like a Hindu
god's, and looping necklaces, girdles, scarves, and other hanging
ornaments define the curves of his body. The lower garment clings
to his body in a series of broad, curving folds. The face is more
definitely Oriental than in most of the earlier Japanese images,
with a little tilt to the eyes and distinct epicanthal folds at their
inner corners. A thin barely visible moustache droops round the
corners of his mouth.

In the Kondo, or Golden Hall, of the temple complex is a co-
lossal threesome in bronze—the main cult image of a seated Yak-
ushi, the Healing Buddha, flanked by two Bodhisattvas standing
ten feet tall, identified as Gakko and Nikko (corresponding to the
Indian gods of the Moon and Sun) [158]. The metal, once
gilded, has turned to a lustrous black. All are plumper than the
Sho-Kannon. All have double chins and the circular pectoral mus-
cles, like inverted shallow bowls, that became a distinguishing
mark of Japanese sculpture. (The Chinese rarely, until Ming
times, exposed as much of the human body as the Japanese.)
Later on this feature became so stylized that the round muscles
are actually set into the flesh of the chest, with a definite indenta-
tion at the rim. This curious anatomical ambiguity sometimes
makes it difficult to tell whether a male or female is intended,
but, as we have already noted at some length, uncertainty of gen-

der is intentional. In China and Japan, we might note parenthetically, the female breast is almost never sharply defined, whether exposed or draped—a striking departure from the Indian tradition.

The Yakushi has a very broad *ushnisha,* or head knob (typical of Japanese Buddha figures), with "ringlets" of hair in pointed knobs. The drapery is simple, falling in catenary curves over the folded legs and then spilling over the edge of the platform in stylized steam-pressed folds. The two attendants are similar to the nearby Kannon, except that their pose is slightly *hanché* and their abdomens gently protrude, with creases above the navel accentuating the plumpness—another touch that became standard in later Japanese sculpture.

The Yakushi triad is protected by traditional guardian figures of fearsome aspect—the Twelve Generals and Four Deva Kings (*deva* being Sanskrit for a god), including a Kongo, the Japanese version of Vajrapani, bearer of the thunderbolt and protector of the historic Buddha, of whom we will see more later.

OTHER FUJIWARA MONUMENTS

Another temple at Nara, Todaiji, built about the middle of the eighth century, celebrated the consolidation of imperial power, at least in theory, over the feudal lords. Its most spectacular feature is the famous Daibatsu, a towering seated figure forty-eight feet high of the Buddha Vairocana (Roshana in Japanese). This is one of the seven Dhyani Buddhas that have on occasion made themselves manifest on earth, as in Sakyamuni. Vairocana, as the Adi-Buddha, the primordial essence from which all being, including the gods themselves, has issued, was an appropriate symbol of imperial authority.

Its creation was also an occasion for demonstrating friendly relations and compatibility between Buddhism and Shintoism. The traditional form of nature worship, based more on notions of

ritual purity than of morality, had myriad deities rather vaguely
defined. In pre-Buddhist days they were not given specific form in
sculpture or painting. The deity at the top of the Shinto hier-
archy was the Sun-Goddess Amaterasu, the ancestress of the impe-
rial line. Before the huge Daibatsu was put up in Nara, she was
consulted at her great shrine in Ise, and appears through a me-
dium to have consented to the creation of the image that so dra-
matically affirmed the Buddhist faith. By now Shinto gods like
Hachiman, god of war, were being given bodily form and placed
in their own or in Buddhist temples. An early example of a
Shinto deity is the goddess in the Matsuo Shrine in Kyoto [168].
Carved of one piece of wood late in the ninth century, she is
simple, solid, possibly made as the portrait of an important
lady. In the images of their national gods the Japanese avoided
the frills and decoration sometimes permitted to Buddhist figures.
Buddhist priests sometimes officiated in Shinto shrines. It
was accepted that one could be both a Buddhist and a devotee of the
national gods. Buddhism did not, as in Brahmin India and
Confucian China, have to contend with long-established and
highly sophisticated native ideologies.

The casting of the huge image took a million pounds of
metal and nearly six years. It was dedicated with much ceremony
in 752. The present version is almost entirely a new construction
of the late seventeenth century; the original was destroyed by fire
during the civil wars at the end of the twelfth century.

More interesting sculpture is found in other buildings of To-
daiji. Here we see that the Japanese blended the Hindu pan-
theon into the Buddhist as the Chinese apparently never did after
the earliest days of Buddhist sculpture in China. There are
strange many-armed deities with names derived from their Indian
forebears, but given a unique Japanese stamp. In India, Hindu-
ism largely absorbed Buddhism. In Japan it was the other way
round. Hindu gods became minor figures in the Buddhist pan-
theon. Among the Nara sculptures are many of the fierce-faced

guardian figures who protected the Buddha. One splendid exam-
ple is a dry clay statue of Kongo, the Japanese version of Vajra-
pani. This "Wielder of the Thunderbolt," it will be recalled, pro-
tected the historic Buddha Sakyamuni during his lifetime. We
encountered him first in the Gandharan relief of the Enlighten-
ment and of Buddha preaching in the Deer Park, in the Freer Gal-
lery in Washington [110]. These fearsome figures, as in China,
have a freedom and naturalism in posture and expression that is
not found—and would, of course, be quite inappropriate—in the
serene Buddhas and Bodhisattvas, made in man's image but not
human. One of the illustrations shows a guardian figure from a
later period (the eleventh century) now standing in the Boston
Museum of Fine Arts [161]. He is Bishamon-Ten, chief of the
Four Deva Kings, a Japanese version of Kubera.

The Kongo was long protected in a secret room of its shrine
in the Todaiji complex, and has retained most of its original
color. It is one of the relatively few eighth-century naturalistic
images that survived the civil wars of the late twelfth century, but
they were much copied in the new sculptures made during the
restoration that followed the wars. Dry clay and lacquer were used
on a large scale in eighth-century sculpture.

Among the works that survived are some unique works in
dry lacquer that have a fresh, naïve charm not found before or
since. These are in another temple in Nara, the Kofukuji, which
was the showplace of the powerful Fujiwara clan. Eight are guard-
ian demons, defenders of the faith, and six are from a larger
group of Sakyamuni's disciples. The illustration [159] shows an
Ashura (Sanskrit for demon) that is anything but demonlike. He
stands five feet high, with three boyish faces, each trying to look
stern, and six tubular arms. The hands from the "main" arms are
pressed together in the gesture of respectful greeting or adoration,
and the four other arms are held out and up, giving the rather
unfortunate effect of a spider or king-crab from a direct frontal
view.

CAPITAL OF PEACE AND TRANQUILLITY

Toward the end of the eighth century the Buddhist establishments of Nara were in disfavor among both the wielders of political power and the more pious of the religious. The temples and monasteries had become so worldly and rich that the imperial court and Fujiwara rulers, like their counterparts of the contemporary Tang period in China, distrusted them. Dedicated Buddhists, for their part, wanted to withdraw to less secular places. Esoteric Buddhism was becoming strong, with Tantric sects of the kind that were popular and powerful in India and China. Adherents of Mikkyo, as such secret doctrine of the Shingon sect was called in Japan, set up seminaries, monasteries, and hermitages in the hills away from Nara. Wood, plentiful in the mountains, became a favorite medium of sculpture.

In 794 the capital was moved to a new town twenty-five miles northwest of Nara. Called Heian-Kyo, the "capital of peace and tranquillity," it later developed into the modern city of Kyoto. Despite imperial attempts to restrict them, Buddhist establishments waxed again in wealth and power. Their rivalries and armed brawls kept Kyoto in continual turmoil. The new city, however, remained the seat of government for four centuries, and the home of the imperial court much longer.

Japan came of age in the four centuries of the Heian or Kyoto period (also often called Fujiwara in art history and museum labels, after the dominant family of the era). By the end of the ninth century a new self-confidence and self-reliance were evident. By then Japan had adapted written Chinese to its own use, having developed a simplified script much more suitable to its own complicated, polysyllabic language. There was a growing body of Japanese literature. Japanese poetry was in fashion. Although Chinese remained the language of high scholarship, there was in general a reaction against Chinese learning. Whatever

Confucianism had to offer in the way of political theory had been absorbed. Japanese painters had struck off in bold, colorful directions of their own. In Buddhism, severely checked by the Great Persecution in Tang China in 845, little fresh inspiration was coming from the mainland. Henceforth Buddhism would develop along distinctively Japanese lines. In 894 the rulers of Japan decided to send no more diplomatic missions to the Tang court.

There was, in this period, one major new religious impulse—originating, as most others had, in China, but now made thoroughly Japanese. This was the growth of Jodo, the Pure Land sect we have already noted in China, with Amitabha (Amida in Japan) as its central cult figure. Its simple message, that everyone could ensure his salvation by invoking the name of Amida, swept through Japan. *Nembutsu,* repeated invocations of the deity's name, was so popular a form of worship that other sects had to use similar formulas. *Nemu Amida Butsu,* "Homage to Amida Buddha," was chanted by more and more.

The cult swept Japan as earlier it had China, although initially it seems that it was mainly favored by the rich. It became the fashion to build private Amida halls—shrines for the worship of this deity who could assure the devotee access to the Western Paradise or the Pure Land without the bother of much learning or of saintly living. One such shrine is the "Phoenix Hall" in Kyoto. Here sits a colossal image of Amida, more than nine feet high, made by the sculptor Jocho of many bits of wood in the middle of the eleventh century [160].

This is an example of the *yosegi* technique of carving figures in wood. Statues made of a single large piece of wood tend to split with age. The Japanese in earlier times had tried to cope with this problem by using woods of certain trees, especially camphor, well aged and dried. The Miroku in Chuguji was of this kind, and, consisting as it did of several fitted pieces, the risk of splitting was less. But it was solid. Now, in Fujiwara times, a new method was used, building up a figure from many small pieces

with a hollow space at the core. The big Amida in the Phoenix Hall of Kyoto is of this second kind.

The Amida is simple and direct in style and ornament, with the reversed saucer pectorals and curved crease above the belly that by now had become canonical. His hands rest in his lap, palms up, with the fingers bent at the second knuckle and pressed together back to back, thumbs touching the first fingers, in an attitude that became a distinguishing mark of seated Amidas in Japan. You will see examples in most major collections of Japanese art in Europe and America. On the walls around him are small and delightful flat carvings of Bodhisattvas, angels, and heavenly musicians, regarded as Amida's escort on his descent from paradise to receive a newly released soul.

The eleventh and twelfth centuries were times of disorder and unrest. The provincial baronies waxed as the authority of the imperial court and Fujiwaras declined. The big monasteries had private armies, formed by alliances with powerful military families, which brawled and fought in the streets of Kyoto. At one time early in the twelfth century two rival monasteries mustered armies estimated at twenty thousand apiece to confront each other in the Capital of Peace and Tranquillity. A new military caste came into being, the samurai, with fealty to overlords and scorn of death as its supreme values. Two rival military families grew in strength in the eastern provinces, the Taira and the Minamoto, whose contention culminated in a fierce civil war in 1180. The temples of Todaiji and Kofukuji in Nara, among other buildings, were largely destroyed in the fighting.

THE KAMAKURA PERIOD—A FINAL FLOWERING

Finally the Minamoto prevailed. In 1185 they moved their military headquarters and the effective seat of central government to Kamakura in the east, on Tokyo Bay, three hundred miles

from the decadent imperial court. One of the new shogun's first acts, however, was to restore the ruined temples of Nara—less, it has been suggested, because he was personally attached to that discredited establishment in western Japan than because he wanted to show up his defeated rivals, the Tairas, who had burned the temples.

In the early postwar years large workshops of sculptors were formed, including an atelier under the direction of the great Unkei (the Michelangelo of Japan, as he has often been called), who was himself the son of a famous sculptor, Kokei. The restorers reached back to the earlier eighth-century styles of Nara for their models. In Kofukuji, for example, new guardian figures, disciples, and saintly sages were added to the early ones that survived the fires, but on a larger scale and this time in laminated wood using the *yosegi* technique. One of the striking new figures is Unkei's imaginary and intensely naturalistic portrait of Seishin (a fifth-century Indian missionary named Vasubandhu) [163]. He stands more than six feet tall, in contrast to the shorter, earlier portraits of disciples in dry lacquer.

The same naturalism is found in the fierce guardian figures, continuing the earlier tradition. There is one notable change, apart from the use of wood instead of dried clay. Now the Guardian Kings are likely to be stripped to the waist and the carver gives close attention to anatomical detail. The resulting complex of bone, muscle, sinews, even blood vessels, gives these figures a flayed look, as if their skin has been stripped off to reveal the underlying structure. A figure in the Freer Gallery in Washington is a good example [162]. The emphasis on naturalism in portraits and guardian figures, based on models from China, is likely to be the most interesting development of Japanese sculpture of this period for the Western observer.

Two developments in Buddhism after the civil war late in the twelfth century had the usual parallels in sculpture. One was the rise of Zen Buddhism, embraced by the samurai who found its

simplicity, directness, and discipline congenial to their military code. The older cults associated with the effete court of Kyoto were under a cloud. Zen gave the new ruling classes a fresh, untainted form of worship suited to their tastes and values. The Japanese "Zen" is from the Chinese "Chan," which in turn derives from the Sanskrit "Dhyani," meaning meditation or contemplation. In its best-known forms, however, Zen is far different from the more traditional meditative sects. It teaches that direct personal intuitions of truth and spontaneous perceptions of spiritual reality are of more importance than prolonged detachment or philosophical speculation. Zen was, and is, an austere, disciplined faith, emphasizing self-examination, and had little use for the magnificent images that had come to be thought of as necessary and proper aids to worship and, for the donor, a means of acquiring merit. Favored Zen works of sculpture were portraits of leading monks. We will look at one a bit later.

The other major trend in Buddhism was the continuing and growing popularity of the Pure Land (Jodo) school, or Amida worship, and other sects proclaiming the efficacy of *nembutsu*— the repetition of the holy name. In an age so far removed from the lifetime of the historic Buddha, in the time of *mappo,* or "the latter end of the law," adherents of the *nembutsu* sects held that ordinary people could not be expected to follow the strict rules of the Middle Way. Devotion to Amida (or another Buddhist deity who might be, for example, the revered Shotoku) and repetition of his name were the keys to salvation, available to all. The popularity of the faith roused the opposition of older Buddhist sects, and its zealous preachers were persecuted—sometimes exiled. But Jodo persisted. Even today its devotees are probably the most numerous Buddhist sect in Japan. In the Kamakura period, however, the attendants of Amida included, more than in the past, images meant to inspire dread and awe, reminding sinners of the terrors of hell as well as the joys of paradise. The shift accorded well with the repressiveness of samurai rule under the Minamotos.

Weakened by the long struggle to repel invasion threats from the Mongols who then ruled China, late in the thirteenth century, the Kamakura shogunate collapsed. The Ashikaga clan who then became dominant moved the capital back to Kyoto. Muromachi, the quarter of the town in which they built their palaces and military headquarters, gave its name to the new era in Japanese history, beginning in the fourteenth century.

A FADING TRADITION

If the Kamakura period was the end of Japan's sculptural summer, its last roses were already stunted and colorless. Old, approved themes and forms were repeated, with little new invention or fresh inspiration. Even in the more congenial atmosphere of Kyoto, plastic art on a monumental scale did not recover its earlier tone.

A masterpiece by Kaikei of the early Kamakura period, now in the Boston Museum of Fine Arts, gives us a glimpse both of the technical smoothness of the Nara ateliers and a hint of the decay that was setting in. Unkei, the sculptor's early employer and teacher, was known as the master of naturalism. Kaikei was the genius of the "sweet," spiritual school. This icon is a standing Miroku in gilded wood, slightly and gracefully *hanché,* with curves and folds in its draperies reminding us that the Kamakura shoguns had restored official relations with Sung China [164]. A somewhat later seated Kannon in bronze, holding a lotus, by another Nara sculptor named Saichi, is also in Boston [165]. We should remember that the naturalistic touches then given to priests and guardian figures were not considered appropriate for icons of deities.

But the faces had long since become predictably round as the full moon, the style of hair and drapery set in stylized patterns, and the creases round the pectorals and over the belly standardized. Most Japanese sculpture that we see in Western museums comes from these later periods—late Fujiwara and Kamakura—

and gives us little idea of the freshness and power of images from an earlier day.

In Muromachi times Zen portraiture remained vigorous, but also tended to become more stylized. Zen enjoyed such favor among the military rulers and samurai that it was almost a state religion. Some of its monasteries, retreating from earlier austerity, became rich on the profits of landowning and trade. When the Mongol tide had been turned back, Japanese commerce flourished with Ming China. Merchants and moneylenders often attached themselves to monasteries, Zen and other, which shared their profits. For example, Kofukuji, the temple near Nara that had been restored early in the thirteenth century, derived large revenues in the fifteenth from a monopoly of customs dues on goods passing through an important west-coast port. The Metropolitan Museum in New York has a portrait in lacquered wood of a Zen abbot of the late fourteenth century, whose strong face and intense eyes could as well be those of a hard-bargaining merchant prince or a feudal landlord as of a spiritual leader. Quite probably he was all three [166].

THE TRUE WORD

Another illustration from Japan shows a fourteenth-century icon of wood, of one of the forms of Kongo, the wielder of the thunderbolt [167]. He is included, not because the image shows any new development in style, but because he belongs to one major trend in Buddhism to which we have so far only glancingly referred in these pages. His Japanese name is Aizen-myo-o. One of his three right hands clutches to his chest a double-ended *vajra,* or thunderbolt, each end consisting of four clawlike prongs of bronze, almost meeting at the apex. We first saw the *vajra,* then a rough, slightly concave, cylinder, held by Sakyamuni's faithful protector, Vajrapani, as he keeps watch over the Buddha's left shoulder during the Assault of Mara and the Sermon in the Deer

Park [110]. Another *vajra* tops the head of the roaring lion that
rests in the figure's hair. A third forms the end of the bell handle
held in the foremost left hand. The remaining four hands hold
other Tantric symbols.

The *vajra* and *ghanta* (bell) are the principal symbols of
Tantric Buddhism, also known as the Vajrayana (The Way of the
Thunderbolt) and Esoteric Buddhism—in Japan, as we have al-
ready noted, Mikkyo. An offshoot of the Mahayana, or Greater Ve-
hicle, Vajrayana was known in most of the Buddhist world, and
long remained dominant (merged with local animism and devil
worship as Lamaism) in certain parts like Tibet, the Himalayan
kingdoms, and Mongolia. In sculpture it is best known to us
through the little gilt-bronze statuettes, seldom reaching monu-
mental proportions, from Tibet and the Himalayan countries
that we will see in every major collection of Asian art.

I do not propose to try to delve much below the surface of
Tantric mysteries or explore their elaborate pantheon. Indeed, by
definition, these "esoteric" doctrines are not supposed to be re-
vealed to, or even within the intelligible grasp of, the uninitiated.
I will, however, try to trace the main contours of this branch of
Buddhism, which takes a bewildering variety of forms from time
to time and place to place. Up to a certain point the doctrine
makes use of ideas familiar from other Buddhist systems of thought
and from Hinduism: Adi-Buddha or Vairocana as the primordial,
unchanging essence of all being (the adamantine quality of the
diamond, another meaning of *vajra*, which represents the inde-
structible truth); the creation of all differentiated forms of being
by the interaction of opposite but complementary principles
(male and female, *vajra*, or male member, and *garbha*, or womb,
yang and *yin*, or in Tibetan Lamaism, *yab* and *yum*). Learning,
meditation, and devotion may lead one a certain part of the way
toward reunion with the universal Buddha-nature. But in Tant-
rism the last stage is open only to those who understand certain
magic formulas which may take the form of mystic diagrams or

forms of words. This stage, beyond the reach of reason, is not open to the uninitiated.

The formula most familiar to outsiders is the chant of Tibetan and Himalayan Lamaists: *"Aum mani padme hum."* *Aum* is the mystic syllable also used in Hinduism, expressing ultimate being—as close as one can come to naming God. *Mani* means jewel, essentially the same as *vajra,* and *padme* means lotus. The two also refer to the male and female parts. *"Mani padme"* = "the jewel is in the lotus," with evident implications of sexual union, and of creativity more generally. *Hum* seems to be a final "amen."

More elaborate meanings are to be found in the mystic formula, but this will suffice for our purposes. Tantrism has an obvious kinship to Hindu Saktism from which it derived in the seventh and eighth centuries, traveling through the mountain passes into the Himalayas and beyond, and southeastward by sea as far as Java. It also reached China and Japan, but it seems to have disappeared in China under the weight of Confucian disapproval. In Japan it endured in an expurgated form in the Shingon sect.

The jewel-in-the-lotus chant of Lamaists was addressed to Avalokiteshvara in his form of Padmapani, the Lotus-Bearer. The Tibetan Dalai Lama is regarded as an incarnation of that divine being. Until recent years Buddhist Tantrism flourished in Tibet as Lamaism. A poignant reminder of its struggle to survive in Indian exile came in 1971 when an Indian newspaper reported a rumor (baseless, it seems) that the Dalai Lama was going to marry an American. Tibetan leaders in India, in protest against such journalistic blasphemy, issued a reminder of basic beliefs: the Dalai Lama "is completely free from all kinds of cosmic sufferings known to mortal beings. He is the Enlightened One who has renounced the world and there is no element of fault in Him" and his role is "to follow the path that has been laid down by Lord Buddha and further lead the world toward a better concept of life."

CHAPTER

9

Southeast by Sea

M ANY Chinese pilgrims made the hard journey to the
homeland of Sakyamuni Buddha in India, to visit the
holy sites, see the Buddha's relics, talk with scholar-
monks, and bring back the latest scriptural texts and images. Fa-
Hsien was one of these. Setting out for India in A.D. 399 by the
central Asian trade routes, he traveled for fourteen years. His
last stop for instruction in Buddhism was in Ceylon. From there,
ready to return home with his accumulated treasures, he "shipped
himself [according to his own report] on board a great merchant
vessel which carried about two hundred men," and sailed east-
ward. A typhoon forced his merchant traveling companions to jet-
tison most of their goods, and he feared for his sacred writings
and images. He prayed to Avalokiteshvara: "I have wandered far
and wide in search of the Law. Oh, bring me back again, by your
spiritual power, to reach some resting place."

After a wreck, repairs, and many more trials they arrived at
Ye-po-ti (Yavadvipa in Sanskrit; *yava*= barley; *dvipa*= island). In
Java (or perhaps it was Sumatra), the land of barley, he found
that "heretics and Brahmins flourish, but the law of Buddha is

not much known." Eventually he made it safely back to China.

In Fa-Hsien's lively and pious account of his travels we find some of the many evidences of Indian commerce with the region we now think of as southeast Asia in the early centuries of the Christian era. There has been long and somewhat testy scholarly debate about the nature and extent of Indian influence in that large area. A "Greater-India" school of historians speak of extensive Indian "colonization" and give the impression that Indians were the dominating sailors and traders. Other scholars point out that the Malays and other mariners were handy with a sail, and that, anyway, unlettered sea captains and deck hands could hardly be purveyors of Indian learning. In any event it seems clear that Indian influence did not spread by massive migrations or military conquests. Probably the most important carriers of Indian civilization were Brahmins invited by southeast Asian rulers to come to their courts as priests and advisers. Others were Buddhist monks, traveling in both directions, and perhaps occasional émigrés fleeing from dynastic quarrels at home.

The Brahmins and others brought to royal courts their language, literature, laws, and religions. And with the religions came their sculpture. For centuries Hinduism and Buddhism existed side by side, with Hinduism tending to be the religion of the courts. Buddhist merchants supported the growth of monasteries. Villagers were not much affected, except presumably to be properly awed by the lavish temples their rulers built to assert their identity with the divinity. The religion of the people was a mixture of nature worship and respect for ancestors, and has remained so in large part even with the advent of more popular forms of Buddhism and Islam. The Hindu caste system never took hold in southeast Asia.

Indian sculpture was translated into local idioms all along the sea routes. To a lesser extent it also traveled by the land route through the passes of Assam and northern Burma. Highly distinctive styles of sculpture evolved and we will now look briefly at a

few of these. But the underlying themes and forms were mainly
Indian, and our earlier discussion of these must suffice as an in-
troduction to the many adaptations that developed in southeast
Asia. In Cambodia and Java the most vigorous and sophisticated
artistic developments took place. This short account will concen-
trate on those two cultures, with an aside on Thailand, where a
distinctive style grew up within the far more rigid bounds of
Theravada, or Hinayana (Little Vehicle), Buddhism.

THE LAND OF BARLEY

Having gone with Fa-Hsien to the furthermost part of Fur-
ther India, let us pause there briefly. In Javanese history there are
two main periods of interest to us: the late eighth and the ninth
centuries A.D., when the Shailendra dynasty ruled in central Java,
and the eleventh to thirteenth in east Java. The Shailendras ap-
parently came from Sumatra, an important trading center and po-
litical force before Java. The court religion was mainly Mahayana
Buddhism, following an earlier period of Shiva worship. In the
tenth century central Java lapsed into obscurity as the result, it
seems, of some disaster, possibly an epidemic or earthquake. Polit-
ical and cultural interest shifted to east Java, where the twelfth
century became Java's golden age of art and literature. East Java
remained the main area of activity until Muslim conquest and
conversion rang down the curtain on the rich profusion of mixed
Buddhist and Hindu art. Bali then remained, as it still is today,
unconquered by Islam and an outpost of Indianized culture.

The most famous monument of the Shailendra period in cen-
tral Java is the huge Buddhist complex of stupas at Borobudur,
in south central Java near Jogjakarta. This architectural *tour de
force*, ranking with Angkor Wat as a wonder of the Asian world,
consists of a flattened pyramid built over a low hill, with five
square terraces stepping up from a huge square base, topped by
three more terraces, circular this time, that lead up to a central

circular stupa [169]. Relief carvings run round each of the square terraces, punctuated by niches in which Buddha figures sit. The reliefs, totaling more than three miles in length, depict scenes from the life of Buddha, the Jataka tales of his previous existences on earth, and other Buddhist scriptures.

The three circular terraces at the top bear seventy-two bell-shaped shrines, each containing a Buddha. This huge mass of stone, pressing down on the lower courses, has caused the bottom to bulge. Long ago it was necessary to reinforce the whole structure by piling up masonry at the outer lower edge, which now forms a broad processional path. At present an international rescue effort is under way to save the massive structure from further collapse.

Borobudur's full name, we are told, is "Mountain of the Accumulation of Virtue on the Ten Stages of the Bodhisattva." The structure was intended to be a statement of Mahayana Buddhist belief, affirming the Buddha-nature in all living things, heightened to pure being at the very top, where an image of the Adi-Buddha was once concealed in the central and highest stupa. A pilgrim, circumambulating the terraces, is led by the scenes he sees to higher levels of consciousness toward ultimate release from worldly corruption at the summit. The repetitive Buddha figures in their niches are impressive, more because of their cumulative impact than from sculptural distinction [170]. But the most pleasing carving is on the long friezes.

Brahminism flourished in ruling circles before and after the Buddhist period. Some of the Hindu statues in the round afford more varied fare than the Buddha figures, and give us a taste of the solid but graceful Javanese style. The Djakarta Museum now houses two of the striking figures from Hindu temples on the Dieng Plateau near Borobudur. One is a massive, pot-bellied "Divine Teacher," apparently a Brahmin sage named Agastya who helped bring Brahminism to south India. Thick-sided and

rounded, with belly, chest, arms, and thighs flowing into each other, he recalls the plump figures of Ganesha and Kubera from India. A lack of definition at the juncture of the various parts of the body is characteristic of Javanese sculpture. The second is a Vishnu, with the slight abdominal protuberance and many bands of girdles that we became familiar with in India.

After the ninth century, as we have already noted, there was a hiatus in the art and history of central Java. By the twelfth century, the arts were flourishing in eastern Java, where two fortified towns, Singarsari and later Majapahit were the main centers. Javanese style did not change much in the transition. An icon of Durga slaying the buffalo demon, now in the Boston Museum of Fine Arts [171], invites comparison with a typical south Indian version made four or five centuries earlier [123]. The basic pose is the same. The Javanese Durga is stockier than her Indian counterpart, but is appealingly graceful in a full-fleshed way. Note that the Javanese image shows the buffalo demon emerging in human form in the last scene of the drama.

In Java as in Cambodia, the ruling kings and princelings identified themselves with deities, Hindu or Buddhist. If a ruler was a Shaivite, the *chandi*, or temple-tomb, that he built housed the sacred *lingam*, or an image of Shiva. The greatest of the eastern kings, Airlangga, who ruled in the first half of the eleventh century, claimed to be an incarnation of Vishnu. His tomb contained a striking portrait of himself as the god riding his mount, the eagle Garuda (which has become the name of the Indonesian national airline). The image now stands in the Madjakerta Museum.

For a satisfactory look at Javanese sculpture we should go to the island itself or to museums in the Netherlands, long the rulers of colonial Indonesia. Many find the plastic art of Java the most pleasing in southeast Asia. Its distinguishing characteristics are a solidity that manages to be graceful and vital instead of ponder-

ous, a considerable degree of naturalism in non-Buddhist faces
(such as those of the "Divine Teacher" and Airlangga mentioned
above), and impassivity of faces even in the liveliest reliefs.

PEOPLE OF MOUNTAIN AND SEA

Continental southeast Asia, from South Vietnam to the bor-
ders of India, is marked by a number of great rivers that rise in
the northern mountains, flow through plateaus and hills, and
reach the sea in fertile deltas. Throughout history there have
been rivalries and cultural differences between the simpler, more
rugged people of the mountains and the more affluent and sophis-
ticated people of the plains, whose economy was based on rice cul-
tivation and sea trade. Early in the Christian era the Khmers oc-
cupied the Mekong delta and the country upriver and to the
west; their cousins the Mons lived in the valley of the Menam,
which empties into the sea near Bangkok, and southern Burma,
and other peoples occupied the Malay peninsula and river valleys
of Burma and coastal regions of South Vietnam. Our interest will
focus on the Khmers and Mons.

The history of the region has been one of pressure, typically
by gradual infiltration rather than invasion, from mountain peo-
ple moving down from the hills in the hinterland of the plains
and the forbidding heights of Yunnan. Wars usually came when
the process was well advanced. In time the Thais and Burmese
took over the lands of the Mons, and the northern Khmers domi-
nated their southern kinsmen.

The Mons were early and loyal converts to Theravada
(*Thera*=teacher) or Hinayana (Lesser Vehicle) Buddhism, cen-
tered mainly on Ceylon. Mon missionaries trained in Ceylon
helped to convert the whole of continental southeast Asia to their
faith. But that came later. At the beginning of the period that
concerns us—from about the sixth to the fifteenth centuries—one

of the Mon kingdoms was Dvaravati, around Bangkok. Buddha heads and standing figures of the time (about seventh century) and place are distinctive. The Brundage Collection in San Francisco's de Young Museum has an excellent head. Typically, the forehead recedes markedly, thick eyebrows grow together, the nose is large, and the lips are fleshy. Standing figures, like that in the Seattle Art Museum, have the same sort of face, and a typical garment with no indication of folds.

Among the surviving Mon works of this period is a standing stone Buddha now in the Nelson Gallery in Kansas City [172]. The resemblance to the Buddhas of Gupta India is marked [111, 114], but the fine youthful face and figure, with the familiar slight belly bulge and bat-wing garments showing no trace of folds, is not to be dismissed simply as "provincial" work of an inferior order. This is more refined and appealing than most Mon figures from Dvaravati, and has been identified as coming from Chiengmai, further north in Thailand.

CAMBODIA: THE FIRST KINGDOM

The first known kingdom in what is now southern Cambodia, stretching somewhat eastward, was called by the Chinese "Funan"—a name apparently related to the modern Khmer word *phnom,* or mountain. Its legendary founder was a foreigner (probably a Brahmin) who married the daughter of a local *naga* king or snake spirit. Among the Khmers the *naga,* often depicted as a nine-headed snake, had symbolic importance. As a water deity he was a constant reminder of the dependency of rice cultivators on rain and irrigation and helped to celebrate later Khmer success in taming the waters around Angkor.

A Chinese emissary to Funan in the third century A.D., with typical Chinese distaste for "barbarians," found the people ugly, swarthy, and naked. He claimed to have persuaded their ruler to

order the men to wear clothing, consisting of a length of cloth wrapped around the waist—the familiar *sampot* of Cambodia and *lungi* and *sarong* of other lands.

Accounts vary as to how Funan disappeared and a new Khmer state emerged, but apparently the process involved pressure and perhaps conquest by people to the north and some incursions from Sumatra. In terms of our own interests, it is enough to note that in the period from the sixth through the eighth centuries Hinduism largely replaced Buddhism as the court religion, centered on the *lingam* cult of Shiva but with Vishnu too much in evidence. Indeed, a favored icon of this period was Harihara, a combined form of Shiva and Vishnu, each forming half of the image. The most easily recognizable feature of each (apart from the attributes he carries, which are sometimes missing from the damaged images that survive) is his headdress. Shiva's half is a mop of hair tied up above his head, and that of Vishnu a cylindrical miter. An excellent example in the Musée Guimet in Paris still has the trident of Shiva and the disc of Vishnu [173]. This Harihara also has the remains of a stone horseshoe aureole that once enveloped the whole figure—a framework, typical of the period, used by carvers to reinforce the tall standing stone statues and give them stability.

A Harihara in the Boston Museum of Fine Arts is as simple and symmetrical as a chess pawn [175]. The softly modeled torso is almost womanish. On the "Shiva side" of the heavy cylinder atop a blocklike head the hair is indicated by stylized "U's" in low relief, and also half of a crescent moon which is one of the signs of Shiva. Again there is a long, thick-lipped Khmer mouth. A very similar female statue stands in the Museé Guimet [176]. She too has been reduced to a basic form (this time distinctly feminine) and from a frontal view is symmetrical except for a slight *hanchement*. Her headdress too is cylindrical, incised to indicate the shape of her coiffure. The modeled chest of a Vishnu of this early period, in Cleveland [177], is a naturalistic touch that later

was more highly developed. It is easy to see why Khmer sculpture, from its earliest beginnings, is favored in the strain of twentieth-century critical thought that admires the reduction of natural form to its basics. These statues immediately remind us of Egypt.

Cambodian figures, in these early centuries and later, are more "ethnic" than the Javanese. They more sharply show such distinguishing characteristics as broad, flat faces; broad, rather flaring noses; long mouths with lips whose thickness is emphasized by their being somewhat thrust out and turned slightly back at the edges (sometimes, in later sculpture, with a raised ridge at the outlines); an almost straight line of the eyebrows. The eyes, however, often are "Western," lacking the epicanthal, or semilunar, fold of skin at the inner corner of the upper lid which Caucasians regard as characteristic of mongoloid races. Can it be that such Asian peoples did not themselves perceive the eyefold as a feature setting themselves off from the Indians, from whom they originally got their themes and forms of sculpture? Possibly the artisans who carved or cast icons of Indian deities (even when they became identified with living Khmer rulers) were simply repeating formulas that were not only familiar from Indian models but prescribed and even sanctified by the very precise canons of Brahminical iconography for various deities, which the Indians had elaborated to an extreme degree. The "fish-eye" was an approved prescription for a Hindu deity—like the shoulder and arm shaped like an elephant's trunk, the mouth in the curves of Shiva's bow or a lotus petal, and so on. Incidentally, "fish-eye" does not indicate, as in usual Western parlance, the bulging eye of a carp, but a minnow-shaped outline.

The garments of the early Khmer images are barely indicated by incised lines at their edges or in the "folds." There are the first slight hints, in the upper edge of the nether garment, of a characteristic that becomes pronounced in later Khmer work. That line becomes tilted, curving downward round the abdomen, and is

sometimes stepped out in a distinct ridge [176, 180, 181, 182].
The female bosom is almost as opulent as in India, but a new fea-
ture is added—two or more curving creases under the breasts, re-
peating their lower outlines.

Our illustrations include one early Khmer Buddhist figure,
a standing Avalokiteshvara in bronze, a bit more than five feet
high, in New York's Metropolitan Museum [174]. The slim
figure has four arms, a slight belly bulge and slightly *hanché* pos-
ture, a kiltlike garment (not much tilted at the waist in this early
statue), Indian fish-eyes, and in the thick cylinder of hair a small
image of a meditating Buddha that identifies the Bodhisattva. He
probably comes from an independent kingdom on a northern pla-
teau that was free of Khmer domination until some time in the
tenth century.

THE GOD-KINGS

The ninth and tenth centuries, sometimes called the classical
age of Khmer art, brought important changes—political, eco-
nomic, religious, and sculptural. Jayavarman II (the suffix "var-
man" in Khmer kings' names means "protected one" in Sanskrit)
established his capital in the Angkor region about 800. He es-
tablished the cult of the *Devaraja,* the god-king, uniting divine
and earthly power. From then on each Khmer king built his own
temple-mountain, an impressive and sometimes huge complex of
structures ascending by stages to a central shrine, topped by the
highest of many towers, in which stood the *lingam,* symbol and
embodiment of Shiva. After his death, the temple apparently be-
came his mausoleum.

Toward the end of the ninth century Yasovarman I founded
the first city at Angkor. It was much more than a temple-moun-
tain and attendant dwelling places. All the structures were part of
an elaborate agricultural and urban complex, incorporating vast
water reservoirs and canals for irrigation and drainage that ena-

bled the Khmers to flourish. The kings, the "protected ones" of the gods and identified with their preferred divinity (usually Shiva in the early reigns), were also the givers of the water that sustained the people and the state.

There is a series of these vast constructions from the ninth through the thirteenth centuries when the Khmer Empire flourished. The central focus of each was a temple compound. In brief, the Khmers solved the problems caused by too much rainfall in too short of time, averted floods during the monsoon, and stored water for use in the dry season. The hydraulic works were as impressive as the temples and, it seems, it was the kingly duty to tend to the one for the public benefit before he exacted the revenues and forced labor to build the other for his personal glorification. It was a water kingdom. Canals that fed and drained the land also served as highways and moats for protection.

In the ninth century there was for a time a movement toward naturalism in sculpture. The Musée Guimet has one superb example in a masculine torso, in which the musculature of the abdomen, chest, and shoulders is finely modeled [178]. It is in a strongly *hanché* attitude. Seen from the front, it recalls the Praxitelean *Hermes* [24], even in the apparent position of the arms, which are mostly missing. Seen from the side, the resemblance disappears; like most Cambodian sculpture, or Indian, the sides are thick beyond most nature. And the difference between sandstone and marble surfaces, which accounts for more of the difference in visual effect between Asian and European sculpture than we commonly realize, is here heightened by a strong standing or striding posture (we cannot be sure which, for the legs are missing) instead of the *Hermes'* relaxed stance, to give the impression of a far more powerful figure than the *Hermes*. The waistband of the torso is slightly tilted, and set out in a ridge. Here for the first time we see the stylized lappet of cloth, hanging down from the point where the lower garment is tied, that becomes a characteristic mark of Khmer carving.

From the ninth-century venture into naturalism the Khmer sculptors moved back, in their free-standing statues, to a more basic form, frontal and symmetrical. A tenth-century Vishnu, now in the Brundage Collection of the de Young Museum in San Francisco, is probably a portrait of a king, or at least a noble [181]. Even in his present truncated state he is nearly five feet high. Little is left of Indian models. The broad face is almost pure Khmer, with broad square face, prominent lips, and a nearly straight line of the long eyebrows. Moustache and beard are indicated in low relief. Vishnu's miter has become a royal diadem. The garment is only slightly tilted below the waist, but is stepped out in a distinct ridge.

Our two illustrations from the tenth century give a glimpse of the sculpture in relief that banded the temple-mountains. Carving of this kind was far livelier than that of statues in the round, which rarely lost their rather stiff frontality and symmetry. But at this time even the reliefs are simpler, quieter, and less ornate than they will become later. One *apsaras* is in the Boston Museum of Fine Arts [180]. Her head is leaning to one side, and she holds a long lock of knotted hair at the other. The heavy ear ornaments remind us of the origins of the long Buddha ear. The upper edge of her sarong is strongly tilted, and in the curves of the cloth-ends that overhang the knot below her navel we find a suggestion of the exaggerated swirls of long lappets and side sashes that are characteristic of later reliefs from Angkor. Similarly the long ropes of hair are later elaborated into many strands that project improbably in all directions, topped by flamboyant head ornaments.

Our second relief, now in the Musée Guimet, comes from a temple built late in the tenth century, near the end of the "classical" period [179]. Here we see in the center an *apsaras* whom the gods created to cause discord between two demon brothers who were rampaging through the universe. Clearly she has succeeded in her mission. On each side a demon pulls at her, claiming her,

and at the same time threatens the other with a club.

Late in the eleventh century a king built the Baphuon as his temple-mountain, covered with gold and housing a golden *lingam* in its central shrine. From this period comes an elegant royal couple at present standing in the Brundage Collection of San Francisco's de Young Museum [182]. Now the waistband is strongly tilted. From the third eye incised vertically on the king's forehead we can tell that he is identified with Shiva. A new feature are the girdles higher than the waistlines, emphasizing the curves of the queen's breasts and the king's pectorals—an accent repeated by the line of the flat necklaces above. The heads and faces have become rounder.

ANGKOR WAT: THE LATE KHMER EMPIRE

Suryavarman II came to the throne in 1113 and died in 1150. He was the builder of the grandest temple-city of them all and the best known in modern times. Indeed, to most Westerners, Angkor Wat (*wat*=shrine) *is* Angkor, and the monument they are likely to take as representative of all Cambodian culture [183]. Its architecture and relief carvings are its chief glories. We have already noted some of the characteristics of the reliefs—a greater flamboyance and liveliness than in the earlier examples we have seen. For those who cannot visit Angkor Wat there are the riches of museums outside Cambodia to fall back upon, the Musée Guimet in Paris being the richest of all. But they are no substitute for the temple itself. In Cambodia's most recent time of troubles sculpture from the Angkor region began turning up furtively in Western art markets, leading to fears of wholesale looting. There were fears that the temples themselves would be damaged in fighting or lapse into decay for lack of proper care.

At the time the Wat was created Khmer sculptural art had already reached, or perhaps passed, its peak. A new style of sculp-

ture in the round emerged somewhat later in the so-called Bayon
period, named for a new central shrine.

The huge construction was built by levies of human labor,
not, as Khmer legend would have it, by Indra, Lord of Heaven.
And the people also supplied the armies for Suryavarman's for-
eign ambitions. He reached further afield than any previous
Khmer king, and briefly controlled the Cham people on the cen-
tral coast of Vietnam. The Chams recovered to send a punitive
expedition that sacked Angkor in 1177. The last of the great
kings, Jayavarman VII, restored royal control, undertook far-rang-
ing military adventures of his own, and built his own temple-city
of Angkor Thom. At the center rose the shrine called the Bayon.

Jayavarman VII was a Buddhist and identified himself with
the Bodhisattva Lokeshvara, Lord of the World. The famous
giant faces that stare from the towers of Angkor Thom are proba-
bly portraits of Jayavarman. Like most colossi, which were
erected in many parts of the Buddhist world (China, Japan, Cey-
lon, and Thailand, for example), they have little subtlety as sculp-
ture. They jolt and impress the viewer by their sheer size, as they
presumably were meant to do by their builders. A head of Jaya-
varman in the Musée Guimet is a far more interesting portrait
[186]. In the same museum are a kneeling woman, probably his
widow [185], and a Buddha protected by a *naga* [184]. In the
Bayon sculptures the heads and faces are more gently rounded
than before and the features less sharply defined. Their eyes are
closed, and they smile. They are Buddhist. Like the Buddha him-
self, the king's head in our illustration wears no ornaments and
lacks the cylindrical hair-do of Bodhisattvas. The queen kneels in
adoration. Probably her arms and hands, now missing, were
raised and pressed together in the gesture of prayer. In her hair
she wears a small image of a Dhyani Buddha, identifying her as a
Bodhisattva, probably Avalokiteshvara's mate. The Naga-Buddha
affirms the traditional Khmer intimacy with and dependence on
water and water-beings.

This was the final burst of Khmer conquest and building. Weakened by wars and massive construction programs, the empire declined. The Thais pressed down from the north and in 1431 captured Angkor itself. The capital was moved to Phnom Penh, where it has remained until our times. Theravada (or Hinayana) Buddhism, radiating from Ceylon, became the dominant religion, of the people as well as the court. A remarkable period of sculptural development, spanning about seven centuries, was at an end.

A SIAMESE BUDDHA

Theravada Buddhism is now the prevailing form of the faith in Ceylon, Burma, Thailand, Cambodia, and Vietnam. "The Doctrine of the Teachers" accommodates two broad schools of thought: "rationalists" who regard Buddha's teachings as the basis of a philosophy that can explain the phenomena of the world and as a moral code based on compassion and self-discipline, without reference to a superior being; and "pietists" who regard Buddha as a supreme god, responsive to prayer, and who believe that acts of merit can save the individual. In this stricter doctrine there is no room for the variety of Buddhist deities and semideities, or the experimentation with new forms of depicting them, that we have found in China, Japan, Java, and Cambodia. Bodhisattvas are largely an outgrowth of Mahayana Buddhism.

Theravada conservatism, combined with a touch of superstition, has attached great importance to copying the Buddha image in "authentic" form. That form might vary considerably from place to place, but within a royal or regional boundary one particular archetype was likely to be recognized as *the* proper way to depict the Buddha. The ideal type could change gradually, as it was interpreted by individual artisans, or a different form imported from elsewhere might be adopted if the newcomer had a reputation for special sanctity and magical powers. We have al-

ready noted the travels of the Udayana Buddha and the importance the pious attached to copies that reproduced it as closely as possible.

We will often see one such archetype, or variations on it, in museums. It evolved in the Thai kingdom of Sukhothai (or Sukhodaya) in the Menam Valley, north of present-day Bangkok. The state was established when Thai chieftains drove out the Khmers in the thirteenth century. A distinctive Sukhothai style of Buddha figure developed. When seated, the Buddha is generally in the modified posture of meditation (the "half-lotus," with one leg folded over the other, without being intertwined), with one arm and hand in the earth-touching gesture. The body is slim, the right shoulder bare, and the robe scarcely suggested by a strap in shallow relief over the left shoulder.

The Sukhothai face holds the greatest interest. Eyebrows are high and arched and the nose is long, thin, and slightly hooked. The hair is in tight coils with an elongated tapering *ushnisha,* which in later times often ends in a flamelike spike. The hairline typically curves downward slightly at the middle, sometimes becoming a well-defined widow's peak. A viewer's general impression is one of elegance and self-containment approaching hauteur.

As the kingdom grew, and the center of gravity shifted northward or southward, and generations of craftsmen tried their hands at reproducing it, the type became modified in various ways. But it is readily recognized in any museum that has a significant collection of Thai sculpture. Our example is from the Musée Guimet [187]. There are other Thai formulas for depicting the Buddha's head, adapted from models from Ceylon. The Sukhothai is the most distinctive.

10

Summing Up

STARFISH ON A ROCK

C OMPARISONS between two traditions in art can be absorbing and enlightening, but are often misleading. East and West had some definite links. The most notable mentioned in these pages are those in the obscure Kushan kingdom of Gandhara early in the Christian era. Common roots reach into other lands and more remote times. We tend, however, to look for causal connections where there are none, or where surmise based on stylistic resemblance is not yet supported by archaeology or history.

Like a starfish on a wet rock, tradition moves almost imperceptibly. An hour, or a century, later it has somehow got from this side to that. It is an essential method of art history to detect and trace the slight movements. Slow developments in style, within a tradition or within a single artist's work, are among the most reliable means of assigning an approximate date and place to the creation of a work of art. But when the method is applied across cultural lines, to deduce that a certain posture found, say,

in India, must have come from Greece, where it appeared earlier, it is permissible to be wary.

A Greek conquest far more lasting and influential than Alexander the Great's, according to one eminent Western art historian, was in the form of the *kouros* [3, 4] who "reappears" as the serene and frontal standing Buddha in Asia [108, 111]. Again, it has been suggested that Polyclitus, inventor of the *hanché* posture in Greece [17], must also be responsible, however unwittingly, for the sinuous shapes of early Indian *yakshis* [99, 100]. The basic frontal standing posture is so natural, almost inevitable, that it has been a starting point in most sculptural traditions, including some, like the Egyptian, not considered in these pages. It is also technically one of the easiest to reproduce. As for the out-thrust hip over a weight-supporting leg, look at any group of people who are waiting for a plane or train, or standing for a considerable time for any reason. Some will stand with weight equally distributed; many will be in an *hanché* posture. To suggest that the Greeks alone learned to reproduce so basic a pose invites skepticism. Art historians of the Indian persuasion might point out that the *hanché* attitude turned up in the Indus Valley, in tiny figurines [94, 95] some two millennia before Polyclitus. But again, any suggestion that these set a pattern for the whole Eurasian continent, or even for the much later *yakshis* in India itself at the beginning of the Christian era, should send us to the archaeologists for more convincing proofs.

To speak of "Greco-Buddhist" art in Japan, as was once the fashion, is to exaggerate the influence of a provincial and fading Hellenism on a culture that developed in its own distinctive way. It is also to ignore the continuing controversy over the true origins of the Buddha image, involving difficult judgments as to the contending claims of the Indian and Greco-Roman styles developed during the Kushan dynasty, and their respective antecedents.

SEPARATE TRADITIONS

Each of the two traditions that we have looked at in these pages evolved separately, by and large. The Western tradition has been more of a unity than the Eastern. Time and again it has returned to its Greek beginnings. From the Renaissance until the twentieth century Greek models were held up as the ideal, and even the Medieval variant borrowed heavily from them, drastically modified by the rejection of nudity. Different stages of the Greek development have enjoyed favor from time to time, among later sculptors and arbiters of taste. At one time prevailing standards favor the blocklike simplicity and directness of the Archaic, at another the restrained clarity and idealized humanity of the Classical, and at still another the naturalism and movement of the Hellenistic. The grip of Greece on the Western mind remained firm until recent times, and is by no means wholly loosened today.

The Eastern tradition, starting from Indian roots, grew luxuriantly into many branches. There was not the same recurring return to sources. New Indian inventions in sculpture spread along with Buddhism (and, in southeast Asia, with Hinduism) so that we find in Tang China echoes of Gupta India, and in Japan's earlier sculptural days there is a close adherence to Chinese models. But each separate culture struck off on its own. Michelangelo at the end of the fifteenth century and Canova at the end of the eighteenth could and did carve marbles that were mistaken for the work of ancient Greek sculptors. A Sung Bodhisattva is unmistakably Chinese, a Fujiwara Buddha Japanese, and an Angkor Naga-Buddha Cambodian. Some of the Buddhist figures in south and southeast Asia and the Himalayan kingdoms are more confusing, with differences perceptible only to a highly trained eye. By and large, however, sculpture quickly took on distinctive styles in each Asian region.

Apart from Buddhism there was not in Asia the unifying influence that Greek thought, then the Roman empire, and then Christianity, provided in Europe. And there were sharper ethnic and cultural differences in the East than in the West. China was the seat of a culture as old as (and, of course, in Chinese eyes, vastly superior to) the Indian. Even today it is not hard to find Confucians who deplore the centuries-long "Indianization" of China through Buddhism as an unfortunate, un-Chinese interlude.

MYSTIQUE OF NUMBERS

Both East and West, we are told, have been fascinated with the relationship of sculpture to numbers. Harmonious art, the Greeks thought, must somehow be related to the harmonies of the natural order, mathematically expressed. The perfect statue must depend on the right proportions. Rules were developed for the measurement of various parts of a figure in relation to each other —canons of perfection. Polyclitus, it is known, composed a detailed canon. About all that survives of it is the rule that the total length of a human figure should be seven times the length of the head. A later Lysippan canon prescribed a more slender, smaller-headed figure.

Hindu rules of iconography became extremely detailed. A certain god or goddess, in addition to having individual attributes or symbols (such as Shiva's trident and Vishnu's disc) and the appropriate vehicle (Shiva's bull, Durga's lion, Vishnu's eagle), must meet certain specifications of measurement. One god should be 124 *angulas,* or fingers, high, another 120. The body below the face should be nine times the length of the face, and so on.

We may wonder whether such rules, Greek or Indian, were not primarily convenient guides provided by one acknowledged master or sage for craftsmen and artists of lesser talent or status. And, of course, in a slow-changing tradition, adherence to ap-

proved forms would be expected, even required. The traditional artisan was not supposed to indulge in novel experiments of his own. Some Renaissance artists, who had more freedom to make innovations, struggled to find mathematical expression for the perfect figure, without much success. The surviving drawings made to fit some supposedly "correct" mathematical formula are often grotesque. Michelangelo, the master carver, and Rodin, the master molder, both emphasized the importance of basic geometric forms but scorned working by mathematical rote. The artist should rely, said the Renaissance master, on "the compass in his eyes and not in his hands." "I perfect my work by eye rather than calipers," said Rodin. Both boldly distorted their figures.

The large, blocklike heads seen in early Chinese Buddhist figures, and again in early Japanese works, were presumably meant to emphasize the importance of the mind at the expense of the body [139, 140, 157]. The line between intended distortion and poor craftsmanship is not easy to draw. Elongated figures like those in the portal carvings at Chartres [48, 49], a stele from the Northern Wei dynasty [140], or the *Kudara Kannon* in Nara [155], please most viewers, for reasons we would find hard to articulate. The large head of Michelangelo's *David* [66] seems fitting in this statue of an adolescent, while a pin-headed Roman emperor [37] and top-heavy *Heracles* by the first Pisano [53] leave us feeling that the craftsman did not see straight or had limited skill.

As for basic geometric forms, in the parts of a human body or in the composition of the whole sculpture, the two traditions were not far apart. The pyramid and cone perhaps came even more naturally to the East than to the West. People have habitually squatted or sat cross-legged on the ground, creating a natural pyramid. The lotus position is the posture of the yogi and the Buddha. And the standing human body, wherever it is, is a natural cylinder, and composed of volumes that can be identified as cylinders, spheres, and ovoids.

In the possibility of reducing an Indian figure to such basic forms modern critics have found much of the appeal of Indian sculpture. It is by no means clear that Indian craftsmen or their Brahmin guides themselves regarded plastic art in terms of solid geometry. What is abundantly clear is that other ideas were associated with the formal structure—the breath control of the yogi, the prosperity of the well-rounded belly, the patterns of limbs and other volumes based on forms observed in nature and daily life (the flaring torso of a lion, for example, or an elephant trunk for shoulder and arm, or a bowl for a breast), and the bodies of divine beings as condensations from the pervading ether. The image of a god must be so shaped that it will attract the god to dwell within it, and the prescriptions for such shapes are to be found in the accretions of tradition that do not, it seems, refer to geometry.

Anyone searching for geometric forms in sculpture should include the ogive, or pointed part-ellipse. It is familiar in the West from Gothic and Islamic architecture. In the East it is rich in connotations—the leaf of the pipal tree under which the Buddha found enlightenment, the petals of a lotus, a flame, and the hooded head of a cobra or *naga,* the snake god [115, 138, 157, 158, 184]. The ogival form is found wherever Buddhism and Hinduism reached, most notably in the aureoles, or nimbuses, of Buddhist figures and, more as decorative detail, in the lotus thrones.

In one respect, of course, geometry is at the heart of sculpture. It is three-dimensional form, differing radically from painting, drawing, etching, and shallow reliefs. We perceive it visually and tactually as something occupying and defining space. However scrupulously we obey the museum signs, we do touch statues, mentally, and their surface qualities are one source of our enjoyment. Even in a Western statue meant to be seen from one point of view, or an Indian figure attached to its background by thick

unmodeled connective tissue, we are acutely aware of depth as well as height and width.

There is a specialized lexicon of ideas, evolved largely in this century, that helps to identify the formal properties of sculpture more precisely and to sharpen the observer's sensibility. Familiarity with that vocabulary is essential for an appreciation of much of twentieth-century sculpture. It is probably less necessary for enjoyment of sculptors working within the traditions we have been considering. If such concepts guided their creative work (as they certainly guide many modern sculptors) they did so subconsciously. Traditional ideas of form were, it seems, more simple—more simple-minded, if you like.

THE HUMAN BODY

Sculptors' interests, East and West, insistently and for obvious reasons have centered traditionally on the human body. It is a flexible formal structure and an infinitely adaptable vessel for prevailing truths and mores and for an individual artist's personal view of his world and art. Whether creating God in man's image, a hero or sage, or a more ordinary mortal, a sculptor must decide whether to clothe it or not, whether to copy nature as closely as possible or to modify and simplify visible forms, whether to emphasize the sensual or spiritual side of living man or, what is more difficult, to attempt the blend that is more true to his nature.

For traditional sculptors the answers to such questions were provided by the tradition in which they worked. Even the innovative artists of later Greece and the Renaissance, enjoying relative freedom as to form and theme, did not depart radically from long-accepted ideas. Basic change came only in the twentieth century, in conscious challenge to the traditions.

From time to time in these pages we have noted how atti-

tudes in the West shifted on so central an idea as nudity. Sculpture donned and doffed its garments as prevailing ideas changed. The early Greeks and some of the Renaissance masters, notably Michelangelo, portrayed the nude proudly, reverently, and enthusiastically, affirming the whole man's self-knowledge and self-reliance but also his limitations. In other times—Hellenistic and Roman, and again after the Renaissance—the erotic element, never absent where the human nude is concerned, became more prominent. By the nineteenth century nudity in sculpture had a certain air of naughtiness, permitted because of its ancient and therefore respectable antecedents, and because it was "art," which was not supposed to have much to do with life and human behavior.

In the East there were fewer oscillations. In India the nude (or, more usually, the nearly-nude) was early established as a traditional way of presenting the human figure, whether as a god, celestial spirit, or mortal, in conventional partly naturalistic forms. Similar attitudes and conventions prevailed in southeast Asia. China and Japan, on the contrary, shunned the nude. It is tempting to think that the difference is accounted for by the marked contrasts in climate or physical endowment. But there seem to be, as we have noted, deeper Confucian reasons why the Chinese publicly negated the body as insistently as the Greeks and Indians affirmed it.

A few Chinese nudes survive in the form of ceramic tomb figurines of Han times (the first or second centuries B.C.). The Nelson Gallery in Kansas City and the Metropolitan in New York each have one example of a male. A recently discovered gilt bronze figure of a woman holding a lamp, also early Han, although heavily clothed, reveals the curve of her breasts. The rarity of examples of any interest in the human form is eloquent. One scholar of Chinese art to whom I talked while writing this book suggested that the Western interest in the human body was aberrant, traceable to the happenstance of early Greek nudity in

athletic games. Michelangelo and Rodin presumably would not
agree.

Where Mahayana Buddhism was the stimulus—indeed, the
very reason—for monumental sculpture, as in China and Japan, a
hierarchy of deities and semidivine beings, set off from ordinary
humanity, provided the almost invariable themes. The historic
Buddha himself (or another manifestation of essential Buddha-na-
ture, such as Amida) appears in limited iconographic forms,
seated with legs crossed or standing with his weight equally distri-
buted on both feet, in contemplation and serenity. The Bodhis-
attvas, capable of enlightenment but choosing to remain in the
world of men and women, are somewhat closer to humankind and
afford opportunities for variety in posture, dress, and decoration.
Semidivine guardian figures, warding off evil, were permitted a
naturalistic expressiveness, especially fearsomeness, not appropri-
ate for those higher on the scale. Only in them, in China and
Japan, do we find a naturalistic seminudity. Lohans and arhats,
monk-sages and great teachers, possibly on their way to becoming
Bodhisattvas, were sometimes portrayed, as we have seen, with in-
tensely naturalistic faces [154, 163].

ENJOYMENT OF SCULPTURE

Zuleika Dobson, according to her creator, was one of those
who say, "I don't know anything about music really, but I know
what I like." Then there was the man who said of art, "I don't
know what I like, but I know what is good"—instructed, presum-
ably, by the prices at auction houses and critical writing. We
might envy them their certainty, yet very well know there is no
facile answer to the question, "Why and how do we enjoy sculp-
ture?" If, contrary to the old Latin saw, tastes *can* be argued about,
then there must be some common ground of shared values on
which the arguers can meet, some objective standards that we can

apply to a form of human experience that is notoriously subjective.

There has been no lack of efforts to articulate principles of artistic judgment. The literature has burgeoned since the eighteenth century, when the word "aesthetic" came into use and thinkers first seriously and analytically tried to answer the question, "What is beautiful?" (or, "What *ought* to be considered beautiful?"). For a long time, beginning with the Renaissance, Western theorizers had what seemed a solid answer: look to the Greeks, at one stage or another of their sculptural development, for the combination of idealization, harmony, and proportion that first and for all time achieved perfect beauty. The standard lingered on in the academies through the nineteenth century.

Attempts to isolate and articulate *the* aesthetic quality—the one distinctive form of perception or feeling or knowledge that sets the aesthetic experience off from all others people can have —are not satisfying to most of us. We suspect that there is no single answer, and that sculpture (at least in its traditional forms) can be enjoyed at many levels, involving our perceptive apparatus, our emotions, and our capacity to know and understand.

Certainly the perception of three-dimensional form, touched on above, is one of these levels, setting off sculpture from two-dimensional forms of art. There are other important modes of enjoyment and appreciation. We feel, for example, what might be called an uninformed, or primary, emotional reaction. Without knowing much if anything about Buddhism we feel something of the serenity and inner peace that an image of the Buddha was meant to instill in us. We have a little shock of horror tinged with sympathy on seeing Donatello's *Magdalen* [59] or an Indian modeler's emaciated lady saint [119]. We feel the strength and imperiousness in a Kushan king [102], or the bronze *Poseidon* brought up from the sea off Greece [12], or Michelangelo's *David* [66]. We are likely to feel a little erotic warmth (but seldom, surely, definite arousal) at the sight of a well-made body in

stone or bronze, whether it is only suggested in a basic form or skillfully mimics nature. A non-Christian wholly unacquainted with scripture shares a bit in the Madonna's grief at the sight of a *Pietá* [47, 72].

In short, traditional three-dimensional forms set certain emotional strings to vibrating. Some modern theorists of art identify this phenomenon as the distinctive quality of aesthetic experience. Indian philosophers long ago elaborated the theory with their usual zeal for detailed classification, finding at least eight kinds of gentle emotional vibrations, called *rasas,* or savorings. These are not emotions that lead the viewer to action but are, as it were, disinterested traces of emotion and shadings of mood, felt by anyone who happens to encounter the work of art, whether or not he is aware of the intellectual and cultural context in which it was made. The artist has succeeded if his Zeus of gold and ivory, reflected in its pool of olive oil, inspires awe and impresses you with the might and mystery of the gods. You are not expected to faint from dread and fear. Pygmalion, falling in love with his own carving of Galatea, exceeded the proper bounds of artistry in this view. And the admirer of the Cnidian *Aphrodite* [22], who hid in her shrine and embraced her (leaving, according to Pliny, "a trace of his lust" on her marble body), was behaving unaesthetically.

At an intellectual level we enjoy knowing the ideas that lie behind a particular tradition or individual piece of sculpture. For a very long time, before Western man tried to isolate the "aesthetic" quality or even thought of "fine arts" as something outside the main stream of daily life, sculpture was meant to instruct, edify, encourage compliance with norms of behavior, stir remembrance of family and heroes, and serve a multitude of such practical purposes. We enjoy traditional sculpture more if we know what purposes its makers had in mind, growing out of the context in which they lived or some private vision of truth. Knowing something of this background we find that our emo-

tional reactions (of the uninformed or primary kind) are strengthened or altered. The Shaivite lady saint or goddess [119] has a different impact when we know her story and the Hindu view of cosmic duality that she is acting out. A splendid Sung Kuan-yin, seated in an attitude of royal ease [152], stirs different feelings after we know a bit of the role of the Bodhisattva and the history of Buddhism in China.

Standards of aesthetic judgment change and elude the most painstaking efforts of analysis. Of such judgment Rodin said, "It is even difficult to talk about it." The one thing we can be sure of is that the latest standards are not the last.

Further Reading

THE reader who wants to explore more deeply the sculpture of particular regions or periods will find the following books helpful. A few titles relating to each chapter are noted. Some, indicated by an asterisk, are available in paperback form.

CHAPTER I
THE GREEK ACHIEVEMENT

Bieber, M. *The Sculpture of the Hellenistic Age*. Rev. ed. New York, 1961.

* Boardman, J. *Greek Art*. New York, 1964.

* Carpenter, R. *Greek Sculpture*. Chicago, 1960.

Hanfmann, G. M. A. *Classical Sculpture*. London, 1967.

Lawrence, A. W. *Later Greek Sculpture*. London, 1927.

Lullies, R., and M. Hirmer. *Greek Sculpture*. Rev. ed. New York, 1957.

Richter, G. M. A. *The Sculpture and Sculptors of the Greeks*. Rev. ed. New Haven, 1950.

————. *Kouroi: Archaic Greek Youths*. 3d ed. New York and London, 1970.

CHAPTER II
ROME TO RENAISSANCE

* Beckwith, J. *Early Mediaeval Art*. New York, 1964.

————. *Early Christian and Byzantine Art*. Harmondsworth, 1970.

Hanfmann, G. M. A. *Classical Sculpture*. London, 1967.

Lowrie, W. *Art in the Early Church*. New York, 1947.

* Martindale, A. *Gothic Art.* New York and Washington, 1967.

* Molesworth, H. D. *European Sculpture from Romanesque to Neoclassic.* New York, 1965.

Porter, A. K. *Romanesque Sculpture of the Pilgrimage Roads.* Boston, 1923.

Salvini, R. *Mediaeval Sculpture.* Greenwich, Conn., 1969.

CHAPTER III
CITY OF DAVIDS

Avery, C. *Florentine Renaissance Sculpture.* London, 1970.

Hartt, F. *Michelangelo: the Complete Sculpture.* New York, 1968.

* Hibbard, H. *Bernini.* London, 1965.

Janson, H. W. *The Sculpture of Donatello.* Princeton, 1957.

Keutner, H. *Sculpture: Renaissance to Rococo.* Greenwich, Conn., 1969.

Pope-Hennessy, J. *Italian Renaissance Sculpture.* 2d ed. London and New York, 1971.

———. *Italian High Renaissance and Baroque Sculpture.* 2d ed. London and New York, 1970.

Seymour, C. *Sculpture in Italy: 1400–1500.* Harmondsworth, 1966.

———. *The Sculpture of Verrocchio.* Greenwich, Conn., 1971.

de Tolnay, C. *Michelangelo.* 5 vols. Princeton, 1947–60.

Wittkower, R. *Bernini.* 2d ed. London, 1966.

CHAPTER IV
ON TO RODIN

Bindman, D. *European Sculpture: Bernini to Rodin.* London and New York, 1970.

* Champigneulle, B. *Rodin.* New York, 1967.

* Elsen, A. *Rodin.* New York, 1963.

———. ed. *Auguste Rodin: Readings on His Life and Work.* Englewood, N.J., 1965.

* Jianou, I. *Rodin.* Paris, 1970.

Licht, F. *Sculpture: 19th and 20th Centuries.* London, 1967.

Post, C. R. *History of European and American Sculpture.* 2 vols. Cambridge, Mass., 1921.

CHAPTERS V AND VI
INDIA (BUDDHIST AND HINDU)

Banerjea, J. N. *The Development of Hindu Iconography.* Calcutta, 1956.

* Coomeraswamy, A. K. *History of Indian and Indonesian Art.* New York, 1965.

Marshall, Sir John. *The Buddhist Art of Gandhara*. Cambridge, England, 1960.

Mukherjee, R. *The Flowering of Indian Art*. London, 1964.

* Rawson, P. *Indian Sculpture*. New York, 1966.

Rosenfield, J. *Dynastic Art of the Kushans*. Berkeley, 1967.

Rowland, B. *The Art and Architecture of India*. 3d ed. Harmondsworth, 1967.

Zimmer, H. *The Art of Indian Asia*. Edited by Joseph Campbell. 2 vols. 2d ed. New York, 1960.

CHAPTER VII
ALONG THE SILK ROAD

Sickman, L., and A. Soper. *Art and Architecture in China*. 3d ed. Harmondsworth, 1968.

Siren, O. *Chinese Sculpture*. 4 vols. London, 1925.

* Sullivan, M. A. *A Short History of Chinese Art*. Berkeley and Los Angeles, 1970.

Swann, P. *Chinese Monumental Art*. New York, 1963.

* Willetts, W. *Chinese Art*. 2 vols. London, 1958. (Revised and abridged as *Foundations of Chinese Art*, New York, 1965.)

CHAPTER VIII
IN THE SUNRISE COUNTRY

* Fenollosa, E. F. *Epochs of Chinese and Japanese Art*. 2 vols. New York, 1963.

Kidder, J. E. *Masterpieces of Japanese Sculpture*. Tokyo and Rutland, Vt., 1961.

Paine, R. T., and A. Soper. *The Art and Architecture of Japan*. Baltimore, 1955.

Rosenfield, J., and S. Shimada. *Traditions of Japanese Art*. Cambridge, Mass., 1970.

Seiroku, N. *The Arts of Japan*. Translated by J. Rosenfield. Tokyo, 1966.

Swann, P. C. *The Art of Japan*. New York, 1966.

CHAPTER IX
SOUTHEAST BY SEA

* Coomeraswamy, A. K. *History of Indian and Indonesian Art*. New York, 1965.

Giteau, M. *Khmer Sculpture and the Angkor Civilization*. New York, 1965.

Griswold, A. B. *Dated Buddha Images of Northern Siam*. Ascona, Switzerland, 1957.

Hall, D. G. E. *A History of South-East Asia*. New York, 1955.

Lee, S. E. *Ancient Cambodian Sculpture*. New York, 1969.

* Rawson, P. *The Art of Southeast Asia*. New York, 1967.

Salmony, A. *Sculpture in Siam*. London, 1925.

Zimmer, H. *The Art of Indian Asia*. Edited by Joseph Campbell. 2 vols. 2d ed. New York, 1960.

Glossary

When languages such as Chinese, Greek, Japanese, and Sanskrit are transliterated into Roman script, various spellings are possible and often encountered. In the text, and in this glossary, the only consistency attempted has been to spell the same romanized word always in the same way. If a spelling is widely used and can be readily recognized for the word intended, that has sufficed. Diacritical markings in Asian words have been omitted.

The following abbreviations are used to indicate languages other than English: Ch.=Chinese; Fr.=French; Gr.=Greek; It.=Italian; J.=Japanese; Lat.=Latin; and Skt.=Sanskrit.

ABHAYAMUDRA (Skt.)—Gesture of protection and reassurance (*abhaya*=have no fear); hand held out, palm forward, and fingers upward.

ADI (Skt.)—Beginning, primordial; as in *Adi-Buddha,* the all-pervading Being from which other manifestations of Buddha evolve.

AGNI (Skt.)—Vedic god of fire.

AHIMSA (Skt.)—Noninjury; central ethical principle of Jainism, which holds that believers should refrain from harming any living thing.

AIZEN-MYO-O (J.)—Form of Tantric divine being, holding the *vajra,* or thunderbolt, worshipped in esoteric Buddhist sects in Japan.

AMARAVATI (Skt.)—Site of a great Buddhist stupa in the first centuries B.C. and A.D., in Andhra Pradesh, south India.

AMATERASU (J.)—Sun goddess; highest deity in the Shinto pantheon, and regarded as the founder of the imperial family in Japan.

225

AMAZON (Gr.)—One of a legendary tribe of warlike women, thought by the ancient Greeks to dwell in a land to the north; depicted in sculpture in battles with Greeks as a symbol of barbarism opposed by civilization.

AMIDA (J.)—Japanese version of Amitabha.

AMITABHA (Skt.)—Buddha in the form of Lord of the Pure Land, or Western Paradise; a form of Buddha widely worshipped in China and Japan, whose followers came to believe they could win entrance to paradise by devoutly repeating his name. Called *Amida* in Japan, *O-mi-to* in China.

ANANTASAYANIN (Skt.)—Vishnu asleep on the cosmic snake of eternity (*ananta*), who lies in the cosmic ocean, before starting a new cycle of creation.

ANGKOR—Region in present-day Cambodia where Khmer kings, beginning in the ninth century A.D., established their temple-mountains and built extensive irrigation and drainage works. Angkor Wat, built in the first half of the twelfth century, is the largest of the temple-mountains.

ANJALIMUDRA (Skt.)—Gesture of prayer, adoration, or respect, with palms pressed together before the chest.

APHRODITE (Gr.)—Goddess of beauty and love, daughter of Zeus, wife of Hephaestus (Vulcan), the god of fire, and lover of Ares (Mars), the god of war; Venus in Latin.

APOLLO (Gr.)—God of the sun, music, and poetry; regarded by ancient Greeks as the archetype of youthful male beauty; consulted through oracles, especially at Delphi, for predictions of future events; son of Zeus and brother of Artemis (Diana).

APSARAS (Skt.)—Celestial dancing girl or female attendant of the gods, making sojourns in paradise a continual delight for worthy male spirits between incarnations.

ARCHAIC—used to describe any artistic tradition in the early stage of development; in the history of Greek art, designates the period from the late seventh century B.C. to the Persian Wars early in the fifth.

ARDHANARI (Skt.)—Half-woman; Shiva and his spouse, male and female principles, incorporated in one body, one half being a man, the other a woman.

ARHAT (Skt.)—Originally, one of the disciples of the historic Buddha; later, any of a larger number of holy men and sages struggling toward the state of Bodhisattva; *Lohan* in Chinese; *Rakan* in Japanese.

ARIADNE (Gr.)—Cretan princess, daughter of King Minos, who helped Theseus kill the Minotaur and fled with him from Crete; deserted by Theseus on the island of Naxos, she was discovered by the god Dionysos and they became lovers; often shown with the god on Roman sarcophagi, symbolizing the union of a mortal with a god.

ARJUNA (Skt.)—Semidivine hero of the ancient Indian epic *Mahabharata*.

ARTEMIS (Gr.)—Goddess of the moon and the chase; sister of Apollo; probably of Asian origins; famous for her readiness to punish mortals who did not show her proper respect, including Niobe; Diana in Latin.

ASANA (Skt.)—Posture of the body, important in Hindu and Buddhist iconography to identify a divine being. *See, e.g., padmasana* and *lalitasana.*

ASHURA (or ASURA) (Skt.)—Demon or antigod, who challenges the authority of the gods, often with great success; became in Japan a guardian figure helping to protect the Buddhist deities. *See also* Mahisha.

ATHENA (Gr.)—Goddess of wisdom, patron and protector of Athens, and daughter of Zeus, from whose head she was born full-grown and armed; the cult deity, as Athena Parthenos (Virgin), of the Parthenon in Athens, where a colossal image of gold and ivory by Phidias stood in the inner sanctum.

AVALOKITESHVARA (Skt.) (pronounced Av-a-low-kit-ESH-vara)—One of the principal Bodhisattvas, *q.v.;* Lord of Compassion, who evolved into Kuan-yin in China (Kannon in Japan); usually wears a small Buddha, seated in meditation, in his headdress, and often holds a lotus or long-necked flask.

AVATAR (Skt.)—Incarnation or corporeal manifestation of a god, especially of Vishnu (*q.v.*).

BARBARIAN—To the Chinese, any non-Chinese; to the ancient Greeks and Hellenes, any non-Greek or non-Hellene; to the Romans, any non-Roman, especially a member of the tribes on the northern and eastern marches of the Empire.

BAROQUE (Fr.)—A term referring to late Renaissance artistic style marked by exaggerated expressiveness, emotionalism, and rich decoration; sometimes called "the art of the Counter-Reformation"; apparently originated from a Portuguese word (*barroco*) meaning an imperfectly shaped pearl.

BACCHUS (Gr.)—Another name for Dionysos (*q.v.*), god of fertility and wine.

BHAKTI (Skt.)—Worship marked by direct and intense personal devotion to a god, as distinct from rituals, magic, and rites performed by priestly intermediaries.

BHOGA (Skt.)—Worship through acceptance of the material manifestations of being, perceptible to the senses, as a form of reality; distinct from rejection of material phenomena as illusory, renunciation of the world, and withdrawal into contemplation in yoga (*q.v.*).

BHUMISPARSAMUDRA (Skt.)—Earth-touching gesture of the historic Buddha, calling the earth to witness his readiness for final Enlightenment.

BISHAMON-TEN (J.)—Chief of the Four Deva Kings, guardians of the four cardinal points of the compass and protectors of the Buddha; identified with Kubera, Indian god of wealth and king of the *yakshas.*

BODHISATTVAS (Skt.)—Divine beings, part way between mortals and Bud-

dhas, who, though able to achieve final Enlightenment and pass into nir-
vana, choose to remain on earth and help suffering mankind; important as
cult deities in Mahayana Buddhism, especially in China and Japan.

BOSATSU (J.)—Bodhisattva.

Bo-tree—Shortened form of *bodhi* (Enlightenment) tree under which the
historic Buddha, Siddhartha Gautama Sakyamuni, achieved Buddhahood; a
giant tree of the fig family.

BRAHMA (Skt.)—One of the three chief Hindu gods, along with Shiva and
Vishnu; the god of creation; represented in sculpture with four faces.

BRAHMINS (Skt.)—Members of the highest of the four castes in Hinduism;
priests, learned men, and teachers whose functions are to officiate at holy
rites, interpret sacred texts, and advise other castes on the law governing
their conduct. Brahminism refers to the system of religious beliefs, philo-
sophical speculation, forms of worship, rules of caste conduct, and social
organization commonly called Hinduism in the West.

BUTSU (J.)—Buddha.

CENTAUR (Gr.)—Mythological creature with the head and upper body of a
human being joined to the body of a horse. Symbols of barbarism, cen-
taurs are often shown in sculpture in combat with the Lapiths, a peaceful
people whose hospitality the men-horses abused by trying to carry off their
women and children.

CHAN (Ch.)—From the Sanskrit *dhyana,* or meditation; name of a Buddhist
sect emphasizing the importance of direct, personal perception of ultimate
truth. *Zen* in Japan.

CHENLA (Ch.)—Name of a kingdom, in what is now Cambodia, that suc-
ceeded Funan and preceded the Angkor kingdoms; first king began rule c.
A.D. 550.

CLASSICAL PERIOD—With reference to ancient Greece, a term applied to the
period from the Persian Wars early in the fifth century B.C. to the begin-
ning of Alexander the Great's rule in 336 B.C.

CONTRAPPOSTO (It.)—Placed in opposition; posture of the human figure in
which the turning of the body on its axis places hips, shoulders, and head
in different directions.

COUNCIL OF NICAEA—Second Council, of A.D. 787, which decided that it was
proper to venerate, but not worship, images, and ordered them restored in
churches.

COUNCIL OF TRENT—Nineteenth Ecumenical Council, 1545–63, convened to
deal with the Protestant movement.

DAPHNE (Gr.)—Nymph loved and pursued by Apollo; rescued by the gods,
who transformed her into a laurel tree.

DEVA (Skt.)—A god in Hinduism.

DEVI (Skt.)—Feminine form of *deva;* a goddess, especially the Great Goddess, spouse of Shiva.

DHARMA (Skt.)—The Law, or rules of right conduct; in Hinduism, varies according to the caste of the individual; in Buddhism, the Law of the Four Noble Truths and Noble Eightfold Path.

DHARMACHAKRA (Skt.)—The Wheel of Law (*q.v.*).

DHOTI (Skt.)—Lower garment worn by men in much of India; a long cloth wrapped around the waist and brought up between the legs to form a loose-fitting loin-cloth.

DHYANA (Skt.)—Meditation or contemplation; in *dhyanasana,* the seated posture of meditation, the legs are crossed and each foot rests on the opposite thigh (the lotus position); became *Chan* in China and *Zen* in Japan, describing meditative sects of Buddhist.

DIANA (Lat.)—Roman goddess of the chase, more or less equivalent to the Greek Artemis.

DIONYSOS (Gr.)—God of wine and fertility, but also a suffering god, focus of the mystical strain in Greek religion; his devotees gave themselves up to ecstatic, often orgiastic, personal adoration; lover of Ariadne, with whom he is often depicted on Roman sarcophagi.

DRAVIDIANS—The indigenous people of India, displaced by or mingled with the incoming Aryans; now often used to refer to the people of southern India, where separatist Dravidian movements for local autonomy or nationhood have developed.

DURGA (Skt.)—One of the names of the spouse of Shiva; often portrayed in sculpture as the Great Goddess who, alone among the Hindu deities, could overcome the buffalo-demon Mahisha.

ENDYMION (Gr.)—Shepherd youth beloved by the moon goddess Selene (Diana), who put him into an everlasting sleep so that she might enjoy looking at his beauty. Their story was a favorite theme of Roman sarcophagi.

FIGURA SERPENTINATA (It.)—A serpentine, flamelike, basically conical form of composition favored by Michelangelo and later sculptors.

Fo (Ch.)—Buddhism.

FUJIWARA (J.)—Powerful family who became effective rulers of Japan in ninth century A.D., governing through ties with the imperial family and high positions at court.

FUNAN (Ch.)—Early Indianized kingdom stretching along the coast of the Gulf of Siam from the Mekong delta to Burma; precursor of Khmer empire; founded, according to legend, by a Brahmin married to the daughter

of a local Naga or snake-deity; known to exist as early as the third century A.D.

GANDHARA (Skt.)—District in mountainous region of present-day Pakistan and Afghanistan; one of the centers of the Kushan empire, beginning c. first century A.D., with capital at Purushapura (modern Peshawar); known for its distinctive blend of Greco-Roman and Indian sculptural styles.

GANDHARVA (Skt.)—Male celestial being or spirit, enjoying rewards in paradise (and the favors of *apsarases*) during the intervals between earthly incarnations.

GANESH (Skt.)—Hindu god of obstacles and success; elephant-headed son of Shiva and Parvati; as Ganapati, leader of Shiva's spirit-army.

GARBHAGRAHA (Skt.)—Womb-chamber; the inner scanctum of a Hindu temple and dwelling place of its chief god.

GAUTAMA (Skt.)—Family name of the historic Buddha, Siddhartha Gautama Sakyamuni, c. 560–480 B.C.

GHIBELLINES—One of the two main parties in mediaeval politics in Italy; supporters of the emperors in their long struggle with the popes (whose adherents were known as Guelphs).

GOPIS (Skt.)—Girl cow-herds or milkmaids; playmates and bedmates of the god Vishnu in his incarnation as Krishna.

GOPURA (Skt.)—Distinctive form of temple gate-tower, at each of two or four main entrances, in south India; usually highly decorated with sculpture.

GOVARDHANA (Skt.)—Welfare of Cows; the name of the mountain which Vishnu, in the form of Krishna, held over his worshippers to protect them from the wrath of Indra.

GUELPHS—*See* Ghibellines.

HACHIMAN (J.)—Shinto god of war in Japan.

HAN (Ch.)—Dynasty ruling China from 208 B.C. to A.D. 220; the first to unite north and south China and to expand westward and southward.

HANCHEMENT (Fr.)—Standing posture in which the hip (*hanche*) is thrust out on the side supporting the weight; known in Sanskrit as *tribangha* (three-bend).

HARIHARA (Skt.)—Combined form of Vishnu and Shiva, each being half of one figure.

HEIAN-KYO (J.)—"Capital of Peace and Tranquillity," which later became known as Kyoto; capital of Japan from A.D. 794.

HELLENISTIC—Term denoting the world and civilization, bordering the Mediterranean and in Asia Minor, influenced by Greek culture, beginning in the fourth century B.C. after the conquests of Alexander the Great.

HERACLES (Gr.)—The most popular legendary hero and demigod among the

Greeks and Romans; regarded as the epitome of strength and valor; son of Zeus by Alcmene, Queen of Thebes. Hercules in Latin.

HINAYANA (Skt.)—Lesser Vehicle; often used to denote the Theravada (*q.v.*) branch of Buddhism, as distinct from Mahayana (Greater Vehicle) (*q.v.*) Buddhism.

HINDUISM—A Western term for the religious faith, philosophy, and social organization of most Indians, beginning with Aryan dominance in north India; based on the teaching and authority of Brahmins as the highest, priestly caste.

HORYUJI (J.)—Temple of the Flourishing Law; first great Buddhist temple in Japan, built in Nara in the seventh century, and rebuilt after the civil war of 1180–85.

HSUAN-TSANG (Ch.)—Seventh-century Chinese Buddhist pilgrim to India, who helped to establish the strong influence of Buddhism in China in Tang times.

HUMANISM—Generally, a system of thought emphasizing the capabilities and achievements of humankind, more or less able to control its own destinies without reference to superhuman powers; in the Renaissance and later, applied particularly to those interested in the revival of ancient Greek philosophy and culture.

ICONOGRAPHY—The study of distinguishing signs (*e.g.*, postures, gestures, mode of dress, accompanying figures, and symbolic paraphernalia) of images, especially of sacred or divine figures.

ILISSOS (Gr.)—A river in Athens, flowing from Mt. Hymettos.

INDRA (Skt.)—Vedic god of rain, and chief of the gods, later subordinated to the triad of Brahma, Shiva, and Vishnu.

INDRANI (Skt.)—Spouse of Indra.

JAINISM—A religion of India originating, like Buddhism, as a protest against Vedic forms of Hinduism in the sixth century B.C. Its central ethical principle is *ahimsa,* noninjury to all living beings.

JI (J.)—Temple.

JODO (J.)—Pure Land; any of the Buddhist paradises; applied especially to the school of Buddhism in Japan teaching that personal salvation and entrance to the Western Paradise are accessible to all who sincerely worship Buddha in the form of Amida.

JOSEPH OF ARIMATHEA—Disciple of Jesus who asked Pontius Pilate for the body of Christ, prepared it for burial, and "laid it in his own new tomb."

KAMAKURA (J.)—City on the Izu Peninsula southwest of Tokyo that became *de facto* capital of Japan late in the twelfth century under the shogunate of the Minamoto family.

KANISHKA (Skt.)—Most important emperor of the Kushan dynasty, which ruled northwest India from the first century A.D. until the fourth; his personal dates are uncertain, but probably he ruled in the first century A.D.

KANNON (or KWANNON) (J.)—The Japanese name for Avalokiteshvara, or Kuan-yin, appearing in thirty-three guises to perform his or her mission of salvation; the most widely worshipped Bodhisattva in Japan.

KARTTIKEYA (Skt.)—Hindu god of war; son of Shiva and Parvati; also known as Skanda and (in south India) Subramania, among other names.

KAULA (Skt.)—One of several Tantric sects of Hinduism, teaching salvation through disciplined enjoyment of worldly pleasure, including sexual union; apparently flourished around Khajaraho c. 1000.

KHMERS—People of southeast Asia who established an empire in territory roughly corresponding to present-day Cambodia and Laos, beginning c. sixth century A.D.; flourished with their capital in the Angkor region from c. 800 to the thirteenth century.

KOFUKUJI (J.)—Buddhist temple in Nara, begun in the eighth century A.D.; the major shrine of the Fujiwara clan; restored after destruction in the civil war of 1180–85.

KONDO (J.)—Golden Hall; usually the central shrine of early Buddhist temple compounds in Japan, housing the most sacred images.

KONGO (J.)—Japanese equivalent of the Sanskrit *vajra* (thunderbolt, diamond, or penis), used especially in esoteric Buddhist sects evolving from Indian Tantrism.

KORE (pl. KORAI) (Gr.)—Maiden or young woman; dominant female theme in Archaic Greek sculpture of sixth century B.C., used in votive or memorial images.

KOUROS (pl. KOUROI) (Gr.)—Young man, sometimes identified with Apollo; usual male figure in Archaic Greek sculpture of sixth century B.C.

KRISHNA (Skt.)—An avatar, or incarnation, of Vishnu, one of the Hindu triad of great gods; known as the god of love and famous for his amorous exploits, especially his love of Rhada.

KSHATRIYA (Skt.)—Name of the warrior and princely caste, second in the Hindu hierarchy to the priestly caste of Brahmins.

KSHITIGARBHA (Skt.)—Hindu god of the underworld; worshipped in China as *Ti-tsang*, in Japan as *Jizo*.

KUAN-YIN (Ch.)—Chinese name for Avalokiteshvara, the Bodhisattva worshipped as the Lord of Compassion; popularly translated as the Goddess of Mercy; ambivalent in gender and capable of assuming more than thirty guises.

KUBERA (Skt.)—Hindu god of minerals and wealth; king of the *yakshas;* Guardian of the North Quarter.

KUDARA (J.)—Japanese name for the Korean kingdom of Paekche, in the southwest of the peninsula, about the first seven centuries A.D.

KUSHAN (Skt.)—Dynasty established by the invading tribe of Yueh-Chih in northwest India beginning about the first century A.D.; famous in sculpture for the styles of Buddhist art produced in its two centers at Gandhara and Mathura.

KYOTO (J.)—Capital of Japan (first known as Heian-Kyo) beginning in A.D. 794; remained seat of imperial court after the effective center of government was moved by the shoguns to Kamakura at the end of the twelfth century.

LALITASANA (Skt.)—Seated attitude of ease; a posture of Hindu and Buddhist deities, with one leg hanging down and the other supported on the opposite knee.

LAPITHS (Gr.)—A legendary people supposed to live in Thessaly, mainly known through their battle with the centaurs (*q.v.*), which was often depicted in Greek sculpture as a symbolic struggle between civilization and barbarism.

LINGAM (Skt.)—Phallus; the symbol of Shiva, often placed in the inner shrine of Shaivite temples as a representation of the god, and worn as an amulet by some worshippers.

LOHAN (Ch.)—Originally, one of the disciples of the historic Buddha; later and more broadly, a hermit or sage on the way to becoming a Bodhisattva, especially revered for his saintliness.

LUNG-MEN CAVES (Ch.)—Buddhist cave-temples near Lo-yang, Chinese capital on Yellow River; built mainly in Tang dynasty, beginning in seventh century A.D.

MAHAPURUSHA (Skt.)—Great Man; a superhuman, recognizable by certain physical marks, who is destined to become a great ruler or religious leader; *e.g.,* the historic Buddha.

MAHAYANA (Skt.)—Greater Vehicle; the branch of Buddhism that elaborated the doctrine of Bodhisattvas and salvation through faith, without the need of scholarly learning and monastic withdrawal from the world, as distinct from Theravada, or Hinayana (Lesser Vehicle), Buddhism; long the dominant form of Buddhism in China, Korea, and Japan.

MAHISHA (Skt.)—The buffalo-headed titan-demon who won control of the universe until defeated by the Great Goddess Durga, in a battle often depicted in Hindu sculpture.

MAITHUNA (Skt.)—Union, usually sexual union; a loving couple.

MAITREYA (Skt.)—The Buddha-to-Come; the future Buddha who awaits incarnation in a later world cycle; sometimes portrayed as a Bodhisattva.

MANJUSHRI (Skt.)—A Bodhisattva who is the Lord of Wisdom.

MARA (Skt.)—Satan; the demon who tempted the historic Buddha to hold back from final Enlightenment, and finally tried to destroy him by violence.

MARDINI (Skt.)—Death or destruction; often encountered in *Mahishasuramardini,* Durga's destruction of the buffalo demon.

MATHURA (pronounced, and sometimes spelled, "Muttra") (Skt.)—Town on the Jumna River, a sacred tributary of the Ganges; one of the capitals of the Kushan Empire beginning about the second century A.D.; long an important center of sculptural art, from the Kushan through the Gupta periods (first to sixth centuries A.D.); birthplace of Krishna.

MAYA (Skt.)—Mother of the historic Buddha.

MEDICI (It.)—Merchant and banking family that became the rulers of Florence, and later, the Grand Duchy of Tuscany, for most of the period from the early fifteenth century to 1737; notable patrons of the arts.

METOPE (Gr.)—Rectangular space, often holding relief sculpture, in a frieze of the Doric order; alternating with narrower rectangular panels (triglyphs) that are marked with three vertical grooves.

MIKKYO (J.)—The secret doctrine of the Japanese sects of esoteric Buddhism based on Indian Tantrism, involving mysteries and magic rites open only to the initiated.

MI-LO (Ch.)—Chinese name for Maitreya.

MINAMOTO (J.)—Powerful clan in Japan that defeated the Taira family in 1185 to become the rulers of Japan, as shoguns, from a new seat of government in Kamakura.

MING (Ch.)—Dynasty that ruled China from 1368 to 1644.

MINOTAUR (Gr.)—Legendary monster, a man with the head of a bull, who lived in the Labyrinth of Knossos in Crete. The Cretan princess Ariadne helped the Greek hero Theseus kill the Minotaur and escape from Crete.

MIROKU (J.)—Japanese name for Maitreya.

MON—Name of a people akin to the Khmers, living mainly in the Menam Valley in present-day Thailand. More or less independent Mon kingdoms existed from the sixth to the fifteenth centuries A.D.

MONGOLS—Nomadic people of north central Asia who conquered much of Asia and eastern Europe in the twelfth and thirteenth centuries under Genghis Khan and his successors; established the Yuan dynasty in China

1260–1368; unsuccessfully invaded Japan late in the thirteenth century; established Moghul Empire in India in the fifteenth century.

MUDRA (Skt.)—Hand-sign or gesture in Hindu and Buddhist sculpture.

MUROMACHI (J.)—Section of Kyoto that became the headquarters of the Ashikaga family as ruling shoguns in 1334, giving its name to the Muromachi period in Japanese history (1334–1573).

NAGA (fem. NAGINI) (Skt.)—Snake or snake-deity; a nature spirit in Hinduism and Buddhism ranking between humankind and gods.

NARA (J)—Capital of Japan 709–784; site of earliest major Buddhist temples.

NARASIMHA (Skt.)—An avatar of Vishnu, in the guise of a lion-headed man who devoured a skeptical Brahmin.

NATARAJA (Skt.)—Lord of the Dance; the Dancing Shiva, symbolizing the five activities of the godhead—creating, protecting, destroying, releasing from destiny, and granting true knowledge.

NEMBUTSU (J.)—A formula for invoking the name of Buddha as a means of salvation; an abbreviation of such forms as "Nemu Amida Butsu" (Homage to Amida Buddha) in the Jodo sects (q.v.).

NEOCLASSICISM—Movement in art and literary history, occurring from time to time in the West, tending to regard the works of ancient Greece as models of perfection.

NEOPLATONISM—A mixture of Platonic ideas and Oriental mysticism, originating in the third century A.D.; revived in the early Renaissance and blended with Christian doctrine; conceives of the phenomenal world as an emanation of the One, with whom a soul is reunited in trance, ecstasy, or death.

NEREIDS (Gr.)—Sea nymphs in Greek mythology; the fifty daughters of Nereus, a sea deity.

NIOBE (Gr.)—Mother of six daughters and six sons who boasted that she was therefore better off than Leto, mother of only two—Apollo and Artemis, fathered by Zeus. The two gods revenged the slight by killing all but one of Niobe's children.

NIRVANA (Skt.)—Extinction or annihilation of material being, earthly passion, and individuality; absorption into undifferentiated, universal Being; the end of the cycles of individual existence.

O-MI-TO (Ch.)—Chinese name for Buddha in the form of Amitabha, the Lord of the Western Paradise.

PADMA (Skt.)—Lotus; symbol of wisdom and the female aspect of the godhead; *padmapani*, lotus-bearer, a form of Avalokiteshvara; *padmasana*, the

lotus position, or seated posture of meditation.

PARSVANATHA (Skt.)—The twenty-third of the Jain Tirthankaras or Saviors, who have attained Perfection.

PARVATI (Skt.)—One of the names of Shiva's spouse; the female energy of the godhead.

PERSEPHONE (Gr.)—In Greek mythology, goddess of fertility and grain; daughter of Zeus and Demeter; abducted and married by Hades, god of the underworld. The grief-stricken mother withheld grain harvests from the world until Hades agreed to let Persephone spend six months each year above ground.

PIETÀ (It.)—Representation of the Virgin Mary mourning over the body of Christ, usually held across her knees.

PLUTO (Gr.)—Also called Hades; in Greek mythology the god of the underworld and husband of Persephone, whom he abducted from the earth.

POSEIDON (Gr.)—In Greek mythology, brother of Zeus and god of the sea; also the producer of earthquakes; armed with a trident; Neptunus in Latin.

PURANAS (Skt.)—Sacred texts of the Hindus, elaborating the philosophy and religion of Brahminism in its later (hence, Puranic) phase, beginning probably about the seventh century A.D.

RAJALILASANA (Skt.)—Seated posture of "royal ease" found in Indian and other Asian sculpture; shows the figure seated with one leg folded in front of the body or hanging down to the ground, the other bent at the knee, supporting the forearm on that side, and the other arm stretched behind to support the body.

RAMA (Skt.)—An avatar of Vishnu, and hero of one of the Vedic epic poems, the *Ramayana*.

ROSHANA (J.)—Japanese name for Vairocana, one of the forms of Buddha, mainly worshipped in the esoteric sects derived from Tantric Buddhism.

SABINES—An ancient people of Italy who lived near Rome; the Romans carried off their women in a scene often depicted in art.

SAKYA (Skt.)—Clan name of the historic Buddha (c. 560–480 B.C.); with the suffix *-muni* means "sage of the Sakya clan"; in Chinese becomes *Shih-chia,* and in Japanese *Shaka.*

SELENE (Gr.)—In Greek mythology, the goddess of the moon. Enamored of the shepherd youth Endymion, she put him into an eternal sleep to preserve his beauty.

SHAKA (J.)—Japanese rendition of Sakya, clan name of the historic Buddha.

SHAKTI (Skt.)—Female energy of the godhead; the Great Goddess; generic name for the spouse of Shiva.

SHIH-CHIA (Ch.)—Chinese rendition of Sakya (*q.v.*).

SHINTO (J.)—Way of the Gods; the indigenous national religion of Japan, combining worship of nature and ancestors.

SHIVA (or SIVA) (Skt.)—One of the Hindu triad of Great Gods, with Brahma and Vishnu; god of destruction, but also of regeneration; regarded by his worshippers as having all the functions of the godhead, including creation and protection as well as destruction; symbolized by the *lingam*, or phallus.

SHOGUN (J.)—Military commander or general in the army. First granted as a temporary rank by the Emperor of Japan in the eighth century A.D., the status became hereditary with the Minamoto in Kamakura and later military leaders who were the *de facto* rulers of Japan, beginning late in the twelfth century.

SHOTOKU TAISHI (J.)—Sage-Virtue; name given the Japanese Prince Umayado (572–621), revered as statesman, sage, religious leader, patron of the arts, and eventually a Bodhisattva; with his mother Empress Suiko, helped to establish Buddhism in Japan and build the temple of Horyuji.

SIDDHARTHA (Skt.)—Personal name of the historic Buddha, Siddhartha Gautama Sakyamuni (c. 560–480 B.C.).

SIKHARA (Skt.)—Tower or spire of a Hindu temple in north India.

SOGA (J.)—Name of the powerful clan who first sponsored Buddhism in Japan and were the dominant family in the government late in the sixth and in the first half of the seventh centuries A.D.; displaced by the Fujiwara.

STUPA (Skt.)—Buddhist relic or grave mound, domed in shape.

SUIKO (J.)—Empress of Japan, who came to the throne in A.D. 593; with the help of her son Prince Shotoku established Buddhism.

SUKHOTHAI (or SUKHODAYA)—A Thai kingdom, established in 1238; known for a certain style of Buddhist sculpture.

SUNG (Ch.)—Dynasty that ruled most of China 960–1279.

SURYA (Skt.)—Hindu god of the sun.

SUTRA (Skt.)—Literally, thread; in Hinduism a collection of precepts and proverbs; in Buddhism narrative scriptures, especially dialogues of the Buddha.

TAIRA (J.)—Name of an important family that was dominant in the Japanese government c. 1156–1185.

TANG (Ch.)—Dynasty that ruled China 618–906.

TANTRA (Skt.)—A sacred text of esoteric Hindu and Buddhist sects. *Tantrism* involves the use of mystical and magical formulas, diagrams, and rites understood only by initiates, often of an erotic nature.

TAPAS (Skt.)—Heat or fiery energy, both physical and psychic, generated by ascetic austerities. An accumulation, as through yogic exercises, gives a human or god great powers.

TATHAGATHA (Skt.)—Perfected or Enlightened One; a name for the Buddha.

THERAVADA (Skt.)—The Learning of the Teacher; a name for the fundamentalist branch of Buddhism that emphasizes the teachings of the early texts and the need for monastic withdrawal; sometimes called Hinayana (Little Vehicle) as distinct from Mahayana (Greater Vehicle); the dominant form of the religion in Ceylon and southeast Asia.

THESEUS (Gr.)—Legendary hero of Athens; delivered to the Cretans as a sacrifice to the Minotaur, he escaped, and later became King of Athens.

TIRTHANKARA (Skt.)—Finder of the Ford; any of twenty-four Jain Saviors who has learned the way to Perfection and release from the cycle of rebirths.

TITANS—In Greek mythology, the first generation of divine beings; six sons of the primordial creators, Uranus (Sky) and Gaea (Earth). Cronus, the supreme Titan, was killed by his son Zeus, who thereupon became chief of the Olympian gods.

TODAIJI (J.)—Great East Temple; built in Nara in the eighth century A.D.; rebuilt after the civil war of 1180–85.

TRIBANGHA (Skt.)—Three-bend; the S-shaped or *hanché* posture of a human figure, bending at the waist, shoulders, and neck.

TUN-HUANG (Ch.)—Oasis outpost of China at the beginning of the silk routes; site of oldest Buddhist cave-temples, begun there in second half of the fourth century A.D.

UDAYANA (Skt.)—A king of Kausambi, a small state near the junction of the Ganges and Jumna rivers in north India, who reputedly ruled during the lifetime of the historic Buddha and caused a portrait image of him to be made.

UMA (Skt.)—One of the names of Shiva's spouse, in the guise of the daughter of the Himalayas.

URNA (Skt.)—The mark on the forehead of Buddha images; possibly originated as a mole or wart; regarded as one of the thirty-two signs of a *Mahapurusha,* or superman.

USHNISHA (Skt.)—The cranial knob, or bump of superior wisdom, on the head of Buddha images; one of the thirty-two marks of a *Mahapurusha,* or superman.

VAIROCANA (Skt.)—One of the forms of Adi-Buddha; Buddha of Light or the Great Illuminator; the primordial, all-pervading, undifferentiated Being, source of all other being, especially worshipped in esoteric Tantric sects.

VAJRA (Skt.)—Thunderbolt, diamond, or penis; an important symbol in
Tantric Hinduism and Buddhism, as a sign of creative energy and unshak-
able faith founded in wisdom; carried by *Vajrapani*, guardian of the his-
toric Buddha, and by certain other deities. *Vajrayana* was an offshoot of
Mahayana Buddhism, emphasizing esoteric formulas and rites, focussing on
worship of Buddha in the form of *Vajrasattva*.

VARAHA (Skt.)—An avatar of incarnation of Vishnu, with the head of a boar.
In this guise he rescued the earth goddess from demons that had dragged
her back into the cosmic ocean.

VARAMUDRA (Skt.)—Gesture of offering or giving, in Hindu and Buddhist
sculpture; the hand is held out from the body, palm facing outward, and
fingers pointing downward.

VARMAN (Skt.)—Protected one; suffix found in the names of Khmer kings,
signifying protection by his chosen god.

VEDA (Skt.)—Any of the four ancient sacred texts of early Hinduism, consist-
ing of hymns, prayers, and precepts (hence, the pre-Buddhist Vedic period
of Indian civilization).

VIRASANA (Skt.)—Posture of the hero; "half-lotus" seated position in Hindu
and Buddhist sculpture, with one foot drawn under, the other on top of,
the opposite thigh.

VISHNU (Skt.)—One of the Hindu triad of Great Gods, with Brahma and
Shiva; the Preserver, and god of love; has appeared in many avatars, or in-
carnations.

VITARKAMUDRA (Skt.)—Gesture of teaching; hand held out, palm facing for-
ward, and fingers extending upward, with tips of thumb and index (or
other) finger meeting.

WHEEL OF THE LAW—In Sanskrit, *dharmachakra;* symbol of *dharma,* or the
Law, especially in Buddhism; probably derived from ancient symbol of the
sun; set in motion by the Buddha's first sermon after Enlightenment.

YAKSHA (fem. YAKSHI) (Skt.)—Nature deity, worshipped in India apparently
before Vedic times, and thereafter.

YAKUSHI (J.)—The Healing Buddha; worshipped especially in the early pe-
riod of Japanese Buddhism; subject of a famous eighth-century sculpture
in Nara.

YANG (Ch.)—Heaven; the male principle; with *yin* (earth; the female princi-
ple), one of the two primary modes of being, from which all other cre-
ation in the material world is produced.

YAVADVIPA (Skt.)—Land of Barley; may refer to one or more of the following
in southeast Asia in the period of Indianization: Java, Sumatra, Borneo, or
Malay peninsula.

YIN (Ch.)—*See* Yang.

YOGA (Skt.)—System of ascetic physical and spiritual exercises, intended to free the practitioner (yogi) from the world of the senses, to acquire self-knowledge, and to unite with the Absolute.

YOSEGI (J)—Technique of sculpture in wood; assembly of many small carved blocks around a hollow core.

YUEH-CHIH (Ch.)—Nomadic tribe that invaded what is now Afghanistan, Pakistan, and northwestern India in the first century A.D.; the Kushan dynasty became their rulers.

YUGA (Skt.)—Any of four periods in a world cycle of more than four million years. In each successive period, the world suffers a decline in virtue and order, until the end of the cycle, when a new one starts; the present period is the *Kali yuga,* last and worst of the four.

YUN-KANG CAVES (Ch.)—Buddhist cave-temples near Northern Wei capital in China, fifth century A.D.

ZEN (J.)—Name of a school of Buddhism in Japan, deriving from Sanskrit *Dhyani* and Chinese *Chan,* meaning meditation; emphasizes direct perception of truth, through disciplined meditation and intuitive insight, rather than theological learning.

ZEUS (Gr.)—In Greek mythology, chief of the Olympian gods, and father or brother of most of them; god of the heavens, and wielder of the thunderbolt; son of the Titan Cronus who, to avoid any rivals for rule of the universe, ate all his children alive. Zeus escaped with the help of his mother, Rhea, and lived to destroy Cronus.

The West

THE following illustrations have short identifying captions, including, in italics, the sources of the photographs. The numbers following each caption refer to the pages of the text on which the object is mentioned.

More complete descriptions of the sculptures shown, their present locations, and credit lines for the photographs, will be found in the list of illustrations.

The following short forms are used in the captions:

Alinari: Fratelli Alinari, (Florence)—Art Reference Bureau.

Brundage Collection, de Young Museum, San Francisco: Center of Asian Art and Sculpture, The Avery Brundage Collection, M. H. de Young Memorial Museum, San Francisco.

The Cloisters, New York: The Cloisters Collection, Metropolitan Museum of Art, New York City.

Freer Gallery of Art, Washington. The Smithsonian Institution, Freer Gallery of Art, Washington, D.C.

Hirmer: Hirmer Fotoarchiv Munchen.

Nelson Gallery—Atkins Museum, Kansas City, Missouri: William Rockhill Nelson Gallery and Atkins Museum of Fine Arts, Kansas City, Missouri.

University Museum, Philadelphia: University Museum, University of Pennsylvania, Philadelphia.

1. Lady of Auxerre. *Hirmer.* (2-3, 7)

2. Hera of Samos. *Hirmer.* (3, 7)

3. Kouros. *Metropolitan Museum of Art, New York City.* (5, 101, 210)

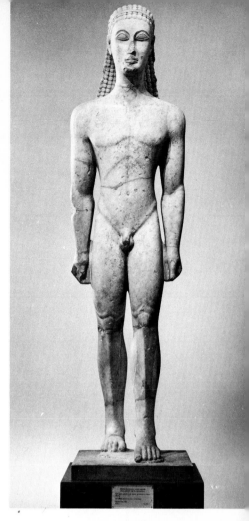

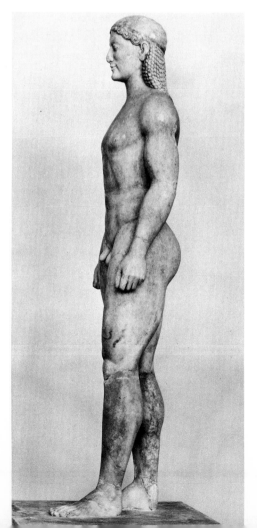

4. Kouros ("Kroisis"). *Hirmer.* (6, 210)

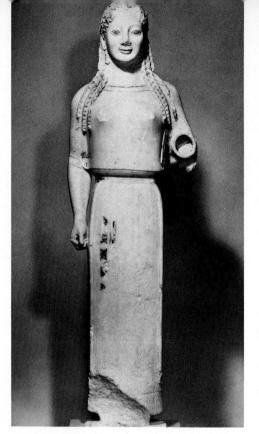

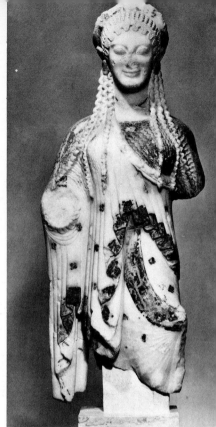

5. "Peplos Kore." *Hirmer.* (6) 6. Kore. *Hirmer.* (6)

8. RIGHT: "Rampin Horseman." *Hirmer.* (8)

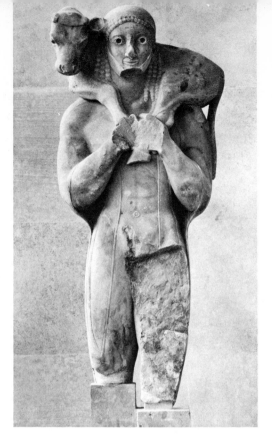

7. Moscophoros. *Hirmer.* (7-8)

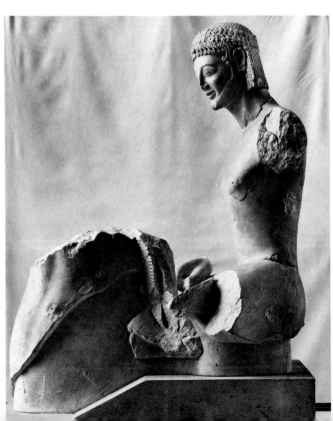

9. Apollo from Piraeus. *Hirmer.* (9)

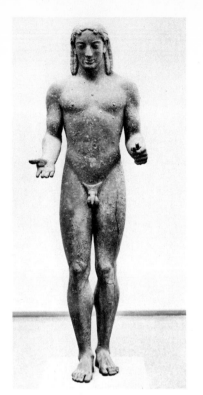

10. BELOW LEFT: Charioteer, *Hirmer.* (9)

11. RIGHT: "Critian Boy." *Hirmer.* (9, 10, 14, 39)

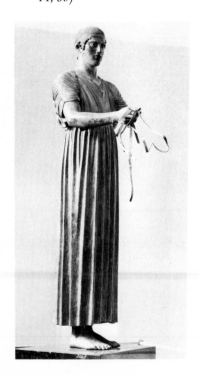

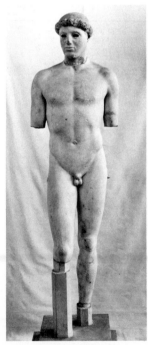

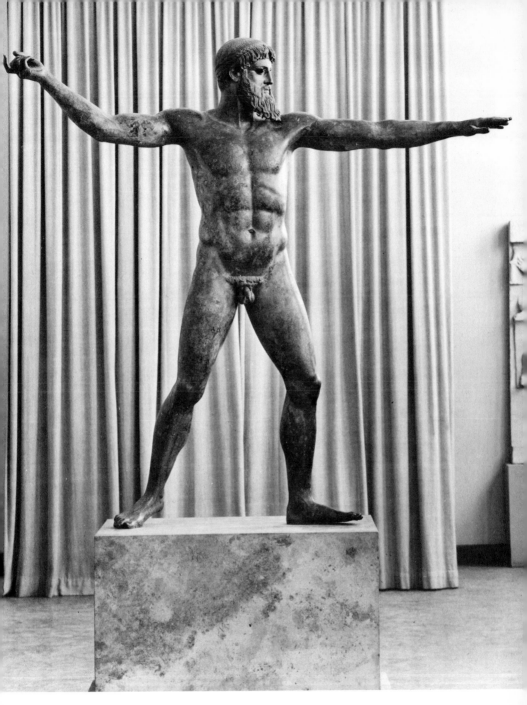

12. Poseidon from Cape Artemesium. *Hirmer.* (10, 13, 14, 27, 218)

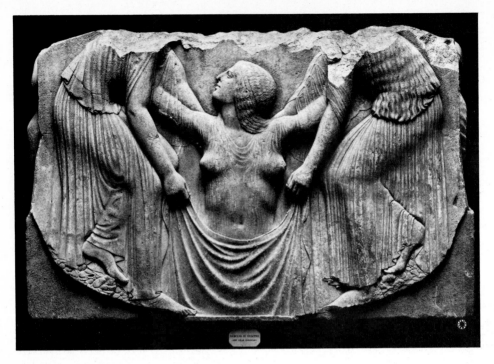

13. "Ludovisi Throne." *Hirmer.* (10, 12, 17)

14. "Boston Throne." *Museum of Fine Arts, Boston.* (10, 17)

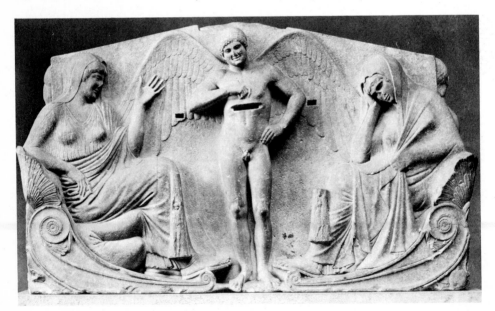

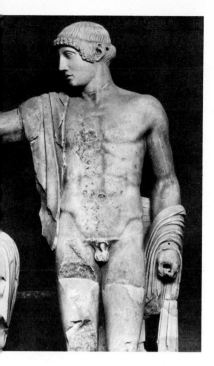

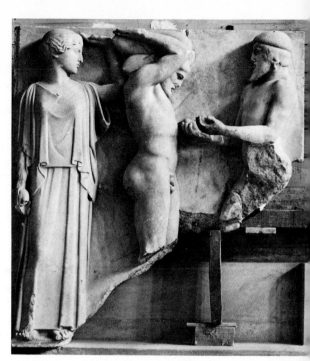

15. LEFT: Apollo from Temple of Zeus, Olympia. *Hirmer*. (11, 14)

16. RIGHT: Athena, Heracles, and Atlas; Temple of Zeus, Olympia. *Hirmer*.
(11-12, 20)

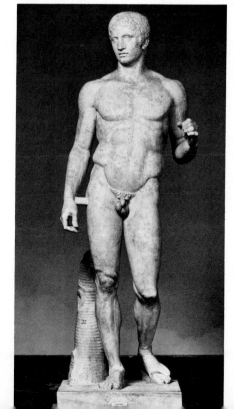

17. Doryphoros. *Hirmer*. (13, 24,
210)

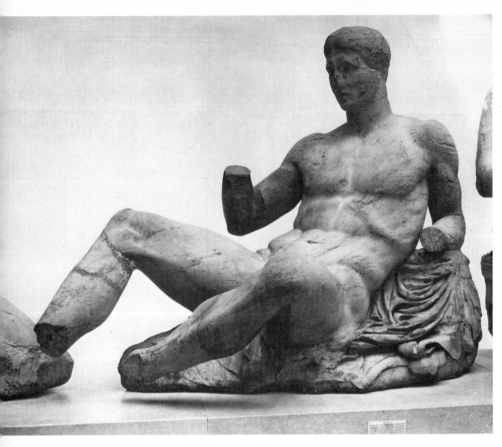

18. Dionysos, from Parthenon, Athens. *British Museum, London.* (16)

19. "Nereid" from Xanthos. *British Museum, London.* (17)

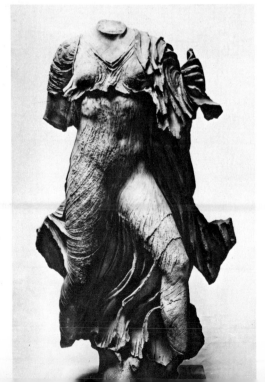

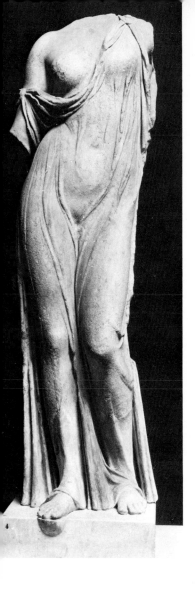

20. "Venus Genetrix." *Hirmer.* (17, 42)

21. Daughter of Niobe. *Alinari.* (17-18)

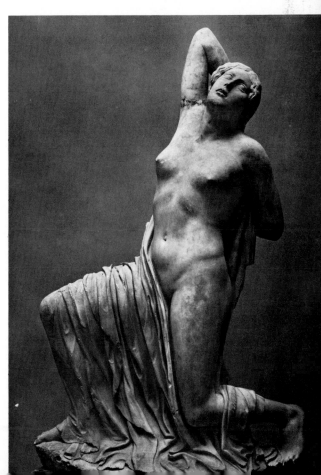

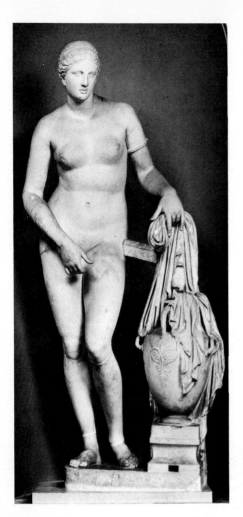

22. Aphrodite of Cnidos. *Hirmer*. (18-19, 24, 42, 219)

23. "Bartlett Head" of Aphrodite. *Museum of Fine Arts, Boston*. (19)

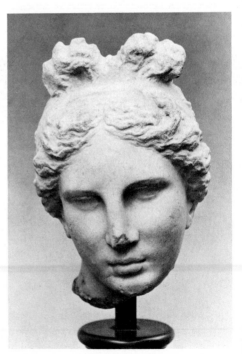

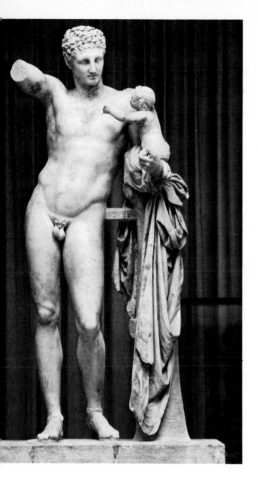

24. Hermes of Praxiteles. *Hirmer.*
(19, 21, 101, 203)

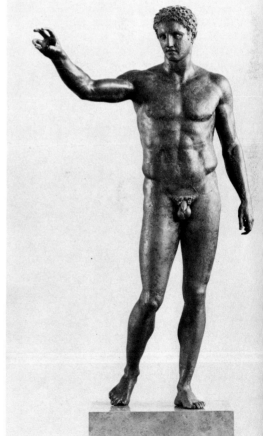

25. Heracles from Anticythera. *Hirmer.* (19)

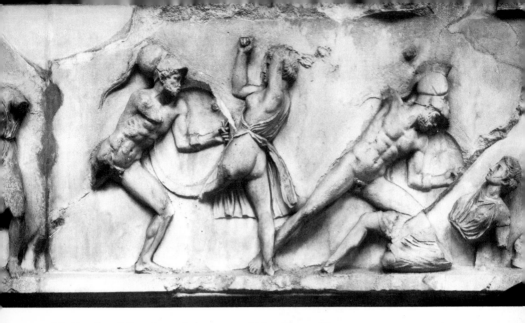

26. Battle of Greeks and Amazons; Frieze from Mausoleum at Halicarnassus. *British Museum, London.* (20, 134)

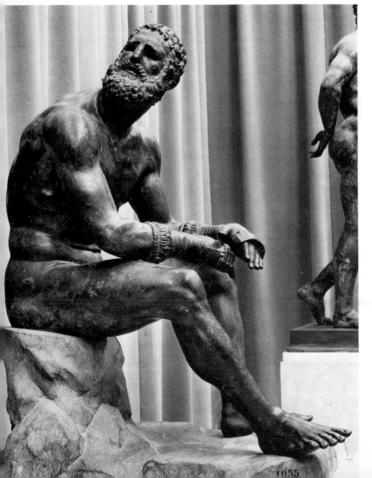

27. Boxer. *Hirmer* (22)

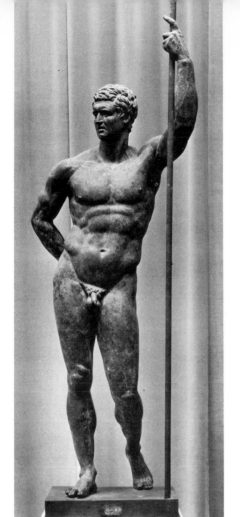

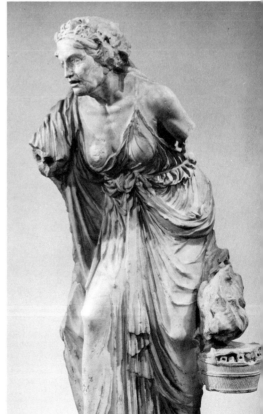

28. Hellenistic Prince. *Hirmer.* (22)

29. Old Woman Marketing. *Metropolitan Museum of Art, New York.* (22, 23)

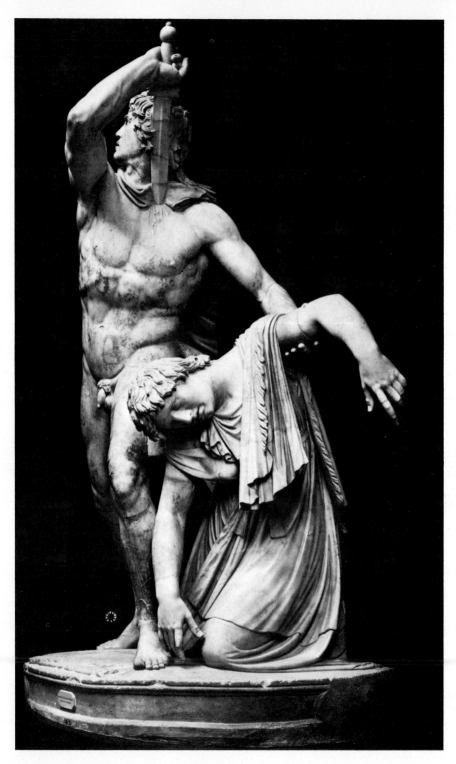

30. Gaul Killing Self. *Alinari.* (22-23, 64)

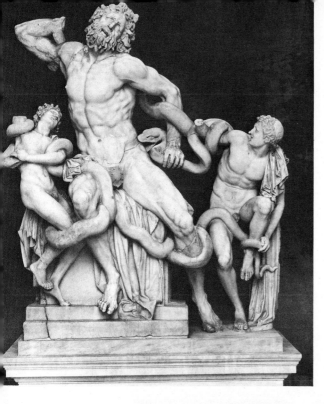

31. Laocoön. *Hirmer.* (23, 24, 64, 67, 68, 80)

32. BELOW LEFT: Aphrodite from Melos. *Hirmer.* (24, 42, 104)

33. RIGHT: Aphrodite from Cyrene. *Alinari.* (24, 42)

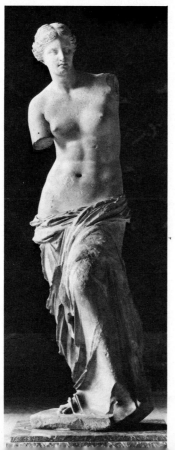

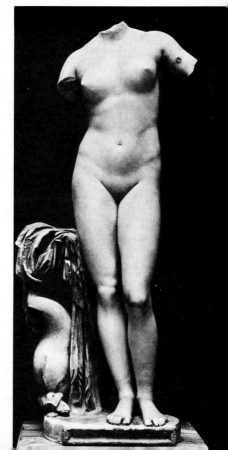

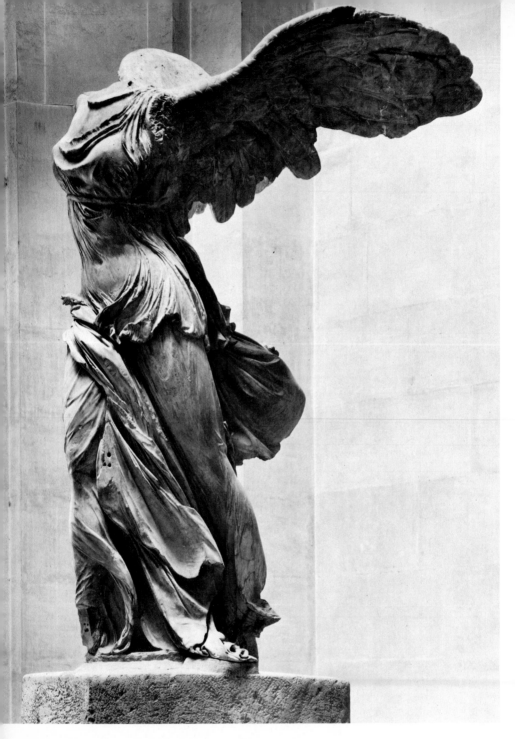

34. Victory from Samothrace. *Hirmer.* (24)

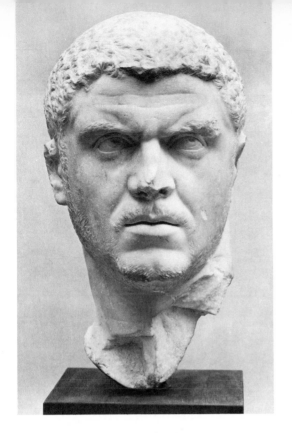

35. Emperor Caracalla. *Metropolitan Museum of Art, New York.* (28)

36. Emperor Augustus. *Museum of Fine Arts, Boston.* (29)

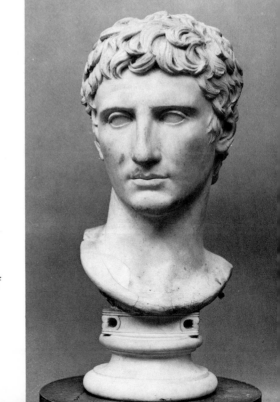

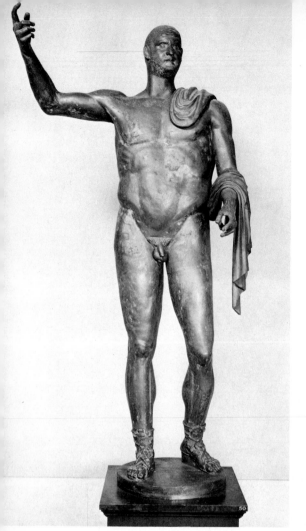

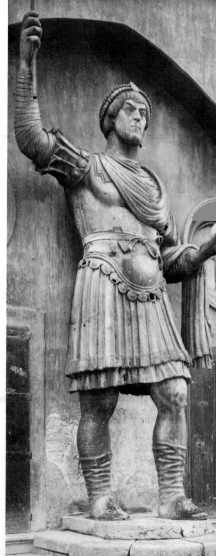

37. Emperor Gallus. *Metropolitan Museum of Art, New York.* (29, 213)

38. Emperor Marcian. *Alinari.* (29)

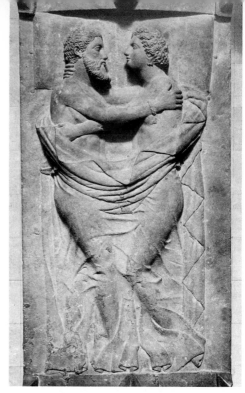

39. LEFT: Etruscan Warrior. *Metropolitan Museum of Art, New York.* (31)

40. RIGHT: Etruscan Sarcophagus Lid. *Museum of Fine Arts, Boston.* (32)

41. BELOW: Etruscan Sarcophagus Lid. *Alinari.* (32)

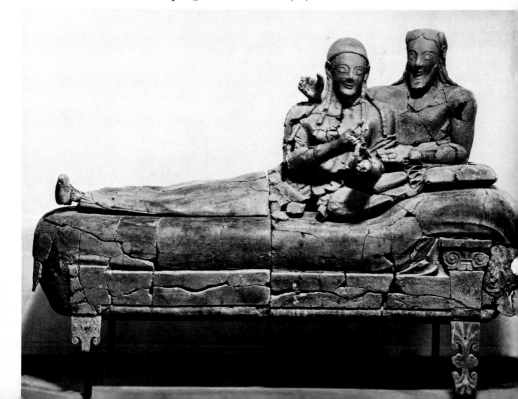

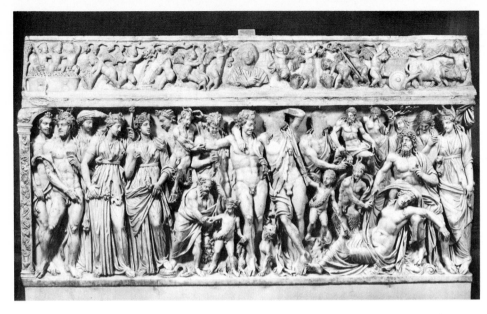

42. Dionysos and Ariadne; Roman Sarcophagus. *Walters Art Gallery, Baltimore.* (33, 59, 111)

43. Sarcophagus of Junius Bassius; Roman. *Alinari.* (33-34)

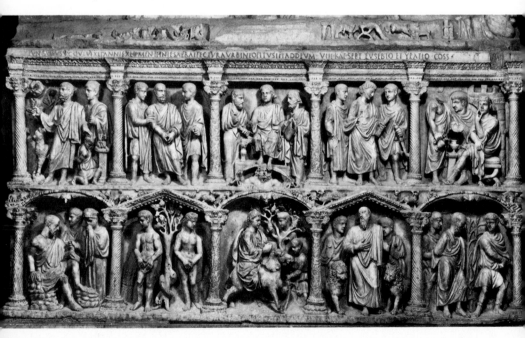

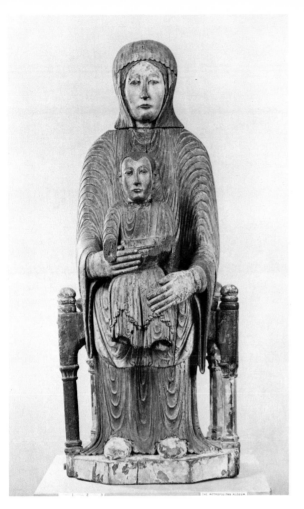

44. Virgin and Child from Auvergne. *Metropolitan Museum of Art, New York.* (37)

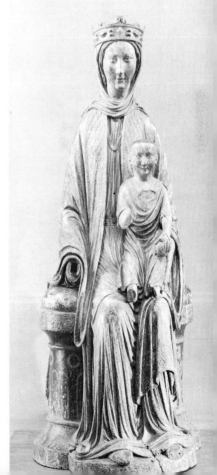

45. Virgin and Child from the Île de France. *Museum of Fine Arts, Boston.* (37)

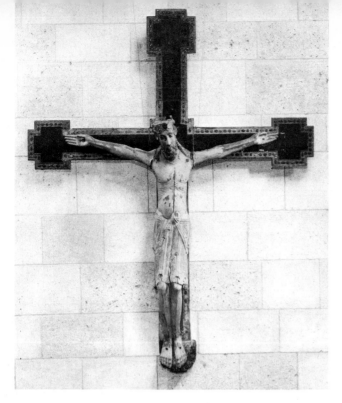

46. Crucifix. *The Cloisters, New York.* (37-38)

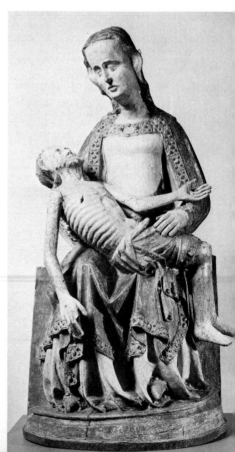

47. Pietà. *The Cloisters, New York.* (41, 219)

48. Royal Portal, Chartres Cathedral. *Lauros-Giraudon.* (38, 177, 213)

49. North Portal, Chartres Cathedral. *Lauros-Giraudon.* (39, 177, 213)

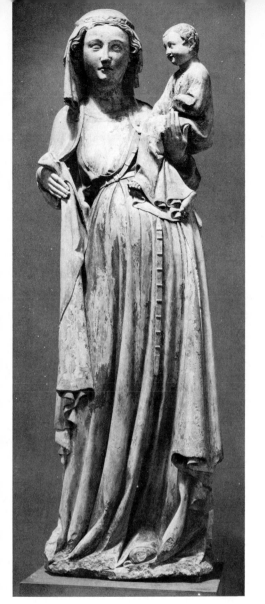

51. Virgin and Child. *Metropolitan Museum of Art, New York.* (40)

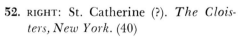

52. RIGHT: St. Catherine (?). *The Cloisters, New York.* (40)

50. OPPOSITE: Virgin from Strasbourg Cathedral. *The Cloisters, New York.* (40)

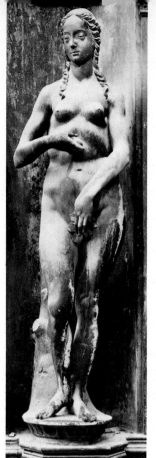

53. LEFT: Nicola Pisano: Fortitude, or Heracles. *Alinari.* (42, 210) **54.** CENTER: Rizzo: Eve. *Alinari.* (42) **55.** RIGHT: Giovanni Pisano: Prudence. *Alinari.* (42-43)

56. Donatello: David. *Alinari.* (45-46) **57.** RIGHT: Donatello: St. George. *Alinari.* (46)

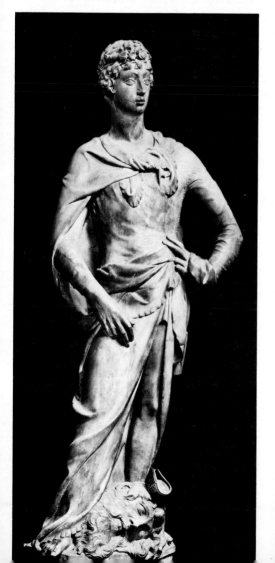

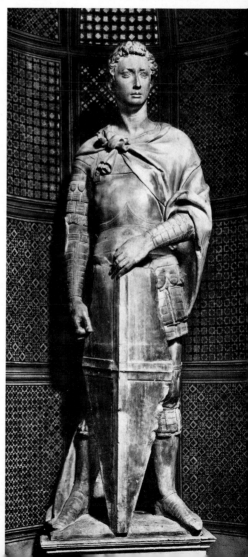

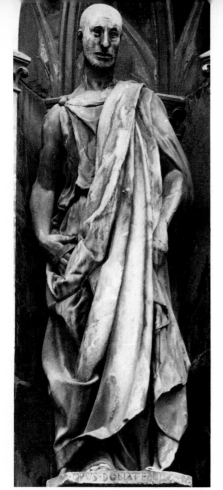

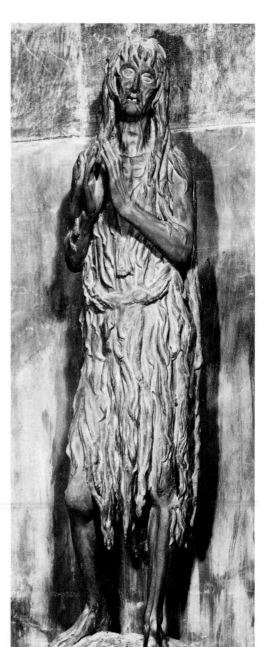

58. LEFT: Donatello: Habakkuk or "Zuc-
cone." *Alinari.* (47-48)

59. RIGHT: Donatello: St. Mary
Magdalen. *Alinari.* (47, 50, 92,
218)

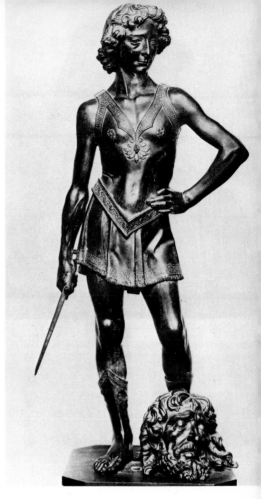

61. RIGHT: Verrocchio: David. *Alinari.*
(50, 54)

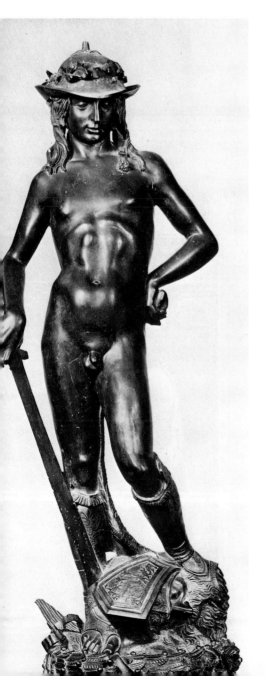

60. LEFT: Donatello: David. *Alinari.*
(48-49, 54)

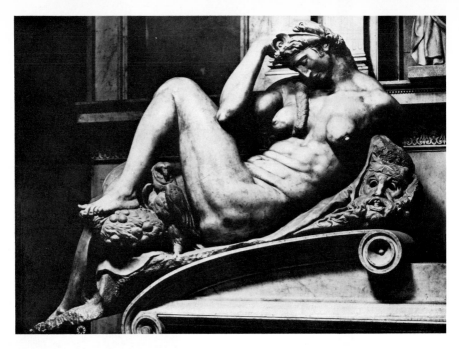

67. Michelangelo: Night. *Alinari*. (58-60, 64)

68. Michelangelo: Day. *Alinari*. (58, 59-60, 62, 64)

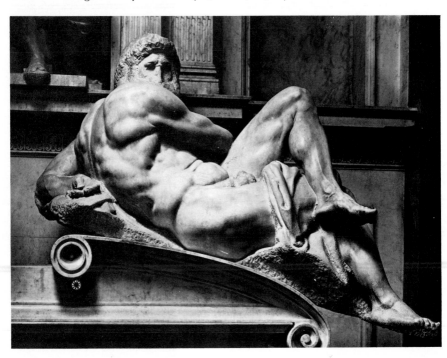

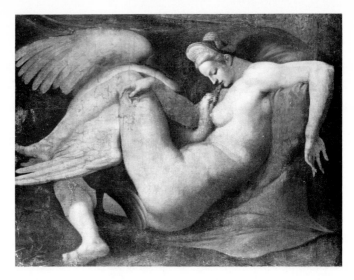

69. Rosso: Leda and the Swan. *National Gallery, London.* (60)

70. BELOW LEFT: Michelangelo: Dying Slave. *Giraudon.* (54, 62) 71. RIGHT: Michelangelo: Victory. *Alinari.* (55, 62, 64)

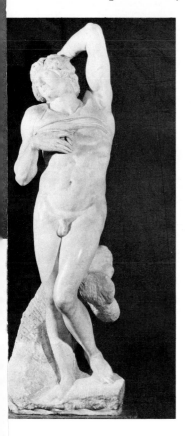

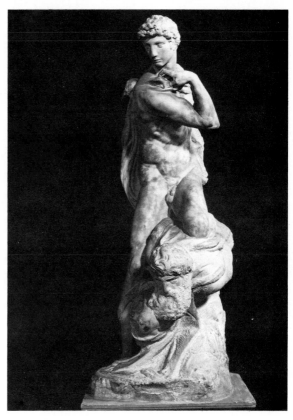

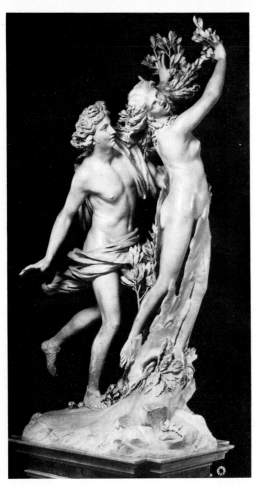

75. Bernini: Apollo and Daphne. *Alinari.* (68)

76. Bernini: Pluto and Persephone. *Alinari.* (68)

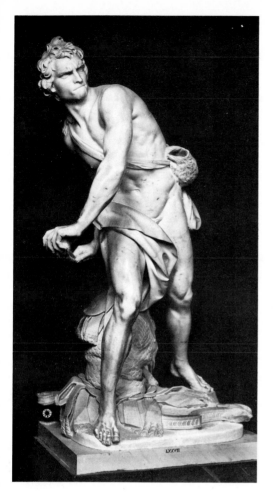

77. Bernini: David. *Alinari*. (68-69)

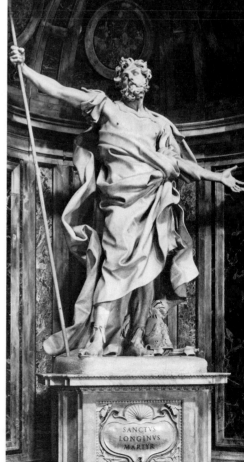

78. Bernini: St. Longinus. *Alinari*. (69-70, 78)

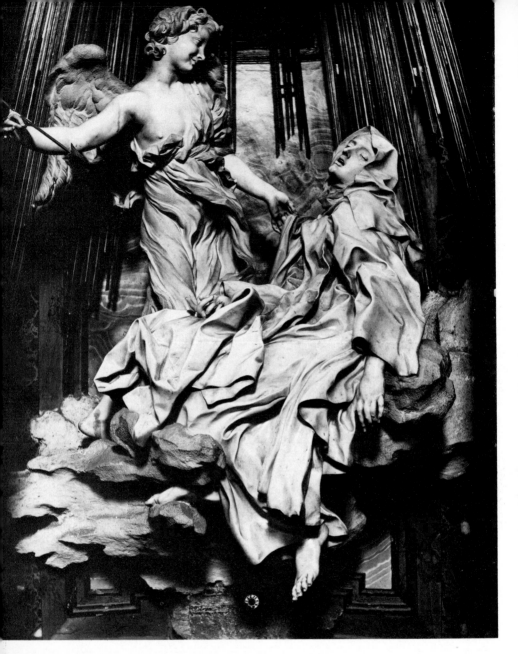

79. Bernini: St. Teresa. *Alinari.* (70-71, 78, 79)

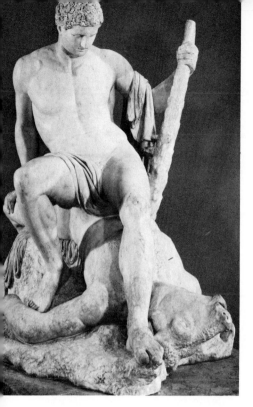

80. ABOVE LEFT: Canova: Theseus and the Minotaur. *Victoria and Albert Museum, London.* (75-76)

81. ABOVE RIGHT: Pigalle: Mercury. *Metropolitan Museum of Art, New York.* (74)

82. RIGHT: Pigalle: Voltaire. *Giraudon.* (74-75)

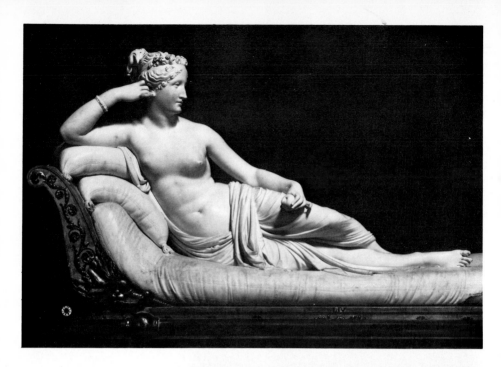

83. Canova: Pauline Bo-
naparte Borghese. *Ali-
nari*. (75)

84. Rude: Napoleon
Awakening to Immor-
tality. *Giraudon*. (78,
79)

85. Houdon: Winter, or *La Frileuse*. *Metropolitan Museum of Art, New York.* (78)

86. Houdon: St. Bruno. *Alinari.* (78)

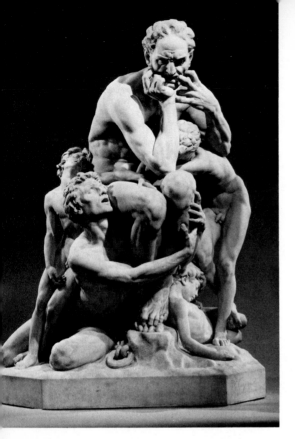

87. Carpeaux: Ugolino. *Metropolitan Museum of Art, New York.* (80, 87)

88. Rodin: St. John the Baptist. *Museum of Modern Art, New York.* (82-83)

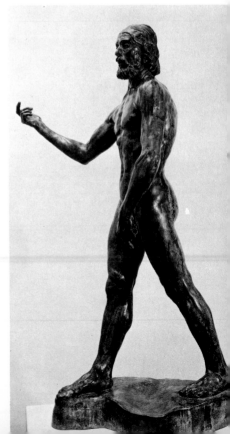

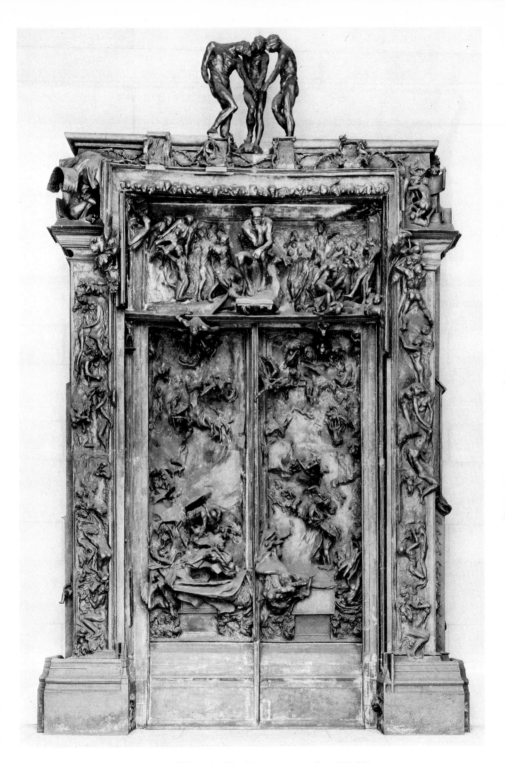

89. Rodin: Gates of Hell. *Philadelphia Museum of Art.* (86-87)

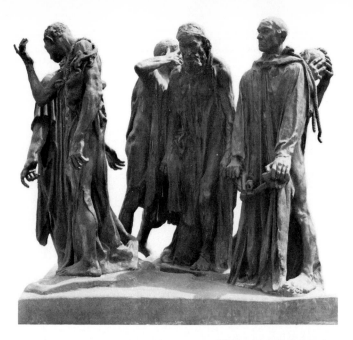

90. Rodin: Burghers of Calais. *Philadelphia Museum of Art.* (82, 87-88)

91. Rodin: Monument to Balzac. *Museum of Modern Art, New York.* (78, 82, 84, 88-90)

92a. Rodin: Christ and the Magdalen. *Musée Rodin, Paris.* (48, 91-92)

92b. Rodin: Christ and the Magdalen. *California Palace of the Legion of Honor, San Francisco.* (48, 92)

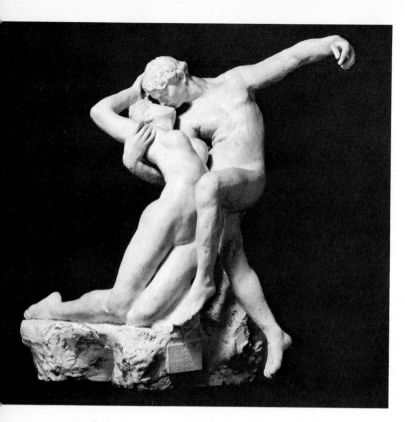

93a. Rodin: Eternal Springtime. *Philadelphia Museum of Art.* (92)

93b. Rodin: Eternal Springtime. *Philadelphia Museum of Art.* (92)

The East

94. LEFT: Dancing Girl from Mohenjo-daro. *National Museum, New Delhi.* (102, 104, 210)

95. RIGHT: Male Dancer from Mohenjo-daro. *National Museum, New Delhi.* (102, 210)

96. Yaksha from Parkham. *Archaeological Museum, Mathura.* (102-103, 107, 127)

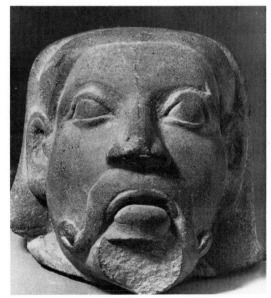

97. Mauryan Male Head. *National Museum, New Delhi.* (103)

 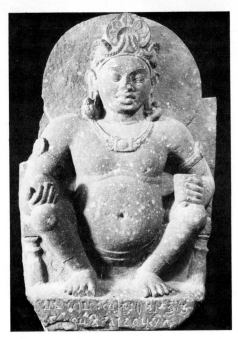

102. LEFT: King Kanishka. *Archaeological Museum, Mathura.* (108-218)

103. RIGHT: Kubera. *Archaeological Museum, Mathura.* (108-109, 114, 127)

104. Nagaraja. *Musée Guimet, Paris.* (39, 109)

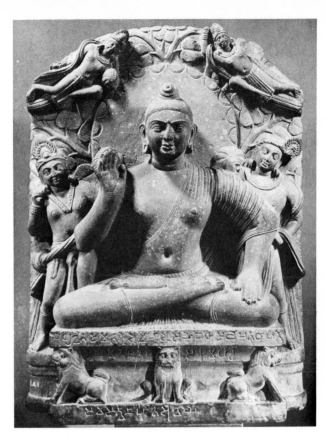

105. Buddha from Mathura. *Archaeological Museum, Mathura.* (109-110, 112, 113, 117, 118)

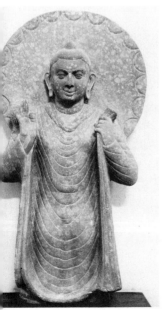

106. Buddha from Mathura. *Archaeological Museum, Mathura.* (110, 112, 113, 120)

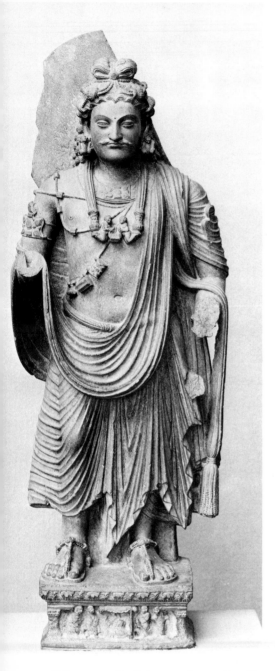

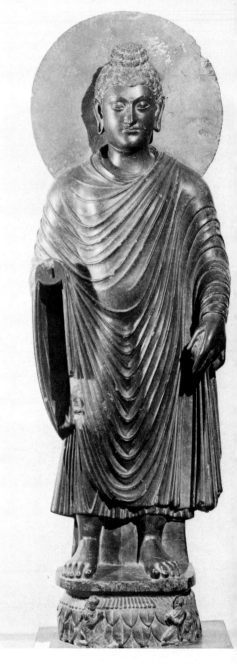

107. LEFT: Bodhisattva from Gandhara. *Museum of Fine Arts, Boston.* (111, 112)

108. RIGHT: Buddha from Gandhara. *National Museum, New Delhi.* (112, 113, 210)

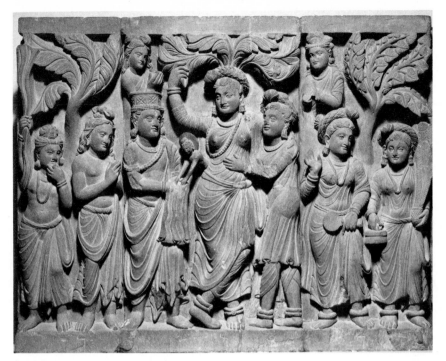

109. ABOVE: Birth of Buddha; Gandhara. *Freer Gallery of Art, Washington.* (114, 115) **110.** BELOW: Enlightenment of Buddha; Gandhara. *Freer Gallery of Art, Washington.* (113, 114, 115, 117, 118, 183, 190)

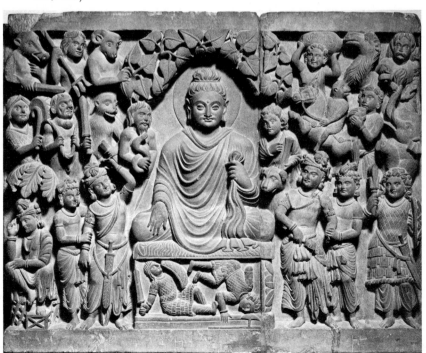

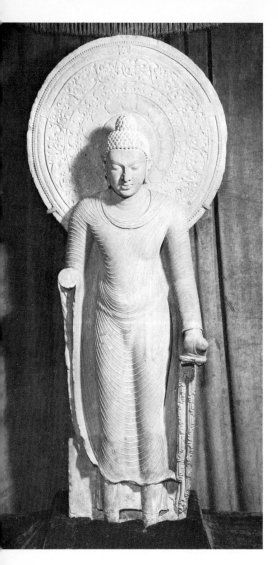

111. Buddha; Gupta Period. *National Museum, New Delhi.* (101, 110, 113, 118, 119-20, 165, 199, 210)

112. Buddha Torso; Gupta Period. *Nelson Gallery–Atkins Museum, Kansas City, Missouri.* (120, 165)

113. Buddha Head; Gupta Period.
Museum of Fine Arts, Boston.
(113, 120)

114. Buddha; Gupta Period. *Metropolitan Museum of Art, New York.*
(118, 120, 159, 165, 199)

115. Parsvanatha. *Victoria and Albert Museum, London.* (121, 124)

116. Gommata. *Eliot Elisofon.* (117, 122)

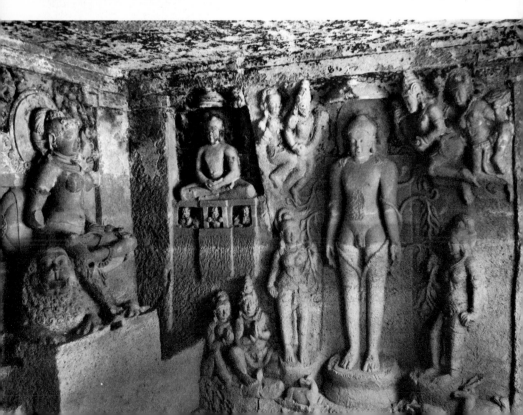

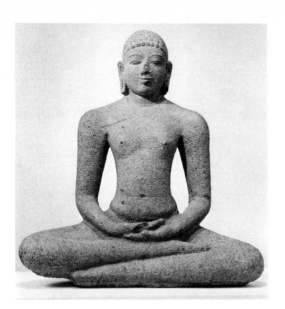

117. ABOVE: Jain Tirthankara. *Philadelphia Musuem of Art.* (117, 118, 122)

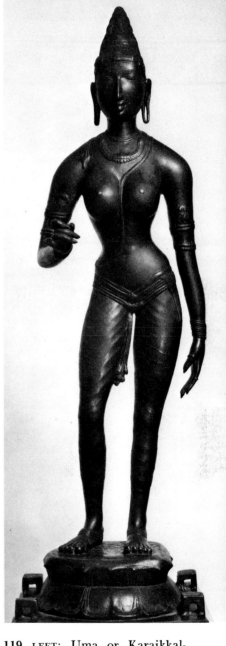

118. RIGHT: Parvati. *Freer Gallery of Art, Washington.* (130, 149)

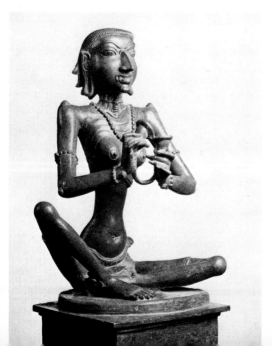

119. LEFT: Uma or Karaikkal-Ammaiyar. *Nelson Gallery —Atkins Museum, Kansas City, Missouri.* (48, 129-130, 149, 218, 220)

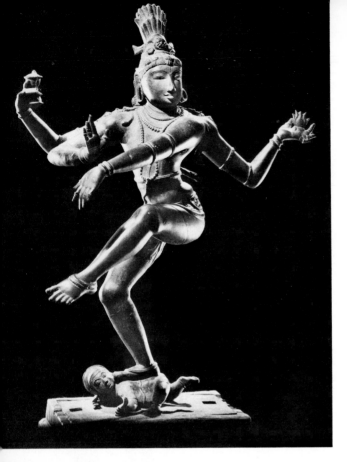

120. Nataraja (Dancing Shiva). *Nelson Gallery–Atkins Museum, Kansas City, Missouri.* (130-131, 149)

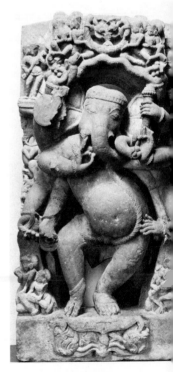

121. Mahaganapati (Ganesh). *Nelson Gallery–Atkins Museum, Kansas City, Missouri.* (127, 132-133)

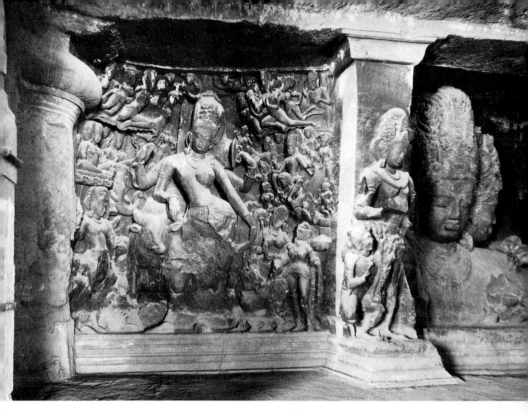

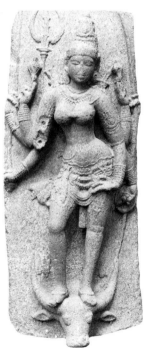

122. Shiva Ardhanari. *Eliot Elisofon.* (130, 142, 161)

123. Durga Slaying the Buffalo Demon. *Museum of Fine Arts, Boston.* (134, 142, 197)

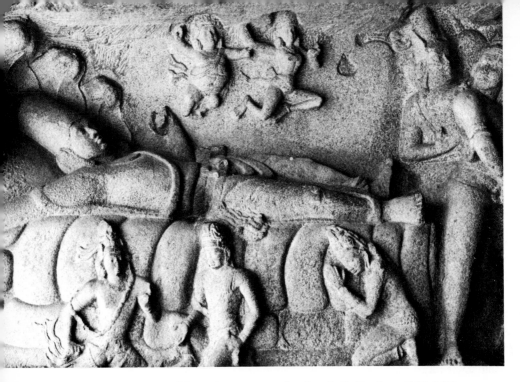

128. Vishnu Anantasayanin. *Lewis Callaghan.* (138, 142)

129. Vishnu Adi-Varaha (Cosmic Boar). *Eliot Elisofon.* (132, 139, 142)

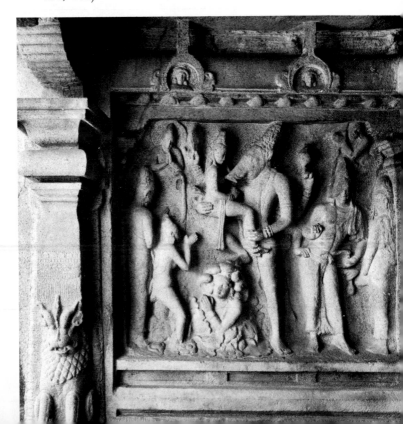

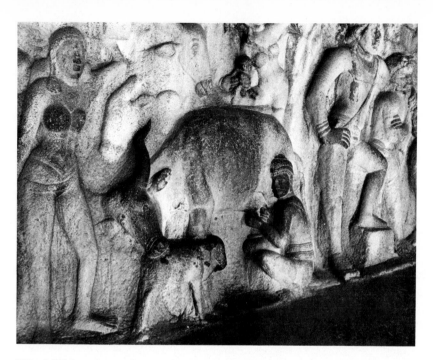

130. Milking Scene from Vishnu Govardhana. *Lewis Callaghan.* (140, 142)

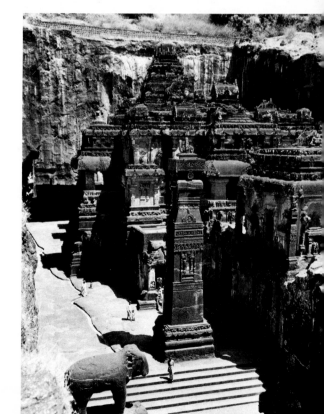

131. Kailashanath Temple, Ellora. *Eliot Elisofon.* (142-143)

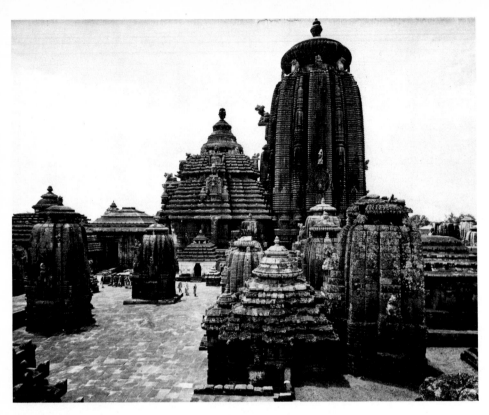

132. Lingaraja Temple, Bhubaneshvar. *Eliot Elisofon.* (144)

133. Arunaceleshvara Temple, South India. *Eliot Elisofon.* (145)

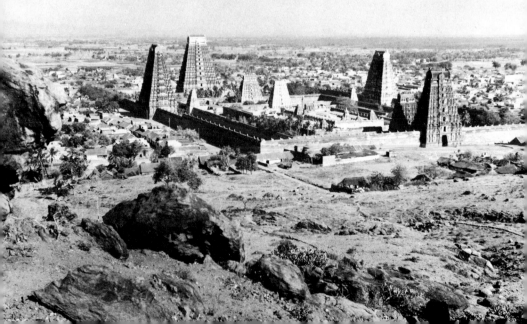

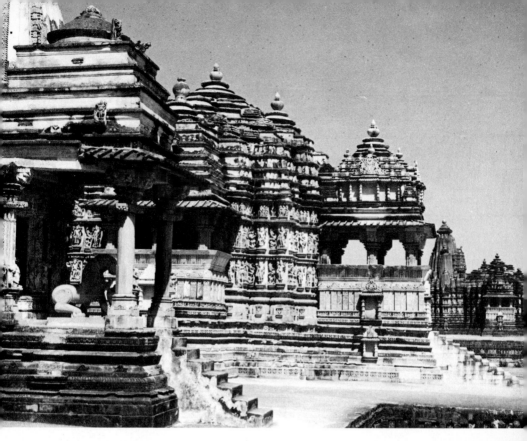

134. Khajaraho Temples. *Lewis Callaghan.* (144)

135. Detail from Kandarya Ma-
hadeva Temple, Khaja-
raho. *Lewis Callaghan.*
(114, 118)

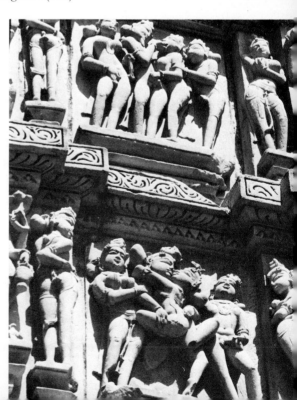

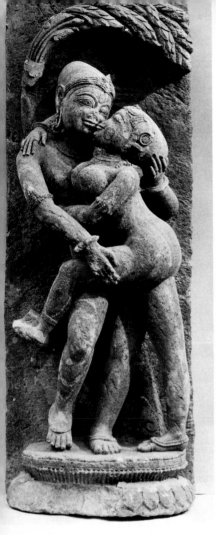

136. Maithuna (Loving Couple). *Metropolitan Museum of Art, New York.* (145)

137. Maithuna (Loving Couple). *Lewis Callaghan.* (146)

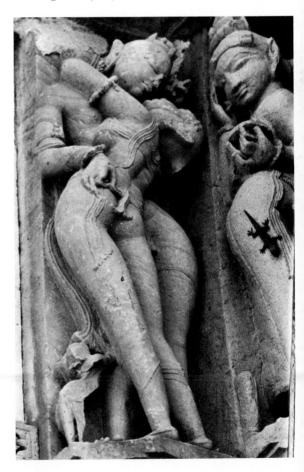

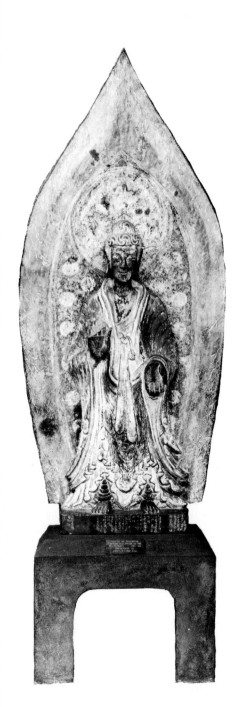

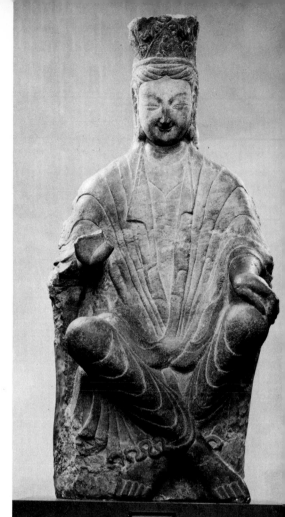

138. LEFT: Maitreya; Northern Wei. *University Museum, Philadelphia.* (158, 159, 171, 214)

139. ABOVE: Maitreya; Northern Wei. *Metropolitan Museum of Art, New York.* (117, 158, 159, 171, 213)

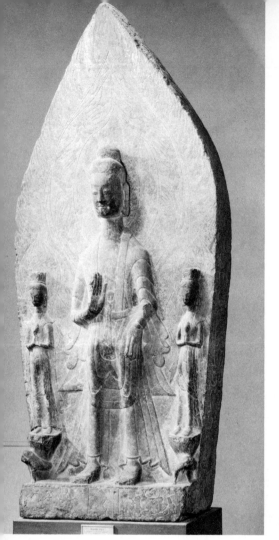

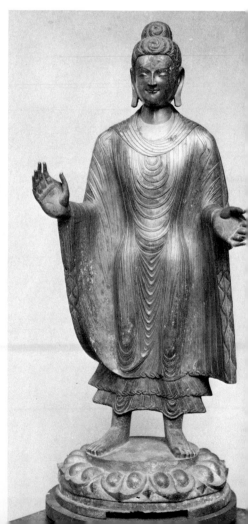

140. Maitreya between Two Bodhisattvas; Northern Wei. *Metropolitan Museum of Art, New York.* (159, 171, 177, 213)

141. Buddha; Northern Wei. *Metropolitan Museum of Art, New York.* (110, 159, 171)

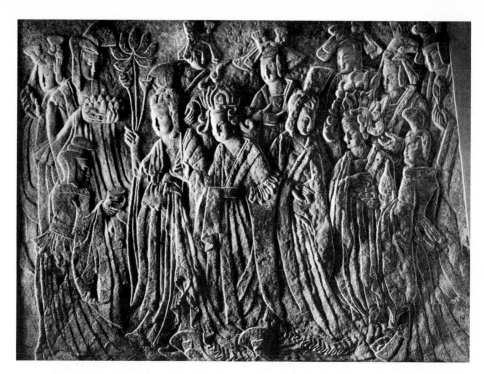

142. Empress and Her Court; Northern Wei. *Nelson Gallery–Atkins Museum, Kansas City, Missouri.* (159, 171)

143. Horse of Tang Tai Tsung; Tang. *University Museum, Philadelphia.* (164)

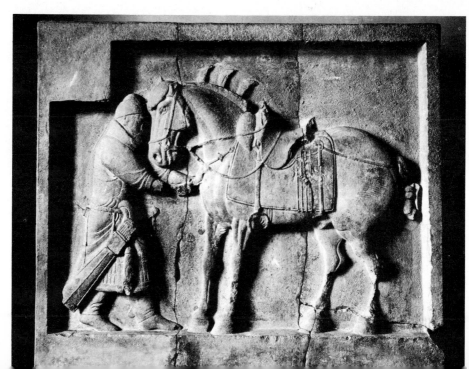

144. Tw
del

147. LEFT: Kuan-yin; Tang. *Metro-politan Museum of Art, New York.* (40, 161, 172)

148. BELOW: Kuan-yin; Tang. *Cleveland Museum of Art.* (40, 161, 172)

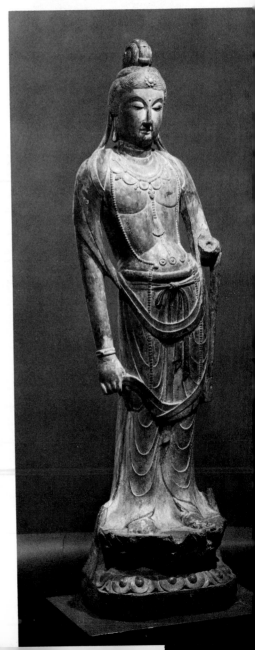

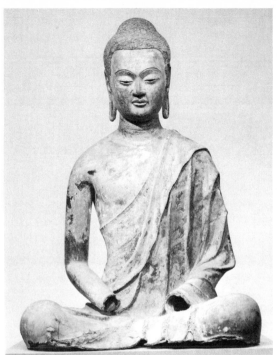

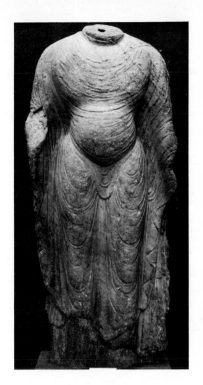

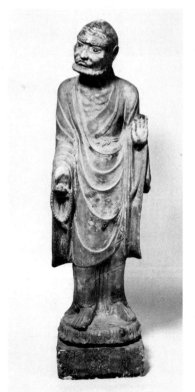

149. ABOVE LEFT: Buddha; Tang. *Metropolitan Museum of Art, New York.* (117, 165)

150. ABOVE RIGHT: "Udayana" Buddha; Tang. *Victoria and Albert Museum, London.* (110, 165)

151. RIGHT: Lohan; Chin. *Brundage Collection, de Young Museum, San Francisco.* (169, 173)

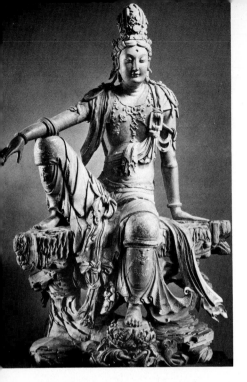

152. Kuan-yin; Sung. *Nelson Gallery–Atkins Museum, Kansas City, Missouri.* (117, 162, 220)

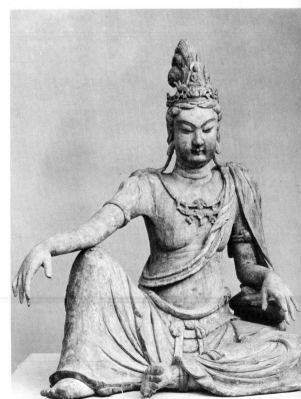

153. Kuan-yin; Sung. *Metropolitan Museum of Art, New York.* (117, 162)

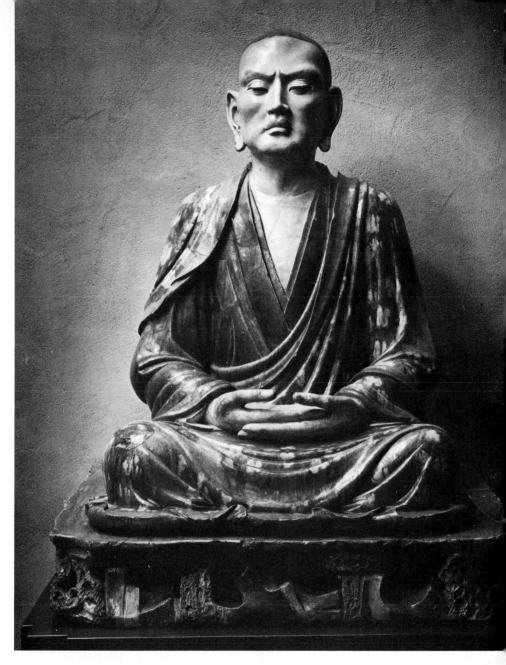

154. Lohan; Liao-Chin. *Nelson Gallery–Atkins Museum, Kansas City, Missouri.*
(118, 169, 173)

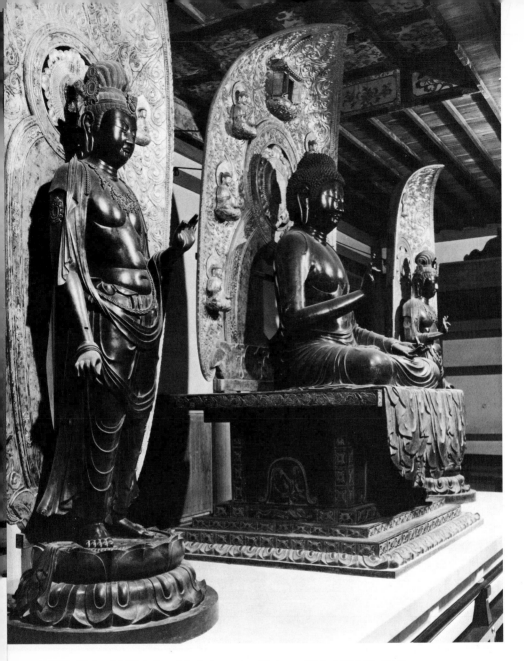

158. Yakushi Trinity. *M. Sakamoto, Tokyo.* (118, 180-181, 214)

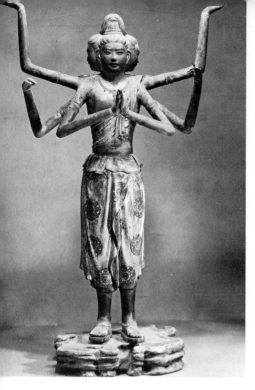

159. Ashura. *M. Sakamoto, Tokyo.*
 (118, 183)

160. Amida. *M. Sakamoto, Tokyo.*
 (113, 185, 186)

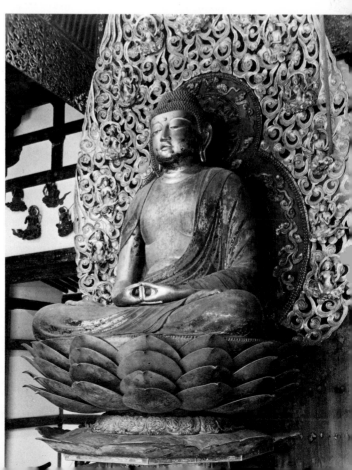

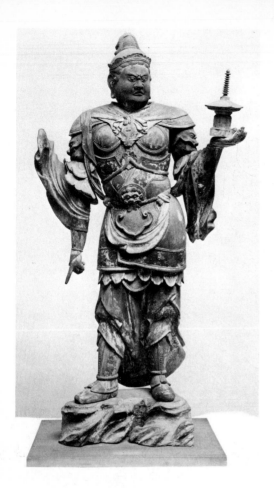

161. Bishamon-Ten. *Museum of Fine Arts, Boston.* (127, 183)

162. Guardian Figure. *Freer Gallery of Art, Washington.* (127, 187)

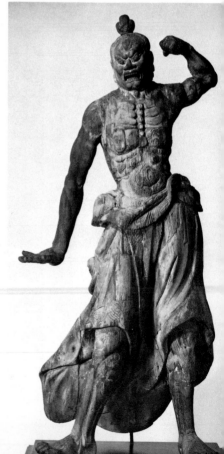

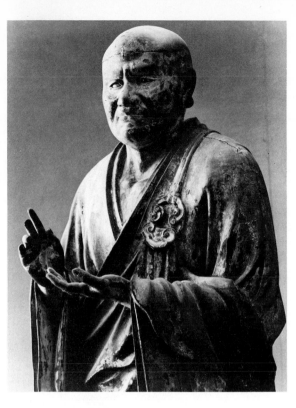

163. LEFT: Monk Seishin. *Japan Cultural Society (KBS), Tokyo.* (118, 187)

164. BELOW LEFT: Miroku. *Museum of Fine Arts, Boston.* (189)

165. RIGHT: Kannon. *Museum of Fine Arts, Boston.* (189)

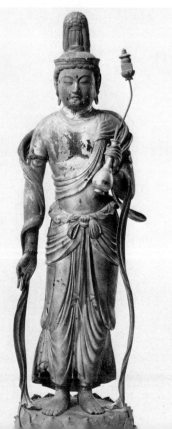

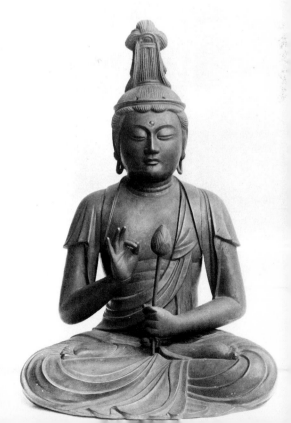

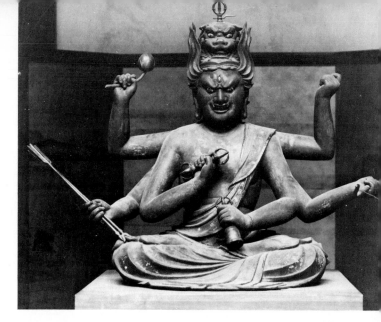

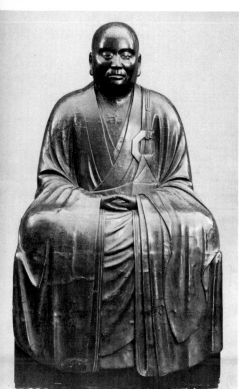

166. LEFT: Zen Abbot. *Metropolitan Museum of Art, New York.* (190)

167. ABOVE: Aizen Myo-o. *Museum of Fine Arts, Boston.* (190)

168. BELOW: Shinto Goddess. *M. Sakamoto, Tokyo.* (182)

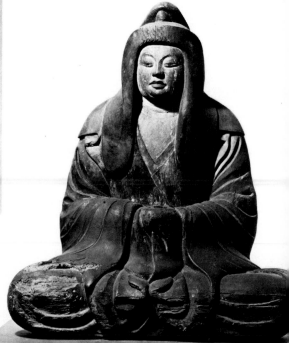

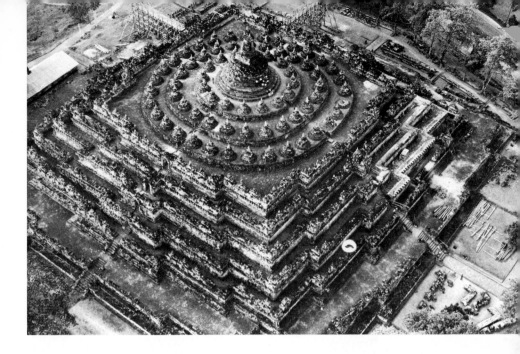

169. Borobudur; Java. *Eliot Elisofon.* (195-196)

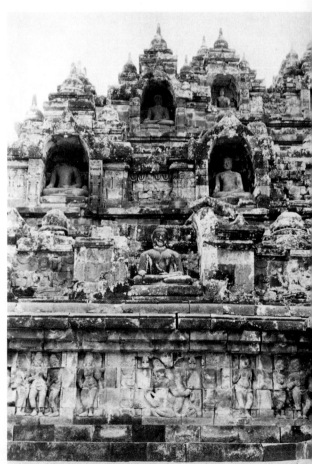

170. Borobudur (detail). *Eliot Elisofon.* (196)

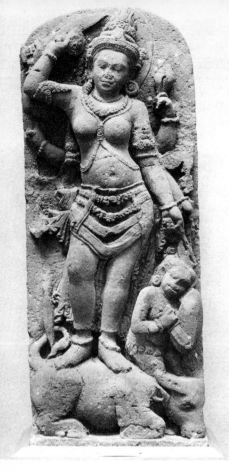

171. Durga Slaying the Buffalo De-
mon; Java. *Museum of Fine Arts,
Boston.* (135, 197)

172. Buddha; Mon. *Nelson Gallery
–Atkins Museum, Kansas City,
Missouri.* (110, 165, 199)

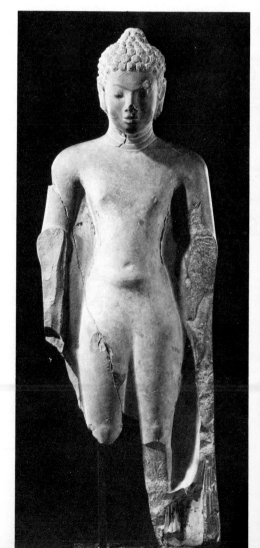

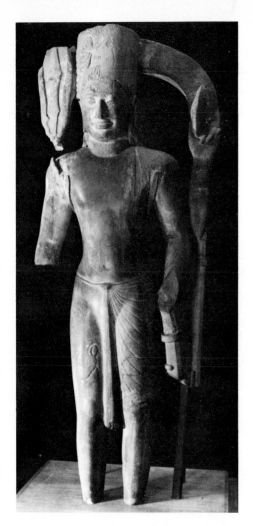

173. Harihara; Cambodia. *Musée Guimet, Paris.* (138, 200)

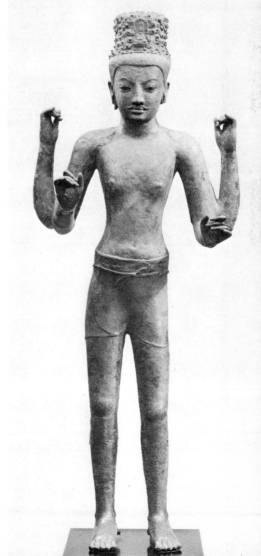

174. Avalokiteshvara; Cambodia. *Metropolitan Museum of Art, New York.* (202)

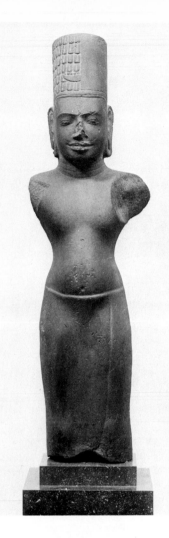

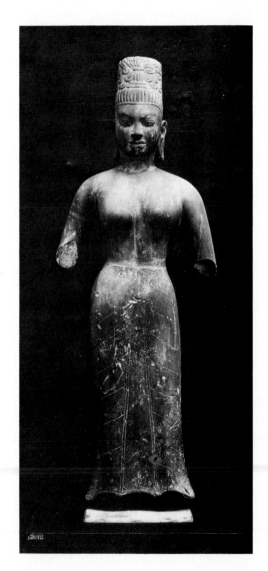

175. Harihara; Cambodia. *Museum of Fine Arts, Boston.* (138, 200)

176. Female Figure; Cambodia. *Musée Guimet, Paris.* (200, 202)

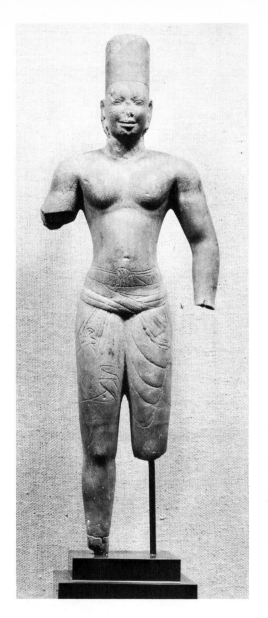

177. Vishnu; Cambodia. *Cleveland Museum of Art.* (39, 200)

178. Male Torso; Cambodia. *Musée Guimet, Paris.* (203)

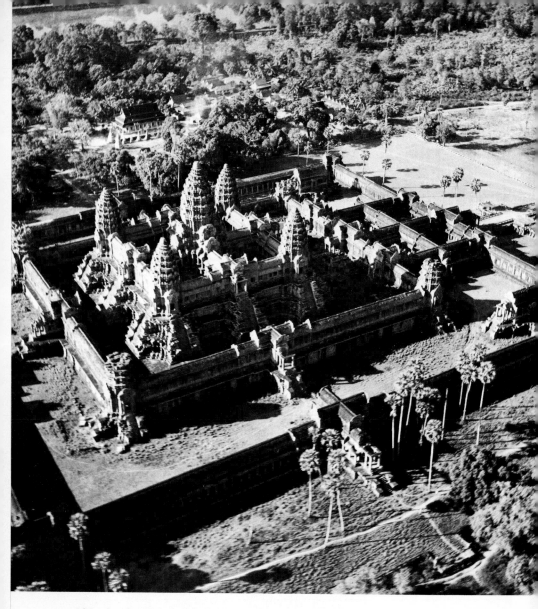

183. Angkor Wat; Cambodia. *Eliot Elisofon.* (205)

184. RIGHT: Buddha Protected by a Naga; Cambodia.
Musée Guimet, Paris. (206, 214)

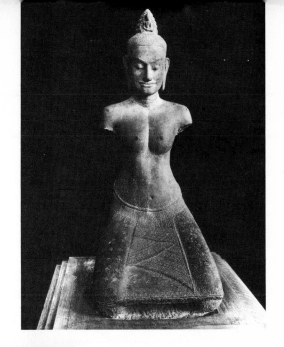

185. Kneeling Woman; Cambo-
dia. *Musée Guimet, Paris.*
(206)

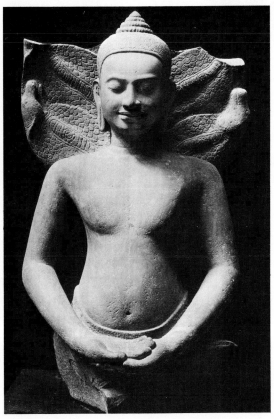

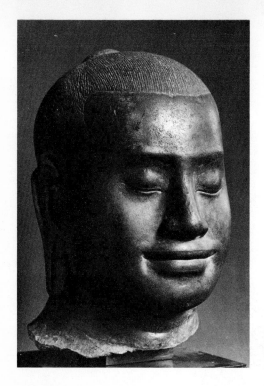

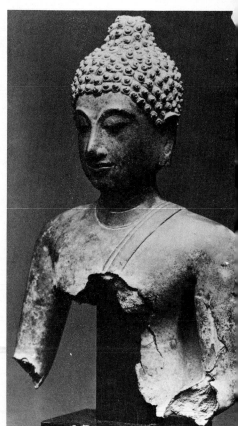

186. Jayavarman VII; Cambodia. *Musée Guimet, Paris.* (206)

187. Buddha; Thailand. *Musée Guimet, Paris.* (113, 208)

List of Illustrations

EACH entry gives, with respect to the object illustrated, the following: title or brief description; material of which it is made; present location (and, in some instances, the means of acquisition); region and date (often approximate) of origin; and, in italics at the end, the source of the photograph or other permission for reproduction. The name of the sculptor appears in italics at the beginning of some entries.

In this list the dates of sculpture are not labelled A.D. after the ninth century.

1. "Lady of Auxerre." Limestone. Paris, Louvre. Greek, c. 630 B.C. *Hirmer Fotoarchiv München.*
2. Hera of Samos. Stone. Paris, Louvre. Greek, c. 570 B.C. *Hirmer Fotoarchiv München.*
3. Kouros. Marble. New York, Metropolitan Museum of Art, Fletcher Fund, 1932. Greek, 615–600 B.C. *Courtesy of the Museum.*
4. Kouros ("Kroisos"). Marble. Athens, National Museum. Greek, c. 540 B.C. *Hirmer Fotoarchiv München.*
5. "Peplos Kore." Marble. Athens, Acropolis Museum. Greek, c. 530 B.C. *Hirmer Fotoarchiv München.*
6. Kore. Marble. Athens, Acropolis Museum. Greek, c. 525 B.C. *Hirmer Fotoarchiv München.*
7. Moscophoros (Calf-Bearer). Marble. Athens, Acropolis Museum. Greek, c. 570 B.C. *Hirmer Fotoarchiv München.*

Chronology

DEVELOPMENTS IN SCULPTURE AND
RELATED HISTORICAL EVENTS

Period	Europe	India
(Developments before the 6th century B.C. are not noted.)		
6th Century B.C.	*Greece* Archaic period in art Century of the *kouroi* and *korai*	Siddhartha Gautama Sakyamuni (the historic Buddha) c. 560–480 B.C. Vardhamana Mahavir (founder of Jainism) c. 599–527 B.C.
5th Century B.C.	Persian Wars 490–478 B.C. Persian sack of Acropolis in Athens 480–79 B.C. Periclean Age in Athens, mid-5th century B.C. Temple of Zeus, Olympia c. 470 B.C. Parthenon, Athens 447–432 B.C. *Myron, Phidias, Polyclitus* *Hanché* posture developed	
4th Century B.C.	*Praxiteles, Scopas, Lysippus* Alexander the Great 356–323 B.C.	Alexander reached northwest India Mauryan dynasty 321–184 B.C.
3rd Century B.C.	*Hellenistic World* Fall of Etruria to Romans After death of	Emperor Asoka ruled 273–36 B.C.; converted to Bud-

China	Japan	Cambodia

Lao-Tze (founder of
 Taoism) 604–
 517 B.C.
Kung Fu-tze
 (Confucius)
 551–479 B.C.

Han dynasty 206
 B.C.–A.D. 220

Period	Europe	India
	Alexander, major political and artistic centers develop at Alexandria, Antioch, Pergamon	dhism and encouraged its spread
2nd Century B.C.	Roman conquest of Greece completed 146 B.C. Laocoön, Venus de Milo, Victory of Samothrace	Sunga dynasty 185–72 B.C. Colossal *yaksha* of Parkham
1st Century B.C.	Copying machines first used for sculpture Beginning of Roman Empire under Augustus 31 B.C.	Great Stupa at Sanchi
1st Century A.D.	*Roman Empire*	Amaravati reliefs Kushan dynasty established c. 50
2nd Century A.D.	Height of development of sarcophagus as sculptural form	Buddha images appear in Mathura and Gandhara
3rd Century A.D.		
4th Century A.D.	Conversion of Constantine to Christianity 312 Capital established at Constantinople 330	Gupta dynasty 320–600

China	Japan	Cambodia
Chinese expansion to west and south under Hans		
		Probable founding of Kingdom of Funan
End of Han dynasty		
Growth of Buddhism		
Northern Wei dynasty 386–535 First flowering of Buddhist sculpture		

Period	Europe	India
	Sarcophagus of Junius Bassius c. 352 Proscription of pagan worship 380 Roman Empire divided into East and West 395	
5th Century A.D.	Sack of Rome by Visigoths 410 End of Western Roman Empire 476	
6th Century A.D.	*Western Europe* Dark Ages	Invasion of northern India by White Huns
7th Century A.D.	Dark Ages	Pallava dynasty in south India 600–850 Carvings at Mamallapuram
8th Century A.D.	2nd Council of Nicaea 787 (approved veneration of images)	Decline of Buddhism; supremacy of Hinduism Kailashanath Temple at Ellora Elephanta Caves at Bombay

China	*Japan*	*Cambodia*

Fa-Hsien's pilgrimage
 to India
Cave-temples of
 Yun-kang and
 Lung-men

China	*Japan*	*Cambodia*
Northern Chi dynasty 550–577 Sui dynasty 581–618	Introduction of Buddhism Prince Shotoku Taishi 572–621; Empress Suiko enthroned 593	First king of Chenla enthroned c. 550
Tang dynasty 618– 906 (China reunited) Hsuan-tsang's pilgrimage to India	Horyuji built in Nara 607 Downfall of Soga clan 645 Dedication of Yakushi trinity in Nara 698	
	Capital at Nara 709–784 Daibatsu dedicated at Todaiji, Nara, 752 Capital at Kyoto (Heian) from 794	

Period	Europe	India
9th Century A.D.		Chola dynasty in south India 850–1150
10th Century A.D.		
11th Century A.D.	Beginnings of Romanesque art Emperor Henry IV humbled by Pope Gregory VII at Canossa 1077	Temples of Khajaraho
12th Century A.D.	Royal Portal at Chartres Cathedral Beginnings of Gothic art	Hoysala, Pandya, and Vijayanagar dynasties in south India 1100–1565
13th Century A.D.	*Italy* *Nicola Pisano,* active 1258–78 *Giovanni Pisano* c. 1250–after 1314	

China	Japan	Cambodia
The Great Persecution of Buddhism 845		Khmer Empire established in Angkor region c. 800 Indravarman, 877–89 (founded first capital at Angkor)
End of Tang dynasty 906 Sung dynasty 960–1279	Fujiwara period 897	Classic period of Khmer art
	Ascendancy of Taira clan c. 1156–1185 Civil war between Taira and Minamoto clans 1180–85 (resulting in victory of the Minamoto) Kamakura period 1185–1333 Todaiji and Kofukuji rebuilt in Nara	Suryavarman II, 1113–50 (builder of Angkor Wat) Sack of Angkor Wat by Chams 1177 Jayavarman VII c. 1181–1228 (restored Angkor Wat and built Angkor Thom)
Yuan dynasty (established by invading Mongols) 1260–1368	Japanese "Renaissance"; master sculptors Unkei, Tankei, Kaikei, Saichi Mongol invasions repelled 1274–81	Spread of Hinayana Buddhism; end of cult of god-kings

Period	Europe	India
14th Century A.D.	*Donatello* 1386– 1466	
15th Century A.D.	Medici family become rulers of Florence *Andrea del Verroc- chio* 1435–1488 Constantinople con- quered by Turks 1453 *Michelangelo* 1475– 1564	
16th Century A.D.	Sack of Rome by Emperor Charles V 1527 *Giovanni Bologna* 1529–1608 Council of Trent 1545–63 (begin- ning the Counter- Reformation)	Moghul Empire established by Muslim Mongols 1526
17th Century A.D.	*G. Lorenzo Bernini* 1598–1680	
18th Century A.D.	French Rococo art Neoclassicists *Pigalle, Houdon, Canova*	
19th Century A.D.	*Rude, Barye* and *Carpeaux* in France *Auguste Rodin* 1840–1917	

China	Japan	Cambodia
Ming dynasty 1368–1644	Ascendancy of Ashikaga clan; beginning of Muromachi period 1334–1573	
		Angkor occupied by Thais; capital moved to Phnom Penh 1432
Ching dynasty (Manchus) 1644–1912		

Index

The titles of works of sculpture illustrated in the book appear in italics. Where page reference is to illustration alone, the number of the illustration appears in brackets.